Withdrawn

THOMAS
NAST

FIONA DEANS HALLORAN

THOMAS NAST

THE FATHER OF MODERN POLITICAL CARTOONS

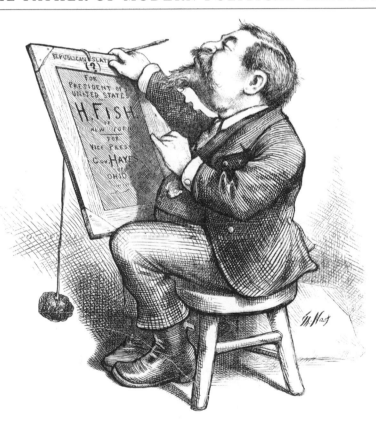

THE UNIVERSITY OF NORTH CAROLINA PRESS *Chapel Hill*

*Publication of this book was supported in part
by a generous gift from Crandall and Erskine Bowles.*

© 2012 THE UNIVERSITY OF NORTH CAROLINA PRESS
All rights reserved. Manufactured in the United States of America.
Designed by Sally Fry and set in Minion by Tseng Information Systems, Inc.

The paper in this book meets the guidelines for permanence
and durability of the Committee on Production Guidelines for
Book Longevity of the Council on Library Resources.

The University of North Carolina Press has been
a member of the Green Press Initiative since 2003.

Library of Congress Cataloging-in-Publication Data
Halloran, Fiona Deans.
Thomas Nast : the father of modern political cartoons /
Fiona Deans Halloran. — 1 [edition].
pages cm
Includes bibliographical references and index.
ISBN 978-0-8078-3587-6 (hardback)
1. Nast, Thomas, 1840–1902. 2. Cartoonists—
United States—Biography. I. Title.
NC1429.N3H35 2013
741.5′6973—dc23
[B]
2012024895

16 15 14 13 12 5 4 3 2 1

For Charles

CONTENTS

ACKNOWLEDGMENTS

Like any work of this nature, this book represents the contributions of many hands. I am grateful to a wide range of people who helped to make it possible and who supported me as I engaged in the research, writing, and revision of the manuscript. Joan Waugh was a model of cheerful patience, critical reading, professional supervision, and personal support during the years it took for this manuscript to be completed. As a mentor, she was equaled only by Joyce Appleby, who set a standard of intellectual, personal, and professional conduct that I hold ever before my eyes. Her support has been unstinting. Brenda Stevenson, Karen Orren, and Kate Norberg commented on my research and helped me refine my ideas. In particular, Kate Norberg's enthusiasm for the project convinced me that it would be great fun to research and write. Jessica Wang, Muriel McClendon, and Eugen Weber were ideal models of scholarly productivity, pedagogy, and collegiality. Thanks also go to Ellen DuBois, Richard Weiss, and Teo Ruiz for their influence on this work. There is no way adequately to thank Mark Summers for his detailed critique.

My colleagues at Bates College, Eastern Kentucky University, and Rowland Hall inspired and supported me as I worked to complete this book. At Bates, Karen Melvin, Margaret Creighton, Michael Jones, Dennis Grafflin, and John Cole generously shepherded me through my first year of teaching. At EKU, John Bowes was an exemplary colleague and friend. Tom Appleton, editor, scholar, teacher, raconteur, and gentleman, showed me how to approach the revisions on this book and understood its pressures better than anyone else. I extend many thanks to Chris Taylor, Brad Wood, Susan Kroeg, Jenn Spock, and David Sefton as well. In Salt Lake City, Kody Partridge welcomed me with open arms and helped to ease my geographic and professional transition. Linda Hampton assisted me with editing when this project seemed overwhelming. I am grateful to her and to all my colleagues at RHSM.

Archivists at a number of institutions provided much-needed assistance. The staff of the Huntington Library, in particular, is outstanding. Profes-

sionals at the New-York Historical Society Print Room, the Columbia University Special Collection library, the New York Public Library, the Houghton Library at Harvard University, the University of Minnesota Library, the Morristown Free Public Library, and the Rutherford B. Hayes Presidential Library went out of their way to support this research. I am grateful to all of them. I also wish to thank the Huntington Library Special Collections for the use of its varied and exceptional collection.

Research for this book could not have proceeded without financial support from the Huntington Library, the Gilder Lehrman Society, the Rothermere American Institute at the University of Oxford, and the National Endowment for the Humanities Summer Institute program. In addition, grants from UCLA's Department of History and support in the form of a junior faculty research grant from Eastern Kentucky University helped to advance the project.

I tender many thanks to my colleagues in the graduate community at UCLA, a large and varied group, ever changing, ever exciting, ever unpredictable. Lawrence Culver, Megan Barnhart Sethi, Sara Hendren, and Chris Bray deserve special thanks. The members of a reading group—and Christopher Bates and Ruth Behling, in particular—provided careful, detailed critiques of early chapters. Miriam Hauss Cunningham, friend and colleague, has been a staunch supporter, cheerleader, and sounding board for years. She has applauded all my successes and empathized with all my failures, as only a true friend can do.

In the course of researching this book, I have enjoyed the hospitality of many friends. Mary Ellen Colton and Barry Bluestone gave me a place to stay while I explored the Houghton Library. Bart Gamber and Tony Kelly entertained my husband and me, showed us Buckinghamshire and Bedfordshire, and helped us to relax after weeks spent in the Rothermere American Institute Library. In Maine, Mrs. Anne Cushman offered me charming company, a quiet nook for writing and reading, and even canine companionship. The collection of her late husband, Bigelow Paine Cushman, proved invaluable to my research. I hope this book honors the scholarship Professor Cushman intended to pursue regarding his grandfather, Albert Bigelow Paine.

At the University of North Carolina Press, Sian Hunter welcomed, guided, and shaped the first version of this manuscript. Her reassurance and enthusiasm reinforced my confidence when it sagged. Charles Grench assumed the reins of the project in 2009, and has helped to bring it—finally—to completion. Many thanks to both. Sara Jo Cohen deserves spe-

cial thanks for her wide-ranging administrative abilities. She solved problem after problem, kept me informed, and generally operated as a friendly contact when I needed one.

To the readers who consistently enthused about the writing, research, and originality of the book, many, many thanks. "Brilliant!" they said. "Outstanding!" they said. And not just because they are my parents. If, in fact, the story I tell here is brilliant and original, it is largely a tribute to the love and encouragement they've provided. John and Nina Halloran offered steady and confident encouragement throughout the long process of revisions. To them, my thanks.

My husband, Charles, always my most stalwart advocate, was a useful sounding board. He lent a critical eye to the editing process and continued to support the manuscript despite the time it took to reach completion. He agreed—twice—to live away from home for an entire summer in support of this book. Without his love, understanding, and encouragement, this project would not be what it is today. Nor would I be.

The more I worked on this project, the more I understood why authors insist that there are errors in almost all historical works. Mistakes sneak in, and one edits knowing that somewhere in the text lurk errors, waiting to appear when it is too late to correct them. Although this book is the product of many hands, any errors in it are my own.

THOMAS
NAST

From Five Points to
Frank Leslie's Illustrated News

Thomas Nast enjoyed the knowing wink. To his biographer, Albert Bigelow Paine, he told a version of his early life. Another version, more complete but less charming, lay within the reach of any knowing reader. Between the two lay not only Nast's experiences, insofar as they can be reconstructed, but also his lingering discomfort with the world that produced him. By the time Nast, born September 27, 1840, won his first job, he knew more of New York's streets than he cared to admit. But the streets forged him. In his work as an artist and a political analyst, Nast's New York remained a potent force throughout his life.

Albert Bigelow Paine published his biography of Thomas Nast in 1904.[1] It was the outgrowth of a series of conversations between Paine and Nast begun at the turn of the century at the Players Club, a Manhattan gentleman's club. The two men, Paine, forty-one years old to Nast's sixty, met when Paine provided Nast with a copy of his first book. Nast complimented the novel and invited Paine to join him before the fire, where the two enjoyed a long talk. Paine had been an admirer of Nast since childhood, and the cartoonist enjoyed his enthusiastic praise. Nast asked whether Paine would agree to write his biography, and Paine agreed.

Paine began to meet with Nast, examine his papers, and compile information about his life. Many of the stories in Paine's earliest chapters recount memories found nowhere in Nast's extant papers, and their tone and pacing suggests a conversation rather than a documentary source. Paine used no footnotes, so determining the source of many of his quotes is impossible, but a reader can hardly help forming the impression that much of the material on Nast's childhood came directly from the artist. In addition, the small number of printed interviews and biographical sketches published during Nast's lifetime are consistent with the facts as they appear in Paine's book, but they lack the detail provided by Paine. Virtually the only information available regarding Nast's first fifteen years appears in the 1904

biography.[2] Nast's voice emerges through Paine's text, and the Paine book represents Nast's life story as Nast chose to tell it.

Thomas Nast was the last child of Appolonia Abriss and Joseph Thomas Nast. The elder Nast played the trombone in the Ninth Regimental Band at Landau, in the kingdom of Bavaria.[3] Nast's birthplace, the Red Barracks, is now a part of the University of Landau. Information about his family is difficult to find, but a few facts are known. Nast was the only boy in his family when he was born, but there apparently had been two older brothers, both of whom were dead. Visits to their graves lingered in Nast's memory enough for him to mention the smell of the box hedges (planted to outline each grave) to Paine almost sixty years later.[4] A sister survived, apparently Nast's only sibling. Despite Nast's deep commitment to family later in life, this sister appears briefly in Nast's earliest memories, then disappears forever from his life story.[5]

Many of the memories Nast provided to Paine at the turn of the century reflect an early childhood of great warmth and pleasure. In recognition of the toy soldiers Nast fashioned from the wax his mother provided, women in apartments upstairs lowered cookies to him on a string. At Christmas, a kindly, bearded gentleman in a fur coat played the part of Pelze-Nicol, or St. Nicholas, walking from door to door distributing sweets to children. Nast's memories of Landau all seem to have been suffused with a sense of dreamy nostalgia. However, not all of Nast's childhood experiences could have been so positive.

In 1846, political uncertainty in Bavaria intruded on the Nasts. The commanding officer of the Ninth Regiment warned Joseph Thomas Nast that he should leave the area before his politics caused trouble. Bavaria, like much of Europe, faced a struggle between a highly educated, politically liberal reform movement and the entrenched power of the aristocracy and military. These tensions erupted in revolution all across the continent in 1848, and Joseph Nast's political beliefs, too freely expressed, might have posed a problem. In response to the warning from his superior officer, Joseph Nast decided to leave Bavaria. According to Paine, the senior Nast joined an American merchant marine vessel. Appolonia Nast, six-year-old Thomas, and his sister departed for Paris, where they found places on a ship bound for New York.[6]

Despite a bout with what may have been malaria, Thomas Nast weathered his transatlantic voyage well, arriving at the Verrazano Narrows in midsummer. His first view of New York was impressive enough to prompt

the decisive child to comment that he was "glad he came."[7] Appolonia Nast found her family a home on Greenwich Street, on the west side of Manhattan Island, and enrolled Nast in an English-speaking primary school.[8] Unable to understand the language, Nast found the experience terribly confusing. He remembered other children "mischievously" directing him hither and thither, including a boy who sent Nast to line up with other children who were about to be spanked. Unable to explain himself, Nast endured a spanking with the others. He rushed home at lunch and refused to return to school. Mrs. Nast, hoping to find a more congenial place for her family, moved east to William Street.

At his new school, Nast spoke German with students and teachers. Even so, he concentrated more on drawing than on academics, using crayons given to him by a neighbor. Not only did he draw at school—his "desk . . . was full of his efforts and the walls of the . . . house on William Street were decorated with his masterpieces"—but he also pursued opportunities to draw throughout the city.[9] Fires attracted his attention, and he often chased the engines of Company Six when they left the station to fight a fire.[10]

Nast's family re-formed in 1850, when Joseph Nast finally returned from the sea. He found work with the Philharmonic Society and the band at Burton's Theatre. Thomas went with his father sometimes, drawing the band in his sketchbook. His sketchbook seems to have been the only object of much interest to Nast in this period. Although he attended two German-speaking schools and an "academy" on Forty-seventh Street, none could hold him for long. Nast's parents hoped that he could become a better student, but their hopes were eternally frustrated. By 1854, Nast convinced his parents that art was the only path for him.

From this point on Nast studied drawing and painting. His first formal training was with Theodore Kaufmann, a German American painter who taught young artists in his studio on Broadway. Paine implies that Kaufmann took Nast as a pupil in part because of their shared German heritage. Although the German immigrant community in New York was large, widely distributed, and constantly shifting, it supported German-speaking schools and churches, bars, and newspapers.[11] These community organizations suggest that Nast's parents may have hoped for a friendly reception for their talented son. All his life, Nast struggled to be punctual, civil, and focused, but there is no mention of these challenges with regard to his study with Kaufmann, who became Nast's first mentor. Rather than a struggle, artistic study seems to have been pure pleasure for Nast. Kaufmann taught

Nast to copy great works in local museums and to draw from life in the studio. He learned techniques for drawing, painting, and composition from peers, masters, and the simple repetition of studio work.[12]

Lessons with Kaufmann alone did not satisfy Nast for long, however. After only six months, Nast moved on.[13] Like many artists, he sought training in a variety of venues. He moved on, first to other mentors, then to classes at the Academy of Design on Thirteenth Street.[14] As part of his training, he, along with other students, visited local museums and galleries, copying the paintings hanging there. Nast especially liked the paintings in the collection of Thomas Bryan, a wealthy New Yorker. Copying the works on his easel, Nast attracted admiring attention. Bryan noticed the young artist, and helped Nast earn pocket money by allowing him to collect the entrance fees of visitors. Nast enjoyed his training at the Academy, and his sideline at the museum was lucrative, but he sought a more permanent position with a steadier income and new artistic challenges.[15]

Illustrated weeklies offered both. Like newspapers in their content and appearance, periodicals like *Frank Leslie's Illustrated News* and *Harper's Weekly* differed from newspapers in a few respects. First, they relied directly on illustration to supplement written content. Second, they included fiction, fashion, health information, and poetry in addition to news. Finally, like magazines, the new weeklies served purposes other than disposable news delivery. For example, they frequently printed drawings, lithographs, and engravings intended for display on the walls of readers' homes, similar to today's poster art.[16] Nevertheless, weeklies directly addressed news, printing sensational stories alongside reports on domestic and foreign political affairs. Because of this ambiguity, and because contemporaries used the two terms interchangeably, the words "magazine" and "newspaper" both apply to these publications.

The first illustrated weeklies, founded in 1851, were *Gleason's Pictorial Drawing Room Companion* and the *Illustrated American News*. On December 15, 1855, Gleason's employee Frank Leslie, born Henry Carter, founded *Frank Leslie's Illustrated News*.[17] *Leslie's* became an immensely popular paper, with circulation of 160,000 in 1860 and a sixty-year lifespan. Only *Harper's Weekly*, founded in 1857, matched it. However, when Nast noticed *Leslie's*, it was still brand-new, vying for readers in an environment of cutthroat competition. The paper sold for ten cents, contained a variety of materials, and relied directly on illustration for its sensational content.[18] Readers devoured the illustrations of city fires, scenes of local life, and portraits of dignitaries.

Leslie's employed two kinds of men to create illustrations: artists and engravers. First, the artist drew the scene, either from life or memory. Then, provided with the sketch, an engraver (or, later, a team of engravers) carved the drawing onto a block of soft wood. The block was used to print the illustration, and the engraver required substantial skill to carve it. Illustrations, then, emerged from a physical and creative interaction between artists and engravers. Both brought specialized skills to the print room. Frank Leslie, his newspaper growing constantly, needed talented young men to create illustrations for the paper. He recruited them from other periodicals, sought them among local artists, and hired them when they appeared on his doorstep. In 1856, Thomas Nast became one of those men, at the tender age of fifteen.[19]

Even at the end of his life, Nast bragged about the way he talked his way into the job with Leslie. He simply presented himself to the owner, offered sample drawings to demonstrate his talent, and insisted on a job. Leslie hesitated but allowed Nast to take on a trial assignment: drawing a ferry on a busy morning. James Parton, a historian and a cousin of Nast's wife, told Paine that Leslie never intended to hire Nast. Leslie told Parton that he "gave him the job merely for the purpose of bringing home to his youthful mind the absurdity of his application." But Nast surprised the editor, producing an excellent drawing with energy, exactitude, and engaging detail. Like most of the editors of his generation, Leslie worried about profit. Recognizing Nast's talent, and despite the boy's age, Leslie hired Nast for four dollars a week.[20]

With the job at *Leslie's*, Nast's childhood effectively ended. He remained employed full time from 1856 until he left *Harper's Weekly* in 1887. It is here, then, that we can pause to examine critically the themes of Nast's version of his early life and its omissions. The themes interconnect, and they are suggestive of some of the contradictions in his later work. The omissions indicate the past Nast preferred to ignore. Emphasized most powerfully in Nast's personal history were a set of ideals that Nast believed to be at the heart of the American dream. Secondarily, a romanticized version of Nast's immigrant community and his family undergirded his narrative. Finally, the glaring omission of any open discussion of his family's religious faith and the ethnic content of his childhood neighborhood point toward the complexity of his later views regarding many ethnic, religious, and political groups.

For Nast, the American dream was a tangible fact, not an interpretative framework. While historians associate the term and concept with the twen-

tieth century, the conviction that American national identity carried with it economic and educational opportunities and the possibility of property ownership far predates the term itself. Nast's personal allegiance incorporated both American nationalism—particularly as opposed to Confederate nationalism—and German ethnic identity. In his life and work, Nast both embraced his immigrant status and insisted upon the essentially American nature of his politics and loyalty.[21]

As his artwork was to make clear, Nast believed quite literally that an American had freedoms and opportunities denied to the vast majority of the world. He would have defined the American dream with reference to these opportunities, much as he defined his own narrative by emphasizing them. The story of his childhood points directly to the possibilities available to immigrant children. Two examples illustrate this point. First, there is the question of Nast's literacy. He stated outright that he could speak no English when he arrived. Although his mother transferred young Nast to a German-speaking school, he never thrived academically. Rather than interpret this in negative terms—as confusing, frustrating, or limiting—Nast chose to emphasize instead his artistic talent. School was irrelevant, in this reading, because what mattered was Nast's ability to transform the vibrancy of the city around him into beautiful, commercially useful illustrations. Second, the confusion of the streets around him was made not threatening but exciting, not dangerous but stimulating. The scenes he witnessed on the street provided Nast the raw material necessary for any artist.

Rather than the scene of poverty, crime, and violence that the city often was, he remembered it as the rich vein of experience from which he could draw to advance his own interests. Specifically, his practice of following fire wagons points to this interpretation, because rather than remembering the devastation of fire in a neighborhood of wooden homes, Nast recalled the excitement of running after the wagons, the heroism of the firemen, and the pleasure of creating drawings of their exploits.[22] Clearly, a powerful sense of opportunity and optimism suffused Nast's personal narrative. It was central to how he understood his own childhood, and how he explained his rise from obscurity to fame and wealth.

By emphasizing the opportunity available in America, Nast did not completely erase his own immigrant experience. Instead, he controlled it by romanticizing it. The fears we can imagine accompanying his experiences of a new school, a foreign language, and a new group of classmates subsided in telling the amusing story of Nast's undeserved spanking. The classic immigrant problem of housing—overcrowding, dirt, danger from the environ-

ment and one's neighbors—reappeared as an exciting environment full of kindly strangers. Nast left out his immediate neighbors in favor of emphasizing his relationships with prominent German artists like Theodore Kaufmann. Likewise, he chose not to remember the angry clashes between immigrants and "native" Americans, emphasizing instead his role as protégé to the wealthy art collector Thomas Bryan.

To be a German immigrant was to buy German cakes at the corner store, to attend a German school, and to apprentice with a German master artist. This romantic memory rewrote Nast's familial situation as well. The absence of Nast's father seems to have been hardly any trouble at all, and his return is couched in terms that ignore any dislocation, resentment, or confusion. The frustration Nast's parents must have felt with his failure at school was explained away almost humorously, with the Nast parents simply capitulating to Thomas's artistic interests.[23] Any hint of tension, poverty, or obstruction of Nast's artistic destiny was erased. For a reader of Paine's biography, this might be less obvious if Nast's family made any appearance in his later life. After his marriage in 1861, however, they simply disappear from the story, never to be seen again. Nast's father's death in 1858 or 1859 is mentioned but merits no comment, and even in Nast's personal papers, there is almost no mention of any family member for the rest of his life.[24] The contrast between his idyllic description of his childhood and this erasure is intriguing but unexplained.

Nast's romantic view of life as an immigrant, in relation both to the community as a whole and to his own family, is nothing new. One reason that biography and autobiography are often suspect as historical evidence is that they tend to emphasize success and reward rather than failure and want. But for artists, self-presentation, even in the suspect medium of autobiography, is an important component of artistic vision. The questions are, how does the artist see himself, and how does that perception affect his work? In terms of national identity and patriotism, art used to advance a national agenda engages in cultural nationalism. If Nast used his illustrations in this way, understanding precisely where he stood with regard to the tropes of national identity and patriotic sentiment matters. Thus, Nast's edited life story offers both insight and frustration to anyone interested in the style and content of his illustrations.[25]

The most glaring omission of his narrative was religion. Later in Nast's life, religion became vitally important, especially to his attacks on Irish immigrants and Roman Catholics of all nationalities. To understand his drawings, and to interpret his opposition to Catholic Americans, it would

be helpful to know Nast's religious history. There are two hints in Paine's account that suggest the Nast family was Roman Catholic. First, an early anecdote Nast related to Paine includes a scene Nast observed while at Mass, and, second, a later passage notes that Nast disliked German school because he was required to confess. He "regard[ed] his sins as too many and too dark for the confidences of the priest's box." Nast's rejection of the scholarship and discipline of school may also have manifested itself in his rejection of Catholic doctrine and practice. Paine relates a tale from 1850 in which Nast snuck out of church to cut an interesting poster off a nearby wall.[26] Nast's neighborhood was a mixture of nationalities, religions, and ethnicities, but the vast majority of his neighbors were Irish Catholics. If his own religion was the same as theirs, what was his contact with the Irish population? This is a difficult question to answer in light of the spotty evidence. If Nast's parents were Roman Catholic, and if Nast was raised in the church, he gave no sign of sympathy with it later in life.

Biography and autobiography defy the simple characterizations of truth and fiction. Instead, the lines between what was and what the subject wished for blur. In Nast's case, the realities of his immigrant childhood retreated in the face of an idealized version of the 1850s on William Street. His faith, his family, and his neighbors morphed into the community he wanted them to be. What follows is a description of the neighborhood as we now *know* it to have been, and the picture is very different from the one Nast painted.

The Neighborhood

Emigration to the United States was often difficult and confusing. Settling into a new neighborhood, surrounded by unfamiliar languages and customs of every sort, could be even more so for a small boy. The two homes Nast occupied during this period, from 1846 until 1855, provide vivid examples of the dynamic environment into which he had been thrust. The first neighborhood, surrounding the Greenwich Street house, was somewhat more genteel, but the Nasts occupied it for only a short time. The second, near the northern end of William Street, plunged Nast into a teeming jungle of crime, commerce, and colorful humanity. Surrounding William Street was a culture of immigrants: Irish, German, Italian, Jewish, Catholic, and Protestant.

The first Nast home in New York is identified only as a house on Greenwich Street, which Paine says was lined with "respectable dwellings."[27] Greenwich Street is quite long, stretching from Second Place, almost at

Manhattan's southern tip, all the way north to Fourteenth Street, almost fifty blocks today. If one were to walk the street from its southern origin all the way to its terminus today, one would pass through the financial district, Battery Park City, Tribeca, and the far western boundaries of Little Italy and SoHo, finally arriving in the West Village. Neither Nast nor Paine specified where along diverse Greenwich Street the Nasts settled. Given the fire of 1835, which burned much of lower Greenwich Street, and the rural nature of New York above Chambers Street, where city hall is today, it seems likely that they found a house in the middle of Greenwich Street, closer to Wall Street than to the Battery. Typical Greenwich Street homes, usually built of wood and standing a little more than two stories high, were disappearing in the 1840s. The advent of iron building materials, and the expanding wealth and commerce of the city, led to a building boom for warehouses and factories, many centered on Greenwich Street. The fire of 1835 wiped out many of the residential buildings of this area, leading landowners to rebuild larger and more commercially useful structures with newer materials. As a result, the Nasts likely found their new neighborhood rather unwelcoming for small children. The number of residential properties diminished with every year, and the streets were increasingly busy with horse-drawn traffic, both passenger and freight. Nast explained their move to William Street partially in terms of his mother's search for a German-language school, but it may also have related to this tension between the older nature of the Greenwich Street neighborhood and its growing commercial atmosphere.[28]

A second possibility for the residence at Greenwich Street is suggested by Howard B. Furer in his book on German America. In the 1850s, Germans established boardinghouses on Greenwich Street. Here, poor or destitute immigrants sought temporary housing while they found work. It is possible that Mrs. Nast moved her family into an earlier version of these boardinghouses. However, there are reasons to think this unlikely. First, Paine clearly implied that Appolonia Nast obtained a house, and that the area was more genteel than poor. However, he made the same claim about William Street, with only partial accuracy. Second, it is unclear exactly when these boardinghouses appeared, but they may not have been available on Greenwich Street in the 1840s, when German immigration was considerably slower than in the late 1840s and early 1850s. Because of the rapid change in the street, its residential spaces may still have been single family occupied when Mrs. Nast arrived. Finally, the fact that Thomas Nast was placed in school immediately suggests that Mrs. Nast was prepared to settle permanently on Greenwich Street, something more consistent with Paine's

assertion that Mrs. Nast moved her family into a private house. Overall, it seems more likely that she moved into a small home and then sought a new one when the school and street proved unsatisfactory.[29]

William Street, by contrast, was a genial mix of residential, artisanal, and small industrial use.[30] Paine says that the Nasts found a house on William Street near Frankfort, a cross-town artery now paralleling the Brooklyn Bridge.[31] William is one of the oldest streets in New York, formerly called Smith Street, and it stretches from South Street, along the East River, up to Beekman Street, ending in a T with Spruce Street.[32] Frankfort is one block north of Spruce, so we can assume that the Nast house sat near the end of William Street, just southeast of Park Row. Six blocks south was Wall Street, center of New York's financial district, and a few blocks north was Franklin Square, the center of newspaper production for the city.[33] Broadway, then as now one of the most important streets in the city, ran two blocks west, and in either direction it offered a wealth of the city's most innovative delights, including shopping at the new "department" store.[34] The German artist Kaufmann's studio was on Broadway, and the Academy of Design was at Thirteenth Street, just off Broadway. Most importantly, most threateningly, was the slum Five Points, which lurked one block west and five north, well within walking distance for a small boy.

It is unclear exactly when Nast moved to William Street, but Paine implies that it was soon after the family arrived in New York. He was certainly there when his father returned in 1850. The story of his father's return illustrates, in part, the way Nast edited his past for history. As Nast told the story, his mother knew that his father was coming, and sent her son for a celebratory cake. Thomas bought the cake at the bakery on the corner and was returning with it when he was accosted in the street. A strange carriage pulled out of traffic, a man leapt out and grabbed Nast, dragging him into the carriage and clasping him tightly. Initially, Nast was terrified, and also concerned about the cake, which was squished between them. He realized after a moment, however, that the man was his father, and they arrived home together. In Paine's telling, this story oozes charm, with the ruined cake, the tender father, and the reunited family. But in its detail it also betrays some of the pleasures and anxieties that must have affected life on William Street.[35]

Young Thomas's errand sent him down the street to a German baker for cake his father would enjoy—something to remind him of Bavaria. We already know from Paine that Mrs. Nast chose her home for its German-friendly neighborhood, but it is worth examining the businesses and resi-

dents on William and surrounding streets to see exactly what kind of immigrant world young Nast encountered on his brief walk to obtain his mother's cake. Commercially, socially, and politically, immigrants and the working poor dominated it. Reading Paine's book in 1904, a reader might have found Nast's reunion with his father charming and funny. But the element of fear was real, and it is worth a second look. With Five Points only a few blocks away, no child on William Street could be ignorant of the dangers surrounding him.

The baker on the corner probably served a clientele almost exclusively of Germans. He may even have chosen his building specifically to be near William Street, or even one side of the street. This was because the immigrant communities of lower Manhattan, especially near the central junction known as Five Points, tended to cluster by ethnicity, religion, and even point of origin. Entire buildings, sides of any given street, or whole blocks were often given over to a single ethnic immigrant group. The dominant group was the Irish, comprising more than two-thirds of the area's inhabitants. Native-born Americans comprised about 10 percent of the adult population. Germans numbered almost 15 percent, while small numbers of Italians, English, Poles, Scots, and non-German Jews made up the rest.[36]

Among German immigrants, two differences mattered. First was religion, which divided the group into three parts: Jews (about half of the German-speaking population), Catholics, and Protestants. Second was region. Most of the Jews originated in a part of what is now Poland but was then Prussian territory. More than half of the Christian Germans emigrated from either Baden-Wurttemberg or Hanover. Nast's family, from Bavaria, joined the smaller group of Christian Germans originating in Bavaria, Saxony, and Westphalia.[37] So the German baker from whom Nast bought his cake might easily have chosen to establish his business on that particular corner for the same reason that Mrs. Nast chose to live on William Street: there was a populous German-speaking community there, and it was growing all the time.[38]

Germans first came in large numbers to what became the United States in the eighteenth century, but by the early nineteenth century, they remained a small minority of American citizens. During the next 100 years, by contrast, the population of German-speaking Americans, mostly immigrants but also their children, exploded. In 1854, the peak of the wave, more than 200,000 Germans joined the American population.[39] That year was the peak not only of pre–Civil War German immigration but also of immigration by refugees of the Revolutions of 1848 in Europe. Although they are

often called "Forty-eighters," and so they called themselves, many of these immigrants came after the wave of revolutionary conflicts.[40] Nast and his family were among the first to leave, having been warned of the coming conflict and unwilling to be hostages to fate. Others delayed, more committed to social and political change or fearful of leaving their homeland. Beginning in 1850, many Germans who fought for liberal reforms, especially in Bavaria and Prussia, abandoned their fatherland for the friendlier shores of America. Thus, when Nast arrived in New York, it was to a thriving and growing German community, but as he aged, that community grew enormously.[41]

Not only did the total number of Germans grow in the early 1850s, the tenor of German American life in New York shifted as well. The Forty-eighters immediately asserted their moral, political, and social leadership. In contrast to the early German community, which spoke low German and derived from the working and farming classes, the Forty-eighters spoke high German, held university degrees, and believed themselves to possess moral authority as a result of their fight for liberal values in Germany. Indeed, they had to exploit these advantages because many of them had no other skills with which to make a living in America.[42]

In the existing German American community, however, the arrogant superiority of the Forty-eighters provoked resistance. Rival newspapers, political positions, and neighborhood landmarks delineated the conflict between the older Germans in New York and the new arrivals. Thomas Nast, by this time engaged in his art education and constantly on the prowl for new images and ideas, must have observed the tension. Even if he ignored the political and literary exchanges—which was possible given his youth and poor reading skills but unlikely given his incessant curiosity—he would have seen the massive growth in population, the creation of leftist political clubs, and the parades staged by Forty-eighters in support of their ideals.[43]

Socially, the neighborhood around William Street was as diverse as its population, yet it still reflected the challenges of the immigrant experience. William Street seems to have been somewhat more genteel than the streets immediately north of it, but it was within easy walking distance (only a few blocks) of a warren of the most terrible slums in America: Five Points.[44] For many immigrants, arriving at Castle Gardens with almost nothing (or, in the case of some Irish immigrants, absolutely nothing), it was in this neighborhood that they found cheap rents and readily available, albeit low-paying jobs. Immigrants with slightly more money often chose to remain

close to these neighborhoods, remaining connected to an ethnic enclave while living a few blocks away in a slightly nicer area. Thus, the immigrant experience could encompass a variety of lifestyles while remaining connected geographically, culturally, and economically. Even if Mrs. Nast managed to obtain a house of her own, and even if she had enough money to keep her family in relative comfort, she was surrounded by examples of the possibilities and perils of immigration. In addition to the artisans and factories mentioned previously, washerwomen, rag-pickers, alcoholics, and beggars shared the streets just north of William Street with prostitutes, pickpockets, and other petty criminals.[45] Frankfort Street, slashing east/ west on a northbound angle from the river, might have provided a partial barrier to this terrible scene of deprivation and vice, but it did not keep little Thomas Nast from roaming.[46]

What might he have seen? We know of several places he walked through references in Paine's biography. First, Nast was once caught trying to cut a poster off of the wall of a brick building at the corner of Houston and Eldridge Streets. Second, Nast remembered admiring the lithograph of a tiger's head, the same tiger used by Engine Company Number Six, in a shop on the corner of James and Madison Streets.[47] The company itself, informally known as "Big Six," occupied a brownstone on Hester Street near Gouverneur Street.[48] We also know that Nast attended art classes with Theodore Kaufmann, whose studio on Broadway required Nast to cross Park Row, about four blocks, and then travel along Broadway a few blocks. The Academy of Art, at Thirteenth Street, was a far longer distance, closer to twenty-five blocks. In walking to the Academy of Art, Nast traversed practically the entire north/south axis of the city center as it then existed.

In this space, between Broadway to the west and Thirteenth Street to the north, bounded by the river on the east, Nast could have witnessed practically everything for which New York was famous. On Park Row, three or four blocks west, genteel families occupied lovely brick homes. Gradually, wealthy New Yorkers were moving uptown, but in the 1840s and 1850s, plenty of impressive homes remained the property of the well-to-do. Crossing Chambers Street toward what is now Foley Square would have taken Nast into Five Points, a very different atmosphere. Filthy, crime-ridden, and prone to disastrous fires, Five Points was coming to symbolize the slum to all city-dwellers. It was also the center of Democratic politics among Irish New Yorkers, and it therefore contained all the detritus of nineteenth-century political life. Handbills decorated buildings, and party stump speakers occupied corners. Bars hosted the distributors of political

patronage. Party operatives escorted newly arrived immigrants to available housing and employment in exchange for political support.[49] Between these two extremes lay the vast majority of the neighborhood, immigrant and native-born alike. Business owners and workers traveled New York's streets daily, on their way to and from work, selling goods and services. Nast could have observed various artisans at work, including shoemakers, bakers, tanners, and printers. He could have purchased almost any commodity in almost any quantity, if he had money of his own to spend. In short, he lived at the beating heart of New York's growing commercial power.

That heart rarely rested easy during Nast's childhood. The anecdote Nast told about his father's return from the sea recounted his terror at being snatched from the street by what he took to be a stranger. His fear, minimized by Paine, must have been very real because danger, whether in the form of stranger, neighbor, or friend, was a constant presence on and near William Street. Nativist riots, race riots, drunken brawls, and simple crime would have been all-too-familiar concerns for the Nast family.[50] One explanation for Nast's silence regarding the darker side of his neighborhood would be that he rarely experienced it. If this were true, he would hardly be expected to dwell on it in his memories.

However, it is hard to imagine that this was so. We already know that Nast walked to school, to art classes, and on errands for his mother. The Academy of Art was far uptown, in a city that virtually ended at what is now Midtown. It was quite a walk for a young boy, even in the nineteenth century, when walking was both a necessity and a pastime. So Nast was definitely in the streets during the day. He also remembered experiences that suggest a familiarity with street life at other times. For example, he loved to chase fire trucks as they sped toward emergencies and to draw their exploits. Not all of these fires could have taken place in broad daylight, and Nast would have been in school during those hours, anyway. So he must have chased fire trucks either on weekends or in the early morning and early evening hours. These were the same times that he would have seen workingmen going to and from their jobs, stopping at taverns, and generally enjoying city life. Another suggestion that Nast had some familiarity with the streets is his tale about how he convinced Frank Leslie to employ such a young man. In that story, Nast walked through the still-dark streets to the ferry landing, waiting as dawn broke. He sketched the landing, the buildings around it, and the static detail of the scene, waiting for the hour when people would rush to board the boat. Only then, in a flurry of activity, would he have added the human life that made the drawing so pleasing.

What might Nast have seen, creeping through the dark streets and then sitting and waiting at the dock?

While we cannot know exactly what Nast saw, it seems extremely unlikely that he was unaware of the teeming human jungle that surrounded him. Uptown, wealthy New Yorkers felt sufficiently threatened by the slums of Five Points, the crime of lower Manhattan, and the questionable business practices of the commercial interests there that they reached out in both regulatory and charitable enterprises. How much more pressing would those problems have seemed to a young mother and her small son? But, of course, the impression Nast gave, especially in pointing to the excitement of fires and his pleasure in drawing, was that he was less afraid of the streets than thrilled by them. So, while we should see his experience with his father's return as a hint of the very real danger that surrounded him, we should also recognize the seductive power of that danger for a youngster whose primary interest in life was the visual representation of the world around him. The Nast who struggled to escape a stranger's unexpected embrace was a vulnerable child in a very tough neighborhood, but the Nast who chased the Big Six was a burgeoning visual journalist who embraced the world around him enthusiastically.

What place did the Nast family occupy in this maelstrom of immigrant and native culture? Amid so much change, especially in the Nasts' economic status, determining their class is difficult, but knowing his class may help to explain why Nast went to work so young. Nast explained his move to Frank Leslie's employ in terms of the seizure of opportunity. However, other factors may also have pushed him toward earning a living, especially in the difficult economic climate of the late 1850s.

Joseph Nast was one of a small number of professional musicians in New York. Nast mentions his father's employment at various music halls and his work with a house band, but he does not say whether Joseph obtained steady employment or only freelance and seasonal work. Joseph Thomas Nast remains a mystery, in fact. According to Thomas Nast's obituary in the *New York Times*, the elder Nast emigrated to the United States through a series of misadventures. First, he traveled to France on tour with his Bavarian band. Once in France, he left the Ninth Regiment for a French naval vessel and directed his wife and children to meet him in New York. Then he deserted the French ship to sign on to an American "merchant cruiser." The American ship failed to return to New York for three years.[51] Thus, when Joseph Nast arrived in New York, he was four years late. In his absence, how did the family survive?

There is no indication that Mrs. Nast worked to support her family, although Joseph Nast's absence in the years between his departure from Landau and his return to the family in New York may have required her to find some income. Most lower-class women worked, especially in Five Points, as washerwomen, cooks, seamstresses, or salesgirls. Many worked in wealthy homes as domestic servants, while others were prostitutes, dancers, and thieves. A married woman working was a telling marker of her working-class status. Even if Appolonia never worked, Nast would have seen working women every day, and could easily have contrasted their lives with those of wealthier, more leisured women on Park Row or at Burton's Theatre. Nast is nearly silent regarding the family's finances, but his interest in earning money at the door of Mr. Bryan's museum and his aggressive approach to Frank Leslie suggest that even if the family had enough money at home, Nast could expect little in the way of support as he grew older, and no pocket money.

In Landau, he might not have noticed the lack so much, but New York was full of young boys with money to spend. The largest and most famous group of these were the newsboys, who spread their product throughout the city on foot. Picking up papers first thing in the morning, these boys sold their stock by shouting out the headlines, and could earn as much as one dollar per day. Newsboys developed routines, including eating in restaurants and frequenting plays and musicals at local venues. Many were orphans living on the street entirely without adult supervision. While newsboys provided a highly visible example of young workers, they were only one of several groups Nast might have observed. Immigrant children frequently worked, selling fruit, picking rags, or in domestic service. Older children, immigrant and native-born alike, worked as apprentices in shops and factories. For Nast, these children may have provided role models, suggesting that work was something he need not wait to commence.[52]

Even if the Nast family was relatively prosperous, the timing of Nast's entry into the working world is suggestive of economic hardship. In the account Paine provides, there is little indication of why, suddenly, Nast abandoned his artistic training and his job with Mr. Bryan to join the staff at *Leslie's*. Perhaps, given the magazine's recent appearance, Nast simply sought a new opportunity. However, Paine and James Parton, Nast's wife's cousin, both suggest that Nast and Leslie found the idea of a fifteen-year-old artist unlikely.[53] What could have motivated Nast to make such a surprising offer to the entrepreneur? One possible answer is the economic trouble New York endured beginning in 1854. At the end of that year, a downturn in

the economy led to layoffs, reduced wages, and widespread privation. This was especially pressing among the city's poorest residents in Five Points, but laborers all over the city suffered. It was in the following year, with few jobs available and a depressed local economy that Nast sought out Leslie. In 1858–59, with the death of Joseph Nast, the young Nast's income must have become even more important. The cause of death is not given, but if Joseph had been ill for some time, his unemployment, coupled with the general economic malaise, may have forced Nast to work.[54]

In need of money, whether from youthful desire or family necessity, and surrounded by scenes he was eager to draw, Nast sought employment within the blossoming world of illustrated journalism. In later life, Nast deemphasized his immigrant experience and minimized the rough-and-tumble nature of his childhood. But when we examine his childhood in detail, the links between what he saw in youth and what he drew later are unmistakable. Nast did not simply emerge from the streets as an illustrator; he brought the sights and sounds of the streets with him to *Leslie's*, capital-izing on his experiences for personal gain.

To begin with Nast's own version of his childhood is to embark on a narrative of triumph over obscurity, poverty, and confusion. Through his talent, so the story goes, a little boy with no physical strength and little schooling became one of America's greatest artists. This tale, while roman-tic and appealing, ignores the context in which Nast lived and the fluidity of the world into which he thrust himself. Nast consistently remembered the world as a rosier place than we now know it to have been, and when memo-ries might have been unpleasant, he edited them for consumption by the genteel audience of the turn of the century. Through his biographer, Albert Bigelow Paine, Nast transmitted a version of the past that emphasized pre-cisely those themes that he believed most powerful in American life: talent, opportunity, and hard work.

A closer reading of the New York of his childhood reveals a tougher city, one in which young Nast might very well have been lost. That he was not is a testament not to the irrelevancy of New York to his life story but to his ability to transform his experiences in the service of his professional and personal ambitions. The world from which Nast came was one of great vibrancy, both in positive and negative terms. Positively, it contained a variety of nationalities and personalities, many exciting and exotic for a small boy. It offered him a microcosm of American life within a few blocks. Young Nast could hardly have avoided the poverty, crime, and simple dirt for which New York was famous. New York's city life, then, was all around

Nast in his formative years. It taught him how to draw by providing raw material on every corner. And Nast used that material not only to hone his talent, but to obtain his first real job. Thus, the street life he chose to ignore at the end of his life must be acknowledged as the basis for his earliest success.

CHAPTER TWO

Early Work and Training

Employment at *Leslie's* offered Nast income and a position within the thriving center of New York illustrated journalism. But Nast was still very young. His work for Leslie served only a part of his artistic ambition. In search of more training, better technique, and wider experience, Nast roamed the city.

On its streets and in its museums, studios, and neighborhoods, Nast received both an artistic and a political education. Scholars of political culture have long recognized the role that education plays in forging political values. But the idea of an education must necessarily be a fluid one. For Nast, as for so many immigrants, education was a process separate from schooling. Nast's political education took place not in a classroom but from the years during which he transitioned from childhood to adulthood. In those years, he absorbed political values not only from his work but also from his family and community.

Publishing Periodicals in New York

Thomas Nast left no records to indicate when he first noticed the thriving publishing world of antebellum New York. We do not know whether his parents read newspapers, although there were several German-language papers they could have read. The largest, the *New Yorker Staats-Zeitung*, catered to New York's German-speaking population. German immigrants like the Nasts also enjoyed the attention of publishing houses. These companies produced books, including translations from English, specifically for the German market. Thanks to these resources, and so long as he was literate, a man like Joseph Thomas Nast need not feel isolated from American politics, society, or culture.[1]

We do not know whether Nast observed the comings and goings of the young men and skilled artisans whose work produced the printed pages that were so common by midcentury. He could hardly have avoided the papers themselves. Distribution, by 1855, consisted of publishers sending a large packet of newspapers to the owner of a newsstand. The owner pasted

the cover of the paper onto a poster, thus displaying its text and illustration as an instant advertisement. The rest of the packet remained folded, and customers purchased their news either from the stand or from a roving newsboy. Newsstands peppered Nast's New York, reminding him at every corner that news meant business.[2]

At some point, Nast must have become aware of the opportunities inherent in the new illustrated newspapers, because he leapt at the chance to use his talent in their service. The ink on the first edition of *Frank Leslie's Illustrated News* was hardly dry when Nast charmed his way into a job, which suggests that he—who so loved drawing the events taking place on the streets—immediately understood what illustrated journalism had to offer. New York presented a uniquely rich market for the marriage of news and images.

Whether regarding newspapers, magazines, books, or prints, New York was the capital of American literary culture. Not only did the state publish one-third of the periodicals delivered in America, but the city of New York held a powerful sway over the imaginations of writers and illustrators. *Frank Leslie's Illustrated News, Harper's Weekly*, and other illustrated magazines reached out to a national audience, both in terms of the issues they addressed and the circulation they enjoyed. Both emphasized the culture of New York visually and in text, and they served as a source of news, gossip, and pleasure for Americans interested in periodical literature. Scenes of the city, jokes about the city, and notations regarding city events all held a special place in these magazines.[3]

The journalistic culture this engendered in New York can be sketched in broad outlines through the personalities and opportunities there. Publishers, artisans, and artists all thrived in the jostling, creative city. The Harper brothers, who played such a central role in Thomas Nast's life, are an example of the young men who exploited the immense opportunities of the era. Beginning with nothing, they built a publishing empire, expanding into illustrated magazines at almost the same moment that Nast began working for Frank Leslie.

There were four Harper brothers. They were James (1795–1869), John (1797–1875), Joseph Wesley (called Wesley) (1801–70), and Fletcher (1806–77). James and John began working in the business in 1817, when they were twenty-two and twenty, respectively. Each had trained with other printers, learning to use the equipment and saving money toward their own shop. The first book published by J. & J. Harper, Printers, was an English translation of Seneca's *Morals*. As the two younger brothers joined their business,

the Harper firm grew, becoming Harper and Brothers in 1833. By that year, the firm enjoyed substantial profits, owned several buildings on Cliff and Pearl Streets (a few blocks from Thomas Nast's future home), and published books from American and European authors on a regular basis. The firm also collaborated with other publishing houses, sometimes in joint imprint, other times simply on contracts. In later years, the Harper firm was equally famous for its periodicals, including *Harper's Weekly* and *Harper's New Monthly Magazine*.[4]

The Harper brothers are a useful example of the vitality of New York's printing entrepreneurs because they demonstrate the rapidity with which publishers could make fortunes, and because their business depended on flexibility and unpredictability. Born on a Long Island farm, these men built a publishing empire in less than forty years. They all participated in the central business, but each supervised branch operations in his particular subfield. For example, Fletcher Harper, most central to the life of Thomas Nast, became a publisher of magazines, notably *Harper's New Monthly Magazine* and *Harper's Weekly*. Unique in the extent of their success, the Harpers nevertheless represent an entire class of men who built businesses on the increasing appetite of Americans for news, entertainment, and literature. In New York, Philadelphia, Washington, Boston, and, to a lesser extent, smaller cities, publishing was a growth industry, promising riches built on the education and interest of readers across the Republic.

In the Harpers, too, appeared the central characteristic of urban publishing: its constant change. From the beginning, the Harpers' business grew by recruiting new writers, seeking out new manuscripts from overseas, and adopting new forms of literature and literary commerce, including the illustrated magazine. Publishing was not a business in which one could sit still, waiting for work to arrive. The Harpers' dynamism was the root of their success. Occasionally, that dynamism could even shade into the mildly unethical, as when they published English books without the permission of the authors or any payment of royalties. Because there was no international copyright law, and because American audiences craved British literature, publishers in America sought the latest manuscripts and fought to obtain them. Frequently, books published in London would be whisked onto a ship, carried across the ocean, and reset for publication in the United States within a few weeks. The Harpers, like their competitors, paid a premium for these works, always hoping to scoop the competition. In the cutthroat publishing world, one had to think on one's feet to survive.[5]

Purloined British books demonstrate the dynamism of the American book market, but they also point to the more mundane aspect of publishing. Someone had to set the type of those manuscripts, often working all night to transcribe the text. Those men, artisans trained through the apprentice system just like the Harper brothers, also thrived in early-nineteenth-century New York. Because of the dependency of printing, especially of illustrations, on artisanal labor, printing companies were places where literary and working-class New York intersected. A young man descended from New York's earliest Dutch settlers and educated at Harvard might stop by the office to present a manuscript, only to find himself standing next to a modestly educated German immigrant artist like Thomas Nast.

Art, as a feature of New York's periodical literature, was not new. Printed images, usually engraved on copper or inscribed into wooden printing blocks, appeared as early as the turn of the nineteenth century. In the 1840s, new methods of lithography, printing from stone, made it far faster, easier, and cheaper to produce prints on paper. This innovation, imported from Europe via New York, meant that current events or sentimental scenes could be represented through images within two to three weeks, and it was the foundation of the businesses of both illustrated newspaper publishers (in the 1850s) and printmakers like Currier & Ives.[6]

Frank Leslie used a method that allowed for even faster printing of wood-block images in newspapers. He hired multiple engravers, broke blocks into smaller squares, and farmed out the inscribing. Working on a smaller portion of a large drawing, craftsmen finished much faster. They then fitted the pieces together, reassembled the picture, and printed from the whole.[7] Some of Nast's drawings executed in this way can be seen today at the Metropolitan Museum of Art in New York City. The lines from the blocks are faintly visible on the prints.[8] Leslie's method sped up print production enormously, and it intensified the already competitive atmosphere among newspaper publishers. Every story was a race to print, with accompanying pictures, often embellished with lurid detail.[9] Whether an event was disastrous, tragic, or splendid, the visual element could substantially enhance the power of the written account. Dynamic, business-savvy publishing men like the Harper brothers saw this and gambled on the success of an illustrated periodical.

Newspaper publishing centered on Franklin Square in the 1840s and 1850s. Many newspapers remained there after the Civil War. The Harper Brothers publishing house operated out of Franklin Square well into the twentieth century.[10] So when illustrated newspapers became a hot new

trend in publishing, their production also centered on Franklin Square, within a mile of Nast's home. Did he notice? He admitted to Paine that he was once so captivated by a poster he saw on the street that he tried to tear it down to keep.[11] Perhaps the images in newspapers, hawked in the street by children his own age and younger, caught his eye as well. There is good reason to think that Nast needed a source of income. How natural for his environment, talent, and need to coincide in illustrated newspapers.

Lucky for Nast, *Frank Leslie's Illustrated News* and papers like it recognized crime, disaster, and informal city life as appealing subject matter for readers.[12] These were subjects with which Nast was familiar. Moreover, he could simply walk out of his door and take a short walk to observe any sort of city life, from slums to mansions to docks and museums. It is hard to imagine a more serendipitous partnership than that between the young Nast and an illustrated magazine. Frank Leslie, persuaded by Nast's drawing of the ferry dock, agreed.

Leslie's

Working for Frank Leslie was rarely dull. The paper thrived on disaster, and Nast's first lesson centered on the business value of tragedy. Illustrated weeklies fed the public appetite for sensation. Fires, floods, murders, and other tragic events attracted readers and therefore provided a constant stream of illustration work. Nast's first drawing to be published in *Leslie's*, in the end, was not the ferry picture he auditioned with but one of a fire whose romantic horror took precedence.

Illustrated journalism, Nast learned, was a business. Its success rested on the public fascination with journalism that could *show* the news as well as report it. Thus, Nast's earliest training as an employee was based in part on the idea that drawings for an illustrated paper should engage the imagination of the readership. To provoke was not only necessary but desirable. And no topic was taboo. He derived another part of his training from the constant stream of visitors to *Leslie's* editorial offices. Artists, writers, members of the public who wished to speak with Frank Leslie or to influence him, and many others all stopped by the office where Nast worked alongside more senior members of the staff. Nast, only a teenager, enjoyed their company and their adult pastimes.

Trips to Pfaff's beer cellar exposed Nast to an even wider acquaintance. Charles I. Pfaff emigrated to New York from Baden nine years after Nast. His beer cellar, one of several restaurant/bars he eventually owned in New

York, catered specifically to the literate and artistic elite of the city. Pfaff welcomed many of New York's most promising young writers, including Walt Whitman, who, patrons complained, "never stands drinks or pays for his own if it's possible to avoid it."[13] He also opened his doors to musicians and members of the musical community such as Maurice Strakosch (who would help young Nast almost a decade later) and Ada Clare. For the artists, engravers, and writers who worked at *Frank Leslie's Illustrated News*, Pfaff's provided a forum for talking, joking, eating, drinking, and general bonhomie.[14]

Nast was the youngest member of the *Leslie's* group, and seems to have been treated with amused fondness. At least one member considered the "fat little dutch [boy's]" artistic talent limited. John P. Davis, a master wood engraver, instructor at Cooper Union, and mentor to many artists, including the noted botanical engraver Anna Botsford Comstock, denigrated Nast's abilities. Writing to Paine near the turn of the century to offer his memories of Nast, Davis described a visit to the young man's bedroom.

The walls were covered, Davis wrote, with drawings. Even the "closet drawers" bulged with drawings. Nast's social life is evident in the topic of these drawings: scenes from recent plays. But the style imitated John Gilbert, the English cartoonist, and Alfred Fredericks, with whom Nast studied during his earliest artistic training. In Davis's judgment, Nast's talent was not so much art as industry. Scathingly, Davis wrote, "The only token of originality was noticeable in the crudeness with which his pencil had traced the lead of his protagonists."[15]

Whatever Davis's judgment of Nast's talent, the combination of Gilbert and Fredericks is interesting. In this period, Nast's work was preliminary, flexible, and exploratory. He was learning, and it showed. But later, when Nast began to take the measure of his powers, his drawings indeed mixed a cartoon style learned from other artists with a tendency toward the allegorical and the mythical. Nast produced cartoons and oil paintings simultaneously. He also created cartoon images based directly on paintings he saw—for example by Jean-Léon Gérôme.[16] In this sense, what Davis saw on Nast's walls represented the young man's lifelong style evolving.

Working at *Leslie's*, however, was a crash course in the popular political questions of the day. Nast worked as part of a team, and that team produced illustrations that reflected a wide range of events, issues, and ideas. In "Our Complaint Book," the paper illustrated the most common problems of street maintenance: dirt, obstructions, and dangerous vehicles.[17] *Leslie's* portrayed the Irish in ways typical of the time, for example assert-

ing, "That love of a fight which at all Irish gatherings, whether political or social, has always formed their most salient characteristic."[18] Tensions over the rights of immigrants and the native-born appeared as well in *Leslie's* coverage of police corruption.[19] If these local issues failed to capture Nast's attention, the paper's work on the presidential campaign offered lessons in both content and style.[20]

Nast's work for *Leslie's* defies simple categorization. No clear divisions separated artists, illustrators, engravers, and journalists. This diversity helps to illuminate the reasons why Nast likely absorbed much of the political atmosphere at *Leslie's*. Nast was employed as a staff artist. This meant that he both provided illustrations and worked in the engraving room, drawing other artists' sketches onto wooden blocks and then helping to cut them out. He therefore participated not only in the work he originated but in the work of Frank Leslie's other artists as well.[21]

Illustrated magazines helped to create a new category of journalist— the "pictorial journalist," or "artist-reporter." Combining observational and reportorial skills, the pictorial journalist traveled to observe events, and provided both textual and visual information to the paper. Thus Nast rubbed shoulders with men who had firsthand knowledge of the stories that appeared in the magazine and whose opinions about the villains and heroes were infused in their art. Watching them, Nast learned that art and politics, art and society need not diverge.

Such a mix of art and reporting must have been stimulating. To ensure that it was, Leslie tried always to create a feeling of urgency in his newsroom. He wrote, "An illustrated newspaper, if it fulfills its mission, must have its employees under constant excitement. There can be no indolence or ease about such an establishment. Every day brings its allotted and Herculean task, and night affords no respite."[22] It is not difficult to imagine the effect this atmosphere must have had on the young Thomas Nast. To add a frisson of danger, and to attract readers, Leslie used his paper to attack the powerful. In 1858, Leslie sent his artists to document the production of "swill milk." The resulting illustrations outraged the milk producers. It was necessary to keep secret the names of Leslie's artists—principally Albert Berghaus, but also Nast and Sol Eytinge—to protect them from threats of violence. The pictorial reporter emerged in those drawings as a hero of the people. It was he who protected children from tainted milk, and he who faced down the angry producers. Young Nast was in the thick of the action at *Frank Leslie's*, whether the story in question was about crime, travel, or politics.[23]

Nast did not work alone. Indeed, almost no one worked alone at *Leslie's*. Once an artist submitted a drawing, Leslie and his editor reviewed it. If approved, the drawing then moved into the art department, where it was transferred to blocks either by the original artist or by a junior employee. In many cases, engravers added details and altered scenes to make the image more pleasing, a process called "finishing." With pencils and India ink, the drawings were transferred to wood blocks. Then the negative space had to be removed. This involved carving away any wood not covered by the pencil and ink. Carving was as variable as drawing. Sometimes the blocks were locked together and a master engraver started the work, breaking the blocks apart for detail work. At other times, the process was the opposite, with the master engraver adding only the final details. At this stage, the drawing was finally ready to be placed into the printing press and married to its text. Clearly, the process relied on collaboration. Not only the physical work but the intellectual, artistic, and journalistic work of representation combined the efforts of the staff. For Nast, this meant that he could observe practically every aspect of illustrated journalism, and even make his personal mark on it.[24]

Nast took an active role in his own political education at *Leslie's*. He formed alliances, most notably with the master engraver Sol Eytinge, and moved up in the hierarchy of employees. By the time he left *Leslie's*, Nast understood pictorial journalism and its role in local politics. His first foray into political reporting through illustration was a scandal involving the sale and distribution of tainted milk. In late 1856 and early 1857, Nast and another artist illustrated a series of articles condemning the production of milk by diseased cows. *Leslie's* campaign against the milk producers provoked angry responses not only from the businessmen who owned the cows but also from the city officials responsible for overseeing milk production. Paine notes that this set of articles, and the accompanying arguments, threats, and pressures from corrupt city employees, provided Nast "his first insight into corrupt city government, likewise a striking illustration of the power of the pencil on correcting evil."[25]

Nast's work for Frank Leslie need not stand alone as an early example of his work in political illustration, however. When Nast and Eytinge, who had become his mentor, left *Leslie's* and began working for the new *Harper's Weekly*, they joined yet another anticorruption battle, this time against the police. Nast's March 1859 illustrations reflected a number of the findings of a report to the legislature on the abuses of the New York Metropolitan Police. Until 1844, New York was guarded by two elected constables, one

for each ward, and they served one-year terms. In addition, marshals appointed by the mayor and a citizens' watch protected the city. An attempt at reform in 1844 failed to provide more police, and the city struggled with crime as its population grew. Finally, in 1857, the state legislature intervened to create the municipal police force, over the protests of the mayor, Fernando Wood. In theory, the new police force was intended as a move toward professionalism, but its operatives were subject to improper influence. Given the clash between the mayor and legislature, and the perennial popularity of police scandal, it is no surprise that *Harper's* considered the police a fitting subject for its attention.[26]

Nast's illustrations for this series exaggerated the contrast between what should be and what was—a particularly effective method to engage the eye. In one image, uniformed ruffians attack a wealthy gentleman. The caption informs the reader that the police department is full of criminals who decided that their business would be better done with the official sanction of law enforcement. This contrast between what law enforcement was supposed to do—that is, prevent and solve crime—and reality—that is, policemen were an officially sanctioned gang of criminals—was a favorite theme in many of Nast's later works. In another image, pretty girls serve as a distraction, and in yet another, officers turn a blind eye to the suffering of poor women they have incarcerated. The most characteristic panel of the six images, however, was the one in which an honest officer, having refused a bribe, returns home to his hungry wife and children.

As in so much of Nast's later work, what is evident here is a worldview in which the greatest evils are violence, hypocrisy, and greed. The greatest good, by contrast, is integrity, and it is honored for its inherent value as well as its symbolic relationship to the power and meaning of manhood. These sentiments, applied to a political scandal in 1859, would echo through Nast's professional and personal life. For example, Nast portrayed Union soldiers in the same light during and after the Civil War. He emphasized good posture, the protection of women and children, and personal rectitude. Such qualities exemplified manliness, and Nast used them to honor men he admired.

By the time Nast produced his police corruption drawings, he had become a full-fledged pictorial journalist. At *Leslie's*, Nast learned drawing, engraving, reporting, and the business of illustrated news. He also absorbed both the politics of the paper and the idea that a paper could be political (and politically flexible). Whatever Nast's personal views, his training underscored the centrality of politics to his work. Between his arrival

at *Leslie's* in 1856 and his departure for Europe, Nast channeled his bright, inquisitive mind in the direction of the paper's positions.

Nast had his own perspective, however. Those views, though hard to determine with certainty, emerged from the world of his childhood. Nast learned politics before he came to Frank Leslie. The politics of the Nast family, and of the neighborhood where Nast grew up, laid a foundation for Nast's early work and for his ideas about public service, political corruption, and the role of the citizen.

The Politics of Childhood

Nast's home on William Street was probably in the Fourth Ward.[27] This placed Nast squarely in the center of a triangle of political opponents, German, Irish, and "native," who fought constantly over internal, civic, party, and national political questions. In 1855, the Fourth Ward was comprised of 10,785 alien immigrants, 2,459 naturalized citizens, and 922 citizens born in the United States.[28] Clearly, the newcomers outnumbered the citizens, and this points to one reason why politics in the Fourth Ward and its surrounding area involved such a mix of European and American, religious, economic, and social concerns. Immigrants remained interested in the politics of their land of birth while embracing many of the most powerful forces in American politics. Men eagerly joined political parties—especially the Democratic Party, which courted immigrant votes assiduously—while retaining preexisting political loyalties based on their county of origin, the street they lived on, or simple personal affinity.

Political culture is a fluid concept. Originated by political scientists who hoped to draw the study of politics from the "legal-institutional" model to one that recognized individual behavior and non-elite populations, political culture has helped to spur the study of what ordinary people do and think. This work, studying "mass attitudes, and behavior beyond the realm of electoral participation," illuminates the presence of political concerns in almost every aspect of daily life. Political culture differs from culture in general in that it can be related to more traditional measures of political action. Thus, neighborhood conflicts become electoral contests and personal vendettas become battles over party leadership, policy, or authority.[29]

At its most basic level, politics is a system of relationships that regulate power. Thus, struggles for control are essentially political in nature, whether they concern overtly political questions—such as nomination for office, electoral behavior, or policy making by state officials—or not.

In Nast's neighborhood, the relationships between the cultural and the political were manifest. Later in life, Nast associated politics with men he admired, notably Grant and Lincoln. This was not just Nast's character, however. Nast grew up in an environment where personal qualities—trustworthiness, ethnic or national origin, liberal values, criminality—related directly to political affiliation and behavior.

The German American community of Nast's childhood was vibrant in part because of its powerful engagement with American and European politics. Naturally, immigrants cared about events in Germany. They had re-ordered their entire lives to protect themselves from the aftermath of the Revolutions of 1848. The course of Liberalism in Germany, and Europe generally, remained a topic of great interest. Immigrants' sense that local and national political values were important also encouraged interest in American political issues. And there was plenty to be excited about in the late 1850s. Germans in New York were especially focused on local political corruption and the national struggle over slavery. Lurking always in the background, as well, were Old World concerns with kings, empires, and European progress.

One powerful influence on the German American community in New York was the ideology that underlay the Revolutions of 1848. Nineteenth-century Liberalism was closely associated with the European middle-class social movements of midcentury, and endured in various forms until the dislocations of the First World War. The fundamental principle of Liberalism was the idea that human history was a story of progress. Scientific inquiry and technological improvement underlay social and cultural growth. These beliefs reinforced more specific positions on local and international issues. For example, Liberals agitated for greater participation by citizens, sometimes including women, in governmental decision-making. They also advocated laissez-faire economic policies, opposed slavery, and encouraged education as a means to social progress.[30]

When, in 1848, middle-class reformers sparked revolutions across Europe, Liberalism underlay their critique of government. Reforms failed, and thousands of disaffected citizens left Europe. Among the migrants the ideology of Liberalism did not die. Indeed, the conflict within New York's German community over the arrogant assumption of leadership by immigrant Forty-eighters points to the fact that the politics of Liberalism transferred to the United States. Communities heavily populated with German-speaking immigrants struggled with the legacy of 1848 for decades, and many representatives of those communities also stood for the political

values of the era. The most famous example of this is Carl Schurz, who served as a Union general, senator from Missouri, and secretary of the Interior in the Hayes administration.[31]

Further evidence of the power of the revolutions and of Liberalism is provided by the city's response to the visit, in 1851, of Lajos Kossuth, a Hungarian revolutionary leader. Kossuth enjoyed an ecstatic welcome by thousands of New Yorkers, many of them immigrants, and he met with Mayor Ambrose Kingsland before parading through the city. Nast's father took his son to the parade, where Nast purchased a "Kossuth hat" and sketched the dignitaries. Any eleven-year-old as sensitive to spectacle and street life as Nast could only have been impressed. It was a sufficiently important day for Nast to remember it to Paine nearly fifty years later.[32]

Liberal political views, whether linked to the specific revolutionary politics of 1848 or not, remained important to Nast's life and work. His belief in the prerogatives of citizenship, the sanctity of voting, the value of civil rights for all, and the foolish failures of most government interventions all point to his absorption of Liberal values as he understood them. His political education took place in the home and within the German American community. He had only to look to his own family's history to see the price loyalty to Liberalism could exact. Nast learned the same lessons from local Forty-eighters like the artist Frederick Kaufmann. Kaufmann taught Nast to see and to draw but also offered a living example of the artist as political actor.[33]

New York Germans were also attentive to local party politics. During the 1850s, large portions of the immigrant community lived on the Lower East Side, especially around Nast's childhood home at William Street, in the Fourth Ward, the Bowery and Five Points, in the Sixth Ward, and in what today is considered the heart of the Lower East Side, the Seventh Ward. Most commonly identified with the Germans was the neighborhood then called "Kleindeutschland," the numbered streets from First to Thirteenth surrounding Tompkins Square. These areas constituted a Democratic stronghold, controlled by Tammany Hall. But politics, even though dominated by Democrats, was hardly organized. Democratic factions, whether the competing Tammany and Mozart Halls or other, smaller groups, constantly jockeyed for prominence. Germans were at the heart of this struggle, and made their voices heard on political questions.

Two among many examples of German participation in politics prove this point. First was the formation of a German faction of Democrats in the confused local election of 1855. Germans founded many "parties," most

of which were Democratic or nativist sub-parties. One organized as explicitly German polled 1,910 votes citywide.[34] Clearly, some Germans were not only loyal to the Democratic Party in 1855 but also interested in controlling its agenda. The Democrats in New York relied on the votes of immigrants. Most Democratic immigrant voters were Irish, but Germans hoped to supplant the Irish as the controlling force within the city's party machine. The significant number of German immigrants settling in New York between 1850 and 1855 suggested that the Germans might challenge Irish dominance as a voting bloc.

Another example of German American political organization is the march of 15,000 workers from Tompkins Square to Wall Street in 1857. Carrying banners reading "We Want Work" in both English and German, these men asserted a Democratic political stand related directly to their immigrant status.[35] The German working class was not alone in supporting Democratic politics. Oswald Ottendorfer, a middle-class Forty-eighter who worked for and then edited the German American newspaper the *Staats-Zeitung*, attacked Republicans as Know-Nothings in sheep's clothing, calling their journalistic proponents "niggerblaetter."[36]

Ottendorfer joined many other Germans in debating the politics of slavery. Not all Germans supported the Democrats. Increasingly, it was slavery that divided Germans between the Democratic and Republican Parties. The Turnerbund, a society of politically active German immigrants that spread nationwide in the 1850s, adopted an explicitly antislavery position in 1855. At its Buffalo, New York, convention, the Turnerbund passed a platform condemning "slavery, Nativism, and prohibition" as the three worst threats to liberty in the United States.[37] Widespread German support for the Republican Party after 1856, especially in the old Northwest but also in urban Democratic strongholds like New York, was crucial to the Republican Party's growing strength and, eventually, to its victory in the presidential election of 1860.[38]

There is reason to think that Nast was inclined toward the German Republicans. First, there is his aversion to slavery. In many of his early illustrations, slaves appear as innocent victims of a tragic and criminal system. These images reflect not only Nast's politics but also his personal life. By the time he joined the sectional dispute, Nast was a member of a social circle, centered on the home of his sweetheart, Sallie Edwards, and her family, that deeply opposed slavery on moral grounds. There, antislavery sentiment was commonplace, particularly in the person of Sallie's cousin, James Parton. Second, Nast's lifelong dislike of Irish immigrants was almost always

linked to his distrust of Democratic politics. Repeatedly, and for much of his career, Nast linked Irish voters to drunkenness, violence, ignorance. They were the living example of the dangers of Democratic—mob—rule.[39]

Whether Nast aligned himself with the German Republicans or the politics of Oswald Ottendorfer, the Democratic "mob" was never far away. Even a cursory examination of Nast's work reveals his antipathy toward the Democratic Party and Irish Americans. The intensity of his attacks on Irish voters cannot be explained entirely by his political views in later life. They originated in his childhood. Surrounded by Democratic Party politics, Nast observed a world replete with Irish political machinations. His political education included a variety of interactions with the Irish in America.

The Irish, then comprising about 60 percent of the local population, dominated ward politics from the nomination process to voting to policy making. Factions of Irish Democrats formed rival clubs. Supported by gangs of young thugs, they prowled the streets and inhabited the pubs. Many were local celebrities. Connections among Irish immigrants, often related to county of origin, time of arrival in the United States, and business relations once in New York, formed a network that underlay every political question, especially in the Fourth Ward.

Party leadership in Five Points and surrounding immigrant neighborhoods was almost exclusively comprised of Irish immigrants. Irishmen in public office were larger than life, drawn mostly from the ranks of "saloonkeepers, grocers, policemen, and firemen." The party hierarchy controlled seniority and jobs, or spoils, and provided employment for a large number of young men who aspired to political office. Economic, social, and political activity combined in the saloons and groceries. The power the owners of those saloons wielded made it hard to miss the way that money, ethnicity, and politics intertwined.[40]

One of several volatile issues associated with the Irish was the role of religion in public education. By the time Nast arrived in New York, two competing systems of schooling were in place. The older, operated through the Public School Society, was overtly Protestant in its teachings, using the King James Bible and reinforcing negative stereotypes about the Roman Catholic Church. The second, created in 1842 in response to the growing power of Irish Catholic immigrants, operated with city government oversight.[41] Although the city schools no longer operated under the Public School Society, administrators failed to end ethnic tension over religion. Elections in 1842, centered on the question of education reform, devolved into massive

violence in the Sixth Ward. By the time the Nast family arrived, the conflict over faith and education had become a perennial political topic.

"Free thinking" schools, founded by immigrants whose experiences with clerical leaders in Europe had soured any interest in religion, whether Protestant or Catholic, provided a third option for some parents.[42] Nast's attendance at a succession of schools suggests that at the very least he sampled some of the variety that New York's educational system had to offer. Later in life Nast was intensely opposed to the encroachment of Catholic ideas into public education. Some of his most famous cartoons, and those that form the basis for his reputation as anti-Catholic, were commentaries on the dangers Roman Catholicism posed to public schools. They suggest that despite his age, the young Nast noticed the centrality of public education to Irish politics, and to the politics of the city.[43]

Nast engaged the Irish on two levels in his cartoon work. First, he addressed specific political conflicts, such as the battle to control New York's schools. Second, he asserted a particular view of the relationship of the Irish to American society. Nast believed that Irish immigrants could not integrate into the culture of civic duty, personal responsibility, and educated progress that Nast believed American democracy required. The origin of these ideas can be found in Nast's political education, and in the political culture of his youth.

L. Perry Curtis, in his examination of caricature in the Victorian period, asserts that Nast's anti-Irish work in the late 1860s and 1870s was a product not of his distaste for specific political behaviors per se, but of his aversion to the atmosphere of bigotry that surrounded the Irish as a group. That is, Nast sought to demonstrate northern, and national, racism, hypocrisy, and anti-Catholic bigotry and to attack the machine system in American politics generally, and he used the Irish to represent those problems. This may be true, and Curtis's assertion is certainly consistent with some of Nast's cartoons from the late 1860s and the 1870s. Nast was a complex individual, however, and even if Curtis's explanation of his anti-Irish cartoons is correct, it requires some expansion. The vicious, unrelenting quality of Nast's attacks on the Irish suggests something far more personal than an artistic choice about symbolism and hypocrisy.[44]

For the teenage Nast, the Irish were his poorest neighbors, the most powerful bosses, the grocery owner down the street, and the most visible local representatives of the Roman Catholic Church. In later years the Irish represented a sophisticated commentary on American life for Nast. They

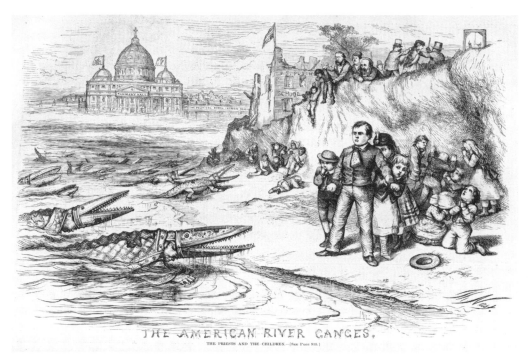

THE AMERICAN RIVER GANGES.

THE PRIESTS AND THE CHILDREN.—[See Page 915.]

"*The American River Ganges,*" Harper's Weekly, *September 30, 1871.*

helped him to point out northern racism and a variety of cultural dangers. But the Nast who used the Irish to symbolize mob violence in the late 1860s came to his work already convinced that the Irish posed a challenge to American society. As he had done with the life of the city's streets, the teenage Nast observed Irish American political activity with open-minded interest. The years he spent learning his craft, working for Frank Leslie, and walking the streets of the Sixth and Fourth Wards shaped his opinions, but he remained flexible. His images of the Irish during the Tweed campaign demonstrate that he saw them both as a threat and as people exploited by their own leaders.[45]

On the other hand, Curtis also identifies one aspect of Irish American life in New York that might have moved Nast to a political position echoed in his later work. African Americans formed a large minority in the neighborhood around Five Points, and violence against them by the Irish was commonplace.[46] Nast had a sincere sympathy for black Americans. He accepted many nineteenth-century racial stereotypes of African Americans, but he deplored violence against them, opposed slavery, and hated the white vigilantes of the 1870s and later. As early as 1863, Nast produced deeply sympathetic illustrations asserting the potential of African Americans to become

productive members of the American middle class. In fact, Nast's images of black Americans offer a stark contrast to his drawings of the Irish. If some of this feeling developed in the 1850s, and there is no reason to think it sprang to life fully formed in the 1860s, it may have motivated Nast's interest in Irish political violence.[47] More personal reasons may also have motivated Nast. Though plump, he was a small man. Early self-portraits suggest a childlike physique—one unlikely to intimidate neighborhood gangs. As a child, he had endured bullying by older, bigger children at school.[48] Perhaps it was this physical vulnerability that underlay his sympathy for black people. If so, it would explain his antipathy to what he perceived as the brutish, uncontrollable Irish thug.

Nast learned about political ideology from his German neighbors and about party politics from his Democratic neighborhood, including its Irish residents. He also grew to maturity in a political world that included native-born Americans. They, too, offered Nast a political education. Americans descended from older immigrants perceived themselves as the natural leaders of American politics, and they resented the influx of newcomers. Christening their culture "native," they constructed a political position around ideas of an originating Anglo-Saxon culture as the bedrock of American social and political values.[49] Both elite and working-class New Yorkers embraced the idea that the native-born were more legitimate holders of political authority. For the elite, nativism expressed itself in the formation of secret societies devoted to controlling political appointments, candidates, and issues.[50] For working-class men, nativism was more often expressed in the politics of everyday life. These men formed their own gangs, fire companies, and men's societies, and often asserted their right to participate in decisions affecting the community. At times, violent clashes erupted between the native-born and immigrant communities over political questions or elections. Nast, with his accented English, was obviously an immigrant. Indeed, he would probably have been capable of identifying each business along William Street as German, Irish, or native owned. Divisions, whether political, ethnic, religious, or national, were so common as to be an accepted part of everyday life.[51]

Nast's German accent might have led to potentially unpleasant attention in the 1850s. The large influx of German-speaking immigrants that followed the failure of the revolutions of 1848 was met with horror among nativists. As noted above, many of the most prominent Forty-eighters were highly educated intellectuals. They espoused radical political ideas and they hoped to rally the German community in America to their cause. To further

this aim, they purchased or founded newspapers, wrote editorials, made speeches, and generally tried to push their way to the front of German American political activity. From the perspective of the nativists, this was a frightening invasion by an activist immigrant group. As bad as the Irish had been—many nativists saw immigrants as little more than resource-sucking disease vectors—they at least had arrived in confusion. It took the Irish some time to establish their powerful hold on neighborhoods in New York, and the nativists had some chance of contesting Irish domination. Germans, on the other hand, arrived in similar numbers but with more financial resources, less desperation, and a cadre of vocal political advocates, so they posed a far greater threat to nativist political authority.[52]

Nativists not only celebrated an imagined Anglo-Saxon past, and derided the new immigrant cultures of the city, but they also explicitly and violently rejected Catholic Americans. Appolonia Nast, migrating from Bavaria with her two children, arrived in a city where anti-Catholic feeling was long entrenched. While Roman Catholic churches were hardly rare—most Irish immigrants were Catholic, after all—to be Catholic was to be an outsider in cultural and political terms.[53] Nativists articulated their specific anti-Catholic agenda late in the century. Still, the basic outline was nothing new. Catholics were not citizens, critics charged, but subjects of the Roman king, the pope. Added to their suspect loyalty was the variety of questionable social practices associated with Catholicism. Nativist propaganda painted Catholics as backward adherents to an ancient, corrupt culture.[54]

In this climate, it is easy to understand why Nast's mother, and Nast himself, might abandon Catholicism, and later attack it. We can also feel some sympathy for the Nast family, having left a Germany where religious difference was a central social schism, only to find a similar set of divisions in the New World. Nast left behind almost nothing to chronicle his youth, so no definitive lines can be drawn between nativist sentiment and Nast's anti-Catholic cartoons. But the similarities in tone and emphasis are striking. Nast sounded the same alarms—about foreign allegiance, social practices, and the danger posed by the pope—as the nativists did during his youth. Tracing the politics of Nast's youth provides sources not only for his basic political ideology and his antipathy to the Irish but also for his anti-Catholicism.[55]

Nast, the immigrant child, growing up at the crossroads of these competing political, religious, cultural, and social forces, must have been confused, especially at first. Perhaps Nast's mother and father read the German-language newspapers for sale on street corners. We know that Joseph

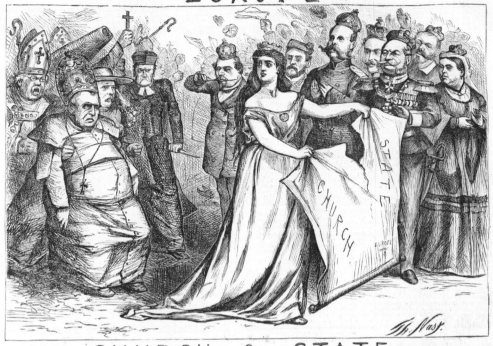

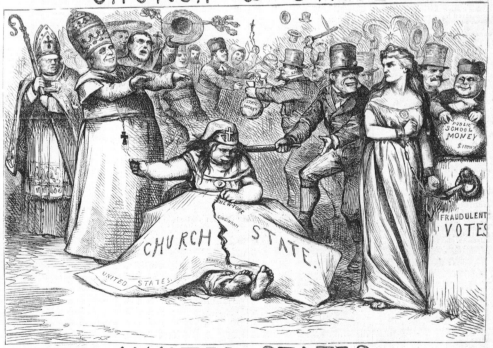

"*Church and State*," Harper's Weekly, *February 19, 1870.*

Thomas Nast took his son to the Kossuth rally, which was a huge demonstration of German solidarity with the political goals of the Forty-eighters. As Nast grew older and more mature, perhaps he noticed the wary glances shot across streets from one pub or polling place or factional stronghold to another. Street fights at election time must have been as exciting as chasing the fire trucks, and those trucks themselves often came upon or precipitated street brawls, many between rival Democratic gangs. Finally, Nast must have known of the periodic violence, only blocks from his home, instigated by the nativist toughs who attacked the businesses of immigrants and shouted anti-immigrant slogans. The complicated, confusing, rough-and-tumble political world of his childhood served him well as an illustrator. Indeed, in the early years of Nast's career, at *Frank Leslie's Illustrated News* and elsewhere, there is ample evidence of Nast's interest in political questions. If ever a man was steeped in the political culture of his time and place, it was Nast.

Of course, no nineteen-year-old can be serious all the time. Nast had money in his pocket and an ever-increasing store of professional experience and personal confidence. His political education was not complete, however. *The New York Illustrated News* offered Nast an assignment that would take him to England, where he would illustrate the Heenan-Sayers boxing match, a fight that pitted an American champion against his British counterpart. Replete with political, ethnic, and popular cultural meaning, boxing matches were extremely popular. For a young reporter, especially one eager to travel but lacking financial resources, it was a plum assignment. In Europe, he would observe politics both popular and revolutionary before returning to find his own country at war.

CHAPTER THREE

Travel to Europe and Sallie

As Nast absorbed politics in his neighborhood, at work, and abroad, he also, between 1859 and 1861, embraced adulthood. Travel in Europe provided Nast a window into the workings of the land he left as a child. He observed sport in Britain, war in Italy, and the uncertain charms of the Bavarian beer house. By the time Nast returned to New York, his training was complete. He joined *Harper's Weekly* as an adult, an artist, and a world traveler. In the same years, Nast cemented the personal relationship that would undergird his artistic and professional success. Wooing and marrying Sarah Edwards completed Nast's transition to adulthood. For all his forward-thinking habits, Nast remained in his heart a traditional man. Home, fatherhood, and the delights of middle-class domesticity appealed enormously to Nast. So marriage provided not only a social position and personal satisfaction but also a measure of the social authority Nast craved.

In 1859, Nast met the woman he would marry, Sarah Edwards. She was the daughter of George Edwards and Sarah Leach Edwards and had two younger sisters, Mattie and Eliza. Sarah also had a half-sister, Ann, and a half-brother, Jack. Both were the children of George Edwards's first marriage. Cousin James Parton, a close member of the family circle and a historian, later became a dear friend to the couple.[1] The Edwards home at 745 Broadway attracted a group of talented and vivacious young people, including "actors, artists, and authors." Jesse Haney, editor of the *Comic Monthly*, introduced Thomas Nast to the Edwards circle and later became Nast's brother-in-law by marrying Mattie Edwards. Nast's courtship of Sarah Edwards, whom he called Sallie, began in the summer of 1859 and continued until his return to New York from Europe in 1861.[2]

The group of friends who liked to gather at the Edwards home dubbed Nast "roly-poly," and this nickname suggests something of Nast's developing personal image. Nast was short, pudgy, and apparently unable to keep his hair in good order. He was also very young. Rather than considering these qualities problematic, Nast transformed them into charming calling cards. "Tommy" missed no opportunity to crack a joke at his own expense.

An early example of this tendency is his "Our Artist" illustration for *The Little-Pig Monthly*. In it, Nast drew himself as a small, round pig bowing deferentially to his readers. The caption reads, "Nast, T., The Little-Pig Artist," and includes a short paragraph that sounds very much as though it were written by Sallie Edwards and one of her sisters.

> "What a duck of a Pig!" cries a young lady at our elbow.
>
> "Why, mamma, he looks handsome enough to kiss!" says a miss one year short of her teens.
>
> And he is a winsome looking fellow, and we think destined one day to astonish the world with some great "Original Picture,"—but all we ask of him is, to "copy nature," and that he can do this most truthfully, all his acquaintances will have to admit, who may place their eyes upon the above most excellent likeness.[3]

Comparing himself to a pig was less common than his simply emphasizing his untidiness. Nast liked to draw himself in his letters later in life, and he drew himself on at least one letter home to Sallie from Europe.[4] In these drawings, Nast habitually appeared with wild, unkempt hair, ill-fitting and wrinkled clothing, and a belly that extended far beyond the width of his shoulders. In contrast, he drew Sallie as a statuesque, elegant, and composed woman, and always at his side to provide the greatest contrast. This idealization of Sallie, and concurrent mockery of himself, continued throughout Nast's life. It provided him with a comic outlet to counter his tendency toward self-importance, and it allowed him to defuse any questions about his English proficiency or social grace. If he lacked polish, he was at least amusing and self-deprecating.

In illustrated journalism Nast found a way to transform the perils of his immigrant childhood into a successful career. Drinking beer at Pfaff's, Nast socialized with a wide variety of New York's literati. That social world embraced Nast as a sort of pet. From it, he learned about art, writing, reporting, and the connections that underlay business relationships. The Edwards circle provided a similar environment. Just as Nast ingratiated himself at Pfaff's to find a place among his co-workers, he settled into the living room at the Edwards house in his private life. By mocking himself, Nast transformed his lack of education and maturity into the very qualities that made him a pleasant companion. He used this method not only in his courtship of Sallie Edwards but also in his travels, employment, and friendships for the rest of his life.

A sense of the fun to be had in the Edwards circle appears in one of

Sallie's letters to Nast from 1859. Undated, it contains a note from Sallie and Eliza, confirming the plans of the group to attend the theater on the next night. The letter is short and sweet, and at its end, Sallie and Eliza add dueling postscripts:

P.S. As my mother said, Oh! I suppose so, we were perfectly delighted, enchanted, and overwhelmed at her condesention [*sic*], that we by our combined effort, managed to muster sufficient courage, to write this eloquent epistle. *Eliza.*

P.S. Don't believe a word of it because I did it all by my own self. *S.*

P.S. Sall you tell a big story. *E.*

P.S. Eliza's veracity, *always* questionable, is now, wanting utterly, altogether minus.

P.S. Oh!! O!!! OH!!! What some people can do and say, is really quite astounding. *E.*

P.S. And nothing can be found to equal it, except the imprudence of others. *S.*[5]

And so on, for a few more iterations. Sallie liked to be informal in her letters, and she matched Nast's ability to mock himself with her self-deprecating style. Addressing a note to him, she wrote, "Mr. Nast—Dear Sir (?) (ahem!)."[6] Clearly, Sallie's charm and sense of fun balanced her dignity and grace.

But not all of Nast's social activity in the Edwards circle related to his developing self-image; nor was it confined to theatricals and silly games. Some of the Edwardses' friends, like Jesse Haney, were humorists, but others were more serious. At least one regular member of the Edwards family circle deserves extended notice. Cousin James Parton became a lifelong friend of the cartoonist. The complex relationship of Parton to the Edwards family—especially their treatment of his wife—reveals details both about Parton and about Sallie Nast. It also suggests the incredible interconnectedness of the literary/journalistic/artistic world in which Nast found himself.

James Parton rose to fame as a biographer. Married to the novelist and columnist Fanny Fern, Parton was a man of many talents.[7] His biographical subjects included Horace Greeley, Andrew Jackson, Benjamin Franklin, and Voltaire. He also contributed letters and articles to a number of newspapers and magazines. Parton admired many prominent Republicans, including *Harper's* editor George William Curtis. Nast met Parton in 1858, just after Parton published his biography of Aaron Burr.[8]

Parton's biographical work on American political figures provided only

one outlet for his interest in politics. As early as 1851, Parton wrote to the *New York Tribune* under the pseudonym An Abolitionist. "We oppose the Fugitive Slave Law," he wrote, "because it does not give sufficient guarantees of freedom, while it secures everything to slavery." According to his biographer, Parton believed that slaves must be discouraged from escape. Their captivity encouraged their will to resist, and the nation owed them more than the poverty that escape to the North usually meant. Parton held mildly anti-immigrant views as well. He agreed with many other writers that immigrants from Europe were ill-equipped for citizenship in America because of the tyrannical nature of European governments.[9] In another letter to the *Tribune*, Parton wrote to support the idea of an international copyright law, a position that Nast espoused many years later.[10]

At least one of Parton's political views found no favor with Nast. Parton believed that men and women ought to have equal rights in social, political, and professional life.[11] In this, Parton echoed the views of his wife, who argued strenuously for female equality. Her novel *Ruth Hall* asserted the value of female independence. In her columns for the *New York Ledger*, Fern argued repeatedly that women deserved education, social choices, and respect. She herself embraced her independence. For example, when she and Parton moved to Brooklyn in 1856, it was to inhabit a house purchased with Fern's money in her own name. This was possible because she insisted upon a prenuptial agreement with Parton, preserving her control over her fortune. Marrying Fern also placed Parton in the unusual position of being the younger partner. In 1856, he was thirty-three and she was forty-four.[12] Her occasional forays into masculine dress, intended in part to highlight the power of men's clothing in society, only underlined her unconventional personality.

The Edwards women disapproved of Fern. Parton's friend Thomas Butler Gunn wrote that Sarah Leach Edwards "detests her, I am sure, first on account of her writings, secondly, because Jim married her- doing it on the sly. . . . Thirdly, because they are and must be . . . radically antagonistic."[13] Mrs. Edwards agreed with many critics that Fern's life and work suggested both a scandalous personal morality and an aggressive radicalism on social issues. Before she married Parton, Fern deserted her second husband on grounds of cruelty and refused family support because it came with strings of dependency attached. Instead, she struck out on her own, writing for a living. This caused a permanent rift with her brother, Nathaniel Parker Willis, carried out in public via magazine articles. Whatever her brother thought about her writing—he discouraged her and told her that she had

no talent—the public made Fanny Fern rich and famous. She used her fame to attack patriarchy, customary restrictions on women, and hypocrisy in every form.[14]

A series of ugly scenes and social encounters worsened the situation. Sallie's family hosted a Christmas party every year, complete with dancing, a play, and punch made from Mr. Edwards's secret recipe. In 1856 and 1857, they excluded Fanny Fern. In 1858, she attended with Parton and her daughters, but everyone found the evening awkward. Worse was to come. Parton's sister, Mary Parton Rogers, hated Fanny Fern. During the couple's visit to the Rogers home, a series of conflicts erupted into physical violence, forcing Parton to rescue his wife and depart in haste. A vituperative letter followed, sealing the antipathy between wife and sister. Parton and Fern attended the Edwards Christmas party again in 1859, but the party failed to heal the rift. Fanny invited the Edwards women to tea, to no effect.

By early 1860, Sallie Edwards and her sisters amused themselves "imitating and ridiculing Fan."[15] This was the other side of the Edwardses' love of fun. They could also be mean-spirited, disdainful, and creatively derisive. But Sallie's distaste for Fanny Fern serves a useful purpose to those interested in Thomas Nast's future wife. Her commentary on Fern's absence from the 1860 Christmas party reveals a woman of decisive temperament, complex vocabulary, and keen sarcasm. She wrote to Gunn, "Our distress [at Fern's absence] was keen, as you may imagine, but with almost supernatural self-control we managed to swallow our agitated feelings and received our guests with astonishing equanimity considering."[16]

The hypocrisy Fanny Fern disdained may have played a role in the Edwardses' disapproval. According to Fern's biographer, Sarah Leach became Sarah Edwards by taking another woman's place. She was the Edwardses' governess when George Edwards's wife died, and Sarah stepped into the role by marrying her employer.[17] With children of her own and an active social life, Mrs. Edwards could afford to be generous to her cousin-in-law. Instead, she ignored the elements of romantic fiction in her own history, while applying a critical eye to Fern.

Perhaps Fern made some remark on this subject, or perhaps Fanny's open, frank discussion of social mores simply offended Mrs. Edwards. In addition, Ann Edwards, Sallie's half-sister, may have hoped to marry Parton herself and resented Fern's position as his wife. The freedom Fern permitted her daughters added to the Edwardses' disapproval. In 1859, when Sallie asked Grace (Fern's daughter from her first marriage) about the family's new home in Manhattan, the girl replied that the drawing room was large

enough for tumbling runs. Sallie, scandalized by the physical and uninhibited activity this implied, found both of Fern's daughters unladylike.[18]

Fanny Fern resented the Edwardses' disapproval. Fern rarely hesitated to confront that with which she disagreed, and in this case, she openly criticized her husband's family, in print. Thus, in 1859, Nast encountered a family in which Sallie's cousin Parton was most welcome while Parton's wife and her daughters were not. Not only was this fact known to the Edwardses' social circle; readers of the *New York Ledger* knew about it as well. Talking with Sallie Edwards as they courted, Nast must have learned a great deal about Parton, his wife, and his politics.

Parton and Nast found much in common politically, not least of which was a shared dislike for slavery and its evils. Fanny Fern shared their views. Resident in Fern's household during 1856–58, as playmate for her daughter, Grace, was Louisa Jacobs, daughter of Harriet Jacobs. Louisa joined the household at table, participated in outings and socializing, and even seems to have been suggested as a wife for friends of the family. Fern and Parton condemned the suffering imposed on both Harriet and Louisa by slavery. They welcomed Louisa into their home as an equal to Fern's daughter. By the time Nast befriended Parton, Grace was the wife of humorist Mortimer "Doesticks" Thomson and Louisa had gone home. Still, the racial equality embraced by Parton and Fern mirrored Nast's own views.

Throughout their friendship, Parton and Nast found many opportunities to exchange views. Parton's description of Nast's creative process is among the only analyses of how Nast worked.[19] Over time, as the two men became closer friends, Parton became a more and more insightful observer of Nast. The transformation of ideas into images captured Parton's attention. Cartooning ranged across the boundaries of time, space, political party, and subject. Its variety attracted Parton, eventually inspiring a book devoted to cartooning.[20]

Parton argued that Nast's cartoons were not merely satire but expressions of heartfelt conviction. "This I know," he wrote, "because I sat by his side many a time while he was drawing them, and was with him often at those electric moments when the idea of a picture was conceived." Parton's access to Nast's creative process demonstrates that he was both frequently present and heartily welcome in Nast's company for a long time. More, it reinforces the sense that Nast thrived on creative interplay. As with the games at the Edwards house, discussions with Parton provided useful sparks for Nast's imagination.[21]

One subject may have caused sparks of a different kind. In 1872, Nast's

opposition to the presidential campaign of Horace Greeley inspired a series of damning drawings. Greeley appeared as the ally of southern Democrats, the betrayer of the freedmen, and a pretentious blowhard with an inflated view of his own accomplishments. By 1872, Nast enjoyed nationwide fame. Parton also boasted a national reputation as a biographer. In 1855, his book about Horace Greeley helped to launch his career. We do not know whether Parton discussed Greeley with Nast, but their likely disagreement about him suggests the complex problems that family and professional relationships posed. On the one hand, the Edwards circle, like the ones at *Frank Leslie's* and later at *Harper's Weekly*, offered Nast a world of educated, engaging people with whom he could discuss everything from theater to immigration. On the other hand, in some cases, Nast's vitriolic pencil must have caused some contention.

The lively discussions of "books and drama, politics and painting" at the Edwards home reinforced for Nast the lessons already learned at home and work. Politics mixed into every aspect of existence, from pleasure to profession to the multiple problems of modern urban life. Joseph Thomas Nast's life, and the parade for Kossuth to which he took his son, suggested the connection. Later, the public crusades for pure milk and against police corruption reinforced the point for young Nast. Discussions about race were not only intellectual; they also had a personal dimension. The presence of a young black woman in Fanny Fern's house demonstrated the human element of any discussion of slavery, equality, and society. Likewise, gender norms were not merely abstract ideas; they governed a very concrete set of behaviors. The struggle between James Parton's family and his wife exemplified this reality. The woman Nast chose to be his wife was the same woman who looked down her nose at Fanny's unladylike daughter. She brought with her, into their home and therefore into his studio, her views of gender and family.

Nast's emerging membership in the Edwards circle also coincided with the beginning of Nast's ascent to the middle class.[22] In Sallie and her sisters, Sarah Leach Edwards, and James Parton, Nast observed the dress, manners, and interests of the middle classes. In political terms, this meant participation in the discussions that were so much a part of middle-class life at the time. Nast's impetus to participate, and to observe carefully, was probably separate, at first, from his interest in Sallie, since all his life Nast strove to improve his financial and social standing. However, his romantic interest in Sallie could only have intensified his wish to fit into her family's rhythms. Together, in the years to come, they built a life that reflected Nast's inter-

est in the themes of middle-class American culture expressed in his work: domesticity, sentimentalism, and respectability.

In order to marry Sallie, Nast needed money. During their courtship, he teased her about her romantic musings on their money problems. "I am very poor," he wrote, "in fact, too poor to be romantic." Given that he spent nearly everything he earned, he added, she would have the chance "to be as romantic as you please" about poverty.[23] But his comments elided a serious issue. Eight months before, Nast recorded in his journal, "Cash on hand $100.00" and "go to church with Sallie."[24] The two were inextricably linked. Nast could not hope to offer Sallie a stable home without a better, more stable job. So he sought work that would fatten his portfolio and improve his prospects.

Almost immediately, opportunity knocked. On Monday, January 30, 1860, Nast spent the day sketching for the *New York Illustrated News*. The next day he finished a drawing for the *News* and called upon the Edwards clan. By Wednesday, he recorded in his pocket diary, "Get yourself ready to start off to England." A trip to the theater with Sallie on Friday, church on Sunday, and a farewell dinner at the *News* on Wednesday, February 8, completed Nast's social obligations prior to departure. He reminded himself, "Get Sallie's address and give her yours" and "buy German-French dictionary."[25]

Nast departed New York aboard the SS *City of Manchester*. In a long letter written in diary form to Sallie, he recorded the details of his journey. He was a good sailor. Unlike two of his companions, the Reverend D. B. Nichols, the superintendent of the Chicago Reform School, and a young man in his charge named Will, Nast never suffered seasickness. He made friends with the sailors, captain, and ship's doctor and bragged to Sallie about his ability to withstand the weather. Nichols disapproved of Nast, however, and soon attracted the artist's ire. Nichols warned young Will to avoid Nast, because "all artist more or less are not worth much." According to the reverend, Nast was "a hard case."[26]

Nast took the criticism with good humor. He considered Nichols faintly ludicrous. A "lecture" on the evils of W. M. Thackeray, whose historical novel *The History of Henry Esmond, Esq.* Nast was reading, prompted the artist to needle Nichols. "I should not read such [a] book, it is very bad for young people," Nichols told Nast. But when pressed, the reverend had to admit he had never read any Thackeray. In fact, he was proud that he "never in his life" had read "such books as those." The only thing worse was attendance at the theater "and such like places." Nast must have betrayed

his amusement, because after this conversation, Nast reported, Nichols "looked at me with piteous eyes, and gave a sigh for my sake." He teased Sallie, "O how bad I must be."[27]

This was the observant, friendly, open-minded Nast. His interest in tourism—in England he spent much more time visiting the National Gallery, going to plays, and taking tea with new friends than engaged in journalism—suggests his hunger for new experiences. In this period, Nast absorbed the cultures around him, both personally and professionally. His diaries reveal little about his political views, but they paint a clear portrait of a young man who liked to laugh and who considered everything fodder for his pencil. These qualities made him a good illustrator, and they would eventually contribute to his success as a political cartoonist.

The Heenan-Sayers Fight

A boxing match, the event that drew Nast to England, was one anticipated by thousands of sporting fans on both sides of the Atlantic. Still illegal in the United States, boxing thrived on an underground world of gambling, national pride, and masculine socialization. It also provided an expression of national antagonism within a controlled setting. *The New York Illustrated News* sent Nast to England to illustrate the fight between two champions, men whose boxing prowess was as significant as their symbolic role as representatives of their respective national identities.

The match pitted England's John "Benicia Boy" Heenan against American Tom Sayers. Boxing was likely a familiar sport to Nast, since it was a favorite in the taverns of his neighborhood. Irish and native-born fighters, as well as those representing practically every other immigrant group, squared off against one another in fights that served partly as entertainment and partly as proxy battles between Democratic factions. Some Democratic politicians, for example Mike Walsh of the Sixth Ward, formed gangs to support candidates of his faction and to intimidate other Democrats. Walsh's gang, called the Spartans, included Jim "Yankee" Sullivan, a well-known local pugilist who later owned his own tavern on Centre Street. Boxing was popular with young boys, and, despite the fact that boxing was illegal, commentary on major fights appeared openly in the newspapers.[28]

Nast first encountered boxing in a professional context at the Morrissey-Heenan fight on October 20, 1858. Working for Frank Leslie, Nast accompanied the columnist Mortimer "Doesticks" Thomson, yet another contact related to the Edwards circle. Thomson was a friend of the Parton house-

hold. In May 1861, after the death in childbirth of his first wife, Thomson married Grace Eldredge, the "unladylike" elder daughter of Fanny Fern. Jesse Haney, who had introduced Nast to Sallie Edwards, attended the wedding, and Henry Ward Beecher officiated. A caricature of Thomson by Nast in the collection of the Missouri Historical Society attests to their acquaintance.[29] For the Morrissey-Heenan fight, Nast produced a set of illustrations detailing the eleven rounds required for John Morrissey to defeat John C. Heenan. Nast, a fan of Heenan's, was disappointed at the outcome. Nast's previous interest in Heenan helps to explain his willingness, the next year, to travel to Britain and cover the fight against Sayers. He probably also calculated that a job as special correspondent would be good for his career.

During the late 1850s, new illustrated newspapers emerged constantly, and Nast worked for several of them. The details of his employment are unclear, but Nast changed his salaried position frequently, earning slightly more with each change. In 1860, when he and Sol Eytinge accepted work with the newly formed *New York Illustrated News*, Nast's weekly income was forty dollars. He supplemented this by providing illustrations for smaller papers, comic weeklies, and books.[30] He needed more, though, if he was to support a wife. So Nast sought more work, and better pay. The assignment to cover the Heenan-Sayers fight would bring both if Nast exploited it fully. So, once in England, Nast worked hard to forge professional contacts. The most important was with the *London Illustrated News*, to which he sold English publishing rights for the same illustrations he was sending back to New York.[31]

Despite the fact that Morrissey won the 1858 fight in America, Heenan was regarded as a national champion. His opponent, Tom Sayers, filled the same role in England. Nast managed to become friendly with Heenan and to gain access to the fighter's practice sessions.[32]

It is worth pausing here to consider that although, as noted earlier, many boxers became political operatives in later life, John Heenan had already established his Democratic credentials by 1860. In the contentious 1859 mayoral race, which pitted Fernando Wood against Daniel Tiemann, Heenan participated in a violent clash between supporters of Wood's Mozart Hall and the opposing Tammany Hall.[33] So Heenan was, in addition to an American boxing hero, a man whose very brawn represented Democratic political violence.

Nast also visited Sayers. With his colleague Mr. Bryant, Nast took tea with the fighter, finding him "very jolly." Sayers proved very gracious. "He treated us very nice," Nast noted in his diary. "If he were a lord he could not

have treated us better." Nast noted that Sayers needed his trainer to read their letter of introduction, since "Tom, I am sorry to say, can not read."[34] Part of Nast's value to the *New York Illustrated News* lay in his ability to provide portraits. Commenting on images of Heenan and Sayers that had already appeared in the *News*, Nast wrote to its editor, "The portrait of Heenan . . . is very good, but Tom Sayers is very bad indeed, in fact it is not at all like him." Naturally, Nast provided better sketches.[35]

Unlike Heenan, Sayers represented not so much a political position as a culture of "sport" in which men of means and little occupation indulged their passion for gambling through a variety of semilegal recreational activities. These men, called "sports," were the primary boxing audience, and they also existed in the United States, where their influence was felt as late as the founding of Las Vegas.[36] Popular culture associated boxing with vice, especially drunkenness and gambling. An illustration titled "A Gambling Scene at Pike's Peak" that appeared in *Frank Leslie's Illustrated News* explicitly linked the sport to degenerate gambling in Colorado, and even to deadly violence. In Nast's case, the touch of scandal emanated from Sayers's camp. The artist warned his editor not to identify a particular woman as "his wife because he will not like [it], she is not his wife but his woman."[37]

In addition to the way that boxers represented the mixture of political and popular culture, the fight itself represented an explicitly national confrontation between America and Great Britain. Not only was each man billed as the representative of his nation, but each wore the national flag in his belt loops during the fight. Songs and poems written about the fight immortalized the men as proxy combatants for their countries. In Heenan's case, he represented not only America but also Ireland, and its oppression by the British. Layers of political meaning, then, were available to any sharp-eyed young reporter hoping to make a name for himself. At the very least, it was difficult to avoid confronting the nationalist frenzy that the fight created among British and American fans.[38]

Heenan and Sayers met in a ring at Aldershot on April 17, 1860. Paine wrote that the fight was so important that Parliament adjourned for the day and Lord Palmerston, the prime minister, complained publicly about the fuss. The fight, which lasted forty-two rounds and ended only when the police intervened, was a triumph for Heenan. Nast's drawings, with commentary, filled a special edition of the *New York Illustrated News*. The success of this edition did not move the *News* to send their correspondent his pay, however, and Nast found himself without any money to continue his travels or even pay for his meals.[39]

In the short term, Nast solved his problem through his acquaintance with John Heenan. The boxer loaned Nast twenty British pounds, while Nast gave Heenan a draft for payment of $100 from the *New York Illustrated News*. Nast had been unable to obtain any money from the paper, but Heenan had no trouble. Asked how he had done it, Heenan replied that he had threatened to "punch their d——d Dutch heads off." According to Paine, Nast wished he had used Heenan to collect the entire amount owed. Even with more money in his pocket, Nast was lonely and homesick. In his diary, he noted Sallie's birthday on May 16. "Send her something," he wrote to himself. He also noted, "three months from home."[40] On May 27, he departed England, but not for home.[41]

The War in Italy

The announcement of Giuseppe Garibaldi's entrance into Italy provided the solution to Nast's financial problem. His drawings of the Heenan-Sayers match, reprinted in London by the *London Illustrated News*, prompted an offer of employment. If Nast wanted to observe Garibaldi's campaign, the *London Illustrated News* would pay for the trip and for any drawings Nast sent back. Broke, Nast had no choice but to accept. There is every reason to think that he would have done so anyway. Garibaldi represented the political ideals of his youth, and the failed struggle that had been so important to Nast's family. To travel with Garibaldi was to observe the essence of European Liberalism in action. Even better, the Italian campaign promised adventure and excitement. Nast would be that most romantic of journalistic types, the war correspondent.

From London, Nast traveled in June to Genoa, where he boarded the *Washington* to steam to Sicily. Garibaldi was amassing troops there, and Nast arrived approximately halfway through the effort.[42] Over the next six months, Nast observed the battle to unify Italy, accompanying Garibaldi's troops from Palermo to Naples.[43] Two aspects of Nast's experience stand out in relation to his later work on the Civil War. First, he developed a powerful admiration for the leadership of Garibaldi, whom he idolized as an exemplar of Liberal political leadership. Second, he learned firsthand the devastation that war could bring to soldiers and civilians, and translated that experience to drawings of both the bravery and the suffering of the Italians.

Garibaldi, like Kossuth, represented the spirit of 1848. Paine, writing many years later but attempting to reflect Nast's views of Garibaldi, called

the leader "a patriot whose religion and whose motto were combined in the one word, 'Liberty.'"[44] Liberal in his political stance, committed to establishing a stable, unified Italy, Garibaldi learned from the failures of 1848 and returned to Italy in 1860 more organized, better funded, and prepared to achieve unification through military conquest. Nast first saw Garibaldi in Italy during the journey of the *Washington*. On June 18, Nast watched as a fishing boat rowed toward the steamer. At one oar, rowing with his companions, sat Garibaldi. The boat had traveled forty miles to convey orders, meet troops, and provide information. Garibaldi met with the officers and took a moment to rest, then reboarded the fishing boat and resumed rowing as it departed. For Nast, this was the kind of personal commitment to war, the kind of selfless devotion to fighting men, and the kind of manliness that leaders demonstrated. Garibaldi was Nast's "hero from that hour."[45]

Nast's simplistic, black and white approach to complex political issues has sometimes been interpreted as reflecting a lack of sophistication. His fascination with Garibaldi might suggest this but for the fact that Nast's admiration for the Italian was composed of so many parts. It is true that Nast was very young, and that in the midst of an exciting time, surrounded by constant danger, Nast could easily have been swayed merely by the romance of war, but he was not. His admiration for Garibaldi cannot be so easily dismissed. Rather than a shallow worship of Garibaldi as a handsome military man, Nast's devotion was based on a complicated stew of family history, personal observation, and political conviction. Added to Nast's emotional connection to the revolutions of 1848 that powerfully underlay his devotion to Liberal ideals was Nast's belief that in Garibaldi was a fusion of masculinity and statesmanship.[46]

That fusion was evident in Garibaldi's very spine. One of the last things Nast did before leaving New York was to have his skull examined by a phrenologist. Like so many nineteenth-century Americans, Nast believed that genetic heritage, national characteristics, personal qualities, and achievement all manifested themselves in the physical body. Phrenological theories posited that breeding, character, and education *literally* shaped a man. His inner life was betrayed by his outward bearing.[47] Garibaldi, whose posture was as rigid as his manner was humble, personified this union of the soul and body. Thus, his handsome face, luxuriant hair, and striking figure in a red cape on horseback attracted followers in part because they pointed to his inner strength. And that strength, in the service of the Liberal politics that Nast supported, was very appealing. It provided Nast with a model by which he might judge all the men whom he met.

Nast's portrayal of the Garibaldi campaign extended beyond depictions of its heroic leader. This was Nast's first personal exposure to military violence, and his work reflected his fascination with the war around him.[48] Nast learned to compose the battle scene, to emphasize the decisive moment, and to identify the representative figure. His drawings appeared in the *New York Illustrated News*, the *London Illustrated News*, and the *New-Yorker Illustrirtr Zeitung & Familienblätter*. On July 6, 1860, he sketched a hospital scene, and on August 20, the shooting of General Fileno Briganti. On October 20, the *London Illustrated News* published his drawing of the Battle of Volturno, and an incredibly detailed one of an incident in which Neapolitan soldiers burned wounded Garibaldian soldiers alive. In each of these drawings, an emerging style is apparent. Soldiers receive individualized facial hair, expressions of fear, anger, or pain, and postures designed to produce a layered composition. The effect is of a crowd of individuals, rather than a faceless crowd.[49]

Nast's drawings show that he was not immune to the horrors of war. There is no evidence that the war was harmful to him emotionally, but in his letters to Sallie Edwards, while reassuring her of both his safety and his devotion, he emphasized his fatigue. In answer to her request for descriptions of the country, he wrote: "When I get my sketches done after traveling nearly all day I am so used up, that [I] can not do it even with my best wishes." She shouldn't worry, however, because "I am always in a safe place when the firing commences." Indeed, he apparently enjoyed enough leisure that he could read Dickens's *Martin Chuzzlewit*.[50] In other letters, he described dining in a restaurant in Naples, watching the sunset over its harbor. Nast made friends, worried about Sallie's friendship with another man, sent angry telegrams demanding to be paid by his employers, and sketched the architecture and social life of Italy.

Although his Italian experience laid the groundwork for his later war coverage, it failed to engage Nast's political sympathies in the struggle. While he admired Garibaldi, and viewed him as generally heroic, he did not adopt the Italian cause as a central political movement in his life. He observed the war, cataloged it in drawings, and stepped back from it when his workday was done. The excitement of the Italian campaign, however, reinforced Nast's commitment to his career in illustrated journalism, despite the uncertain pay. His war experiences helped to shape his style, teaching him to work quickly and to identify the emotional center of a scene. He saw, too, how politics and war could intersect. Garibaldi personified the union

between nationalism and the Liberalism Nast had grown up with. The Italian general set an example that would resonate in Nast's later work.

Back to Sallie

By the time Nast traveled to Europe, his and Sallie's courtship was fully under way. He wrote to Sallie regularly, signing his letters, "your lover," and once wrote in terrible distress at the thought of her taking walks with another man. His devotion to Sallie failed to prevent him from noticing the "very fine looking girls" at his hotel in Lucerne, and again in Basil, however.[51] As for Sallie and her family, they missed Nast. Up to their usual fun and games, the Edwardses recited a poetic homage to Nast that year:

> We have a friend this year with glorious Garibaldi,
> Of Theatre des Edwards the capital Grimaldi,
> Not least in our esteem, though mentioned last,
> Health and a swift return to artist her, Nast[52]

Nast found himself in Lucerne on an errand very much related to Sallie. Despite his years of work, he had almost no capital. Without it, marriage and a family remained out of reach. So Nast traveled to Germany to spend Christmas with his extended family with the hope that an elderly aunt might give him some family money. His travels already had the air of a grand tour. He had visited the Crystal Palace in England and various restaurants and churches in Italy, and then played tourist across Switzerland. In Lucerne he enjoyed the opera *William Tell*, commenting that "the conductor knew the singer could not sing so he made [as] much music as possible so one could not hear the singing." Everywhere he went, Nast sketched what he saw.[53]

Travels in Germany revived Nast's memories of his youth. He took a day trip to Strasbourg, where, he wrote, "I thought that I was the same little boy that I was fourteen years ago." He remembered everything "so well as if I [were] by yesterday."[54] The next day, in Landau, Nast again felt a wave of nostalgia. He visited the restaurant and inn where he and his mother stayed, writing in his diary of his "pleasure [that] I will be in the city in which I was born." Typically, he also recorded his encounter with a tedious man who "bored me to death" talking about an encounter with the Prince of Baden.[55]

Landau welcomed the artist heartily. As soon as he arrived, he called

upon his aunt, and found that everyone remembered him. From old acquaintances of his parents to the lady who ran the butcher shop, everyone "cried out Thomas" or offered Nast "an embrace, with a sweet kiss." The day ended with a festive evening at the local beer garden. Two days later, that pleasure had paled. "The only enjoyment the Germans find is the beerhouse," Nast wrote. The atmosphere—especially the "smoke and the noise"—proved uncongenial. Even the enthusiastic welcome began to wear on Nast. On the morning of December 23, a couple came to see him while he was still dressing, kissing him despite the shaving soap on his face. He finally finished shaving half an hour later, after they left. The next day he complained after a visit to another family that "German kindness is shown by eating and drinking." If he declined anything, Nast reported, "they think you slight them, and your host feels offended."[56]

Finally, he began to make some headway on his errand. Mrs. Weber paid Nast one hundred marks owed to his mother. A visit to his aunt elicited only frustration. "She had nothing to say to me," he wrote, but that "she is well off." A paternal aunt who lived elsewhere had "a little fortune which she would like to give over to ours," so Nast tried to find her.[57] By the last day of the year, Nast succeeded. His aunt was so "astonished" to see him that she began to cry. "I had to dine with them," he wrote. "They would not let me go to my Hotel anymore." That night, Nast slept in the house where his father grew up. "I should like to stay here for life," he decided, especially because "the women are very agreeable and amusing."[58] Financial matters proved less agreeable. His aunt claimed to have only a little money, barely enough to live on. Later, she said that although she had no money to spare at the moment, she "*would* give me *something worth* having" someday, and Nast concluded that "if she does not give her fortune to somebody else she will give it to *me*."[59]

By the time Nast left Landau, on January 11, 1861, he had so little money that he had to travel third class. His visit to family had been a success, but any hope of an inheritance was far-fetched at best. He was candid with Sallie about his financial worries. His European sojourn might earn him enough money or fame to allow them to marry, so he informed her of his money worries regularly. The trip had not been a success from a financial standpoint, but it had earned him a great deal of publicity, and that could lay the foundation for future employment, especially now that the United States seemed to be on the brink of civil war.

By the standards of New York artists, Nast's entry into the illustration of war themes was rather late. While Nast rambled across Italy, musing

on the beauty of Naples and writing to his sweetheart, Americans sweated through a summer of angry election rhetoric. As Nast toured Germany and commented on the poor quality of opera in Landau, his family and friends in New York watched the South respond to Lincoln's election. First South Carolina and then Mississippi rejected the new president and abandoned the Union. As political cartoonists worked feverishly to lampoon both sides—and to mock Abraham Lincoln—Nast sailed home. He arrived in New York on February 1, 1861, the same day Texas seceded.[60] It was the last state of the first wave of seceding states, and Nast found himself suddenly immersed in a city, and a nation, gripped by a political fever.

Given his intense interest in war and public affairs, made more acute by his experience with the heroic Garibaldi, it seems reasonable to assume that Nast was anxious to return to the United States and observe the war firsthand. His first surviving statement on the secession crisis, though, was remarkably low key. He had been in Europe for nearly a year when he left Liverpool for New York. Scribbling ideas for saleable drawings, he commented, "Send sketches to Mr. Thomas [of the *London Illustrated News*] soon . . . about the Southern excitement."[61] If Nast read about the crisis in English newspapers before departing Liverpool, he left no mention of it. His letters to Sallie are silent on the issue. It seems that even for a man as deeply political as Nast, romance came first. He emphasized not his eagerness to record the clashes of armies but his longing for her company.[62]

Sallie proved as beguiling in person as she had been when he was writing to her from Italy. Nast had been nearly broke when he returned to New York. His employer, the *New York Illustrated News*, was in disarray. Financial affairs improved quickly, however. The paper's new owners retained Nast at a better salary and paid him regularly. With his income assured, Thomas and Sallie married on the day before Nast's birthday, September 26, 1861, in the early morning before church.[63] Nast had little money to begin his life with Sallie, but his future seemed fairly stable. In a classic gesture of Nast's economic optimism, he bought a piano on credit so that Sallie and he could enjoy music together. They spent two weeks at Niagara Falls honeymooning. In letters to her parents, illustrated with tiny drawings by Thomas, Sallie described a madcap tour across the falls in a tiny carriage, numerous evenings spent on the veranda of the local hotel, and calm strolls through the grounds and town with her new husband. Public affairs intruded as soon as the couple returned to New York, however. Thomas's position required that he observe important national events, many taking place in Washington. He was off by train within a week.[64]

How did marriage affect Nast politically? Women's historians have detailed the complex rules that regulated female behavior in the nineteenth century. Expected to create a nurturing home, to maintain the family's emotional core while protecting its honor through personal chastity and public morality, women struggled to conform to or confront the "cult of domesticity." But men were caught in the same web. Masculinity, in Nast's lifetime, brought its own pressures, boundaries, and expectations. One of these was that voting was linked inextricably to a man's position as a husband and father. As Albert Bigelow Paine put it, writing about Nast's marriage, "This was responsibility. This was life." As the head of his household, Nast assumed responsibility not only for his own political opinions but for the decisions that would affect the health and safety of his family. Part of the burden of his authority was this power, and it was as obvious to a man of Nast's time as his wife's feminine duties were to any woman.[65]

Sallie's personal politics are unknown. Her family's conflict with Fanny Fern suggests that Sallie probably espoused a relatively traditional view of gender relations, but on the other hand the Edwardses' lively drawing room conversation provided Sallie and her sisters with the intellectual tools to understand and discuss politics. She and Nast did not discuss politics in their correspondence, but later Sallie would be an invaluable assistant to Nast in his cartooning. In many cases, Sallie suggested titles for her husband's cartoons. She checked the captions and quotes for errors, confirmed historical allusions, and wrote business letters in her beautiful handwriting. Nast's scrawl was nearly illegible, so her epistolary services proved invaluable. Early in their marriage, the couple established a domestic pattern. While Nast worked, Sallie read to him—newspapers and "standard fiction"—and they discussed his current project. In the evening, Sallie sewed while Nast read from a stack of newspapers. When provoked, he paced the floor and talked the issue out, testing his ideas against Sallie's ear. Eventually she would observe, "Well, once more the affairs of the universe are settled," and they would retire to bed.[66]

When Nast wrote to Sallie, even when he was reporting on political exchanges his comments almost always focused on his own professional advancement. When he mentioned the Senate and his visits to the White House in his letters in 1872, for example, his point was that his fame made political men seek him out. Politicians' views, votes, and arguments do not warrant discussion. In other words, politics were the meat and potatoes of his work, but he did not discuss them for their own sake. If marriage to Sallie made specific changes to Nast's political opinions, we do not know them.[67]

Marriage also provided an added impetus to succeed professionally. To support Sallie, and eventually their children, Nast needed to earn more money. As an illustrator, he had many options, of which political work was only one. So why did he choose to emphasize politics? The answer lay in a combination of personal interest and professional ambition. Nast's work, from its beginning in 1855, involved politics on almost every level. He could have allowed professional inertia to carry him forward; after all, he was already providing political illustrations and could continue to do so without straining his talent. But the man who had observed New York's rough-and-tumble political scene with interest for many years took a passionate interest in national and local politics. Nast gravitated to politics not because he happened to have worked as a political illustrator; he worked as a political illustrator because he was so drawn to politics.

Nast could have asked to remain in New York with his new wife. He might have been transferred to stories that involved municipal elections, local crimes, or juicy scandals, which would require no travel. But the private ambition he had always felt, added to his new responsibility to Sallie, argued for assignment to the big story. And the biggest story of 1861 was in Washington. If, through hard work and ingenuity, Nast could provide better drawings faster than other illustrators, he could earn money that would justify Sallie's faith in him. Thus, his status as the head of a household not only elevated his stake in the political system; it also heightened his commitment to success in illustrated journalism.

Only days after his return from Europe, Thomas Nast embarked by train to Washington, D.C. Despite his laconic mention of the "southern excitement" in his diary while he was at sea, Nast was eager to witness history in the making. Assigned to document Lincoln's inauguration, Nast wrote excited letters home to Sallie, detailing the cities through which he traveled and the people he saw. His interest in them is the same interest he had shown in people around him since adolescence. It was the interest that led him to draw his neighbors, local politicians, international boxing matches, and Italian Liberal heroes. In short, it was a political curiosity nurtured in his youth that was now poised to interpret the most important crisis in the United States' short history.

In his travels, Nast had witnessed a moment in Italian history so momentous it is called the Risorgimento (the resurgence or rebirth). On his return, he altered his own status within the polity when he married Sarah Edwards. A newly minted master of his own small world, Nast faced the Civil War with remarkably rich experiences to call upon.

CHAPTER FOUR

Compromise with the South

On September 3, 1864, Thomas Nast's cartoon "Compromise with the South" appeared in *Harper's Weekly*. The cartoon was a hammer blow for Lincoln and against peace. In it, a Union soldier, head bowed, reluctantly shakes hands with the Confederacy over the grave of Union men who fell for a worthless cause.[1] A vote for the Democrats, Nast implies, is a vote that invalidates all our sacrifices. The weeping Columbia, collapsed at the foot of the grave, only reinforces the impending tragedy. The drawing was so popular that *Harper's* printed a second run, and the Republican Party asked for the printing rights for a campaign poster. In all, several hundred thousand copies of the cartoon flooded the reading public. If ever there was a smash hit in nineteenth-century cartooning, this was it. By the time "Compromise with the South" appeared, Nast had been profoundly politicized. His early professional experiences, combined with his familial and local politics, helped push him from illustration into political cartooning. His coming of age professionally and politically during the Civil War only enhanced that development.

Nast was political long before 1864. He could hardly escape politics, in fact. Not only did he learn political ideas as a child, not only was New York almost rabidly political during his youth, but his immersion in the illustration department of *Frank Leslie's Illustrated News* made it impossible for Nast to escape the political culture of the late 1850s. Yet it was "Compromise with the South" that secured Nast's position as an observer of American politics. After its publication, Nast was no longer one artist among many. With the success of this image—especially its use by the Republican Party—he had become a minor celebrity.

Early in the war, Nast worked primarily for the *New York Illustrated News*, but his drawings of the front appeared in *Harper's Weekly* as well. Relatively quickly, Nast transitioned from drawings of the war to sentimental but politically charged illustrations. The content of these drawings, and their importance as the base of Nast's popularity with the public, helps to

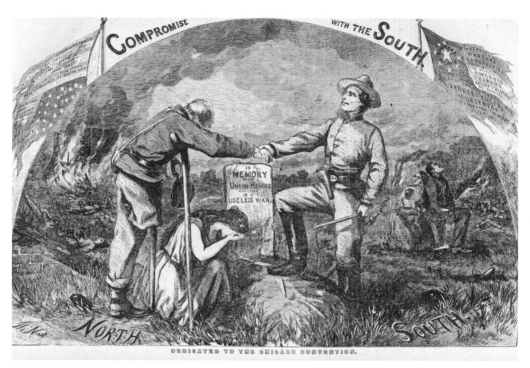

"Compromise with the South," Harper's Weekly, *September 3, 1864.*

underline the continuity of Nast's political values. Nast's sentimental illustrations also represented a larger culture of lithography. They reflected both Nast's fresh approach to cartoon art and his reliance on common concepts and images in political prints.

It was the Draft Riots of 1863 that pushed Nast decisively into the realm of party politics, though. More than any other event of the war, the riots solidified Nast's allegiance to Union, the Republican Party, and emancipation. They aroused in Nast the wicked wit so appealing to readers, a wit based not only on Nast's ambition and political ideals but also on his outrage and sense of personal peril during the riots. In this context, "Compromise with the South" seems a natural outgrowth of Nast's Civil War experience as a whole. Its success helped launch the next stage of his career. Celebrity brought with it many pleasures: increased income, acclaim from both the public and the powerful, a greater freedom to draw what he liked, and social access to circles that otherwise would have been closed to him. It also thrust him into the center of the national political struggle, where he remained for twenty years.

Before Harper's

Nast ended the war as *Harper's Weekly's* most famous artist. His first encounter with the war fever that gripped the nation, however, was with the *New York Illustrated News.* As a staff illustrator, Nast produced drawings to satisfy a public passion for information. Readers wanted to know not only what happened but how it looked. Working for the *News*, Nast traveled to Washington, D.C., for Lincoln's inaugural. It was his first extended observation of Abraham Lincoln, a man he would help to reelect in 1864 and to whom he would ascribe a plethora of virtues.

Nast met Lincoln when the president-elect visited New York City on February 19, 1861. Lincoln's reception was not so much effusive as physically abusive. Crowds jostled him, trying so desperately to reach him for a word or handshake that his clothes were torn and his hair mussed. Nast sketched the president from the street during a parade, then made his way to the civic reception that evening, where he produced more drawings. The crowds were again brutal. Nast forced his small body through them to shake the president's hand. He remembered many years later that Lincoln was pleased to be so welcomed but too preoccupied with the precarious state of the union to really rejoice. Nast's primary impression was that Lincoln looked very different from how he was pictured in the cartoons Nast had seen. Exactitude in likenesses was a standard accomplishment among illustrators, and one for which Nast would later be justifiably famous. His observations of Lincoln suggest that he saw the world both as an artist and a political commentator.[2]

The *News* liked Nast's drawings enough to commission further work from him. Leaving Sallie, he traveled by train through Philadelphia and Baltimore to Washington, where Lincoln would be inaugurated. At Philadelphia, Lincoln's speech at Independence Hall and the Continental Hotel elicited more drawings. Baltimore's reception of the president-elect was expected to be problematic, so there were no public events. Lincoln simply passed through in the night. Nast produced a drawing anyway, basing it on second-hand reports. It was a night scene, the background filled with darkness as a way to cover the fact that he could not illustrate any of the details of the scene.[3] Nast arrived in Washington in time to observe and draw the Peace Conference, Buchanan's farewell to the city aldermen, and a session of the Congress. In true Nast fashion, his sketch of Congress included one member with his feet up on his desk and another draping himself across his chair in a very undistinguished manner. The irreverent Nast who had

called himself "Little Piggy" was still there, no matter how professional his sketches had become.

Nast's sensitivity to the sectional tension in Washington was acute. He told Paine that on one occasion while he was standing in the lobby of the Willard Hotel—Lincoln's headquarters—he heard one man say, "I am from Maryland, and stand by my colors!" Another responded, "I am from Virginia, and stand by you!" The presence of Horace Greeley and a group of abolitionists may have increased the tension that day, but Nast's memories reflected what Paine calls a "feeling of shuddering horror." Nast saw clearly that the population was deeply divided and that violence lurked near the surface. "It seemed to me," Nast told Paine, "that the shadow of death was everywhere." Nast paced in his room. He could hear other men doing the same thing all around him.

Paine relates a story from this period that is representative of Nast's developing romance with America. With tension thick in his hotel room, and convinced that the entire city was poised for a violent outbreak, Nast was unable to work. He heard a man emerge from his room onto an outside balcony at the Ebbett House. According to Nast, it was as though the city itself held its breath, waiting to see what the man might say or do. The man began to sing, "Oh, say can you see . . ." and the tension broke like a dam. People gathered in the streets, sang along, and left their rooms to embrace in the hallways. "All of Washington had been saved," Nast said, "by the inspiration of an unknown man with a voice to sing that grand old song of songs."[4]

THIS WAS THE NAST whose sentimental illustrations would enchant the nation. Despite the vagaries of his immigrant past, despite his childhood among some of New York's roughest, poorest, and most alienated citizens, Nast had adopted America as his home. He identified the emotions of the men and women around him, then enhanced those feelings. If Americans loved the poetry of patriotism, Nast would provide images which showed Columbia enshrined. At war, while other artists drew images of camp life, he focused on how the nation felt about camp life, and the difference was profound.

Sentimental Illustrations for Harper's Weekly

When he returned from his honeymoon in October 1861, Nast still worked for the *New York Illustrated News*. He developed his skill at drawing soldiers

in uniform, marching, at rest, and in battle during his travels with Garibaldi, and that skill earned him a better salary, first at the *News*, and then — briefly — at *Frank Leslie's Illustrated News*. Leslie's talent for mismanaging money was as brilliant as ever, though, and Nast found himself out of work almost immediately. He sent a batch of sketches to *Harper's Weekly*, and the editors accepted them with alacrity. Nast was not yet under contract with the magazine, but he was a staff illustrator and was well paid.[5] He remained with *Harper's* for the next twenty-five years.

Initially, Nast illustrated sketches from other artists and worked with Sol Eytinge in the engraving department. Artists working for *Harper's* in the field included Winslow Homer, Arthur Lumley, and A. R. Waud. In fact, Waud, arguably the most famous battlefield illustrator of the Civil War, accused Nast of signing his own name to drawings that Waud sent from the front. Nast was the engraver on these drawings, but it was Waud who was the artist. This issue had come up between the two before at the *New York Illustrated News*, where a December 28, 1861, illustration titled "Rebel Horsemen Scouting Between Anandale [*sic*] and Fairfax" was signed "T.N." in the lower right-hand corner. The "T" is clearly that which Nast used later in his abbreviated signature. The image was based on a Waud sketch, and even shows Waud crouched behind a pile of logs, watching the scouting party ride by. His sketch pad is clearly visible, as is his face and beard.[6]

Nast's first signed work for *Harper's Weekly* was a simple illustration. Northerners wanted to see the camps, battlefields, movements, and daily life of its armies, and artists like Nast provided detailed illustrations to satisfy them. While Waud and others accused Nast of creating his drawings from others' sketches, Nast always claimed that these illustrations were the result of his work in the field. He said that in the early years of the war he drew from life, much as he had done in Italy. But it is not clear that Nast was actually in the field, that is, observing battles and sleeping in soldiers' camps in the way Waud had. Given Nast's investment in his war record, and later controversy over whether he actually observed the war firsthand, an examination of where he was and what he did is the first step in understanding his war work for *Harper's*.

Nast claimed that he traveled to the battlefield and observed the war firsthand. According to Paine, in the spring of 1863 he visited Fort Moultrie, in South Carolina, where he met General Benjamin Butler. Carrying his sketchbook, Nast moved on to several of General Philip Sheridan's camps. Nast claimed that Sheridan liked him and invited the young artist to set up a semipermanent base in his camp.[7] Nast's account of his trip cannot be

verified, and serious discrepancies between his accounts and historical fact suggest that either Paine misrecorded the timing of the trip or Nast misremembered it.

But the more important point to be made here is that Nast was not interested in the kind of war reporting perfected by Waud and Winslow Homer. It was simply not Nast's style to settle in a single camp, follow one unit at a time as it moved through a series of engagements, and become close enough to really depict the action as the soldiers saw it. And since Waud and others did it so well, Nast could not carve a niche for himself with that kind of reporting. Instead, Nast made friends, watched and sketched, but moved around. He needed only a relatively small amount of raw observation to combine with his imagination and produce illustrations.[8]

Yet, on at least one occasion, Nast did attempt to observe a large battle. He left for western Pennsylvania on Wednesday, July 1, 1863, to observe Robert E. Lee's army. While waiting in Harrisburg to obtain a pass to move toward the battle zone on Friday, Nast happened to see Sallie's cousin Henry under arrest. The two men spoke. Observing their interaction, a group of officers began to question Nast about how he knew the prisoner. He explained the family connection but found that he, too, was now to be detained in order to give testimony at Henry's trial that afternoon. "Is not this jolly?" Henry asked, but Nast failed to find it so. That afternoon Nast learned that Henry had "stolen horses, killed a [c]alf, and had a rebel signal flag on his person." Worse, Nast reported, the Englishman "behaved very badly during the trial, laughing, speaking loud, and [talking] to me."[9]

Nast's problem in all this was to establish his identity. He tried to explain his presence in Harrisburg but had no way to prove that he was a journalist. During the Civil War, the movements of noncombatants, and especially of journalists, were peripatetic and unsupervised. Many carried safe conduct passes and letters of introduction, but others did not. Aside from his sketchbook, Nast carried little specialized equipment that a Union officer would recognize. Luckily, Nast encountered General Julius Stahel, whom he knew, and asked the general to vouch for him. Though Stahel agreed, Nast still found himself confined to town for the weekend.[10]

It is a measure of Nast's relative obscurity in this period, despite Paine's efforts to demonstrate that Nast was popular with soldiers and civilians throughout the North and widely hated in the South, that he went unrecognized. To the provost marshal of the camp, and then to its commanding officer, and with the support of a major general, Nast protested that he was a journalist, to no avail. On Saturday, he invited the provost marshal to

send a telegram to Fletcher Harper in New York, but it was Independence Day and Harper had already left for his country home. The telegram went unanswered while Nast cooled his heels.[11] After an interminable weekend spent observing Confederate prisoners and talking with Union soldiers, Nast was finally released on Monday. It was too late. Nast would have to make his drawings from second-hand accounts of the wounded men he met on the road as he hurried toward the battlefield.[12]

Artistically, Nast hardly needed direct war experience. The images he created for *Harper's* reflected the emotional reality of the war for the Union home front. Thus, the power of Nast's work lay not in its fidelity to reality but in its penetration into Union hearts and minds. Fletcher Harper, publisher of *Harper's Weekly*, liked Nast and allowed him the freedom to create many sketches drawn largely from his imagination. Nast pointed to this freedom as an example of the mutually respectful and affectionate relationship between him and Harper. Nast probably did visit Union camps, at least a few times, but those visits were not the stuff of which his illustrations were made. Instead, it was the combination of his store of visual experiences— those images he could reproduce from memory, such as a camp full of soldiers—and his talent for touching the most powerful emotions of the reading public.[13]

Nast's work touched North and South alike. "Sixty-three was a poor time to investigate," Paine wrote to excuse Nast's tendency to redraw sketches sent to his employers by other artists. Emphasizing the value of Nast's drawings as an army recruiting tool, and the ire they elicited from southerners, Paine implied that Nast was unable to travel south because he would have been "burned at the stake." Despite the fact that Northern publications could be difficult to obtain in the South, readers must have found a way to find *Harper's*. In every description of Nast's work in these years, the vituperative mail *Harper's* received about him is mentioned. It is likely that some of it came from southern sympathizers with the North, or those who felt that Nast's depiction of southern violence (especially jayhawking) was too strong. But Paine, John Henry Harper, and others writing about the period all assert that most of the mail was from residents of the Confederate states, and that they hated Nast passionately.[14]

One surviving example of that hatred is a set of drawings in the collection of the Gilder Lehrman Society of New York. The drawings are dated 1863, and are reproductions printed in Baltimore in 1934. They are identified as the work of Adalbert Johann Volck, also known as "V. Blada." Volck, born in 1828, lived in Baltimore, where he produced pro-Confederate car-

toons during the Civil War and worked as a dentist. Volck is an interesting character, especially in his role as a critic of Thomas Nast. A native of Augsburg, Volck grew up in Bavaria, the same province where Nast spent his earliest years. Volck fled Bavaria in the wake of the Revolutions of 1848. Like Joseph Thomas Nast and his son, Volck's interest in politics emigrated with him, and the sectional crisis was central to his political participation. Volck remained in Baltimore during the Civil War, smuggling medicines to the South, illegally housing Confederate partisans, and handling communications for Jefferson Davis. Lithographs like Volck's appeared in most major cities in the 1860s, but it is not entirely clear how Volck printed his drawings. Given the political position the drawings represented, especially when they attacked Lincoln, they might have attracted unwanted attention if published openly. Any printer could create a simple lithograph, however, and it is even possible that Volck obtained his own press. Somehow, he produced copies of his drawings and distributed them among southern sympathizers. Given the porous nature of the border with the Confederacy, and Volck's ability to send materials across it, there is every reason to think that his cartoons were available in the South.[15]

The drawings are interesting in part because they were created at the moment just before Nast's popularity began its meteoric ascent. Nast's work was widely noticed, well liked in the North, and still mostly sentimental and illustrative. The drawings' political themes were expressed with solemn sincerity rather than the irreverent wit of later years. But the Volck drawings reinforce the impression that Nast's sincerity was capable of offending, even infuriating, southerners and their sympathizers every bit as much as later cartoons would. It is hard to evaluate southern reaction to Nast's drawings as fully as we would like for three reasons. First, the shortage of paper, ink, and other printing materials in the South, as well as the shortage of manpower and the disruption caused by war, meant that few southern newspapers flourished during the war.[16] Second, those few prewar papers that continued to publish and the even fewer new papers published for a substantial time during the war have not always survived in archives. Finally, *Harper's Weekly* did not retain correspondence mailed to it by southern readers. Paine says that the paper was flooded with letters either praising Nast for his wonderful evocations of camp life and the hardships of the war or vilifying him for his partisanship and cruelty. John Henry Harper, writing his memoirs in the early twentieth century, remembered the same outpouring of comment. Neither the praise nor the criticism is available for readers to examine today.[17]

What did survive, however, are Volck's cartoons. They can provide an otherwise unavailable window into pro-Confederate reaction to Nast's early work. There is no doubt that they were intended to comment on and to be compared to Nast's drawings.[18] Some of the positions in which men and woman are placed are exactly analogous to the position of figures in Nast's drawings, but they convey opposite meanings. An example of this is Volck's drawing "Cave Life in Vicksburg during the Siege." Nast's Christmas drawing for *Harper's* in 1862 showed two adjacent images: in one, a woman prays at the window while her children sleep. In the other, a lonely Union soldier sits at his fire dreaming of home. The picture was intended to evoke simultaneously the sacrifice of Union families for the war and the enduring spirit of home, a home for which Union soldiers yearned and of which they were so protective. In Volck's drawing, a woman similarly kneels in prayer at a battered trunk. She is alone in a cave, surrounded by furniture that clearly belongs in a fine home. There is no visible food, and the impression is of poverty, want, and isolation, demonstrating the way that the Union war effort had destroyed southern homes and southern families.

The Volck images that appear to comment on Nast's series of drawings in 1863, which vividly portrayed the cost of war and the honor of Union soldiers, rely more on content than physical mimicry.[19] In Volck's images, Northern soldiers appear as rapacious looters, wanton destroyers of the homes and food of innocents. Volck's drawings portray the Union as an invading force, and Union soldiers, the same men Nast idolized, represent all the violence inherent in the idea of invasion. Another favorite target for Volck's pencil was the behavior of black southerners. In Nast's drawings, black men and women are the targets of southern racial violence. They suffer lynchings, murder, whippings, and degradation. Black people in Volck's drawings, on the other hand, are sly, dangerous, ignorant, and lazy, stereotypes that were entirely consistent with the tradition of caricature that portrayed a world after black emancipation.[20] Volck's drawings, and others like them, also set the stage for the apocalyptic images that would portray Reconstruction as a wasteland of black corruption. While Nast attempted to use the humanity of the slaves to assail southern racism, Volck argued that it was the slaves themselves who were the central danger to southerners. They constituted a dangerous element, held in check by southern will.

Volck's drawings may be the best surviving pictorial example of the enmity Nast's early work aroused among southern sympathizers. Yet they seem to respond not to Nast's cartooning but to his sentimental illustra-

tions. Although Morton Keller, writing about Nast's cartoons from 1863, considered the political content subordinate to the emotional, he acknowledged that Nast was expressing political ideals. J. Chal Vinson and Albert Bigelow Paine did the same. But none could avoid the conclusion that the sentimental illustrations' central power was their emotional appeal. As with Nast's childhood, it is here that the concept of political culture helps to explain the connections between art, emotion, and political convictions. Volck's drawings demonstrate that effective wartime illustrations had to both address the politics of their viewers and tap into their emotions. And in order for Nast to create a world of enshrined Northern soldiers, noble leaders, and bravely suffering families, he had to attack the southern war effort by appealing to emotion. He also challenged the appeal made by antiwar Republicans and Democrats. In short, his war illustrations addressed the political questions of the moment not through reason and intellect, or even through satire, but through the heart.

In order to understand the political cartoons that Nast produced later in the war, it is necessary first to examine his earlier sentimental images. Political, emotional, passionate, and personal, these drawings allow us to chart the increasingly sophisticated connections he drew among politics, culture, and art. In addition, they demonstrate Nast's evolving style. Given that many of them were drawn within two years of the end of his European sojourn, it is remarkable how different they are from the Italian drawings. Nast's passionate devotion to the Union, his opposition to slavery, and his burgeoning sense of himself as a political thinker are all present, almost from the beginning of his war work.

Thomas Nast did not invent sentimental illustration, of course. Lithographers, including Currier & Ives, Louis Prang, and a variety of others in New York, Philadelphia, and Boston, fed public demand for visual stimulation by printing a stunning variety of illustrations, both sentimental and political. Currier & Ives specialized in black-and-white political images, usually produced on a thick cotton paper and titled in a characteristic black font, that sold for twenty-five cents each at the beginning of the 1860s. Few national, international, or local issues, political or social, escaped the lithographers' comment. The sheer volume of available lithographs points both to the competition any artist faced and to the popularity of lithography. Most lithographs, though, were produced anonymously. Sometimes the printer's name, not the artist's, appeared at the lower right of the image or above the title.[21]

Political commentary was not Currier & Ives's only specialty. The firm

also produced extremely popular color lithographs depicting the pleasures of middle-class American life. Ice skating, dancing, sleigh rides, and sailing were all the subjects of beautiful color prints. For the emerging middle class, leisure and the home were crucial markers of social status. So even if one could not spend an afternoon gliding across the snow of Central Park in an open sleigh, one could experience it second hand by hanging a print in the parlor showing this particular winter pleasure. Americans liked to hang images of American family life in their homes. To serve that appetite, lithographers produced more images, and made them ever more evocative of a home life that was warm and loving, comforting and stable.[22]

It was this tradition that Nast joined when he began to produce imaginative illustrations of the war for *Harper's Weekly*. If Currier & Ives could sell lithographs to Americans by idealizing family life, then perhaps the public would purchase periodicals that did the same. And in 1862 and 1863, sleigh rides had given way to absent soldiers in the minds of wives, mothers, fathers, and children. Nast's ability to gauge public desires was emerging at this time, as he fused the sentimentality of the existing lithographic tradition with the pressing issues confronted by a journalist/artist. The result was a series of drawings that expressed not the factual view of war provided by illustrators like A. R. Waud or Arthur Lumley but the war as experienced at home and in camp.

Just as Nast did not invent sentimental illustration, he was not the first artist to insert the emotions of war into his drawings. Nevertheless, Nast's work moved the public in ways that other artists could not. This was partly the result of Nast's innate ability to notice detail. An example of this gift for observing the particular is apparent in a letter from him to Sallie in 1863. On his way to Pennsylvania to observe Gettysburg (the trip that would end in frustrating confinement), Nast was optimistic and cheery. He wrote to Sallie about the dust on the road, the way rain had tamped it down for the moment, and the potential for more rain in the lowering clouds. Boys ran alongside the train, he said, begging riders for their used newspapers. Nast even drew Sallie a little sketch of the boys.

He was especially captivated by a fussy little termagant across the aisle. She was "doing a good deal of loud blazing" about how she would travel to Washington no matter what anyone said. There was no use for travelers to "dress up" for train trips, she said, because "one gets very dirty." But Nast observed that she was "dressed to kill, all the color in the rainbow was on her and her bonnet had all the different flowers in the world." Her lunch was "a piece of bread a yard long (believe it my dear) and away it went, you

"The Result of War," Harper's Weekly, July 18, 1863.

know where."[23] This kind of attention to the world around him was characteristic of Nast. He liked to sketch the people he saw on the street, a habit he retained until the end of his life, and remembered details about them to report back either in his drawings or in letters to or conversations with friends.[24]

In Nast's sentimental illustrations, the pragmatic vision that infused sentimentality into the cold reality of war and talent for picking out the most amusing, telling, and visually appealing details of the world around him merged. But Nast's approach was distinctive in other ways as well. In his drawings he employed several characteristic organizational schemes. First, he liked to provide parallel images, usually contrasting two visions, but sometimes presenting more. Parallelism could also provide temporal and geographic motion, allowing Nast to contrast leaders of North and South, the war in the two sections, and life before and after the war under various scenarios. Second, he filled the borders of his drawings with—often violent—miniature images, many of which were far more pointed than the central images. Third, he inserted the most evocative symbols of all sentimental drawings: women and children. Again and again, when Nast

needed to express a particularly heinous concern, he would use the bodies of women and children to show how bad the situation really was. They served as the emotive and moral heart of his work. Finally, Nast employed the elements to emphasize distance, violence, or despair. Clouds, snow, wind, rain, and darkness all appeared in Nast's work when their symbolism could reinforce the sentimental point. Three examples of Nast's sentimental illustrations demonstrate his use of these techniques.

"Christmas Eve" inaugurated the double-circle method. Nast liked to construct the circling borders using images of natural materials, and here they are drawn as a ring of holly. In the left-hand circle a woman kneels at the foot of a bed where her two small children sleep, praying for the safety of her husband, who appears in the circle to the right. He sits alone by a night fire, wearing all of his gear, staring at a panel of photographs. Nast drew each figure in profile so they could face one another. Their connection is obvious. At this special family holiday, Northern families' were divided. Their devotion to Union was more powerful than their personal desires, but the suffering was hard to endure. Nast divided the image horizontally as well, emphasizing the joys of Christmas above and the horrors of war below. The weather played its part as well. Above, snow falls gently as Santa climbs down a chimney on the left and rides his sleigh on the right. Below, snow covers a battle scene on the left, and a raging winter sea rocks naval vessels on the right. The image in a circle between the man and the woman, a line of graves marching into the distance, sends the most straightforward message: She prays for her husband's safety and for his protection from the grave.[25]

Another sentimental illustration, "The War in the Border States," contrasted the heroism and compassion of Union soldiers with the suffering inflicted on women and children by the war. Two central images appear within circles of bent wood. On the left, a Union soldier gives bread to a starving mother while her son bites into a crust. It is snowing, and the women and children around the soldier are clearly miserable. Another soldier, slightly to the right, hunches his shoulders within his coat. In the background to the left, yet another soldier marches by, passing a roll to a girl as he goes. In the circle on the right, a woman mourns her husband, killed by falling debris, while her children recoil in horror. Smoke billows in the background, and soldiers file by oblivious to her suffering. *Harper's Weekly* used rectangular paper, just as newspapers do today, and therefore circular images would not fill the entire page. In the corners of this drawing, Nast inserted four scenes that emphasized the destruction of the war. The images

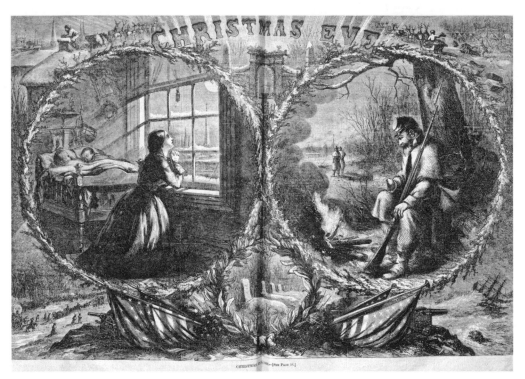

"Christmas Eve," Harper's Weekly, *January 3, 1863.*

in the upper and lower left and lower right depict a bomb's destruction of a village and bridge as jayhawkers watch a small farm from the trees. In the upper right-hand image, they have descended upon the farm wife, who pleads on her knees as they take away her livestock and horses.[26]

A week later, Nast used the template of sentimental illustration to show how he envisioned the world after the Emancipation Proclamation.[27] What is so remarkable about this drawing is that it shows how quickly Nast wedded his political views to sentimental illustration. Lincoln issued the Emancipation Proclamation on January 1, 1863, and it aroused intense debate. Lithographs for sale in New York depicted variously a nation of interracial couples, black presidents, and unrestrained licentiousness.[28] Images predicting that the nation's racial distinctions would dissolve and that Lincoln had doomed himself and his party were equally common. But Nast disagreed with these gloomy assessments. Instead of doom, he foresaw the application of American liberty to the black population. Nast believed American liberty, the American dream, was comprised of very specific elements: education, a job, dignity at work and home. "Freedom is not . . . a house and clothes, it is not a happy life," wrote one observer. But for

Nast, as for Lincoln, these things were precisely what freedom entailed. Nast could be a very literal thinker, and "Emancipation" showed precisely what he believed the New Year could provide to black Americans.[29]

In "Emancipation," a central panel encircled with a simple white border forms the focal point. Within, Nast has subverted the sentimental tradition by portraying a black family in the precise position that any sentimental illustration might show a white family. Mother cooks the dinner while Father plays happily with his children. A plush chair and a knick-knack-covered mantel assert the family's comfortable income. Likewise, the framed image of Lincoln hanging next to the hearth proves their patriotism. Yet Nast was not content to leave it at that. To the left of this scene are images of the past: a slave auction, blacks being chased through the wilderness, black families being separated, and slaves being whipped and branded. Women and children appear in each scene, including a barebacked woman receiving the blows of her master. To the right of the central scene is a better world. Former slaves are attending "Public School" in one image and enjoying a mutually respectful relationship with white overseers at work and the benefits of a salary in another. The women and children here are clean, well-dressed, and smiling. The children appear mid-scamper. At the very top of the illustration, the weather appears yet again. On the left, thunder and lightning drive away the slave catcher and his vicious hounds. On the right, soft clouds embrace Columbia and a group of cheering soldiers.

While "Emancipation" is more obviously political than "Christmas Eve" or "The War in the Border States," in that it expressed explicit approval of the president, all three provide examples of the way that Nast's work was both sentimental and political. Most of all, though, his work was highly personal. Unlike reportorial drawings, and of course those he engraved from other artists' sketches, these illustrations allowed Nast to express his ideas fully. The prints were extremely popular. "Emancipation" appealed so much to abolitionists that it was reprinted as a poster.[30]

As these drawings demonstrate, Nast was free to experiment with form, content, and emotive intent in his work. He was no longer engraving the drawings of other men. Instead, he had become a popular artist in his own right. Northern audiences responded to his ability to identify with their feelings—about the war, the president, the soldiers, and the South. It is not hard to imagine Nast continuing to produce sentimental illustrations for the rest of his career. But he did not. Instead, the political content of his work became more and more pointed, more and more partisan. Nast changed from an artist interested in the war to a man for whom politics

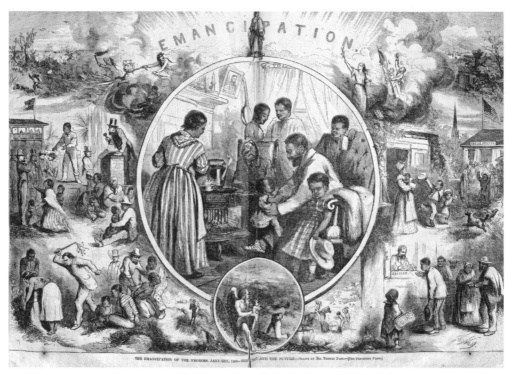

"Emancipation," Harper's Weekly, *January 24, 1863.*

were life's breath. The catalyst for his wholehearted adoption of politics as his main theme was the most violent upheaval in New York during his lifetime: the Draft Riots.

The Draft Riots of 1863

Thomas Nast's political education, his experience as a resident of New York's rough-and-tumble streets, and his professional development as an illustrator of current events all came together in July of 1863. The riots that overtook New York in that month shocked the nation. They began as a conflict over the Conscription Act of 1863. Angry that poor men would be drafted while richer men hired substitutes, a mob attacked the draft offices in Manhattan. Four days of rioting followed, leaving homes and businesses burned, more than 100 citizens dead, and the city government in disarray. The mob targeted black New Yorkers specifically, because the Irish connected conscription with the Emancipation Proclamation. In addition to class conflict, then, the riots centered on a rejection of the war for emancipation.[31]

Thomas Nast's public support for the Emancipation Proclamation made him fearful for his own safety and that of his family. To his memories of Five Points and the Irish gangs of his youth, Nast could add the rampaging mobs of July 1863. The riots seared onto Nast's mind a set of images that would never really go away. As his style evolved, it was the riots, as much as the election of 1864 or "Compromise with the South," that pushed Nast toward a more partisan, radical, political stance.

Nast nearly missed the riots. As noted above, he intended to observe the Battle of Gettysburg, and he left for Pennsylvania on July 1. Traveling by train, Nast arrived in Philadelphia, where he wrote to Sallie of the recruiting posters exhorting "Men of Color" to "Come Forward for the Defense of the City." His mood was optimistic, and he reassured Sallie that his room in a local hotel was "very nice."[32] Nast's next surviving letter, written on Independence Day from the military prison camp at Harrisburg, was far less sanguine than the first. "Another miserable day," it began. Nast had spent the day shuttling between the provost of the camp and General Darius Nash Couch. As discussed earlier in the chapter, neither the provost nor the general was sure of Nast's identity, and neither would agree to release him. They believed that Henry was a spy, and Nast may have believed it, too. He wrote to Sallie that "he will be sent back to England as soon as possible." Nast's confinement was largely the result of the army's inability to confirm his identity.[33]

General Couch wanted to send a telegram to the Harpers in New York, but it was Saturday. Nast knew that Fletcher Harper would "not be in town on a day like this and will not come back till Monday morning, so I will have to wait all that time." His frustration was palpable, made worse by pouring rain. Nast used the time to visit Confederate prisoners and observe their condition and morale. Many, he said, were eager to return and "will fight it out to the last." Others, confined to a room that "smells like a pig sti [sic]," were hardly so enthusiastic. Nast sketched these men, but he considered the trip a near loss. The only benefit, he wrote, was that "it has done me a great deal of good all ready [sic], seeing the real life again."[34]

There would be plenty of real life awaiting Nast when he finally returned to New York. His credentials confirmed by Fletcher Harper, Nast left Harrisburg and hurried toward Gettysburg to sketch the aftermath of the battle there.[35] He followed the action to Carlisle, drawing the camp while Confederate batteries shelled the Union forces. From Carlisle, Nast wrote to Sallie. The letter was messy, he explained, because he was writing it while rifle shots cracked in the background. His English deteriorated

due to fatigue. "I fell [feel] so very tired, that I do not know with myself," he wrote. "I am writing this behind a table wher ther all [are] some 12 offie [officers] drinking, singing and playing cards." Camp life was not congenial for Nast, who missed his family passionately. The longer he was away, the more intense became the closing lines of his letters. "O! Darling loving wife," he wrote from Carlisle. "God bless you dear heart and expect to see me soon again, hoping to kiss you both in reality. God bless you my dear darlings, good night." Frightened by the shelling and eager both to see his family and to turn his sketches into illustrations for *Harper's Weekly*, Nast returned to New York around July 12.[36]

The city simmered with tension. July was the month in which the Conscription Act, passed by Congress in March, went into effect. The act intended to encourage men to volunteer for the Union armies, and it used the threat of conscription to achieve that goal. It also allowed anyone to avoid service if he could provide $300 to hire a substitute. The implication that the rich man could avoid the war while the poor man must fight and possibly die infuriated many New Yorkers. Ire against the substitution clause, as it was called, was felt most keenly by Irish New Yorkers. Many of the earliest volunteers had been Irish, and even the celebration of victory at Gettysburg could not erase a sense that the Irish had given more than their fair share of blood to the Union.[37] Moreover, the Irish comprised a larger proportion of the city's poor than any other immigrant group. As a result, they were least likely to have the money to buy a substitute. The old conflict between "native-born" Americans, more likely to be wealthy, and immigrants in the slums now focused on the draft.[38]

Newspapers made the situation worse. Each paper supported a particular political or ethnic group, and each expressed its opinions in the starkest terms. *The Metropolitan Record* began to fulminate against the draft in March. *The Journal of Commerce* implied that Lincoln and his cabinet were "murderers," while the *Daily News* suggested that the Republicans hoped to draft Democratic citizens and see them die in battle. Worst of all, the perennial tendency for violence against black New Yorkers was encouraged. Benjamin Wood, editor of the *Daily News*, warned that once white men left for the front, blacks would take their jobs, an assertion that seemed borne out when striking longshoremen were replaced by black workers in June.[39] The relationship between the Irish and black communities in New York was a complex one. The Irish in general had opposed abolition and expressed opposition to an equal role for black Americans in civic and economic life. Protective of their tenuous hold on jobs, home, and security, many

Irish New Yorkers feared that black men *could* take their jobs.[40] There were plenty of Irish men and women whose racial ideas were balanced between suspicion and a grudging acceptance. Provocation served only to inflame the suspicion and tamp out the possibility of acceptance. In short, by railing against the Conscription Act and suggesting the possibility (or likelihood) of heinous conspiracies against Irish Americans, Democratic newspapers encouraged the most extreme of views and pandered to existing tensions.

According to at least one source, it was the newspapers that eventually sparked the riots. The first 1,200 names of the men to be drafted were drawn on July 11, a Saturday. They appeared in print the following day. Sunday was a day off of work for almost all New Yorkers, and as a result the entire city was free to read the names, debate their significance, and plan a response. Unlike a busy Monday or hurried Friday, Sunday was a day when discussion could range freely from the evils of conscription to the nefarious goals of Abraham Lincoln. And workers liked to drink on Sunday.[41] No one drank more, more often, and with greater public effect than firemen. So it was bad luck that a few of the first names drawn were those of firemen in the Black Joke Engine Company. Usually exempt from military service because of their service to the city, the Black Joke Company objected strenuously to the draft. Pulling their wagon to the offices of the provost marshal, firemen began to pelt the windows with stones. It was the spark that began four days of arson, lynching, looting, and drinking.[42]

Roaming bands of rioters attacked a variety of targets. Historian Adrian Cook has argued that there were actually four riots. The first was precipitated by opposition to the draft. Another was a reaction to the idea that African Americans could take Irish jobs. A third was an assault on the divide between the rich and poor, especially with regard to conscription. Finally, some portion of the riot is ascribed to simple criminality, an urge to loot and vandalize unrelated to any political purpose. All of these, whether interpreted as parts of a single riot or as separate riots, caused massive destruction and substantial loss of life. Most of the victims were the city's black citizens, including the children housed at the Colored Orphan Asylum, most of whom barely escaped through the back door. Nast remembered seeing the bodies of dead children in the streets.[43] Black men were lynched, black homes were burned, and the possessions of many blacks were stolen by men and women who followed the more violent rioters and used the confusion as a cover for theft.[44]

Theft motivated some rioters to attack white citizens as well. Represen-

tatives of the city government, Union army, and especially the conscription effort were popular targets. Republicans were also in danger, as was any man perceived to be rich enough to buy his way out of the draft.[45] Not all of the damage was intentional. Fires set in one building might spread to another, and landlords endured losses incurred by attacks on tenants. The disruption of the city's streets for four days was, at the very least, a difficult price for the poorest to pay. Four days out of work could mean weeks of hunger for a family dependent on sewing, rag-selling, or day labor for subsistence.

The riots shocked the nation. Newspapers, deeply involved in the rhetorical prelude to the riots, rushed to provide news of the destruction. Thomas Nast, who so recently returned from two weeks of imprisonment and Confederate shelling, ventured into the streets to make sketches. He saw the body of a murdered Union soldier, "the children of rioters dancing about him and poking him with sticks." Determining that the streets were too dangerous for him, Nast returned to his wife and daughter on 125th Street. Other artists remained in the streets, providing sketches to newspapers and lithographers.[46]

It is important to pause here for a moment to consider the effect of this, the most destructive urban riot in American history, on Nast's emotions. We can imagine the physical reality of the riot through description, and can sympathize with the fear it would cause in a citizen, particularly one who was publicly identified as a Republican, sympathetic to emancipation, and prosperous enough to buy his own exemption. The destruction of property alone was massive. Concern for personal safety, fear for the safety of loved ones, and generalized anxiety for neighbors would all have been common, powerful emotions. Yet nineteenth-century city dwellers inherited a tradition of civil unrest. For them, riots were not simply a fearsome event. The tradition of political unrest translated into urban violence could be described as a trajectory from the Paris riots of 1789, to the barricades of 1848, to the criminal gangs of 1857, to the angry workingmen and women of 1863.[47]

Anyone who reviewed that narrative would recognize that urban riots were events of national, not just local, importance, and that their scope and effect could not easily be predicted. So anxieties surrounding a riot were not only personal and immediate but collective and far-reaching. For Nast, raised with stories of the glorious revolutionaries of 1848 and witness to the gang-related unrest of the 1850s, the implications of this fact must have been inescapable. Moreover, Nast worked in a newsroom, a place

where connections between the past and present and the local and the national were a staple of everyday life. So combined with Nast's likely fear for home and family and his political reaction to the Irish immigrants' violence against black Americans was a sense that this was a crucial moment in the struggle over union.

Nast thought often of Sallie and baby Julia. It is clear from his letters, beginning in this period but stretching spottily over the next forty years, that he hated to be away from home. When traveling, he worried endlessly over Sallie's health and well-being. When Julia was small, he wrote asking plaintively whether she was "doing any new tricks."[48] This concern for his wife's health and his family's welfare was sharpened with distance. Thus, his sojourn in Pennsylvania amplified his anxiety about being away from home. The frustration so evident in his letters was as much personal as professional. Sallie is an enigmatic figure; ever present, she almost never speaks for herself. As a result, it is difficult to know what her feelings might have been during the riots. However, riots are often gendered events. They can reflect gendered political ideals, such as the protection of female virtue from an invading force. They can incorporate female activism, as with the Paris Commune in 1871. Most commonly, press coverage of riots emphasizes the damage done to women. Their homes destroyed, their spouses and children hurt or dead, women become the representatives of the city as a whole. We know that Nast initially attempted to sketch the riot, but he beat a hasty retreat when the violence seemed too close. It is hard to imagine that at that moment the man who drew women and children to portray the violence and destruction of the war did not think of his own family. For all the political meanings of the riot, then, the more personal ones were likely uppermost in Nast's mind.

From the safety of his home in Yorkville, Nast could consider the politics of the riot.[49] Nast's psychological distance from his old neighborhood, where rioters raged still, was as important as the physical. From his vantage point uptown, Nast's view of the riots crystallized: it was a conflict started by Irish men, against America's perennial victims, black men. Nast's sympathy for black families already appeared in his sentimental illustrations. It would become more and more strident.

The Irishman had not yet assumed his role as the ultimate thug in Nast's work, but he soon would. Other artists used the Irish to represent the evils of the city, from street violence and drunkenness to poverty and sexual license. Nast could easily have seen these images, if not in local newspapers then in local print shops or in the work of cartoonists he admired, such

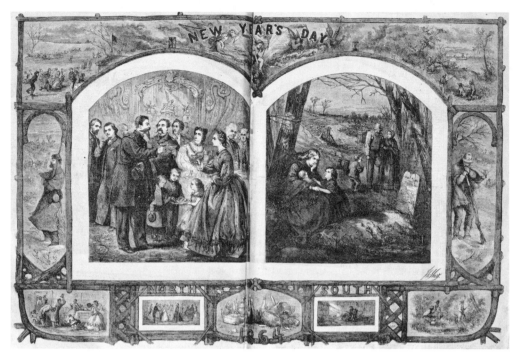

"*New Year's Day,*" Harper's Weekly, *January 2, 1864.*

as Englishman John Tenniel. The centrality of the Irish role in the Draft Riots did not escape Nast's neighbors or colleagues. After all, Irish votes provided the power base of the city's Democratic machine. It must have seemed that whenever opposition threatened to derail Republican goals, it was the Irish who were in the way. Nast could have observed for himself that the crowds around the Colored Orphan Asylum were largely Irish. As his sympathy for African Americans deepened, his ambivalence toward the Irish grew. He was no longer a child, and the dangers of the streets no longer seemed quite so exciting. Instead, Nast considered the riots from the perspective of a property owner and a husband and father. And from that vantage point, they seemed to reinforce the idea that the Irish, and by extension the Democrats, were a dangerous force in American politics.[50]

If the riots hardened Nast's feelings against the Irish and aroused compassion for African Americans, they also pushed him more and more toward the Republican Party. At the beginning of the war, Nast's mentor, Fletcher Harper, was opposed to the Republicans and to emancipation. By late 1863, however, that had changed. Nast's feelings, on the other hand, are harder to identify. He was a man whose passions were intense, and intensely personal. He was moved by suffering, by devotion, by dramatic acts.

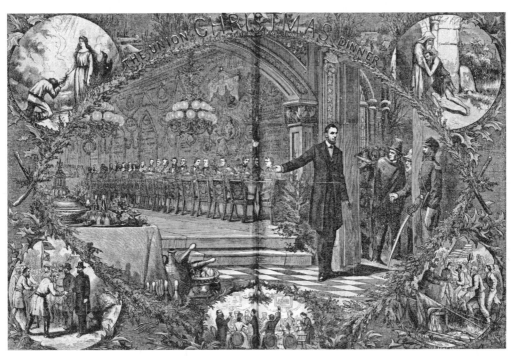

"The Union Christmas Dinner," Harper's Weekly, *December 31, 1864.*

In this context, he could have adopted either party, and then shaped his perceptions of the war around his political inclinations. Clearly, he recognized the suffering of both sides. His sentimental illustrations show again and again his compassion for the depredations of war.[51]

This is why the Draft Riots mattered. While Nast saw the suffering of white families in both the North and South, his sympathy for black Americans tipped the scale toward Republicanism. Later in his career, Nast depicted the Irish in ways that today we associate with the worst kind of stereotypes. By the standards of his day, however, he was almost radical in his political beliefs about black Americans. Like many other Republicans—though not all—Nast believed blacks deserved freedom, education, employment, and dignity, and he expressed those thoughts in his drawings. Added to his concern for African Americans was his dislike of the Irish. Whatever antipathy had been nurtured in his childhood, by the end of the riots Nast was fully committed to the view that the Irish were a threat to civic peace. Their Catholicism only added to the sense that they were aliens. The close alliance between the Irish and the Democratic Party combined with the central role the Irish played in the riots could only have reinforced Nast's Republicanism.[52]

The Effect of "Compromise with the South"

Nast's political education was almost complete by 1864. He had personal experience with the variety of political positions, activities, and personalities New York had to offer. His travels to Washington, D.C., and to Union army camps, where he was able to observe firsthand some of the most famous and influential national political figures, expanded his education. Like the Harper brothers, he had embraced the positions of the Republican Party. So by the time he drew "Compromise with the South," Nast had adopted a complex and party-oriented politics. The image made him famous and helped to cement his professional status.

There is no evidence to suggest that Fletcher Harper knew that Nast's drawing would be a sensation. The drawing reflected not only Harper's views but also those of his political editor, George William Curtis.[53] Both men must have been surprised at the wild reception of the image. *Harper's Weekly* sold out, and the publisher was forced to print another run.[54] The timing of the drawing was perfect. In late August, even Lincoln believed that he would lose the election. But just as Nast's cartoon appeared, striking a massive blow against the Democrats, so did news of William T. Sherman's successful assault on Atlanta. Suddenly, the tide turned. The Republican Party, recognizing that it had discovered a spectacular election tool in Nast's drawing, obtained permission to reprint it as part of a campaign poster.[55] Even Paine, writing almost fifty years later, refers to the response as "startling."[56] Nast's pride in the success of his drawing was unbounded.

And he was not subtle about his triumph. Nast tended to be amusingly self-deprecating at times and pompously self-righteous at others. When it came to "Compromise with the South," pomposity usually won out. He liked to point first to Lincoln's assessment of his work. According to Paine, the president said, "Nast has been our best recruiting sergeant. His emblematic cartoons have never failed to arouse enthusiasm and patriotism, and have always seemed to come just when these articles were getting scarce."[57] Also according to Paine via Nast, President U. S. Grant sang Nast's praises as well. Nast and Grant were, indeed, friends, and Grant returned some of Nast's admiration, but Paine's recounting of Grant's comments stretches credulity. Grant was asked, "Who is the foremost figure in civil life developed by the Rebellion?" "Without hesitation," writes Paine, Grant named Nast: "He did as much as any one man to preserve the Union and bring the war to an end."[58] This is an extraordinary statement, and it

calls to mind scholar Roger Fischer's assessment of Nast. His greatest invention, Fischer wrote, "was probably himself."[59]

There is some truth to Fischer's evaluation. By 1864, Nast was a creature of his own making. From his immigrant past, Nast chose what parts to keep and what to shed. He embraced the energy of New York's urban culture while differentiating himself from the melting pot of his childhood neighborhood. This was a man whose first purchase upon marriage was a piano. As Fischer put it, Nast "married into old-line Yankee culture and embraced it with the fervor of the prodigal son come home."[60] He intended to become middle class, and that required that some parts of his past be obscured.

Rather than follow in the footsteps of other artists, such as A. R. Waud and Winslow Homer, Nast forged an alternate path. He created imaginative works not to transmit facts but to render emotion. When those drawings brought him greater artistic freedom, public recognition, and the authority to speak on national political questions, Nast cemented his position with the oft-repeated endorsements by the Union's two greatest heroes. It was, indeed, a monumental act of self-invention. Yet there is a core of reality to even Nast's greatest flights of fancy. He was genuinely famous for his work, and he was genuinely popular among powerful and influential men. "Compromise with the South" evoked a response that cannot be dismissed as merely a figment of Nast's imagination.

What caused such an emotional response to "Compromise with the South"? Who was Nast attacking? Finally, why did Nast's attack strike such a chord with the nation? Understanding the context of the cartoon, its targets and their positions, and the connection between Nast and the public are essential to understanding the popularity of "Compromise with the South" and its effect on Nast's life.

Nast's target was the Democratic Party and its nominee for president, General George McClellan. McClellan was a compromise choice for the Democrats. One faction of the Democratic Party, led by Clement Vallandigham, insisted that the war was a failure and that the best course for a new administration was an armistice and eventual peace. Speaking on January 14, 1863, Vallandigham evaluated the state of the Union. "The rebellion is not crushed out," he said, "its military power has not been broken; the insurgents have not dispersed. The Union is not restored; nor the Constitution maintained." The solution, he argued, was to withdraw Union troops, declare a cessation of hostilities, and try to renew the social and cultural ties between North and South. As for slavery, the North should "let

[it] alone."[61] If that meant that the South would remain independent, so be it. For many Democrats, this was unacceptable. Despite their opposition to Lincoln, they believed in the preservation of the Union and refused to accept that the war was entirely lost. At the party convention in Chicago, the Democrats split the difference by nominating McClellan, who pledged to pursue the war and preserve the Union, and adopting a party platform drafted by those who sought a peace settlement.

As if opposition from the Democrats was not enough, Lincoln also confronted a revolt within his own party. Sentiment against Lincoln simmered throughout the war. In the streets, the "Lincoln Catechism," a pamphlet attacking Lincoln's bid for reelection, jokingly asked, "What is a President?" The answer: "A general agent for Negroes."[62] Republicans who opposed Lincoln's policies shied away from that kind of invective, but they felt strongly enough to secretly suggest replacing Lincoln with another nominee, perhaps Salmon P. Chase. Criticism of Lincoln's war policies and his approach to presidential leadership was relentless. In the end, Sherman's victory in Atlanta silenced those Republicans who opposed Lincoln and the party retained its nominee.[63]

The election in 1864 proved brutal. Satirical images, poems, songs, and essays poked fun at both sides. In late August, when Nast composed "Compromise with the South," the outcome was far from clear. So Nast's intention was to paint the darkest possible picture of the results of a Democratic victory. Slavery would remain, he insisted, so a black family is pictured in chains on the right. The South would be free to retain its sovereignty, which would brand the war effort a failure, thus the grave with the inscription, "In Memory of the Union Heroes in a Useless War," and the bowed head of the wounded veteran on the left. Consistent with his previous, sentimental drawings, Nast avoided endorsing Lincoln directly and instead emphasized the emotional and personal costs of the war.[64]

Nast's position was familiar, and his imagery was consistent with other images from the illustrated battle for the presidency, but the size of his audience was unprecedented. *Harper's Weekly* enjoyed a readership of more than 90,000 in October of 1859. In 1861, readership reached 120,000. It remained above 100,000 for the rest of the war.[65] Only *Frank Leslie's* could claim similar numbers. So in any given week, Nast could expect to reach more than 100,000 Americans with a drawing.

This was far in excess of the printing capacity of a lithograph company like Bromley, or even of Currier & Ives. Moreover, *Harper's* contained written commentary. Unlike people who purchased a lithograph on the street

or in a printer's shop, *Harper's* readers could expect a detailed explanation of the political events of the week. Thus Nast benefited from the written and the visual in his connection to the public. Finally, Nast's work entered the home of many readers by subscription. In order to view Nast's drawings, a reader need not leave his or her home, need not enter a print shop or spend cash. Citizens could choose to buy *Harper's* at their local grocery, print shop, or tobacconist, but they did not have to. Like television today, *Harper's Weekly* was a staple of home life, read not only by husbands and fathers but also by wives, mothers, and older children. As a result, a personal connection formed between an artist and a reader that could not be formed between the two with a one-run lithograph.

This personal connection sheds light upon one of the enduring mysteries of Nast's success. Clearly, "Compromise with the South" was a good representative of the national discussion about the war and the presidency. Politics and sentiment mingled in Nast's work in general, as they mingled in the minds of many Americans. No historian has been able to explain precisely why Nast's work struck a chord with the public. Perhaps it was the fact that his drawings are striking, even shocking. On the other hand, many of the best features of Nast's work were shared by other artistic products of the time.

An example of this commonality is in the central characteristic of political illustrations: the likeness. Nast boasted a great talent for creating caricatures that were instantly recognizable. But Nast was not the only artist who created recognizable faces. There are countless examples of nineteenth-century illustrations and cartoons in which the central figures, especially Horace Greeley, Abraham Lincoln, U. S. Grant, and other prominent statesmen, are instantly familiar. By the time Nast's work appeared before the public in *Harper's Weekly*, lithographic representations were expected to provide accurate likenesses. Anything less would have been confusing and unusual.[66]

Moreover, the tradition of presenting faces that the reader could recognize was as old as it was widespread. The earliest satiric illustrations relied on objects, such as the pope's hat or a king's crown and standard, to identify central figures.[67] By the eighteenth century, however, artists' ability to represent the human form in a naturalistic way was far more advanced. Relying on physiognomy as a teaching tool, artistic training emphasized both accuracy of representation and the "personality types" in faces. By the era of William Hogarth and James Gillray, English satirists were learning to expand their repertoire by distorting reality. Enough of the physical

characteristics of the people in illustrations were preserved for recognition, but other parts were stretched and squashed so that the personality of the targets could be expressed in visual terms. Satirists such as John Tenniel, whom Nast admired, learned directly from these traditions.[68] Thus Nast was not only surrounded by a rich body of caricature portraying accurate faces; he was an inheritor of a satiric tradition.[69]

So Nast's ability to produce a recognizable face is unlikely to have been his work's primary appeal. Paine wrote that "in the drawings of Nast . . . there was a feeling which appealed more directly to the emotions than could be found in the work of his fellows."[70] Morton Keller, writing almost seventy years later, described Nast's talent as a "special receptivity to the most powerful public emotions of his time." For Keller, Nast and the public enjoyed a symbiotic relationship. Nast's ability to tap into the public's emotions made his work especially arousing for readers. In turn, reader response and public adulation fired Nast's creative spirit and prompted him to work ever faster and with ever more intensity.[71] Other scholars attribute Nast's illustrations' appeal to the powerful emotions they evoke and then cite the evidence of his popularity to prove the point.[72] The Cartoonists' Guild, whose expertise seems unimpeachable, takes a mixed position on cartooning as a whole. Cartoonists are popular, it argues, because their work lacks "ponderousness" and adheres to the maxim that "less is more." But a truly great cartoonist, it adds, is one whose individual personality is present in the work. There is "a consistency of touch and observation" that allows the reader not only to identify with the sentiment and artistic value of the cartoon but also to sympathize with the mind and heart of the cartoonist.[73]

That readers were able to discern Nast's thoughts and feelings in his illustrations seems a far more likely reason for his appeal than either his technical skill or his emotional connection to the public. His cast of stock characters included a variety of recognizable figures: the Irish thug and the Chinese immigrant, for example, who, with exceptional detail, Nast rendered as amusingly unattractive; and his favorite symbol of national purity, Columbia. Although many of the themes of his drawings were similar to those found in other cartoons, what set his work apart was a palpable sense among his readers that his personality was present, and it boasted a sharp and ruthless wit. What Nast had was charisma. Even if Nast's charisma was central to his popularity, this does not fully explain the particular appeal of "Compromise with the South." Historians have pointed to two reasons for its attraction. First, it unified all the arguments for Lincoln and Union into a

single, forceful image, and it thus struck a chord in the heart of most voters. Second, it is the first example of Nast's cartooning, that is, Nast became wildly popular for his cartoons, therefore his first cartoon was wildly popular. However, neither of these arguments is really satisfying. The first fails to acknowledge the fact that a number of cartoons produced by other artists made the same point in much the same way. The second attributes cartoon qualities to a drawing that is really closer to a sentimental illustration.[74]

Nast's primary message in "Compromise with the South" was that a vote for the Democrats, that is, for General George McClellan, was a vote that invalidated the sacrifices of the Union dead. Other illustrators had expressed the same idea.[75] One lithograph in particular even looked like a Nast drawing. On one side of the illustration, a wealthy man reads a newspaper with the headline "Congress should drive Lincoln out of the White House . . . Compromise with the South . . . Slavery," while his wife pours him an evening cocktail. On the other side, a group of women and old men waving a banner that reads "God Save the Union" look on as Union troops fight and die in a haze of smoke. The images not only indicate a rejection of compromise based on Union losses but also highlight the class tensions underlying the Draft Riots.[76] In a Philadelphia lithograph titled "A Thrilling Incident During Voting," an old man confronts a Democratic pamphleteer: "I despise you more than I hate the rebel who sent his bullet through my dead son's heart!" he cries. "You miserable creature! Do you expect me to dishonor my poor boy's memory, and vote for men who charges [sic] American soldiers, fighting for their country, with being hirelings and murderers?"[77] Louis Prang, one of the most famous midcentury lithographers, took a similar position in his print "Democracy." Here, the emphasis was on change over time. Andrew Jackson makes John C. Calhoun beg "Pardon! Pardon!" while McClellan begs Jefferson Davis for peace. A sneering Confederate soldier, observing the scene, comments, "Those northern dogs, how they whine!"[78] Opponents of Lincoln also used images of death to capture public attention. In New York, Bromley & Company distributed a lithograph titled "The Grave of the Union," which shows Republicans burying coffins marked "Constitution," "Free Speech," and "Habeas Corpus." Lincoln's penchant for telling jokes was another target of numerous lithographic cartoons.[79]

If the content of Nast's drawing was familiar, was it his style that appealed to the public? "Compromise with the South" has been associated with the beginning of Nast's career as a cartoonist, and its popularity has been explained by identifying it as the first of Nast's string of undeniable hits. The

problem with this explanation is that "Compromise with the South" lacks many of the characteristics of cartoons, or even of political satire. It is more closely aligned to Nast's sentimental drawings in its message, style, and composition.

First, it lacks what historian E. H. Gombrich calls the "willing suspension of disbelief." In satirical works, he argues, the cartoonist attempts to make an outlandish suggestion believable. The audience is willing to believe, for a moment, because the outlandish touches on a core of truth. In later years, Nast would employ just this method by portraying men as animals, classical politicians (notably Julius Caesar), and inanimate objects (most famously, Tweed's head as a bag of money). In this case, however, each player is represented only as himself. There is no need for a metaphorical reference to evil because Nast is quite direct. A vote for McClellan would end the war, victimize the black man, and invalidate the sacrifices of the Union dead. No subtlety is required, and none is offered. It is the sincerity of Nast's sentiment, rather than satire, that engages the audience.[80]

The style of "Compromise with the South" lacks the characteristic cartoon elements, as well. Caricature and political satire are intended to puncture pretensions, to damage the political persona of a public figure. Here, there is no identifiable figure to satirize. Indeed, unlike Nast's later work, the only recognizable individual is Columbia, whom Nast never caricatured.[81] She represented his highest hopes and deepest disappointments. She warns, begs, threatens, cajoles, and mourns, but never jokes. The other figures are anonymous, representing the whole of the Northern war effort on the one hand, and the generalized danger of the Confederacy on the other. Neither is distorted, though. In cartoons, faces, bodies, and gestures are distorted or exaggerated in order to emphasize foibles or hypocrisy and to ridicule. But here both of the central figures are literal representations. Indeed, it is only in the wealth of detail in the drawings that Nast exaggerates. Rather than a simple evocation of the electoral choice, Nast has inserted the wounds of the Union soldier and the multiple weapons of the southern man, the broken sword, and the burning house. Most tellingly, he has drawn the kneeling, supplicant black family. These are not cartoon images but sentimentalized evocations of the "imagined" war. They demonstrate the North's desire for emotive illustrations rather than political satire.[82]

Finally, the composition of the drawing resembles Nast's other sentimental illustrations. Within a semicircle are the central figures shaking hands across a Union grave. Outside the semicircle's border, arching above

their heads is the title. On the left side of the title is an American flag, and on the right, a Confederate flag. Within the semicircle there are predictive drawings: on the left is a burning home, and on the right, a suffering black family. The words "North" (left) and "South" (right) at the base of the drawing identify the figures. A weeping female figure, Columbia, provides the most devastating image of grief as she weeps over the fresh grave of the fallen. The dark background and swirling clouds overhead add to the gloom. These elements, from the circular frame to the woman's body symbolizing suffering, are characteristic not of Nast's political cartoons but of his sentimental style.[83]

If "Compromise with the South" is better understood as a highly political sentimental illustration than as a cartoon, how can we fit it into Nast's overall progression during the war years? When the war began, Nast was a staff artist. His ability to express his own ideas was relatively limited, and he clashed with the artists whose work he engraved—and sometimes claimed as his own. With at least limited battle-front experience, Nast began to incorporate the emotional reality of both the battle and home fronts in his sentimental drawings. These satisfied a public need both for sentimental evocations of the war and for idealized visions of the home, family, and nation. From the beginning, these drawings were political. They vilified southern troops, idealized Union men, honored the sacrifice of Northern families, and pointed to the hopeful potential of the nation's black residents. Over time, these themes became more and more dominant for Nast. The Draft Riots radicalized him. Confronted with the violent opposition to Republican policies, black freedom, and the effort to save the Union, Nast responded by cementing his commitment to the ideals of the Union. It should come as no surprise, then, that by the fall of 1864 Nast was ready to commit his pencil wholly to Lincoln's reelection effort. "Compromise with the South" was his expression of that commitment, and it stands not just as the beginning of his cartooning but as the ultimate expression of his view of the war itself.

CHAPTER FIVE

Falling in Love with Grant

Despite the success of his employment at *Harper's*, Nast continued to experiment with other art forms and other avenues for self-expression. Illustrating books offered one lucrative option. As with his work at *Harper's*, Nast's drawings for books ranged from simply illustrative to sentimental to overtly political. He continued to paint as well, exhibiting his work in a variety of venues and exploring both traditional illustration and caricature. By the end of the 1860s, though, political themes had begun to dominate Nast's work. The impeachment of President Andrew Johnson proved an irresistible subject. Even more exciting, and capable of keeping Nast focused on politics, was the election of General U. S. Grant to the presidency. These two political campaigns pushed Nast ever more deeply into the world of political art, and helped to cement his celebrity by 1870.

Beginning in 1860, the young artist worked as an illustrator for books. That year, Nast worked on four illustrated volumes. Much of Nast's earliest illustration work appeared in children's books, Civil War histories, and books of poetry and fiction. For example, in 1860, Nast provided several drawings for *Laugh and Grow Wise: By the Senior Owl of Ivy Hall*, a children's book originally published as a series of stories in *The Little-Pig Monthly*. The same year, Nast contributed an illustration for Nathaniel Chipman's *Sacred Poems*. In 1861, portraits and battle drawings by Nast appeared in Evert Duyckinck's *National History of the War for the Union* and Orville Victor's *History, Civil, Political and Military of the Southern Rebellion*. A similar pattern held for the rest of the war years.[1]

The boom in illustrated magazines included funny papers, to which Nast sometimes contributed. In 1866, he provided caricatures for *Phunny Phellow*. Still working for *Harper's*, Nast chose not to sign the *Phunny Phellow* cartoons. A friend remarked, "You'll have to look to your laurels, Nast; that chap on *Phunny Phellow* is after you."[2] Between book illustrations, freelance drawings for funny papers, and painting, Nast's pencil rarely stopped.

Success in black-and-white media never diminished Nast's attraction to painting. Throughout the 1860s he exhibited paintings in New York, gar-

nering positive reviews for both his technique and thematic choices. In 1864, *Frank Leslie's Illustrated News* reviewed the National Academy of Design's annual exhibition, noting Nast's contributions. Ironically, the reviewer identified lack of color as Nast's "shortcoming," an opinion that foreshadowed Nast's later competition with cartoonists who used color.[3] In the same year, Nast showed paintings at the Artists' Fund Society, sharing space with Winslow Homer. *Leslie's* noted—waspishly—that Nast's work appeared in the third gallery while Homer's hung in the first. Still, Nast's *Yankee Decoy* attracted praise as "one of the best pictures of the exhibition."[4]

It seems that Nast struggled to attain recognition for his painting. *Leslie's*, for example, noted in 1864 that paintings with "pretentious names" sold better than simpler works by men like Nast. In the spring of 1865, *Harper's Weekly* reviewed that year's exhibition at the National Academy of Design and complained openly about the placement of Nast's paintings. Nast's *General Sherman's March through Georgia—His Advance Arriving at a Plantation* hung high above a door, adjacent to a stairwell. Described by *Harper's* as "full of expression" and "busy, bustling, surprised movement," the painting could hardly be seen in its odd position near the ceiling.[5]

Colorful, painted caricature work met with greater success. The year after the end of the war, Nast created the *Grand Caricaturama*, a series of enormous murals lampooning public figures and commenting on current affairs.[6] The murals were hung at the site of an opera ball thrown by Max Maretzek. Nast's collaboration with the Moravian-born composer highlights the continuing bonds between Nast and the immigrant community from which he came.

New York opera benefited from the talents of many immigrants, of whom Maretzek was but one. Maretzek worked closely with his countryman Maurice Strakosch, whose opera company featured many stars of the nineteenth-century stage. Why Maretzek chose a modestly successful illustrator and cartoonist to provide the decoration at the opera ball might remain a mystery if not for the connection between Maretzek and Strakosch. The impresario worked briefly with Strakosch at Burton's Theater in the 1850s. Nast's father played in the band at Burton's, and Nast sometimes joined him there.[7]

On April 5, Maretzek opened the doors to his "Opera Ball," welcoming patrons to the Academy of Music, decorated with Nast's painted caricatures. These huge canvases—each measuring nine by twelve feet—entertained guests with humorous images of public men and women. Nast commented on the effect many years later in his chalk talks.

The *Grand Caricaturama* bridged Nast's interest in fine art to his increasing emphasis on the relationship between personality and politics. In execution, the paintings pointed toward Nast's interest in the way that political activities and public life reflected the inner man or woman. In one image, a scowling President Johnson kicks the Freedmen's "Bureau" (represented by the piece of furniture) down the stairs, tiny African Americans spilling out of its drawers. In another, opposite the Johnson picture in the *Harper's Weekly* reprint, a serious Ulysses Grant sits, framed by Nast's comment: "The Idol We Worship."

Many years later, Nast remembered the *Caricaturama* as an experiment in reaction. Visitors commented on Nast's work as they circulated through the Academy. According to Paine, the guests who also appeared in the canvases typically "appeared to think them excellent until he came to his own." Then "the change in his expression was great." One irate subject cornered the artist to complain about his "non-portrait." While the other paintings resembled their subjects, he declared, his "wasn't the least bit like him." At that moment, another guest stepped up to comment on the likeness: "I should have known it if I had seen it in the middle of Africa!" All seemed well, until the second man saw his own portrait and "his jolly expression faded quickly away and I think he experienced what real sympathy meant."[8]

Nast understood the fortitude it took to accept a caricature. "The shock is great and the revelation unpleasant," he observed. Caricaturists, by their nature, made poor friends. They exaggerated characteristics best suited to ridicule. Observers who "laugh at the other fellow" failed to see the joke when the drawing lampooned themselves. The artist's "truthful character" meant that he could not participate in a social world that required compliments—what Nast called social "taffy"—and mutual admiration. By the time he recalled the *Caricaturama*, Nast knew only too well the price for successful satire. In 1866, the *Caricaturama* served as his introduction to the effects of his work on his social and political life.[9]

Never inclined to shyness, Nast caricatured himself, too. His self-portrait in the *Caricaturama* emphasizes his scraggly hair, round face, and short stature. The painting connected Nast's interest in fine art with his emerging talent as a political cartoonist. In it, Nast holds not a pencil but a pallet, and he is in the act of painting on canvas, reinforcing his self-image as a formally trained artist. In fact, the caricatures displayed at the academy were not simply cartoons—ephemera by any standard; Nast offered them for sale through the Somerville Art Gallery.[10] Clearly, he thought of them

both as entertainment and as art. His work for *Harper's* tended to reflect that same dichotomy, as did his dual interests in illustration and painting.

But in print Nast turned more and more to politics. He employed his pencil to illustrate the national mourning for Lincoln, then applied it to the national disgust with President Johnson, and, finally, used it to document the rise of General Grant to the Republican nominee for president. As a result of these exciting political campaigns, and the acclaim Nast won for his work on them, by the end of the 1860s, Nast turned ever more intently to political themes.

No clear division emerges between Nast's sentimental drawings and his political ones in the mid-1860s. His Lincoln drawings illustrate this point. In the multipanel "Thanksgiving Day" (1864), Lincoln is at the center. Surrounded by reasons to be thankful—and to mourn—the president appears as the patron of both the military and the slaves. Almost a month later, Lincoln appears again, this time as the generous paterfamilias, offering a place at the Union Christmas table to Southerners. "Lay down your arms," Nast captioned the lower right-hand panel, "And you will be welcome." Political amnesty, cultural reunion, and an end to hostilities all linked politics to the sentimental values of family and history.

In April 1865, Nast mourned Lincoln's death with a deeply heartfelt drawing of a kneeling Columbia weeping over his coffin. Flanking her, the army and navy mourn as well. In 1866, Nast returned to the political Lincoln, publishing a full-page illustration of the president's entry into Richmond, Virginia, in 1865. The joyous welcome Lincoln receives from Richmond's black population pointed to the president as emancipator. In each case, Nast emphasized accuracy in his portraiture and detail in his backgrounds. These drawings are representative of how Nast was able to send a political message while simultaneously tapping into the public's patriotic mood.[11]

In many respects, 1866 served as a transitional year for Nast. The *Grand Caricaturama* established his talent for combining fine art and politics. Likewise, his work for *Harper's* remained a mix of sentimental illustration and political cartooning. Throughout the spring of 1866, Nast provided readers a steady supply of small drawings to illustrate "A Chronicle of Secession." Only rarely do the drawings lean toward caricature or exaggeration. During the same period, Nast offered *Harper's* a few larger, more detailed illustrations. For the February 24 issue, for example, he produced the full-page drawing of Lincoln's 1865 entrance into Richmond, Virginia. Nast

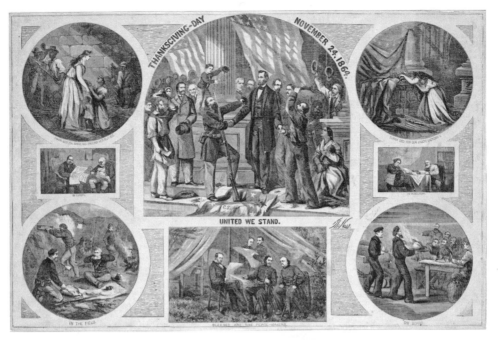

"Thanksgiving Day, 1864," Harpers Weekly, *November 24, 1864.*
Courtesy of the John Hay Library, Brown University Library.

captured the national sense of loss with his drawing of Lincoln while re-inforcing the sense that an unfinished project—emancipation—remained pressing.[12]

If Nast looked to President Johnson for good news, he found only dis-appointment. For Nast and many of his fellow Republicans, 1866 and 1867 brought disappointment and even outrage as Johnson pursued policies that put him on a collision course with Congress. As the conflict between the president and Republican legislators grew, Nast's illustrations moved deci-sively toward cartooning.

Working in concert with political editor George William Curtis, Nast attacked Johnson in the pages of *Harper's Weekly*. The paper began with rea-soned disagreement but moved quickly to open opposition. In June 1866, Curtis argued that "politics is the art of expediency" and that men "may honestly differ" about how to achieve the goals of Reconstruction.[13] By Sep-tember, however, the paper attacked executive power and suggested that the president's policies represented a threat to both Reconstruction and the nation.[14] In late October, Curtis reprinted the complaints of former auditor of the Treasury Isaac Arnold, who had accused President Johnson of be-

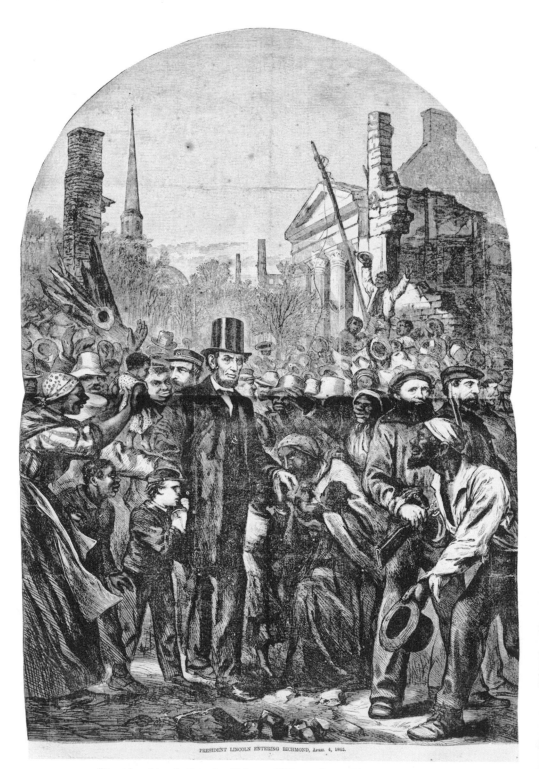

PRESIDENT LINCOLN ENTERING RICHMOND, April 4, 1865.

"President Lincoln Entering Richmond," Harper's Weekly, *February 24, 1866.*

traying Lincoln's memory. Johnson had "deserted [Republican] principles" and consorted with men who "crowned their long catalogue of crimes by the murder which placed you in the Executive chair."[15]

Paine, doubtless echoing Nast's sentiments, characterized the president's Reconstruction policy as a surrender, "body and soul," to the Confederacy. Johnson lost his mind, Paine suggested, when he suddenly found himself president. Nast remained quite sane. As did the paper's, the intensity of Nast's opposition to Johnson grew with time. At first, he directed his ire against acts of violence rather than the president. In August, for example, Nast decried attacks on freedmen in New Orleans and Memphis in "Which Is the More Illegal?"[16] But the week after Curtis published Isaac Arnold's comments, Nast delivered a blow to the president with a double-page cartoon, "Andy's Trip." Under a caricature of Johnson is the question, "Who has suffered more for you and for this Union than Andy Johnson?" Around the center image of Johnson are other illustrations of the president making various statements that undermine his leadership. Hammering away, Nast insisted that it was Johnson who "forgot" Union veterans and Union families. Finally, just before the election, Nast offered readers "King Andy I."

"King Andy I" echoed Curtis's warnings about executive power. Enthroned, orb and scepter in hand, Johnson scowls down upon a changed nation. His enemies, the Radicals, line up to be executed. Liberty hangs her head in shame at her own chains. Johnson's exaggerated nose, knobby knees, and crossed feet emphasized his usurpation, suggesting his unfitness for power.[17]

Not everyone embraced Nast's vehemence. Curtis began 1866 expressing moderate views. But as Curtis became more frustrated, and as his editorials moved toward open condemnation of the president, he began to understand the value of Nast's pencil. "The pictures you suggest are, as usual, telling arguments and hard hits," he wrote. Still, he hesitated to use them. Fundamentally, Curtis placed his faith in reasoned argument. Nast preferred the hammer-blow of satire. The disagreement between editor and cartoonist was never resolved.[18]

When the congressional elections of 1866 reinforced the power of the Radical Republicans, Curtis and Nast threw the weight of *Harper's Weekly* behind Congress. For Curtis, a variety of issues affected the paper's stance. Support for the Radical Republicans in Congress joined with a desire to limit executive power—in the case of this president in particular—and a conviction that the South could be remade socially, politically, and economically.

Johnson rejected the idea that the national government could impose

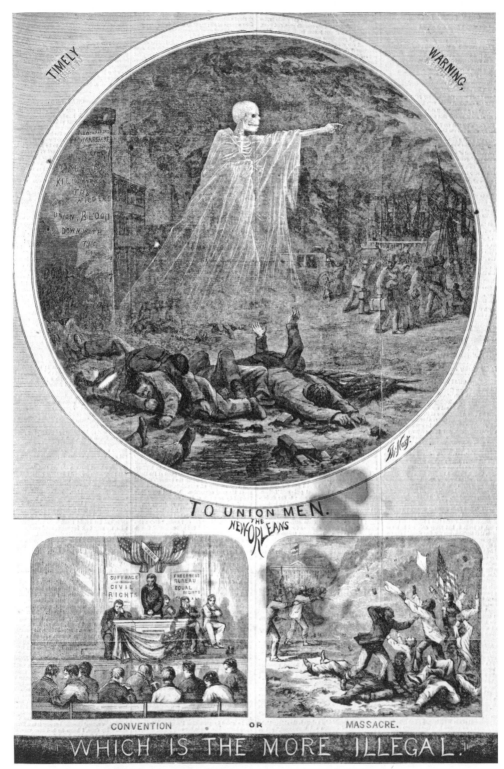

"Which Is the More Illegal?," Harper's Weekly, *September 8, 1866.*

social change, particularly in regard to the freedmen. At the same time, he spoke openly of punishing the rebellious states. At first, Radicals mistook Johnson's desire to punish the Southern states for a commitment to the freedmen. Curtis looked forward to forceful Reconstruction policies. He expected President Johnson to impose far harsher terms than President Lincoln did and to join the Radicals in their effort to integrate black Americans into the polity.

Profound disappointment followed. Johnson, it turned out, had no intention of imposing social or political changes on the Southern states. He wanted to punish secessionist leaders but not alter the power dynamic between the states and the nation. Worse, Johnson offered Southern whites a great deal of control over the Reconstruction process, including the early constitutional conventions. Rather than use national power, then, to remake the South, Johnson used his executive power to ensure what he considered a fair balance of power between the national and state governments. Curtis watched with dismay. As the year progressed, his editorials increasingly focused on the president's intransigence, his rejection of the congressional effort to impose racial justice, and his departure from early expectations.[19]

Nast took a simpler approach. He understood the conflict between Congress and the president, but the plight of freedmen struck a far louder chord. Many of his cartoons between 1866 and 1868 focused on presidential power—symbolized most obviously in the figure of King Andy—but more commonly, and with more force, he used his pencil to urge freedmen's inclusion in politics and society. The optimism and sympathy for slaves Nast demonstrated during the war grew, in these years, into outrage on behalf of the free black residents of the South.

As he had done in 1863, Nast emphasized freedmen's potential in American life. Emancipation offered the nation a population of families. For Nast, the family unit offered financial, emotional, and social stability. He attacked Johnson, then, but not merely in terms of Johnson's policies. Nast left the complex political philosophy to Curtis. In his cartoons, the artist emphasized the suffering of freedmen, the barbarity of the night riders, and the dangers of Johnson's Reconstruction policies to real men and women—people whose potential could be lost through northern inaction.

The attack began in January 1867. On the twelfth, Nast expressed his support of the Civil Rights Bill with the cartoon "(?)Slavery is Dead(?)" A two-page spread of illustrations ironically titled "Southern Justice" appeared in *Harper's* in mid-March. At the end of the month, Nast returned to Johnson,

presenting the president again as King Andy. In the "Ampitheatrum Johnsonianum," Johnson, surrounded by his cronies, watches black Americans attacked and killed.

Nast's work illustrating books also provided an opportunity to attack the president. By 1865, Nast claimed credit for illustrations in twenty-one books. In 1866, with the war over and Nast's reputation enhanced by the success of "Compromise with the South," illustration jobs seemed to pour in. Ten appeared in 1866, six in the year after, and nine each in 1868 and 1869. By the dawn of the 1870s, Nast enjoyed widespread renown for his ability to provide authors with incisive, sometimes amusing, illustrations.[20]

One example demonstrates his increasing interest in politics and satire. In 1867, having illustrated a volume by Dickens, a reading textbook for children, and a Union soldier's memoir chronicling his imprisonment at Andersonville and other Confederate prisoner camps, Nast turned to a book called *Swingin' Round the Cirkle*, by the satirist David Ross Locke, written under the pseudonym Petroleum V. Nasby. Writing from the point of view of Nasby, who was prejudiced, satisfied with corruption so long as his own life was left untouched, opposed to progress, and reflexively suspicious, Locke used an exaggerated Southern dialect that Johnson's opponents found hilarious. The book began with a dedication to Johnson: "To Androo Johnson, The Pride and Hope uv Dimocrisy." Nasby's critique of Johnson rested on the argument that Johnson represented the worst kind of American values. The Nasby character embodied both Johnson and his presumed constituency.[21]

Nast and Locke made natural allies. Like Nast, Locke presented himself with a charming self-deprecation. Unlike Nast, however, Locke excelled in the use of language. In his lyceum speeches, he began with an introduction calculated to amuse by contrasting a pretense to humility against extensive self-promotion. "The man who blows his own horn," Locke insisted, "generally plays a solo." Humility demonstrated character. Indeed, according to Locke, "honest merit is always retiring and shrinking," a fact to which he jokingly attributed his own relative anonymity. "In addition to my excellence," he added facetiously, "I have wisdom, natural and acquired." On and on Locke could proceed, in the same vein, inviting his audience to laugh with him and at him. When Locke supplied the words and Nast the drawings, the potential for both satire and amusement knew no bounds.[22]

THE JOHNSON PRESIDENCY pushed Nast closer and closer to cartooning. Most of Nast's personal possessions and correspondence have disappeared,

but enough evidence remains to explain what he thought about his career. For example, from the relative calm of the 1880s, Nast contemplated his work. He explained the obscure origins of his creativity, the effects of caricature on his personal life, and the value of caricature to public discourse. Though recorded late in his career, these thoughts help to explain the professional and artistic transformation Nast experienced in the middle and late 1860s.

Observers like James Parton and Albert Bigelow Paine sought in vain for Nast's creative source. Nast acknowledged its obscurity. "Genius and ideality and inspiration are gifts," Nast insisted, "and cannot be created." If an idea struck Nast in the middle of the night, or while he was traveling, he learned he could not rely on memory to preserve it. "When an idea comes," he wrote, "it needs to be secured at once as it is fleeting." The result was a life filled with scribbling and sketching. "Many corners of envelopes, margins of newspapers, cuffs etc." provided a space for Nast to secure his ideas when they surfaced.[23]

Far from accidental, haste comprised an essential component of Nast's work. If he failed to jot down the idea, he knew it would disappear. The nature of political satire imposed haste as well. Nast knew that "his best hits are often gotten up on the spur of the moment," because "the main object is to strike while the iron is hot." Careful preparation of line and form, composition and likeness sometimes disappeared in the hurry. Faced with having to produce illustrations quickly, Nast worried about "the moral lesson which is to be taught" from his drawings so he sought "force and clearness" rather than grace.[24] Observers, in fact, appreciated that Nast's cartoons had to be both quickly created and carefully targeted. "Although hastily got up for a temporary purpose," one critic wrote, Nast's drawings showed "originality of conception, freedom of manner, lofty appreciation of national ideas and action, and a large artistic instinct."[25]

Just as Nast enjoyed working in both paint and pencil, he enthusiastically consumed the work of both American and European artists. Thus European painters and cartoonists, including William Hogarth, Honoré Daumier, and James Gillray influenced the work he produced.[26] Nast's particular favorite among European cartoonists, and the man whose work he identified as a model, was John Tenniel.[27] Born in 1820, Tenniel illustrated Lewis Carroll's *Alice in Wonderland* and *Through the Looking Glass*. He was also a cartoonist, responsible for the drawings in *Punch*, a British magazine devoted to political and social commentary. Tenniel worked at *Punch* for his entire professional life, and in that time he produced more than

2,000 drawings. After a brief period at the School of the Royal Academy, Tenniel was self-taught, and he began to exhibit paintings at the same age Thomas Nast entered the professional world, fifteen. Tenniel joined the staff of *Punch* in 1850. By 1864, at the same time that Nast's artistic freedom was expanding and his fame was beginning to grow, Tenniel had succeeded John Leech as *Punch*'s primary cartoonist.

When Nast sought examples of political satire, then, Tenniel was the most visible star for him to emulate.[28] Nast insisted that he came up with his own ideas. The idea of being given editorial direction repelled Nast. As an example of an artist who drew what was required of him he offered Tenniel. Reading about the *Punch* artist in the *London Magazine*, Nast observed, "His cartoons are always written down by the editor after post-prandial council with the staff." More, Tenniel produced the required drawing, "whether a double or single page, or the work full or slight," in less than two days. Nast admired Tenniel but considered the Englishman's process unacceptable.

In Nast's case, even the contributions of engravers and other staff intruded into his desire for complete artistic control. The printing process required that engravers reproduce an artist's drawing on hard wood. In the translation, engravers sometimes altered the picture. This "could hardly be satisfactory to the artist, for his work, good or bad, is the offspring of his own invention," Nast asserted. Happily, advances in paper and printing technology solved part of this problem. By the time Nast reflected on his craft, in the 1880s, he enjoyed better control over the reproduction of his drawings. Drawing on "tinted paper," he commented, provided "so much freedom, as one need not be hampered by the thought of the engraver's idea of it."[29]

Independence guaranteed control. But it also helped to focus blame. Nast's work relied on mockery, and that meant that Nast had both fans and foes. Fans, of course, appreciated the cartoonist's creativity and political insight. They offered "resounding praise." Foes disagreed. They complained of "his stupidity, want of taste, bad work and general degeneration." Nast collected public responses to his work, dwelling on the "stinging vehemence" of the criticism.[30]

Criticism hurt. But Nast believed that caricature offered the public a valuable tool. "People don't like to be preached at and criticized in this self-indulgent age," he wrote, "but that doesn't say it is not good for them." His work, he claimed, taught the public the hard truths of American politics. In addition, he insisted, caricature respected its subjects. He might offend,

but at least he never drew "namby-pamby portraits" of great men. The great men of the day—Grant, Lincoln, and their equals—deserved to be treated seriously. Here, perhaps more than in any other statement he made, Nast demonstrated the rationale for his embrace of political cartooning over sentimental illustration. It was not enough to offer readers a "pretty pose." Great men, and dangerous times, required art with meaning.[31] And no man exceeded the greatness of U. S. Grant.

In May 1868, the Republicans met in Chicago determined to choose a worthy successor to Lincoln who would not stand in the way of a more radical approach to Reconstruction. They sought a nominee, according to *Harper's*, with "sagacity, intelligence, tenacity, modesty, and moderation." In highlighting these qualities, *Harper's* echoed its endorsement of Lincoln in 1864. Then, the president offered "perfect patriotism and great sagacity" plus "profound conviction and patient tenacity."[32] The man who best embodied those qualities in 1868, editor George William Curtis decided, was Ulysses S. Grant. Nast agreed. The Chicago convention offered a chance for Nast to enhance his professional reputation and express his political ideals. His performance there earned him more applause from Republicans, while their nominee became his greatest hero. All the skills and interests developed during the war and honed during the Johnson administration came to Nast's aid as he plunged into national politics.[33]

Nast loved heroes. Throughout his career, he balanced his contempt for hypocrisy against a desire to elevate the heroic. The best example of this tendency was his adoration of U. S. Grant. Not merely a general, Grant represented the salvation of the Union to Nast. Just as Nast displayed his admiration for Garibaldi and Lincoln in his work, he began drawing Grant as an exemplary man. In Nast's drawing of Columbia pinning a congressional gold medal to his breast on the cover of *Harper's*, Grant, in uniform, stands erect, appearing far more formal than he did in real life.[34] Grant appeared again at war's end as "Our Conquering Hero" and "Ulysses the Giant Killer."[35] Two years later, in "Prometheus Bound," Nast linked Grant to the mythic past. As Prometheus, Grant appears bound while Confederate furies tear at his nearly naked body. Below the illustration, Nast uses Percy Bysshe Shelley's version of the Greek tragedy *Prometheus Unbound* as a template to criticize President Johnson's policies. "We track all things that weep and bleed and live," the furies say. "When the great King (Andy) betrays them to our will."[36]

So when Grant's nomination as the Republican presidential candidate seemed certain, Nast went to work on a celebratory image. The result ex-

emplified the mix of art and politics that characterized Nast's work in the 1860s. On an enormous piece of fabric, Nast painted two pillars, each representing a presidential candidate. The Democratic pillar remained empty, since the Democrats would not meet until July. On the other pillar, Grant represented Republican hopes. Between them stood Columbia. Speaking for the nation, the party, and Nast, she points to Grant, challenging the Democrats: "Match Him!"

When Nast hung the canvas on the convention stage, he carefully concealed it behind a curtain. When Grant officially won the nomination the curtain was dropped, revealing Columbia's imperious demand. The delegates exploded with applause. Nast's reputation as an asset to Republican presidential politics—built on his success with "Compromise with the South"—soared to new heights. "Match Him!" went on to become a campaign slogan, a song, and a poem.[37]

After the Republican convention, Nast turned his attention to the other side. In July he mocked the Democratic nomination contest. Salmon P. Chase, chief justice of the U.S. Supreme Court and a man whose work on behalf of the freedman might have attracted positive attention from Nast, appeared in "A Wild Goose Chase." A week later, Chase appeared in the guise of a doctor. For the "Sickly Democrat," he prescribed a glass containing a black voter. "Oh!" the patient cries, "Must I swallow him whole, Dr. Chase?" The irony of Chase's potential nomination for president by the Democratic Party proved too enticing for Nast to resist, and another cartoon in that issue showed Chase officiating at the wedding of the black voter to the Democrats. Looking on, and demonstrating Nast's interest in the many players involved, were other candidates (Horatio Seymour, James R. Doolittle, George H. Pendleton, and Thomas A. Hendricks), interested parties (including representatives of Tammany and newspaper editors), and the inevitable Confederates who appeared so often in Nast's work as Democratic villains (Confederate cavalryman Nathan Bedford Forrest among them). The message needed no elaboration: Democrats courting black voters defied logic. It was the Democrats' confusion, though, that really attracted Nast's pencil. As they cast about for a candidate, voting over and over at their convention, Nast no doubt watched with glee.[38]

In the end, the Democrats chose former New York governor Horatio Seymour. Nast recycled the "Match Him!" concept to attack the candidate. Seymour attracted special attention from Nast because during the war, Seymour opposed Lincoln's draft policy and spoke out against its infringement of civil liberties. Nast linked this position to the murderous rampages of the

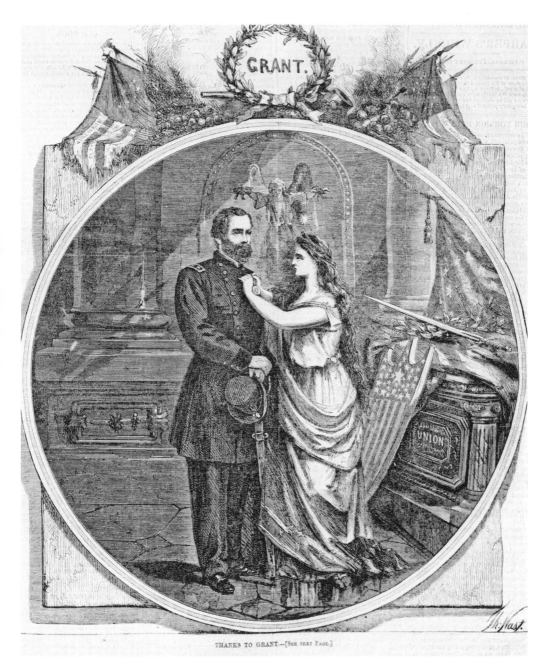

THANKS TO GRANT—[See next Page.]

"Thanks to Grant," Harper's Weekly, *February 6, 1864.*

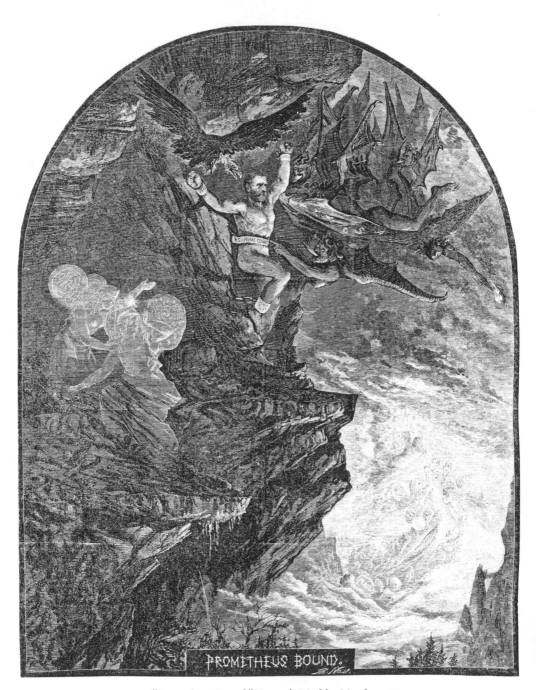

"Prometheus Bound," Harper's Weekly, *March 2, 1867.*

New York Draft Riots of 1863 and blamed Seymour for the destruction. The governor's speech to New Yorkers that was intended to calm the city only cemented Nast's distaste. Seymour addressed his audience as "my friends" and asserted that the conscription law was unconstitutional, both of which Nast considered proof that the governor and the Democratic Party alike pandered to the rioters.[39]

Thus, when Seymour emerged as the Democratic nominee in 1868, Nast's pencil found an especially juicy target. In October, relying on readers' recognition of the "Match Him!" campaign slogan, Nast produced a two-panel cartoon titled "Matched?" On the left, Grant stands elegantly in his Union uniform. At his feet lie captured emblems of victory: a flag, a sword, and guns of the Confederacy. Above Grant's head is a quote from the general's response to his nomination: "Let us have peace."[40] The phrase became Grant's campaign slogan. On the right, Seymour, his hair drawn to look like horns, likewise surveys symbols of his record: rioting Irishmen, the burning Colored Orphan Asylum, and a lynched black man. At Seymour's feet lies a dead African American baby. Seymour's statement, "A mob can revolutionize as well as a government," appears above his head, reinforcing Nast's point.[41] It was this kind of work that earned Nast so much attention. He used Seymour's appearance, words, and past to suggest that not only was the Democrat no match for Grant, but he represented evil itself.

By the time Seymour appeared as Lady Macbeth, Nast's partisanship was in full swing. August drawings attacked the Democrats for voter intimidation, invoked the Lost Cause, and supported Grant's insistence that peace was the road to the White House.[42] By September, peace no longer held center stage. One cartoon used the campaign song "Keep the Ball Rolling." In it, Grant rolls bowling balls—labeled Vermont, Maine, and other states—toward pins topped with the heads of Democratic politicians, including Seymour. Republicans, remembering the power of Nast's work in 1864, combining the Lady Macbeth image with Nast's "Compromise with the South," produced a campaign pamphlet for general distribution.[43]

September brought readers one of Nast's most famous cartoons, "This Is a White Man's Government," in which he combined several previous lines of attack into a single image. A disenfranchised black voter lies prone under the boots of three Democratic constituencies. Irish thugs, unreconstructed Confederates, represented by Nathan Bedford Forrest, and the moneyed interests of the Democratic Party, represented by New Yorker August Belmont, join forces to crush black civil rights. Nast peppered the image with political symbols. This was no ordinary black voter, but a Union

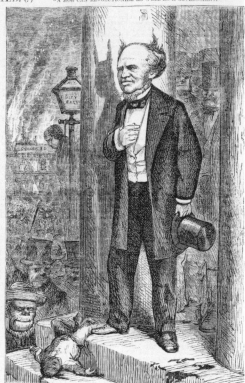

"*Matched?*," Harper's Weekly, *October 31, 1868.*

veteran still in his uniform. At his head lies the American flag in the dirt, and to his left the ballot box lies just out of reach. Behind the Irish thug is a burning building representing the Draft Riots. As he often did, Nast relied on repetition for emphasis. The Irishman holds a club labeled "a vote"; Forrest wields a knife labeled "The Lost Cause"; and Belmont holds cash.

The cartoon combined reality and fantasy in ways that invited readers to do the same. Nathan Bedford Forrest, for instance, appeared for several reasons. By 1868, the Confederate cavalryman already served as a Southern boogeyman. His actions at Fort Pillow, where Confederate soldiers under Forrest's command killed more than 200 surrendering black Union soldiers, aroused hatred and disgust among many readers of *Harper's Weekly.* So readers recognized Forrest as a symbolic figure. But Forrest was Tennessee's delegate-at-large to the 1868 Democratic convention, so Nast found a perfect focus for one aspect of his attack on the Democrats. Simultaneously, "Fort Pillow Forrest" represented the war, the refusal of Southern Democrats to accept their loss, and the repression of black civil rights. The

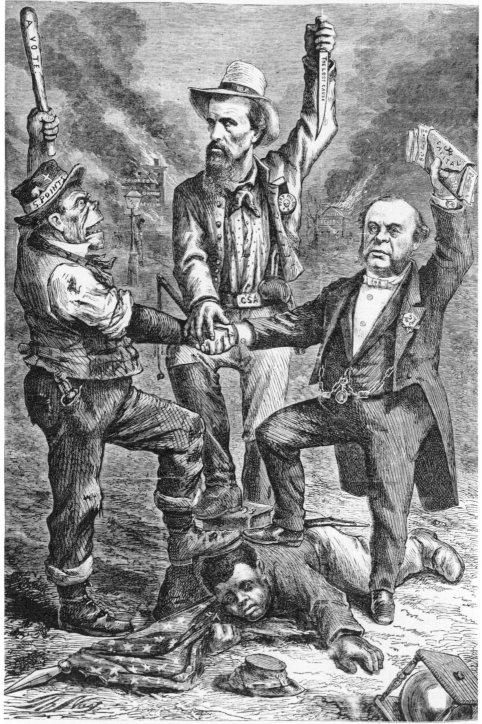

"We regard the Reconstruction Acts (so called) of Congress as usurpations, and unconstitutional, revolutionary, and void."—*Democratic Platform.*

"This Is a White Man's Government," Harper's Weekly, *September 5, 1868.*

appeal of the drawing was not only its powerful political point but also the wink to the reader. Anyone who knew about Forrest's presence at the Democratic convention knew that Nast played not just on the past but the present, and readers felt as if they joined Nast in an inside joke.[44]

Nast's choice of title for the cartoon demonstrated the same interplay between reality and representation. Voters may have recalled Stephen Douglas insisting, in 1858, that American government "was made on the white basis," to include only white men "and their posterity forever." The idea that the government ought to be restricted to white men appeared in a variety of places in 1868. In February, Senator Daniel Clark of New Hampshire asked Americans whether they would reward the sacrifices of black soldiers during the war with exclusion from the polity. When the nation sought their help in wartime, he asked, "Did you point to the sign over the door, 'Black men wanted to defend the white man's Government?'" Like Nast, Clark focused on the symbolism of a black man in a Union soldier's uniform, asking, "Did you say, 'Don't disgrace it; this is the white man's Government?'"[45]

Southern governors insisted on the primacy of white men in government. Governor Benjamin F. Perry of South Carolina publicly argued that "this is a white man's government, and intended for white men only."[46] Most crucially, Seymour, running against U. S. Grant's message of reconciliation— "Let Us Have Peace"—warned against allowing black men to join the polity. As *Putnam's* wrote, the Democrats believed "that political rights shall be enjoyed by white men only, or, as they express it, under 'a white man's government.'"[47] These statements ran like a river under Nast's title. Without the title, the cartoon conveyed threat but not hypocrisy. With it, Nast pointed directly to the Democratic presidential candidate and prompted readers to ask not whether black men deserved the vote but whether all white men were truly fit to have it.

In "This Is a White Man's Government," Nast treats black veterans with respect. The black man crushed by Democratic voting blocs wears his Union uniform well, and the presence of voting symbols signified his position as a potential American citizen. Nast's audience knew he supported the rights of the freedmen. His work over the years left no doubt of that. After his celebration of the Emancipation Proclamation in January 1863, Nast's optimism about black freedom appeared often. In March that year, Nast illustrated an attack by the U.S. Colored Troops, emphasizing their willingness to die for the cause. An accompanying article told the story of the unit's heroism and reinforced Nast's point: black soldiers offered the Union

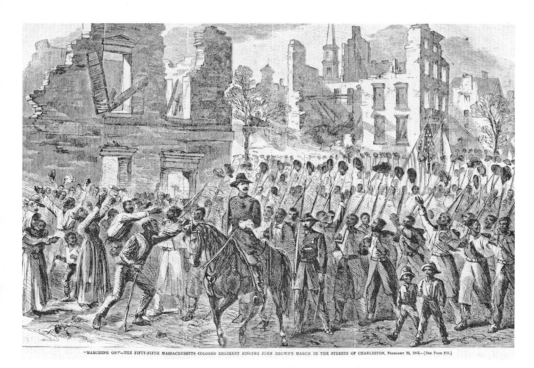

"Marching On!," Harper's Weekly, March 18, 1865.

the potential to field "the steadiest rank and file in the world."[48] Later, Nast used one of his wartime illustrations to produce *Entrance of the 55th Massachusetts (Colored) Regiment into Charlestown, S.C., February 21, 1865*, an oil painting portraying the triumphant moment when black soldiers marched into Charleston, reputedly singing "John Brown's March."[49] Likewise, in "Pardon" and "Franchise," a wounded black veteran dramatizes the hypocrisy of readmitting Confederate leaders to full citizenship while denying those rights to men who lost limbs in the service of the nation.

But Nast never adopted an entirely positive view of black Americans. Like everyone else of his generation, he grew to maturity in a world where race usually determined destiny. The same sensitivity to cultural norms that helped the cartoonist respond to public tastes and tickle a reader's fancy made him vulnerable to stereotyping. So while the election of 1868 elicited some of Nast's most sympathetic images of freedpeople, it also provided opportunities to show the limits of Nast's optimism and open-mindedness.

One example of those limits appeared in Nast's work at the end of September 1868. In another attack on Democratic electoral efforts, Nast turned to racist imagery drawn from minstrelsy. In two-panel "All the Difference in the World," his anti-Democratic message is the same. The top

panel shows Democrats courting the votes of Irishmen, drunken and filthy, while disdaining the citizenship of honest black farmers. The bottom panel shows Democrats trying to convince black voters that the party can represent their needs. In both images Nast employed stereotypical physical characteristics. The Irishman wears the hat, boots, and ragged clothing to go along with his ape-like jaw and general air of disrepute. Nast drew on a long-standing tradition of Irish caricature for that picture. Below, two fancily dressed, thick-lipped black men are pictured, one strutting with head held high and a white woman on each arm, toward the other, seated, his arms held up in surprise as a white man shines his shoes.

As he had done with Forrest, Nast addressed both popular perceptions and reality. Readers would have recognized Nast's version of black men from the minstrel shows, but those who followed politics carefully also would have noted the relationship of the bottom image to vice-presidential candidate Francis Preston Blair. The Missourian had been among President Johnson's most trusted friends, and it was Blair who had warned Johnson about the dangers of racial "amalgamation" in 1865. Now the man who feared black and white social mixing sought the vice presidency. Nast played on Blair's position when he mocked the Democrats' efforts to recruit black votes.[50]

The point was that the Democrats courted all the votes they could find. If those votes came from opposing camps, or from contradictory positions, so be it. To vote Democratic thus meant voting not just for the party of the South but also for the party willing to do anything to obtain power again. Nast anticipated the arguments of historians who describe the Democratic Party as having invented a category of "whiteness" that provided prima facie citizenship. To be white was to be able to vote, and because the Democrats welcomed people sometimes excluded from the racial and social category of whiteness, particularly the Irish, they represented a party rooted in a pan-European pragmatic inclusivity. If they now intended to woo black voters, too, Nast linked that development to their open arms for immigrants. Republicans, the reader must perforce believe, had purer motives and more reliable political values.[51]

If *Harper's* doubted the talents Nast brought to the *Weekly*, October demonstrated their power. Week after week, the cartoonist hammered away at Seymour and the Democrats. References to the Ku Klux Klan, to immigrant voting, to the disenfranchisement of black voters, and to Seymour's pallid charms—as compared to Grant's—filled the pages of the *Weekly*. In his final cartoon for the month, Nast returned to the *Macbeth* theme. Sey-

mour and his running mate, Blair, appear as witches, stirring a "Hell-Broth" of "CSA-KKK" soup. No one could mistake Nast's allegiance to Grant and the Republicans. As much as Nast despised Seymour and idolized Grant, though, it was violence against freedmen that inspired his most powerful images of the campaign. Nast's support for emancipation and his interest in and optimism about the potential of black citizens came together in the most compelling cartoon of the fall, "Patience on a Monument."[52]

With "Patience on a Monument," Nast departed from his deeply partisan work slightly. Although he remained committed to the presidential election and to the victory of U. S. Grant, Nast's frustration with southern racial violence bubbled over in this cartoon. Presidential Reconstruction failed to create the world Nast imagined in "Emancipation." Instead of settling into tidy black households overseen by benevolent black patriarchs, former slaves confronted a world of competing white power brokers and seething Southern white resentment. Violence punctuated this period, demonstrating that blacks' status change from slave to free had not erased their subordination.

"Patience on a Monument" reflected those failures and the frustration felt not just by Nast but also by many of his readers. In some ways, the drawing reprised the theme of "This Is a White Man's Government." On the left, a mob of Irish immigrants is shown burning the Colored Orphan Asylum during the Draft Riots. On the right, a mob of Southern whites burns a Freedmen's school. Atop the monument in the center of the illustration, a black veteran mourns his losses. The inscription reads, in part, "A NEGRO HAS NO RIGHTS WHICH A WHITE MAN IS BOUND TO RESPECT" and "THIS IS A WHITE MAN'S GOVERNMENT."

In significant ways, though, this image differed from its predecessors. First, the black veteran in "Patience on a Monument" sits high above the fray, rather than lying crushed under the boots of the white men. But the elevation is symbolic not of success but of disappointment, because at the base of the monument lie the bodies of the man's wife and children. What separates this veteran from the idealized patriarchy Nast imagined in 1863 was not just the violent men to his left and right but also the racism of the South as a whole. With the inscriptions on the monument, Nast indicted Southern whites using their own words and an account of recent history. At the top, a list of the crimes of slavery appears. Below that are references to the Draft Riots and Fort Pillow. Lower still is a catalog of the various ways Southern states attacked black civil rights. "We are bound to have a war of races," reads a quote from a Texas newspaper, "and when

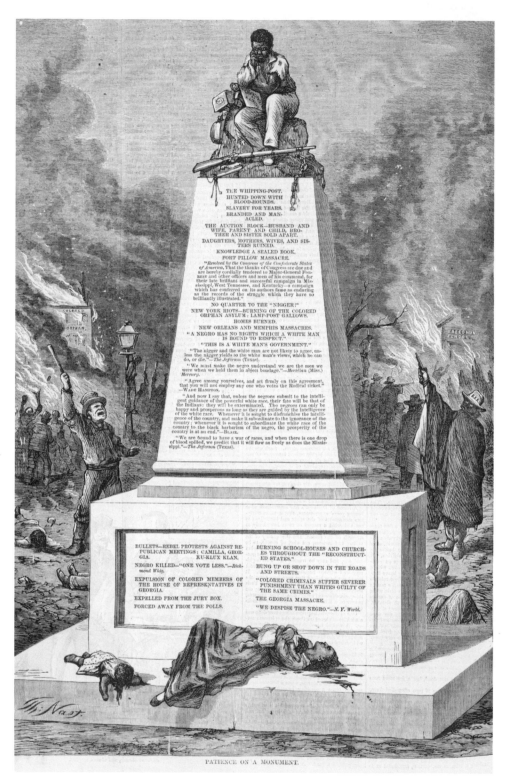

"Patience on a Monument," Harper's Weekly, *October 10, 1868.*

there is one drop of blood spilled, we predict that it will flow as freely as does the Mississippi." Slipped into the last section, a long quote from Blair links the Democratic ticket to Southern violence. With "This Is a White Man's Government," Nast insisted on the value of black men as voters. He warned that the Democratic coalition posed a danger to the nation. Here, he complained that the long struggle to free the slaves and integrate them into national life was slipping away in a sea of blood.[53]

The emphasis on family in "Patience on a Monument" also distinguishes the illustration from "This Is a White Man's Government." In the latter, Nast's black veteran reaches for the ballot box. At issue were the civil rights of freedmen, couched in political terms. In "Patience on a Monument," civil rights seem to be a minor consideration. With an inscription quoting Wade Hampton, Nast nodded to the party struggle in South Carolina: "Agree among yourselves, and act firmly on this agreement, that you will not employ any one who votes the Radical ticket." Another quote inscribed on the monument, from the *Richmond Whig*, acknowledged that every black voter killed or denied access to the polls was "one vote less." But despite his recognition of the significance of black voters to the Republican Party, Nast's focus is on the tragic consequences of the violence against black families. Nast addressed this theme in the past in "Matched?" with the murdered black baby at Johnson's feet. In later cartoons, too, Nast focused his readers' attention on the human cost of white supremacy by including the bloodied bodies of women and children.

It is worthwhile to pause here for a moment to recall Nast's youth. The young man who adopted Garibaldi as a personal hero had a profoundly optimistic, idealistic, and perhaps naive view of the potential for social and political change. Marrying Sallie, some of whose family members were opponents of slavery, like James Parton and his wife Fanny Fern, only cemented the potential for Nast to view emancipation with hope rather than cynicism. Finally, years of work for illustrated newspapers—especially *Harper's Weekly* but also *Frank Leslie's Illustrated News* and the *New York Illustrated News*—had provided an education in political possibility. Newspapers that constantly strove to capture the big story, the tragic tale, and the scandalous whisper had to believe that big things might occur and that big changes meant limitless potential for a change in the nation's story.

So when Nast produced a series of cartoons supporting his new hero, Grant, who defended the freedman against white violence, it is reasonable to accept his sympathy as sincere. Nast's personality and experiences enabled him to link Grant's election to the success of Reconstruction, the pro-

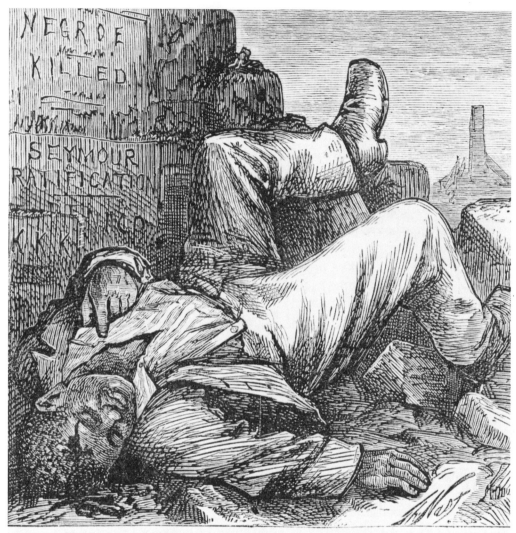

"**ONE VOTE LESS.**"—*Richmond Whig.*

"One Vote Less," Harper's Weekly, August 8, 1868.

tection of black families, and the intervention of the federal government to prevent the reassertion of white supremacy in the South.

Grant's victory delighted Nast. As a citizen and a Republican, the cartoonist celebrated his party's victory and the ascension of a man he believed to be the perfect leader for the time. As an ambitious young father, Nast enjoyed the reputation his drawings brought. If he could rise above the pack of illustrators with whom he worked during the war, Nast might finally earn enough money to comfortably support his family. In the after-

math of the election, Republicans patted one another on the back. Nast received his fair share of accolades. These included letters of praise from newspapermen like *Tribune* editor John Russell Young and expressions of friendship from the president-elect himself. When, for instance, the nation waited for Grant to announce his cabinet, Nast drew a cartoon showing Grant shaking a group of cats out of a bag. He drew them headless and sent the unfinished cartoon to Grant, asking him to "add the heads" for his cabinet members. Grant declined. But the exchange was pleasant, and it showed the way that Nast's successes had made him confident, even pert. He knew that his work helped Grant win, and he knew that Republicans knew it.[54]

During the first year of Grant's presidency, Nast experimented widely. Contributing one or two cartoons per issue, he commented on topics as divergent as the religious dedication of businessmen and the doctrine of papal infallibility. It was a year during which he worked steadily for *Harper's* while expanding his work as an illustrator for humorous, satirical, and political works.

In January 1869, he remained jubilant over Grant's win. In "Peace on Earth and Good Will Towards Men," in the January 9 issue, Grant and Columbia welcome the New Year. Two months later Nast's cartoon inspired by Jean-Léon Gérôme's *Death of Caesar* (1867) appeared. In it, Nast replaced Caesar with Andrew Johnson and carefully drew the other figures with the faces of leading American politicians.[55] For the rest of spring, Nast published only sporadically in *Harper's*.

His association with the *Weekly*, though, continued to enhance both reputations. On May 15, the paper celebrated Nast's career by reprinting the tribute offered to him on April 29 at the Union League. On that night, thirty-six members of the league presented Nast with a solid silver vase, made by Tiffany and Company. Instead of handles, the vase boasted two figures stabbing "the open-mouthed monster of Secession." The league complimented Nast's "genius" and his commitment to "popular sentiment in favor of the Union and of equal rights for all" and thanked him for his help in the "preservation of his country from the schemes of rebellion." The award recognized the extent to which Nast's success at *Harper's Weekly* had transformed him into a political power, someone with both access and influence.[56]

The rest of 1869 provided a variety of sparks for Nast's creativity. An entertaining image in July mocked men who spent "Six Days with the Devil and One with God." Visited by a Bible-toting angel, the self-important businessman pictured in the cartoon puts her off, saying, "I am too busy to see

you now. Wait till Sunday." In August, violence against Chinese immigrants in California inspired an angry Nast's "Pacific Chivalry." In later years, Nast would return to the question of Chinese immigrants, decrying the abuse they suffered and connecting anti-Chinese violence to the problem of unreconstructed Southern whites. But no single issue held Nast's attention for long in 1869. In September he drew a cartoon supporting the Harvard rowing team in its contest with Oxford, and in October he complained that a college education no longer placed enough emphasis on intellect and that women should consider the home their proper domain. His illustrations for the rest of the year were equally eclectic. Nast's talent for humor and ridicule remained powerful, but no subject seemed to stir him the way that the presidential election did.[57]

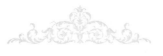

CHAPTER SIX

Tweed

In the late summer of 1871, Thomas Nast received a visitor to his Harlem home. The man was a representative of the Broadway Bank, and after an introductory period of small talk, he asked Nast whether it was true that he would be traveling to Europe soon to study art. Nast said that he was too busy to leave just then. "I have reason to believe," the man replied, "you could get a hundred thousand dollars for your trip."[1] Nast understood that this was a bribe, and that his visitor represented the Democratic machine, based at Tammany Hall. The machine's boss, William M. Tweed, was the target of a campaign to destroy the power of the Democrats and reform city government. The *New York Times*, *Harper's Weekly*, and Nast's unrelenting pencil were the primary weapons in the fight. Clearly, Nast's cartoons were hitting home, and Tweed hoped that he could induce Nast to abandon the crusade against the machine.

Nast asked whether he might be given $200,000. The answer was yes. What about $500,000? After a slight pause, the gentleman dropped all pretense. "You can. You can get five hundred thousand dollars in gold to drop this Ring business and get out of the country." The banker must have thought that he had finally hit upon Nast's true desire. Five hundred thousand dollars was not a fortune that would rival that of the Astors, Vanderbilts, or the railroad barons, but it was enough money to catapult Nast into the upper classes. Nothing would be impossible with five hundred thousand dollars.

Yet the answer was no. "I made up my mind not long ago," Nast told the man, "to put some of those fellows behind the bars, and I'm going to put them there!" The man replied, threateningly, "Only be careful, Mr. Nast, that you do not first put yourself in a coffin!" Already, Sallie and the children had been moved to Morristown, New Jersey, to protect them from the possibility of violence. Lurking toughs, threatening letters, and the removal of a friendly local police captain had all presaged this visitor. It was clear that the stakes were rising, both for Nast and for his primary target: Boss Tweed.[2]

The confrontation between Nast and Tweed had been a long time coming. The two men had a serendipitous history together, beginning when Nast was only a child and Tweed was a promising young Democrat in the toughest ward in New York. The two men becoming enemies and Nast joining, then leading, the fight to destroy Tweed is one of the most dramatic episodes in Nast's life. Two points make the Tweed period important. First, Nast's participation in the campaign against Tweed catapulted him to the forefront of his profession. He became a man whose work could change minds, topple leaders, and influence elections. Not mere editorials, Nast's cartoons captured public attention and inspired public outrage. Editorials supplied evidence. Nast helped people react. Second, the Tweed crusade made Nast a celebrity, toasted in both New York and Washington, D.C., and fame gave him power—political, social, and economic.

When Thomas Nast entered school on Cherry Street, he was probably between eight and ten years old. Nast liked it no better than any other school. He preferred to draw, wander the streets, and chase fire trucks. A nearby company, the Big Six, was one of the best in the city. In a city whose fire companies resembled gangs as much as public servants, the Big Six's men were tall, tough, and willing to fight any other men who might arrive at the scene of a fire. Sometimes fighting between fire companies was so fierce that fires raged unchecked because there was no one left to operate the hoses. Home owners could only watch despairingly as their possessions burned.[3]

If anyone could understand why the Cherry Street School repelled Thomas Nast, it was one of the Big Six, William Tweed. Tweed, a Cherry Street dropout, was a strapping young man with a bull neck and a talent for trouble. He was also a promising young member of the Democratic Party. By the time Tweed left the Big Six for political office, Nast was almost eleven years old. It is easy to imagine the impression Tweed might have made on Nast. At five foot eleven and solidly built, Tweed was physically impressive. His fireman's gear, including the hat emblazoned with a tiger's head, its teeth bared, would have only made him more awe-inspiring to a young boy.[4]

The neighborhood that nurtured these two men seethed with both crime and political intrigue. Gangs roamed the streets both day and night, grocery stores doubled as saloons and gambling halls, and many residents struggled against grinding poverty. Scrambling for any chance at self-improvement was a way of life, as was excessive drinking for others. Nast and Tweed took very different paths. At nineteen, Tweed was earning his stripes as a brawler,

learning how to lead other young men and absorbing Democratic political ideas. At the same age, Nast was a correspondent in Italy, heralding exciting political changes and his revolutionary hero.

With the coming of the Civil War, the differences between Nast and Tweed widened. Tweed joined the Board of Supervisors in 1857, building a Democratic power base that allowed him to become the city's de facto mayor by 1860. By 1865, his fortune, plundered from city contracts and supplicants to the board, was impressive and growing. Tweed's reputation, both nationally and locally, was closely tied to the traditional systems of spoils and patronage. He was a "Boss." Nast, in the same years, embraced the new Republican Party, the Emancipation Proclamation, Abraham Lincoln, and Ulysses S. Grant. Relying on the productive combination of his talented hands and an imaginative mind, Nast built a reputation as an idealist and patriot. Thus, while Tweed was becoming a symbol of city corruption, Nast was emerging as a truth-teller, a gadfly, a man who valued honesty and purity above all other virtues.

Long before Boss Tweed became the target of Nast's pencil, his organization controlled much of New York politics. Founded in 1789, the Tammany Society was originally a fraternal organization. According to one of its early chroniclers, the Society was organized in part to offer a social and political base for men who were excluded from the ranks of the city's "aristocrats." It hailed "republicanism" and offered the city "the smile of charity, the chain of friendship, and the flame of liberty." Over time, the Society built an alliance with the Democratic Party and the legions of Irish immigrants pouring into New York. By the 1850s, the New York Democratic Party had come to rely on the Society as its political machine. A decade later the two were inseparable, and for many New Yorkers the words "Tammany," "Democrat," and "Irish" would have been nearly synonymous.[5]

William M. Tweed began his political career while foreman of the Big Six. He attended political meetings and even clashed with infamous Democratic thugs like Isaiah Rynders. In 1851, seeking a more formal role in city politics, Tweed ran for and won a seat as a city alderman. In 1853 the city sent him to U.S. Congress, where he remained for two years. He took a seat on the Board of Education when he returned, and in 1857 he won a seat on the Board of Supervisors, where he remained until 1870. The Board of Supervisors "was a golden opportunity for a crafty man," and for Tweed, "it had the further advantage that it was never in the limelight." As Tweed's innovative methods of stealing money from the city developed, that anonymity proved immensely valuable.[6]

On the board, Tweed rallied supporters, built a coalition, and exerted control over board appointment power. In particular, he wanted to control the men who served as inspectors of elections. Given the notoriously fluid nature of the franchise in New York, election inspectors could choose to see much or ignore much. Under Tweed, they could be pointed toward the corruption that Tweed thought ought to be exposed and away from that which served the Democrats' needs. In other board business, Tweed and his associates claimed a percentage of revenue or profit as the fee for decision-making.[7]

By 1870, the four main players of the "Ring" were in place: in addition to Tweed, who had also become a state senator and deputy street commissioner, was Peter B. Sweeny, who controlled electoral positions; Richard Connolly, who kept the books; and A. Oakey Hall, a former district attorney who had become mayor of New York in 1869. These four men supervised a much larger group of city employees, ward heelers, and friendly businessmen. In all, it was a network designed to simultaneously govern the city and steal from it. Efficiency was a virtue, because efficiency made graft easier and more lucrative.

Tweed should not be equated to the violent and unpredictable gang leaders of the 1840s and 1850s. The men in charge when Nast was a child were long gone. Instead, the Ring represented a more sophisticated version of Democratic machine politics. As New York City government became more complex, and as the money flowing through the city's coffers grew to unprecedented proportions, graft became a system of license and permit. Tweed's power came not from roving gangs of Democratic thugs— although those still existed—but from his ability to issue a contract to suppliers of toilets, or carpet, or dining room chairs. He and his associates collected fees for permits but also helped to arrange inflated cost estimates and cheaper materials and engaged in other skimming practices.[8]

Rich men knew how to live well in the Gilded Age. As Tweed's money began to pile up, his personal style became more and more opulent. He took to wearing an enormous diamond stick pin in his tie. His suits, which had to be made larger and larger as he grew from merely fat to massive, were cut precisely and finished expertly. His carriage, office furniture, wife, and home all reflected his increasing fortune. Tweed owned land all over Manhattan. He had not one but two yachts, and he owned two homes—one on Fifth Avenue and the other in Greenwich, Connecticut.[9]

Of course, he was not the only man in New York whose carriage was plush with velvet. The Harpers enjoyed their wealth, as did the families building

grand homes along Fifth Avenue. There were many newly rich men in New York in the late 1860s, and most of them showed it off. Tweed's wealth, however, was gleaned from city coffers—from tax revenue, and wealthy men like the Harpers and George William Curtis found that both immoral and distasteful. Tweed's power base was equally unpleasant. Newly arrived Irish immigrants, almost exclusively loyal Roman Catholics, frequently unemployed and too often drunk—these were Tweed's constituents, his enemies charged.[10] The powerful strain of nativist thinking, so central to New York politics for decades, emerged here. Not all of Tweed's supporters came from Irish, immigrant, or Catholic communities. But whatever coalition of voters Tweed organized, his enemies preferred to think of him as the puppet master for a gang of Irish thugs.[11]

Ironically, the Irish had been at the root of an early amity between the city's elite and Tweed. Wealthy New Yorkers rejected Tweed in 1870. But when Irish rioters engulfed the city in violence during the Draft Riots of 1863, they viewed Tweed very differently. In that chaotic moment, Tweed remained calm. His envoy saved Republican mayor George Opdyke's home from a mob bent on burning it down. He stood with Governor Horatio Seymour as he tried to calm crowds at city hall. Tweed represented one of the few Democratic organizations to stand solidly for the Union. For wealthy New Yorkers, fleeing in panic from the burning city, Tweed briefly appeared to be an oasis of calm competency.[12]

Even before 1863, Tweed attracted positive attention from some of the city's anti-immigrant elite. When he returned from Congress in 1854, the Know-Nothing Party, a nativist political faction, attempted to recruit Tweed for public office. He refused. Their interest in him stemmed at least in part from his membership during the 1840s in the Order of United Americans, a nativist fraternal and political organization. During his mayoralty, James Harper held similar nativist views.[13]

But Tweed represented neither a nativist nor a purely pro-immigrant position. Rather, he and his Tammany associates (including Governor John T. Hoffman and Mayor Hall) offered voters a path balanced between Republicans and another faction of Democrats, Mozart Hall. Iver Bernstein has identified a "Tammany-style nationalism" that embraced immigrant voters while asserting their essential patriotism and the centrality of American national identity to Democratic politics. Particularly for the Irish, the period after the Draft Riots offered a chance to reaffirm Democratic and immigrant loyalty. Tweed, having condemned the riots and rejected the Republicans, showed the way. Tammany meant stability, and it

attracted enthusiastic loyalty from immigrants and grudging support from some wealthy New Yorkers who valued order.[14]

Popularity with New York's immigrants translated into votes, and Tweed's increasing power over city government began to alarm reformers. It appeared that Tweed could do anything, have anything, he wanted. But his opponents, including the Citizen's Association and the Union League, could never prove specific wrongdoing. And along came Nast. With a group of other newspapermen, he would soon demonstrate the power cartoons could offer a campaign against Tweed.

George Jones, the publisher of the *New York Times*, and his editor, Louis J. Jennings, hated Tammany Hall. Jennings, an Englishman, hated it partly because he believed that the Irish vote was a negative influence on New York's government. Jones disliked the Tammany leadership for its vulgar display of wealth and its disdain for honesty. An even greater reason for his enmity was the cozy relationship between many of the city's newspapers and the Democratic machine. He asserted that Tweed bribed the *New York World* to prevent negative reporting and to ensure complimentary coverage of Democratic politics. "[The *World*] will not depart from its single principle of taking the highest bid for its services," he wrote in 1871. Other Democratic newspapers ignored Tammany, leaving New York Democrats with no "reputable journal" to expose the fraud. Tammany greased a variety of wheels to prevent negative reporting and ensure minimal scrutiny of its finances. Chafing at this system, Jones worked with Jennings to attack Tammany.[15]

There is no evidence to show exactly when Fletcher Harper and Thomas Nast joined forces with George Jones and Louis Jennings. What is clear, though, is that Jones and Jennings noticed Nast's ability to skewer Tweed. They saw an opportunity to leverage the power of the cartoon in a crusade against Tammany corruption and for Republican reform. Nast's first cartoon in the crusade against the Ring appeared in the September 11, 1869, edition of *Harper's Weekly*.[16] It was in reference to the Ring's attacks on August Belmont's leadership of the Democratic Party. Belmont was "inefficient, undevoted, unsuccessful and unpopular," according to Tammany. But Nast mocked not Belmont but Tweed, indicating the Boss's desire to take a national role and making fun of the idea that all the party's sins could be blamed on Belmont.

Nast addressed corruption in city government even before he first caricatured the Tweed Ring. In "The Government of the City of New York," in 1867, he combined stereotypical images of the Irish with symbols of New York's underworld. In the background of this bar scene, a boxer stands

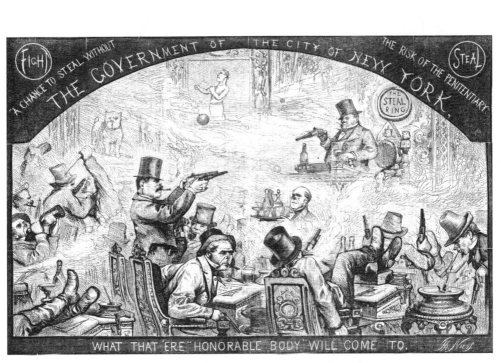

"The Government of the City of New York," Harper's Weekly, *February 9, 1867.*

ready to fight. On the left, a man wields a dagger in a bar fight. On the far right, a man spits into a large, ornate spittoon. In the forefront, slouch lantern-jawed Irishmen holding guns and drinking liquor. Sitting above all of this, surveying his domain, is a heavy-set man with a large revolver. Above his head a plaque reads, "The Steal Ring," and across the arched top of the drawing runs an explanatory line, "A chance to steal without the risk of the penitentiary." If Nast intended the seated man to be Tweed, there is no sign of it. He is a symbol rather than a caricature.[17]

In December 1869, Nast again attacked Tammany Hall, but in this case his cartoon was devoted more to highlighting the contrast between Republican rectitude and Democratic corruption than to the Tweed Ring itself. President Grant is pictured as Robinson Crusoe, while a footprint on the sand promises the presence of other humans on the island. Rather than evidence of a friendly neighbor, however, the print warns of the presence of the "Tammany Tribe." Politician and lawyer Peter Barr Sweeny, whom Nast later dubbed "The Brains," represents the tribe. His neck is ringed with human skulls, and small drawings of savage men burning various civic boards ("The Board of Education," "The Croton Board," "Board of Health") surround his portrait. The contrast between Grant's Republican mission—establishing peace in the nation—and the danger posed by

Democratic politicians in New York, and by extension the nation, could not have been more clearly established.[18]

Later that month, Nast linked Tammany to Roman Catholicism with "The Economical Council, Albany, New York," in which the council is comprised of Catholic cardinals. In the seat of power sits Governor John T. Hoffman, with Sweeny at his right. The fat-bellied Tweed stands among the bishops, his look of righteous satisfaction firmly in place. Guards, their faces clearly Irish, unpack huge crates of "tax payers' and tenants' Hard Cash." Mayor Hall appears as "O.K. Haul." In the background is the phrase that would brand William M. Tweed as William "Marcy" Tweed forever: "To the Victor Belong the Spoils." Nast attributes the quote to "Pius A. Jackson," but it belongs to U.S. senator William Marcy, a Jacksonian politician whose name became synonymous with greed within the spoils system.[19]

Nast's cartoons in the spring focused on the same themes. "The Greek Slave," in particular, linked Irish immigration to Democratic voting fraud. An Irishman, induced to emigrate by rosy promises, finds himself "landed and branded" in New York. His chains tie him to the Tammany stump, where the rewards for voting include rum and whiskey. Nast recycled images from his Civil War cartoons, portraying Irishmen as slaves whose overseers whipped them not to prod them to work but to go to the polls. The masters, of course, sit back to enjoy the power and wealth public office could provide.[20]

Some of Nast's 1870 cartoons offered a broad education in corrupt Ring activities. The level of detail in his drawings, both in terms of issues and of personalities, helped show the Ring in all its dimensions. "Shadows of Forthcoming Events," which appeared in January 1870, is an example. Here, twelve separate boxes form a single cartoon on a two-page spread.[21] The issues addressed include public education, the Fire Department, the Board of Health, electoral performances by Tammany leaders, immigration, voting fraud, and drunken violence by Irish New Yorkers. Tweed appears twice, once in his "Americus" fire brigade uniform and once as a candidate atop a campaign stump. The rampant corruption of the city's electoral process is variously shown, from the policemen who keep a gentleman from voting by using their billy clubs, to the Irish thug who oversees the "ballot-box stuffers brigade." Through these images, Nast demonstrated to his readers exactly the issues they ought to be concerned about.

By August, with the gubernatorial election looming, Jones and Jennings of the *New York Times* saw the potential power of a combination of editorials and cartoons. The effort would have two goals: to harm Tammany and

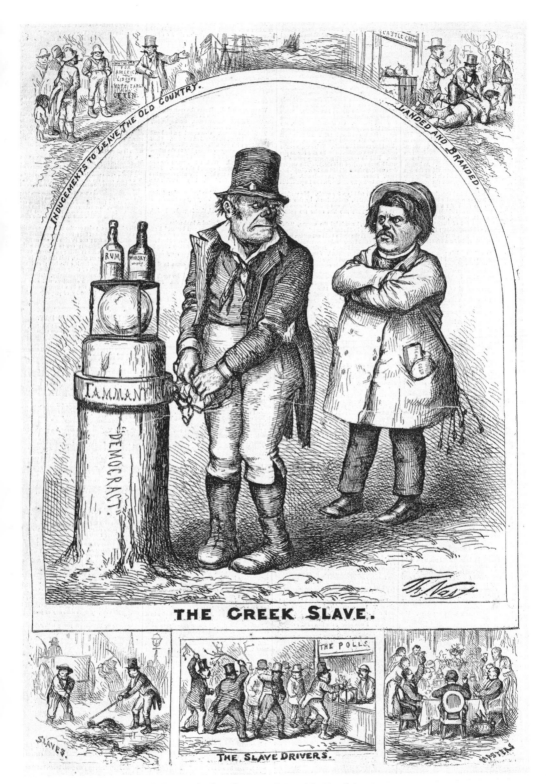

"*The Greek Slave*," Harper's Weekly, *April 16, 1870.*

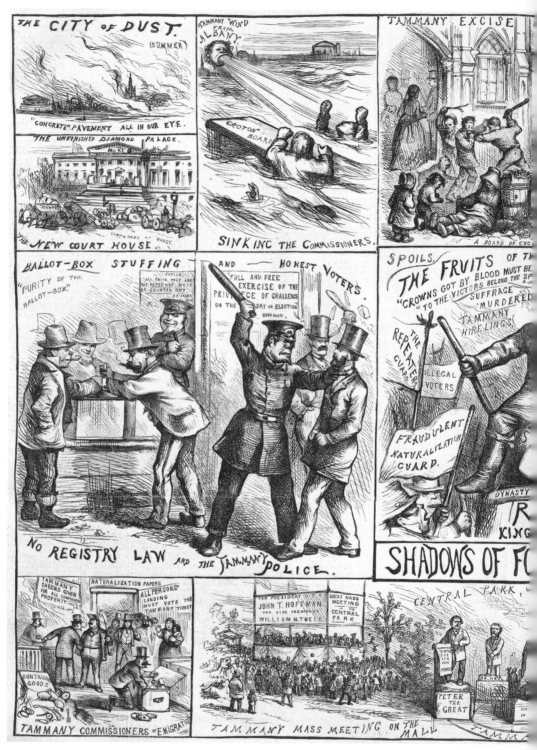

"Shadows of Forthcoming Events," Harper's Weekly, *January 22, 1870.*

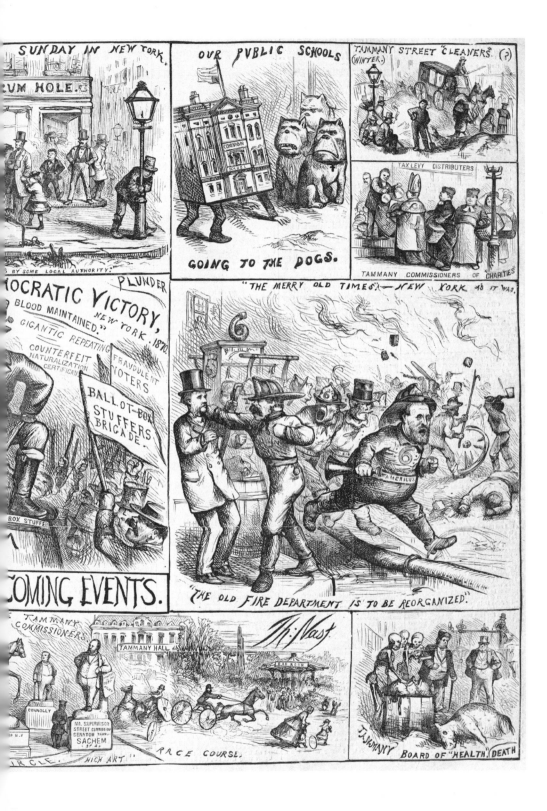

SUNDAY IN NEW YORK.

RUM HOLE.

BY SOME LOCAL AUTHORITY.

OUR PUBLIC SCHOOLS

COMMON SCHOOL

GOING TO THE DOGS.

TAMMANY STREET "CLEANERS." (?) (WINTER.)

TAX LEVY DISTRIBUTERS

TAMMANY COMMISSIONERS OF "CHARITIES"

DEMOCRATIC VICTORY, NEW YORK, 1870.

PLUNDER

"BLOOD MAINTAINED."

GIGANTIC REPEATING

COUNTERFEIT NATURALIZATION CERTIFICATE

FRAUDULENT VOTERS

BALLOT-BOX STUFFERS BRIGADE.

BOX STUFFER

COMING EVENTS.

"THE MERRY OLD TIMES" — NEW YORK AS IT WAS.

AMERICUS

"THE OLD FIRE DEPARTMENT IS TO BE REORGANIZED."

Th: Nast

TAMMANY COMMISSIONERS

TAMMANY HALL

CONNOLLY

MR. SUPERVISOR STREET COMMISSIONER SENATOR TAMMANY SACHEM

RACE COURSE.

CIRCLE. "HIGH ART"

TAMMANY BOARD OF "HEALTH" DEATH

Tweed in any way possible and to support the Republican candidate for governor and any Republican city candidates. Fletcher Harper agreed that *Harper's Weekly* would participate, and Nast was only too ready to attack the man who represented the Irish vote in New York and whose activities violated all of Nast's political ideals. George William Curtis, whose writing would establish the *Weekly*'s position, was a staunch Republican and famously reform-minded. Grant's appointee to the federal Civil Service Reform Commission, Curtis opposed political machines wholeheartedly. His support was never in doubt.

In September, the *Times* began its campaign with an editorial attacking Tweed's wealth. "Most of us," it read, "have to work very hard for a subsistence." Tweed, on the other hand, could teach young men how to become millionaires ten times over in only a few years. The secret, the *Times* asserted, was "the monstrous abuses of [public] funds, corrupt bargains with railroad sharpers, [and] outrageous plots to swindle the general community." As yet there was no proof of Tweed's wrongdoing, so the editorial was purposely vague.[22]

For some New Yorkers, no proof was required. Writer Ethel "Effie" Parton, who as a child often played with her little cousin Julia Nast, recalled a walk with her grandmother, Fanny Fern. The little girl noticed a particularly grand home and asked her grandmother who lived there. "A thief," she said. The occupant was Peter Sweeny, and to a journalist like Fanny Fern, he was undoubtedly corrupt. She, like many New Yorkers, abhorred the corruption of Tammany Hall, and passed on to her granddaughter the sense that there was little difference between outright theft and political graft.[23]

The *Times* continued to attack the Ring, and Nast's pencil assisted. But as long as there was no evidence against the Ring, the *Times* and *Harper's Weekly* stood alone. Evidence was on its way, through an unexpected channel. A disaffected Democrat, Jimmy O'Brien, held copies of the city government's secret books. O'Brien tried to blackmail the Ring with his evidence but failed. Thus, while the *New York Sun* and *Evening Post* were attacking the *Times* for its campaign—arguing that Jennings and Jones were ruining the *Times* with their unproven claims—O'Brien was deciding what to do with the proof the reformers needed.

The pressure on Jones and Jennings was expressed in print and rumor.[24] Against *Harper's Weekly*, Tammany employed stronger measures. The Harpers published the textbooks for New York city schools, and had done so for many years. In early 1871, the Board of Education announced that it would cancel its contracts with Harper and Brothers, so the company had

to decide whether the crusade was worth any price. As always, Fletcher Harper was Nast's champion. He convinced his brothers that Nast should be allowed to continue. The question was not, he argued, whether the fight was worth this or that price. Instead, they should ask, What is the price of capitulation?[25]

George William Curtis's position at this point is unclear. Voting, to Curtis, was a sacred duty, and public service was the utmost contribution to civic life. Only intellectualism appealed to Curtis more, and men who combined scholarship with high-minded politics were ideal. Curtis had once hoped to be such a man, but his nomination for Congress failed to attract party support and his bid for state office failed at the ballot box.[26] Instead, he used *Harper's Weekly* to express his passion for government and to influence public opinion.

Curtis was already famous for his support of the Radical Republicans, especially Senator Charles Sumner. Like the senator, Curtis believed in government as a force for good, both socially and morally. He despised corruption, at any level. As did the Revolutionary generation, Curtis believed that honest, educated men, Christian men with pure hearts were the natural leaders of American politics. Tweed violated all of Curtis's most deeply held convictions about leadership.

Chroniclers of Curtis's politics have been oddly silent with regard to the Tweed Ring, and Curtis's letters are equally quiet. In his 1895 biography of Curtis, Edward Cary failed to even mention the Tweed Ring. The closest he came to a reference was his complaint that in New York (both the city and the state) both Republicans and Democrats could be corrupt. In some cases, corrupt activities crossed party lines, as with the "Tammany-Republicans." However, Cary offers this information only to preface his discussion of Roscoe Conkling's political attack on Curtis at the Republican state convention of 1870.[27] Robert Kennedy, examining Curtis's political philosophy, also ignores the Tweed Ring, discussing Curtis's inability to achieve high office in New York or national office, then jumping directly to Curtis's activities on behalf of civil service reform.[28]

Curtis's view of the crusade appears in his private and published responses to Nast's cartoons. The published comments must, of course, be considered in light of his role as editor. They served to celebrate the magazine as well as the cartoonist. Curtis's private praise of Nast, however, indicates his approval of the campaign. Consistent with his lifelong support of reform, Curtis congratulated Nast for "Who Stole the People's Money?" "You have never done anything more trenchantly witty," he wrote

in a friendly note. "My wife and I laughed continuously over them. They are prodigiously good." In an editorial in *Harper's*, Curtis recalled Nast's work admiringly. The Ring cartoons, he wrote, showed that Nast was "less a humorist than a moralist." They were "so true that they [were] terrible." The most famous reaction from Tweed—so often quoted it became the title of a widely read book about Nast—was "Let's stop them damned pictures . . . I don't care so much what the papers write about me—my constituents can't read—but damned they can see pictures." This statement is probably a distortion of a private comment, but it captured Tammany's frustration. Much more likely was a reported complaint by Tweed that the more Nast showed him in prison garb, the easier it would become for New Yorkers to imagine him imprisoned. Quoting the Boss (though editing it for language—Curtis printed "But they have eyes, and they can see as well as other folks."), Curtis pointed out that Irish voters, so often treated with disdain in the pages of the *Weekly*, proved Tweed right. Once they saw his corruption in Nast's cartoons, they "desert[ed] the criminal." Nothing written in *Harper's* or the *Times* could compete with Nast's pictures for their impact. It was "the terrible laugh of Nast" that killed the Ring.[29]

Nast and Curtis worked together for more than twenty years. It is one of the great ironies of their story that in biographies of Nast, the Tweed campaign is a central theme while biographies of Curtis have largely ignored it. Fortunately for history, Nast's cartoons provide a window into Curtis's views. By the summer of 1871, responding to the threat against Harper and Brothers, Nast unleashed a storm of vituperative images.[30]

In early July, bookkeeper Matthew O'Rourke offered the *New York Times* evidence of mismanagement from the Comptroller's Office. The fraud involved tens of thousands of dollars. The *Times* printed the story on July 8. From there, the Ring began to unravel—slowly at first, then with increasing speed. Rioting on July 12 between Irish Protestants and Catholics revealed Tammany's inability to police the city effectively. The governor, elected through Tammany support, and the members of the Ring faced bitter criticism from both Republicans and Democrats. For Republicans, it was yet another example of the dangers of Irish immigrants. This time, unlike in 1863, Tweed and his deputies were the problem, not the solution (as during the Draft Riots). For Democrats, especially Irishmen, the riots exposed the limits of Tammany's support.

For Nast, the riots were a confirmation of all his worst fears and a literal bloodletting. In 1866, Nast had joined New York's most famous Civil War regiment, the Seventh. He was a longtime supporter of the regiment, having

painted an oil portrait of its march out of New York on April 19, 1861. Ten years later, Nast marched as a reservist with the Seventh as it confronted the rioters. He watched as a woman and a girl were shot dead. The experience recalled his fear during the Draft Riots, reinforced his dim view of the Irish, and showed him—along with many other appalled New Yorkers—that the Tammany regime could not keep the streets safe.[31]

On July 18, Jimmy O'Brien finally made up his mind. In the wake of the riots, and with the *Times* crusade still going strong, he delivered his evidence. O'Brien's materials would be even more damning than O'Rourke's. They revealed that rather than tens of thousands of dollars, Tweed and his cronies had stolen millions from the people. As the evidence arrived on Jennings's desk, Nast was working like a demon. O'Brien's evidence, showing accounting irregularities, was relatively complex. It is unlikely that Nast carefully examined the financial evidence himself. He hardly needed to. Nast's work attacked machine politics in general, not its specifics. Though once the evidence surfaced, removing the possibility that Tweed and his cronies were innocent, Nast was free to draw more viciously.

Over the next four months Nast produced some of his most famous work. New Yorkers pored over every drawing. The emerging evidence of massive corruption by Tweed and the Ring, printed in the *New York Times*, competed for attention with Nast's more visceral evocations of the dangers of Tammany Hall in *Harper's Weekly*. Jones and Jennings explained Tammany Hall's exploits with factual detail, with numbers; Nast emphasized the hypocrisy, greed, and gluttony. Like his Civil War illustrations, these drawings relied on Nast's ability to stir emotion. He focused his work on Tweed's great bulk, his sneer, and the bullying tactics employed by the Ring.[32]

For Nast, what had been a campaign for reform became a campaign against the abuse of public trust. Nast's commitment to the ideals of the American Dream was intense. Throughout his career, he championed suffrage as both a right and a responsibility. Those who abused the ballot box were always fair game, and Nast loved to attack any politician for hypocrisy, self-involvement, or demagoguery. When Nast died, *Harper's Weekly* described him as a "patriot" who "lived and worked and died a true lover of his country and a stalwart warrior in her behalf."[33] So Tweed, whose organizing skills had produced a political machine of massive proportions and unassailable power, was an ideal target. He took what ought to have been pure and admirable and made it dirty and embarrassing. Worse, he stole from the immigrants he claimed to serve and bought their continued sup-

port with charity drawn from his pilfering. Nast's own immigrant experience, his struggles with money in early life, and his distaste for the Irish combined to make Tweed a "political antichrist."[34]

More than simply an affront to Nast's personal ideals, however, the Tweed Ring represented everything about the Democratic Party that Nast loved to attack. Nast's Irish thugs symbolized his personal experience and his adherence to Republican ideology. Likewise, his attacks on Tweed followed closely the Republican line. Democratic politics, Republicans argued, was inherently corrupt. Democracy was the party of the immigrant, the party of theft from the public coffers, and the party of a variety of social ills: drink, violence, racial inequality, and political corruption.

It is worthwhile to pause for a moment to reflect on the quantity, as well as the quality, of Nast's work in 1870 and 1871. When his mind was truly engaged in a fight, he could be both tenacious and vicious. His productivity increased until he was working at a fever pitch. He submitted as many as seven drawings a week to the *Harper's Weekly* offices. He addressed the same issues again and again, attacking his targets from every angle so that no reader could miss his point. One example of this tendency is his repetition of Tweed's defiant stance. The question, "What are you going to do about it?" appeared in at least two drawings, and in a slightly altered form in another.[35]

Five of Nast's most famous cartoons from 1871 appeared between August and November. They represent a period of almost manic production on Nast's part. Because he was drawing at such a rate, his emotions inflaming his artistic drive, the composition of these drawings is substantially different from Nast's other work. They demonstrate how Nast's obsessive interest in the crusade helped him to refine his work.

The first two of these cartoons appeared in the August 19 edition of *Harper's Weekly*. The larger of the two, "Two Great Questions," was composed of two related illustrations. The top asked, "Who is Ingersoll's Co?," and the bottom, "Who Stole the People's Money?" In the top drawing, Tweed appears at the head of a crowd of corrupt Tammany Democrats. James Ingersoll, rendered at less than half Tweed's size, his arm outstretched toward Tweed, says to the *New York Tribune*'s Horace Greeley, "Allow me to introduce you to my Co?" In the lower image, "Who Stole the People's Money?," a group of men representing various companies stand in a circle, each man pointing to the one beside him. The words "Twas Him" at the bottom of the image indicate their passing the blame. As in the illus-

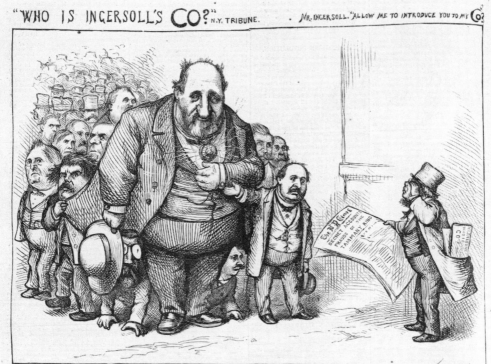

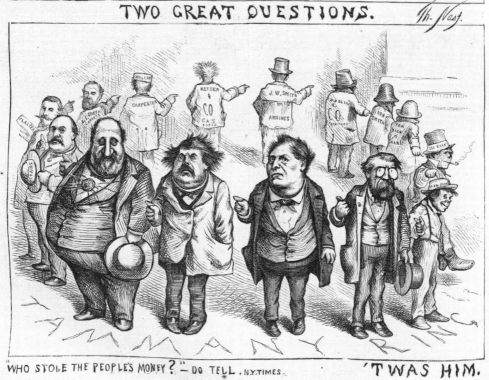

"Two Great Questions," Harper's Weekly, *August 19, 1871.*

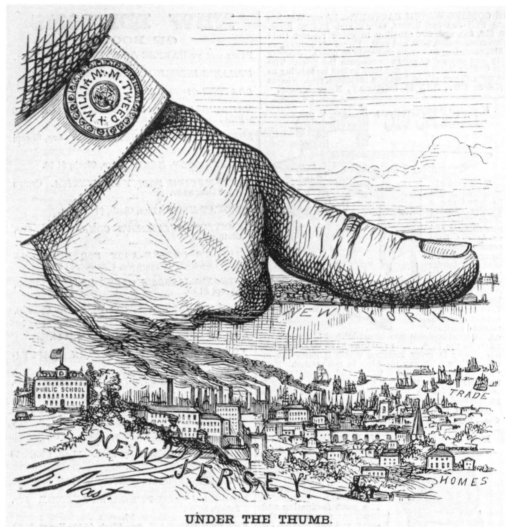

UNDER THE THUMB.

THE BOSS. "Well, what are you going to do about it?"

"Under the Thumb," Harper's Weekly, *June 10, 1871.*

tration above it, Tweed looms large, but unlike in the Ingersoll drawing, the three other Ring leaders share a prominent position.[36]

The other drawing in the August 19 issue was much smaller and printed toward the back of the magazine. Often devoted to more frivolous subjects, sometimes reinterpretations of subjects drawn better in a larger version, the small cartoons that often appeared at the back rarely garnered much attention. But two of the five famous Tweed cartoons were small drawings from the back. "Under the Thumb" presented a view of New York

from New Jersey. The tidy towns and proud public school of the foreground served as a contrasting backdrop to the island of Manhattan, flattened by Tweed's enormous thumb. It was the kind of simplistic graphic depiction Nast rarely produced. Instead of a complex human interplay, it presented a single idea. Rather than a caricature of Tweed, it was a symbol of him, but he is clearly identified by the name on the cufflink. The message would have been crystal clear, even to a reader with no political education: One man had too much power.

Tammany, and New York's Democrats, noticed of course. At the end of the month, the *Times* laughingly reprinted an attack on Nast that appeared in the pages of the *Irish People*: "Let Harpers grunt and groan away, Until they crack their pygmy throttles; Nast must care his thirsty throat, 'Tis that keeps him in empty bottles." "Mr. Nast must have as many lives as a cat if he survives that," the *Times* snickered. "We, too, pity him." Gleeful at the success of their provocations of Tammany and local Democrats, the *Times*, *Harper's*, and Nast moved forward.[37]

In September, the clarity and simplicity of the thumb drawing gave way to a more traditional Nast image. In "A Group of Vultures Waiting for the Storm to 'Blow Over.'—'Let Us *Prey*,'" Nast drew Ring heads on vultures' bodies. Tweed's body, naturally, is adorned with the flashy diamond tie pin that was his trademark. Perched on a cliff, the four leaders of the Ring look uncharacteristically worried. The bleached bones of their victims—"Law," "rent-payer," "New York City," "Liberty," and others—are no consolation as a wicked storm rages around them. Lightning has just struck the boulders behind them, which threaten to tumble down.

Mark Twain, fast becoming one of America's most popular satirists, joined Nast's fight in late September. Perhaps inspired by Nast's "The Economical Council," the author published a wry rewriting of the Westminster Catechism in the *New York Tribune*. Echoing Nast's play on the Ten Commandments as followed by the Tammany machine (for example, "Thou Shalt Steal" and "Thou Shalt Vote Often"), Twain mocked the apotheosis of money. "What is the chief end of man?" he asks. "To get rich" is the answer. "In what way?" "Dishonestly if we can; honestly if we must." The catechism addresses the major players in the Ring, suppliers engaged in fraudulent contracts on the city hall project, and the famous chairs and carpets that cost the city so much in graft. If, in years gone by, Americans honored founders like "Washington and Franklin," the catechism asserts, they should now emulate the Ring. With "The Revised Catechism," Twain joined what was becoming a chorus of opposition.[38]

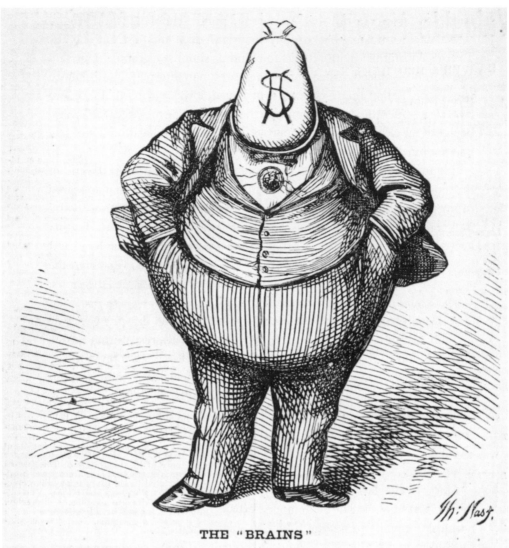

THE "BRAINS"

THAT ACHIEVED THE TAMMANY VICTORY AT THE ROCHESTER DEMOCRATIC CONVENTION.

"The 'Brains,'" Harper's Weekly, *October 21, 1871.*

That fall, New Yorkers turned increasingly to the *New York Times* for news of the mismanagement of city government. Nast responded with the fourth of his famous small drawings.[39] In "The 'Brains,'" Tweed stands alone, his fantastically bulging belly hanging over his legs, his diamond pin gleaming where his heart ought to be, and his head replaced by a bag of money. Instead of a heart, he had a gem; instead of a head, cold cash. In case the point lacked clarity, the title reinforced it. Any sense of moral

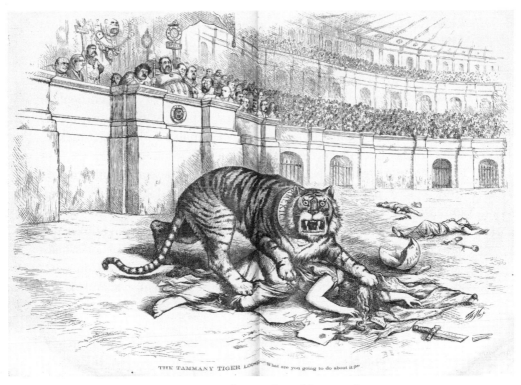

"The Tammany Tiger Loose," Harper's Weekly, *November 11, 1871.*

revulsion, or even of dismay, on the part of the reader would harden into anger at the subtitle: "Well, what are you going to do about it?" Here again was the oppressive thumb of August 19. Tweed was bloated on the people's money, and the question was, indeed, what they would do about it.

As the November elections approached, other cartoons kept up the heat, pressing Nast's central points about gluttony, avarice, and the use of power for personal gain. Finally, in the issue dated November 11 (but appearing on newsstands November 4, just before the election), Nast unleashed the most powerful of his images, "The Tammany Tiger Loose.—'What are you going to do about it?'" Spread across a double page, is a Roman coliseum. Seated in the audience on the left, Tweed and his Ring look out over the dead bodies of Mercury, labeled "Trade," and Justice, her scales laying beside her in the dust.[40] But in the center, where a reader's eye likely dwelled, Columbia lies prone. Her charter of Law has been torn; her republican crown has fallen to the dirt. Her sword, "Power," lies broken and out of reach. The rapacious, vicious, and unstoppable Tammany Tiger, its fangs bared and its claws outstretched, stands on her body, one hindpaw on her

knee, one forepaw on her head, the other poised to strike the fatal blow. "What Are You Going to do About It?" the Tiger roars. The menace of the Ring appears ready to spring off the page.

Nast rightly claimed credit for crystallizing the position of Tweed's critics with this image. The Ring threatened everything virtuous, efficient, or honest in the city. But Nast was not the first to portray the Tammany Tiger in this context. Joseph Keppler, too, drew Columbia and the tiger in combat. Did his work influence Nast?[41]

During the Civil War, Nast had been accused of passing off other artists' work as his own, notably by *Harper's* illustrator Alfred R. Waud.[42] Nast vigorously asserted that all his ideas were unique. He claimed that he rejected ideas, even good ideas, suggested to him. Joseph Keppler might have disagreed. In 1871 the future owner/artist of *Puck* was publishing a German-language version of *Puck* in St. Louis. His cartoon "Who Will Conquer?" appeared there on October 22. A Roman coliseum full of spectators is pictured, as is a classically dressed female figure, "Reform," fighting an enormous tiger, "Corruption."[43]

There are crucial differences between Nast's image and Keppler's in both style and content. Nast's coliseum is rendered more precisely, with greater detail. His drawing was oriented horizontally while Keppler's was vertically oriented. Tweed and his gang watch the action from the emperor's box, gloating. The most obvious difference, though, is in the artists' messages. Keppler left the outcome of the fight in doubt. His "Reform" stands, powerful, and determined. She pushes against the tiger's collar like an Amazon. The battle, Keppler suggests, is ongoing; reform can win. In Nast's image, the tiger has done its damage but it also engages the viewer with its glare, challenging him to do something about it, as was Nast.

The similarities, however, are striking. Could Nast have borrowed Keppler's idea? Nast did, indeed, borrow from other artists when it suited him. Whether or not he got the idea for the illustration from Keppler's, it seems likely that Nast was inspired by French painter Jean-Léon Gérôme's *Ave, Caesar, Imperator, morituri te salutant* portraying the aftermath of a gladiatorial battle. Gérôme's emperor presides over the event from his shaded box, just as Nast's Tweed does. The painting provided Nast a ready-made template, into which he had only to insert Tweed and his henchmen and Tammany's symbol. And using the work of academic painters pleased Nast. It connected his cartooning to his early training at the National Academy and nodded to his interest in European fine art. He used Gérôme in other cartoons, too. Nast seems to have taken the position that creating cartoon

art from painting was entirely legitimate and even complimentary. But originality mattered to Nast. In his long struggle for editorial freedom, Nast needed to prove that his ideas were his own.[44]

The best evidence that Nast drew his cartoon independently of Keppler's is the timing. If Nast did copy Keppler's idea, he would have had to obtain *Puck*—all the way from St. Louis—draw the cartoon, and submit it to *Harper's Weekly* for engraving in a very short period of time. The October 22 issue of *Puck* likely appeared on newsstands on October 15, so copies *might* have reached New York by the end of the month. However, given the time required for engravers to translate a drawing onto printing blocks, Nast would have had to have submitted his drawing around November 1 at the latest. It is difficult to imagine how Nast could have copied Keppler within this time frame.

Nast's biographer, for his part, defended his subject against critics. Nast's "mastery of line and color value was then, and remains today, a matter of discussion" among his peers, Paine wrote. But these talents mattered little, compared to Nast's "originality of idea . . . absolute convictions . . . and splendid moral courage." As for "The Tammany Tiger Loose," Paine observed, it was a masterpiece, copied by other cartoonists as would be "a new element or principle." This is a neat example of reversing the accusation; by asserting the perfect acceptability of other artists' borrowing from Nast, Paine ignored the accusations against the artist and simultaneously condoned the practice of cartoonists stealing ideas from one another. As with so much else in Paine's book, answers to Nast's critics appeared in the guise of hints and defensive denials. Given Nast's history with Waud and his obvious use of paintings for inspiration, it is impossible to dismiss the idea that he copied Keppler. So little documentary evidence of Nast's work process survives that we cannot know for sure exactly where he got his inspiration.[45]

The effect of "The Tammany Tiger Loose" lay not only in its size and visual force but also in an accident of fate. On October 8, 1871, due in part to the combination of drought and prairie winds, the city of Chicago caught fire. By Tuesday, October 10, smoking ruins stretched along the length of the lake. New Yorkers, intimately aware of the danger of fire in any city, clamored for news, and *Harper's Weekly* provided it. The October 28 edition illustrated the fire in glorious detail. On the cover, refugees were pictured huddled in the street in their nightclothes, while inside pages showed the burning Chamber of Commerce and opera house and Chicagoans rushing over the Randolph Street bridge. Titles of illustrations included "Chicago in

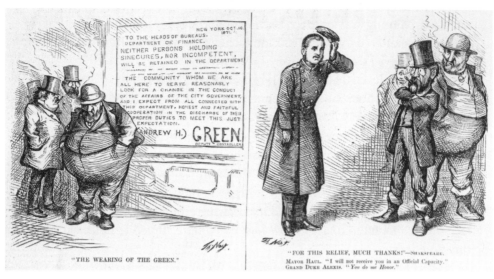

"For this Relief, Much Thanks!," Harper's Weekly, *November 11, 1871.*

Ashes," "Chicago in Ruins," and "Chicago in Flames." Only one small Nast cartoon and an editorial reminded readers that the anti-Tweed campaign still raged in New York.[46]

On November 4, the paper continued to focus on Chicago, but two Nast drawings appeared. Only one, a small sketch of Tweed driving a donkey cart, directly attacked the Ring.[47] Because of interest in the Chicago fire, circulation spiked. The paper reported selling 135,000 copies of its October 21 issue. Two weeks later, that number had more than doubled, to 275,000. As a result, when the November 11 *Harper's Weekly* appeared, Nast enjoyed an even bigger audience than usual. Thus the six Nast cartoons attacking the Ring struck with even greater force. The first, and largest, was "The Tammany Tiger Loose." On subsequent pages, though, readers found Tweed manipulating the ballot box, gorging on spoils, pretending innocence, and exemplifying corruption so intense that the visiting Grand Duke Alexis of Russia thanks "Mayor Haul" for refusing to receive him.[48] Clearly, during the two-week break, Nast's work piled up, ready for the resumption of hostilities with Tammany Hall. The *Weekly* published his drawings one after the other, sending a volley of bullets at the Ring as the election loomed.

By the election, though, the momentum against the Ring had reached avalanche strength. Jimmy O'Brien delivered his incriminating papers to *Times* editor Jennings in late July. At a mass meeting in Cooper Union in early September, men like John Jacob Astor, prominent businessman and

previously the chairman of the "whitewash committee," an attempt by Connolly to establish the veracity of the city's books, and the German Forty-eighter Oswald Ottendorfer shared the stage with George Jones. They railed against the Ring. On September 6, a committee of citizens began to examine the city's finances. In early October, the Booth Committee issued its report, finding that Tweed and his companions had stolen millions upon millions of dollars. Judge Wilton J. Learned signed an arrest warrant for Tweed on October 26. Finally, the election came, and the Ring's power shattered.[49]

Tweed was not imprisoned in 1871. He remained free until 1873, when a minor charge briefly caused his arrest. It took until December 1873 for Tweed to actually be declared guilty of a crime. Even then, his imprisonment was temporary. He fled New York in 1875, making it all the way to Spain before he was caught. Promised clemency in exchange for full disclosure, his health failing, Tweed agreed in late 1877 to lay bare the secrets of the Ring. His prosecutors lied. They never released the Boss. By then, he was a sick old man, and he died in prison on April 12, 1878.[50]

The Ring may have died, but political corruption had not. Nast's triumph over Tweed helped to ensure greater oversight over city finances for a time, but Tammany recovered. By the end of the century, political reformers modeled on George William Curtis were hammering away at the resurgent Democratic machine. Indeed, the bridge between the Mugwumps of the 1880s and the Progressives of the 1900s was built in part by opposition to Tammany Hall. With the power of the visual, Nast's cartoons helped make that possible. A single artist, fired by indignation and free to express his opinions in the face of opposition, threat, and bribery, could shift the allegiances of voters. Even voters whose loyalties had been considered safe for Democrats could be moved. Nast pointed to the crusade as an example of what cartooning could do for a candidate, party, or cause. More, he took his place among reformers, secure with credentials that could not be bested.

CHAPTER SEVEN

The Campaign of 1872

The fall of Boss Tweed firmly established Nast's reputation. But the Tweed campaign represented only the beginning of a period of intense work and growing fame. Between 1871 and 1873 Nast demonstrated the power of his pencil beyond any doubt. In fact, while the cartoons of the fall of 1871 remain his most famous, Nast's work in 1872 was more plentiful, more pointed, and much more focused on national politics. He became, in 1872, the most famous political cartoonist in America.

Nast's success in 1871 had a variety of consequences, not all of them anticipated. To the power of his cartoons was added the power of public adulation. Nast's personality helped. Simultaneously proud and humble, Nast's character offered much for the public to enjoy. Even his enemies found Nast occasionally charming. Tweed himself, obviously no fan, met Nast one day in Central Park. When Nast tipped his hat with a smile, Tweed "returned the salutation."[1] It was these qualities—the sunny optimism and love of fun—that balanced Nast's passionate convictions. But Nast's ascent to fame occurred during a uniquely fraught moment in national, and Republican, politics. So while Nast enjoyed his newfound fame, his pencil never stopped. Instead, in 1872 Nast built on the foundation of the Tweed campaign an unassailable reputation for political cartooning.

On March 23, a small Nast drawing portrayed New York caught between the "Tammany Ring" frying pan and the "Erie R.R. Ring" fire. This little image made two points about Nast's career at this moment. First, it indicated that his engagement with the Tweed scandal was not over. References to Tweed and the Ring continued throughout the year, as Nast promoted the prosecution of Ring members and linked Horace Greeley, *New York Tribune* editor and Liberal Republican presidential nominee, to them. Second, it predicted Nast's future. Nast leapt from the Tweed campaign straight into the flames of national politics. So 1872 proved even hotter than the previous year. It was not so much New York as Nast himself that fell out of the frying pan and into the fire of party and presidential blood sport.[2]

The 1872 Presidential Campaign

As Nast surveyed the effects of his new celebrity, and asked how he might use it, the looming campaign for president seemed an obvious target for his pencil. Nast's access to his hero, Grant, the Senate, and Washington's social scene promised a wealth of new ideas. Indeed, Washington teemed with hot button issues, and the coming presidential campaign promised to be fierce.

Its ferocity lay partly in a split among Republicans. A group of leading Republican senators, editors, and other prominent men had begun in 1870 to talk about their discontent with the Grant administration, which they viewed as corrupt. They feared that Congress, in pursuing the goals of Reconstruction, had expanded the power of the federal government and the president too far. They wanted to see a return to what they considered the basic principles of the Republican Party. This group, led by Carl Schurz of Missouri, received enthusiastic support and publicity from a variety of newspapers. The editors of those papers became powerful forces within what was called the Liberal Republican movement. Charles Sumner, who was famous for his staunch opposition to slavery and a powerful force in both the Senate and the Republican Party, shared some of the Liberals' ideas. He opposed President Grant's policies and abhorred what he saw as corruption. It would be a great coup for Schurz if he could attract Sumner to the ranks of the Liberals.[3]

Nast considered the Liberals a joke. He defended Grant by mocking the Liberals and twisting their ideas. Grant's advocates applauded Nast's work, but not everyone loved it. George William Curtis, always a proponent of "unity of sentiment" and moderation in politics (at least within the Republican Party), found Nast's aggression distasteful. He wanted Nast to draw cartoons that reinforced Curtis's reasoned, thoughtful editorials. But Nast drew what he liked. Worse, in Curtis's view, was the way Nast attacked public men. The disagreements between editor and cartoonist—largely about strategy up to this point—developed, that winter, into open conflict. The source of the break lay partly in Nast's portrayal of Charles Sumner.[4]

Sumner was an American hero. Caned in the Senate for his outspoken antislavery sentiments, a leader of the Radical Republicans, Sumner devoted his life to public service. For Curtis, Sumner represented not only the citizens of Massachusetts but also the needs of enslaved black Americans and the suffering of the freedpeople. He led the Senate in its fight against Andrew Johnson, and demonstrated the immense authority to be gained from the combination of a powerful intellect and an unstinting work ethic.

Curtis not only admired Sumner but also socialized with him in Washington. Upon Sumner's death, Curtis eulogized him as "A son so beloved, a servant so faithful, a friend so true."[5]

Curtis complained that Nast's cartoons made his life difficult. Scheduled to dine with the senator, Curtis asked the Harpers, "How can I eat his bread, knowing that the paper with which I am identified holds him up to public contempt?" The editor objected to Nast's caricatures of Sumner on strategic grounds as well. Two weeks later, he wrote from Washington that Nast should not attack "those with whom we must finally cooperate." The enemy, Curtis insisted, was the "Ku Klux Klan Democracy," not Republicans who differed with the president on specific policies. Moreover, because cartoons were "so much more powerful and unmanageable than writing," Nast should hesitate before using them to harm members of the better party. Curtis seems to have expected Nast to take his advice. He was to be disappointed.[6]

Nast considered Sumner both admirable and problematic. More importantly, though, he refused Curtis's view that his cartoons should only attack Democrats. On January 28, while visiting Washington to observe the political scene for himself, Nast "faced the lion in his den." Curtis kept silent about "'making fun of his friends,'" Nast wrote to his wife, "and so I did not say anything either. I did not care what he said, as I am here to see myself as *things* are, or at least as I see them."[7] In a letter several months later, Nast told the writer and political power broker Norton Parker Chipman that Curtis had again been "remonstrating . . . at *Harper's* on behalf of his *personal friends*." Each time Curtis complained, according to Nast, his pleas met with a dustier response.[8]

What Nast observed in Washington convinced him that the president's opponents deserved mockery. In the February 3 issue of *Harper's*, Nast again attacked Sumner, Schurz, and their congressional allies. He mocked the response to Grant's message on civil service reform by portraying Sumner (and other senators) as children balking at taking their medicine. They "cry for it," the caption reads, but in the end it is not "a savory broth to Senators long accustomed to arbitrary appointment for services rendered."[9] Here, as he would be in later cartoons, Sumner is pictured with a well-padded midsection, a mane of thick, wavy hair, and an air of dissatisfaction. In other images, Nast emphasized his view of Sumner's personality by showing the older man with his nose pushed up into the air. All suggested a man who believed in his own genius and relied on his power and reputation but utterly lacked humility.[10]

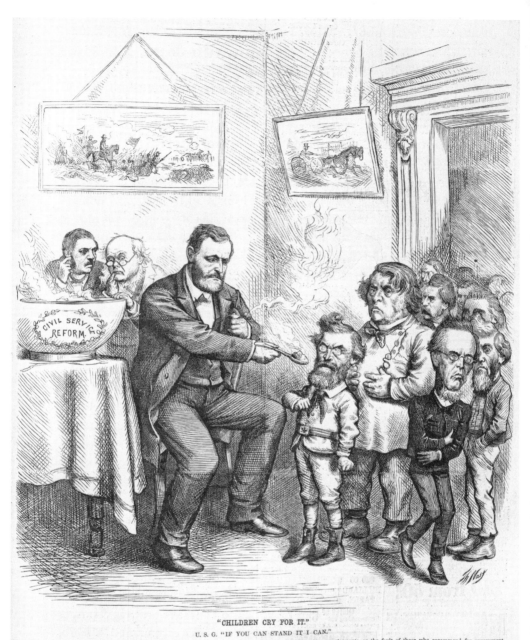

"CHILDREN CRY FOR IT."

U. S. G. "IF YOU CAN STAND IT I CAN."

"If bad men have secured places, it has been the fault of the system established by law and custom for making appointments, or the fault of those who recommend for government positions persons not sufficiently well known to them personally, or who give letters indorsing the character of office-seekers without a proper sense of the grave responsibility which such a course devolves upon them. A civil service reform which can correct this abuse is much desired."—GRANT'S MESSAGE.

"Children Cry for It," Harper's Weekly, *February 2, 1872.*

For all his insight, Nast hardly needed to invent negative characteristics for Sumner. The senator's admirable qualities like persistence, honor, and courage battled with his unfortunate arrogance. J. B. Pond, a young man in the 1850s and later an employee of the Redpath Lyceum Bureau, recounted a story about his brush with the senator from Massachusetts that echoed Nast's view of Sumner.

Pond's father idolized Sumner, calling him "the Honorable Charles Sumner" even in casual conversation. Once, when Sumner was to give a lecture near Pond's family home in Wisconsin, the elder Pond insisted that he and his son go see the great man. Pond, just back from the slavery conflict in Kansas, agreed. He and his father walked nine miles to hear Sumner and sat in the front row. Afterward, the senior Pond hoped to shake Sumner's hand, but the senator slipped out the back of the theater before they could ascend the stage. The next day, Sumner was to travel by train to Milwaukee for another engagement, and Mr. Pond persuaded his son to board the train and seek out Mr. Sumner. Approaching Sumner in the parlor car, where he was reading, Mr. Pond said, "The Honorable Charles Sumner? I have read all your speeches. I feel that it is the duty of every American to take you by the hand. This is my son. He has just returned from the Kansas conflict." Sumner looked past his admirers, seeking the porter. Finding the man, he said, "Can you get me a place where I will be undisturbed?" According to the younger Pond, his father's "heart was almost broken." In the remaining twenty-five years, he never again mentioned the "honorable" Charles Sumner.[11]

There is no direct evidence that Thomas Nast encountered this aspect of Sumner's character. But Nast visited Washington in 1872 and corresponded with Sumner about the copyright hearings in the Senate.[12] While in Washington, Nast dined with President Grant, visited the Senate, and socialized widely. He enjoyed the ebb and flow of gossip. "From the President down," he wrote to Sallie, "they all have their little stories to tell, their little troubles to pour out to me."[13] Doubtless, some of the gossip centered around Senator Sumner's opposition to Grant.

Nast also recounted to Sallie President Grant's complaints. Curtis and his friends, including Senator Sumner, opposed Grant and were planning to try to block his nomination, the president said. He found it offensive that they tried to direct his decisions, but when he refused to "do just as they say" they "get mad and kick him more than they ever did any other President before."[14] Nast believed in Grant's simplicity of spirit. He was a

soldier, a hero, and not a puppet to be ordered about. "Children Cry for It" reflected Nast's position and rejected Curtis's request for restraint.

Nast was still in Washington when the February 3 edition of *Harper's Weekly* appeared. Feeling betrayed, Curtis fired off a letter to Nast complaining bitterly that Nast's work harmed civil service reform, the Republican Party, *Harper's Weekly*, and—not least—Curtis's social life. "I am confounded and chagrined," he began, that "Children Cry for It" ridiculed "my personal friends and those whom I asked you especially to spare." His editorials were moderate, Curtis argued. Nast's cartoons were extreme. So in a delicate political dispute, cartoons hurt more than they helped. If only Nast would conform to Curtis's "unity of sentiment," all would be well. From Nast's perspective, anyone who fought the president deserved the sharp end of his pencil. Curtis replied that he supported the president "sincerely," but "I respect the equal sincerity of my friends who differ." He offered the same regard to Nast. It was the cartoonist's "want of regard for my friendship" that so "sorely touched" Curtis. He knew better than Nast, he insisted, the "mischief" cartoons could create.[15]

Curtis had a point. He insisted that men like Sumner and Schurz were allies, not enemies. They "have really supported the [civil service reform] movement," he argued. He knew them well, and he was convinced that "they mean what they say." Curtis saw the matter as a conflict over policy. Grant espoused one set of ideas, Sumner and his friends another. The back and forth of politics required this dialog, and nothing about it was unusual. Nast's admiration for Grant had no place in that kind of negotiation. But reasonable commentary, of the type Curtis provided, could help to illuminate the relevant issues and clarify the negotiations. Nast's cartoons only muddied those waters by offending the very men Grant needed to court. But Nast and Curtis were looking in different directions. Nast cared much less about civil service reform than about the political fortunes of the president. So the nomination occupied his attentions, and the nomination looked complicated.[16]

Opposition to Grant's renomination posed the central problem for Curtis, too. If he supported the president, he would have to oppose senators he might need for his Civil Service Commission. Nast was eager to do battle on Grant's behalf. Curtis had not yet made up his mind. During the same month that Nast and Curtis exchanged testy missives about Nast's cartoons attacking Sumner, Curtis wrote several fence-straddling editorials on the subject of the presidential nomination. In late January, for instance,

Curtis argued at length that Schurz's opposition to Grant did not necessarily make him disloyal to the Republicans or an ally of the Democrats:

> If, therefore, the President should be renominated, and Senator Schurz should actively oppose his re-election, his attitude would be really that of Wendell Phillips in 1864, who showed why Mr. Lincoln ought not to be re-elected, while no one could suspect Mr. Phillips of wishing the election of General M'Clellan. It is true that practically to speak against Mr. Lincoln was to speak for General M'Clellan. But no one supposed that the speaker sympathized with the rebellion of the slave-holding interest. So to speak against General Grant would be virtually to support his Democratic opponent. But if Mr. Schurz were the speaker, we, at least, should not suppose him to be the advocate of the Ku-Klux. His attitude, like that of Mr. Phillips, would be that of independent criticism, which would yet be in sympathy with the party whose success the criticism imperiled.[17]

Curtis's hesitation did not imply a failure to defend the president, nor did it lack limits. In the same article, he insisted that if Schurz meant to accuse President Grant of corruption, he should do so. If not, he should cease implying that Grant was corrupt. But as a whole, Curtis sought a middle way—to demonstrate respectful disagreement without attacking members of the Republican Party who chafed at the idea of another term for Grant.

None of Curtis's arguments convinced Nast; nor did they sway the Harpers back in New York. In a letter to Sallie, Nast said that Fletcher Harper Jr. even said that if Curtis was that much upset he "'may send in his resignation.'" The senior Harper echoed his son, saying that he preferred that the *Weekly* use its strength and that he thought the cartoonist was "oftener right than Curtis, and he would rather have [his] opinion on this question than Mr. Curtis's."[18] With both cartoonist and publisher firmly opposed to his calls for moderation, Curtis found himself in an awkward position.

Even more annoying than Nast's refusal to submit was the enthusiasm with which the cartoonist was welcomed by officials in Washington. At a dinner party on February 1 hosted by Colonel N. P. Chipman, then the congressional delegate from Washington, D.C., the host introduced Nast to a variety of important Washingtonians. Chipman invited "the great men" of Washington, Nast wrote to his wife, "and I can tell you they came with a vengeance." The vice president, secretary of war, and various generals were

among them. Also at Chipman's home were Supreme Court justices, senators, and "members of the press and in fact every body that could come." George William Curtis had originally declined his invitation but shocked everyone by appearing late. He came "to see who was here and he did not seem to like it very much," Nast commented acidly.[19] A few days later, Nast sat next to Secretary of State Hamilton Fish at a dinner. They talked so much that other guests joked it was a "'Nast-y-Fish' dinner."[20]

On a return visit to Washington in early March, Nast met Senator Schurz. That week, *Harper's* published Nast's drawing "Mephistopheles at Work for Destruction," in which Schurz, as the devil, presents Sumner with a tantalizing vision of America. The caricature mocks Sumner for his pomposity—he wears a medallion inscribed "Honor to Sumner"—and Schurz for his scheming while attacking both men for their attempts to tear down the president. Schurz, displeased to have been lampooned so relentlessly, insisted that Nast leave him alone. The cartoonist refused, of course, and added that his paper would not prevent him drawing whatever he liked. In that case, Schurz said, "I shall publicly chastise you!" Nast laughed.[21]

For Nast, the pressure brought to bear by Curtis, Schurz's threat, and the arrogant self-assurance of Sumner combined to forge in Nast a solid wall of opposition. Nast would defend the president, attack his enemies, and spare no one. That Sumner was a great man, honored by the nation for many accomplishments, did not matter to Nast. Nast's struggle against Curtis and his adoration for Grant provided him with a venomous sort of inspiration. And all this came at precisely the moment when he took the measure of his powers.

While Nast created images to ridicule the Liberals and support Grant, Curtis approached the crisis with long, reasoned editorials. An editorial of early February set the tone. The upcoming Cincinnati convention, Curtis insisted, posed a serious danger to the Republican Party. If Grant's critics sought to control the nomination process, and thus the platform, they could only do so by threatening to bolt. Bolting would weaken the party and allow the Democrats the chance to win the White House. Curtis offered measured language and respectful consideration of the ideas of the Liberals, writing that "no man . . . is bound to be a mere partisan, nor to surrender his independence, his principles, or his views of a just and wise national policy." But he also warned that those who called themselves "Liberals" risked the terrible "moral influence" that a "Republican defeat must be upon the national welfare."[22]

His frustration, though, showed clearly. "Politics are not a mere game,"

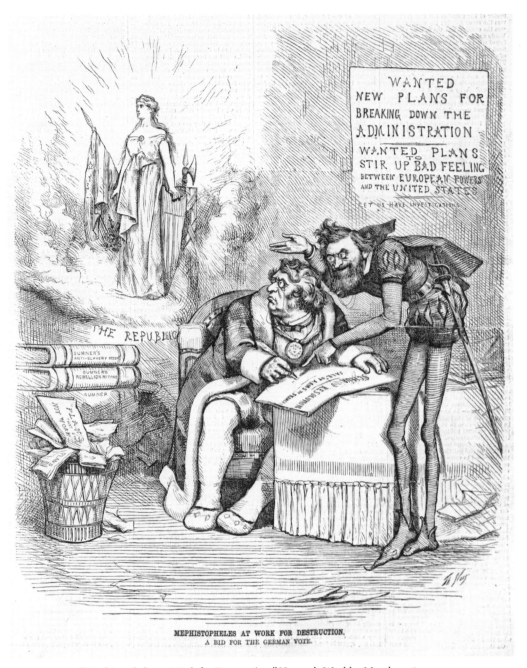

"Mephistopheles at Work for Destruction," Harper's Weekly, *March 9, 1872.*

he wrote in April, "in which one side having lost and the other won, there is a smiling adjustment of the board for a new turn." Instead, party politics sat firmly upon a foundation of principle. Each party had certain ideas about "the very nature of government and of human rights." The differences among Americans had not been healed by the Union victory or by the end of the war. Thus the choice of a presidential nominee, and of a party, was essentially a choice about bedrock values. Though Curtis retained his reasonable tone, he hinted at the danger in the Liberal movement. A large rally at New York's Cooper Union on April 12, at which Horace Greeley attacked Grant and reiterated his support for the Liberal movement, only confirmed Curtis's fears.[23]

Curtis had no particular loyalty to President Grant and, unlike Nast, felt that there was ample room for critique. But Curtis defended Grant based on the idea that presidential leadership and party politics worked together. The Republican Party's primary objective, Curtis asserted, should be to retain power in the House, Senate, and White House, and in order to accomplish this, the party had to remain unified. But those who objected to Grant, Curtis argued, abandoned party unity. They did so not because they opposed his policies, said Curtis, but because they "do not like President Grant." This was unacceptably personal. With the Liberals in mind, Curtis wrote teasingly, "As the country sees the unquestionably good results of General Grant's administration, yet hears that he is corrupt, ignorant, and weak, it replies with a smile that it is astonishing how well corruption, ignorance, and weakness administer the government!"[24]

In March, Nast's work appeared on every cover but the first. Four weeks in a row, he hammered at the Liberals and their critique of Grant. For his part, Curtis wrote that while rumor insisted "the Republicans who favor the renomination of the President are bitterly intolerant of those who do not," in fact the contest was more serious and more complex than that. He examined the rhetoric of the Liberals and urged both sides to be more moderate. Honor and caution, married to reason, would lead to a discourse worthier of statesmen, he thought. Nast poked a little fun at this idea on March 16 with "The 'Liberal' Conspirators (Who You All Know, Are Honorable Men)."[25] A week later, he reinforced the point in "A Few Washington Sketches," drawing the Liberals engaged in various outlandish activities. Above the caricature of Schurz, who is drawn with very long, skinny legs, is the comment: "There is only one step from the sublime to the ridiculous."[26]

April brought more covers featuring Nast cartoons, and a still more pointed critique of the Liberals. As their Cincinnati convention approached,

"A Few Washington Sketches," Harper's Weekly, *March 23, 1872.*

the question was whether they intended to try to influence the nomination outcome at the Republican convention in Philadelphia or to create an entirely separate nomination process. If the latter, they risked playing into the hands of the Democrats, weakening the Republican Party as a whole and making an opening for a Democratic candidate. Curtis noted this possibility—and his hope that Sumner would recognize and avoid the hazard. Nast dramatized the problem by showing the Liberals in dangerous seas. Aboard their small boat, the "Cincinnati Convention," the Liberals tossed about in roiling waters, perilously close to the Democratic rocks of "slavery," "KKK," and "Tammany Ring Corruption."[27]

Nast wrote to his friend Chipman in April to discuss the results of the campaign so far. His cartoons, he insisted, "are always in accordance with my sincere convictions but sometimes, I get too many abusive letters" to be sure that he was right. The solution was to "go back to first principles, and consider Grant is an honest man and is more competent to fill his position now, than he was four years ago." This view, that Grant's heroism and personal character suited him to be president even if he had to learn on the job, fit perfectly with Nast's personality-driven approach to politics. In the same vein, he dismissed his Republican targets' complaints: "Republicans are not used to being caricatured yet; . . . they consider themselves sacred." While it was all right to "hold the president up to public scorn," woe betide anyone who "dare say a word about them."[28]

At the beginning of May, the Liberals met in Cincinnati to debate the presidential nomination. In his opening remarks, Colonel William Grosvenor of Missouri asserted the virtue of those who attended. They were men who had "surrendered their share in a victorious party because of their convictions of duty."[29] The speakers who followed Grosvenor outlined a series of objections to the president, his policies, and his nomination that were rooted in principle. As did Curtis, they insisted, they felt deeply the power of party and the importance of loyalty to it. But they disagreed with him about the future of Reconstruction and the need to find accommodation with the South. They decried the corruption they saw in the Grant administration. Their platform called for various reforms of the civil service and tariffs, plus universal suffrage and amnesty for former Confederates.

Then came the work of choosing a nominee. Though the Liberals originally argued that they sought only to influence the Republican Party as a whole, by May it was clear that they would present an alternative slate. A leading candidate was B. Gratz Brown, former senator from and current governor of Missouri. David Davis, an associate justice of the Supreme

Court who would go on to become a senator, was also in the running. A third possibility was the Massachusetts patrician Charles Francis Adams. But in the end, after six ballots, it was Horace Greeley who, to everyone's surprise, won the nomination.[30]

Though Greeley's biographer has pointed out his "broad national appeal," there is no denying that his nomination met with shock and amusement in some quarters. Liberals, Curtis argued, "could have done nothing that seemed so much a jest as what it did." Greeley was "not a strong candidate" but "naturally timid and a compromiser." Worse, he was easily led but hard to deter from his "prejudices," which were "deep and strong." He was "destitute" of judgment and would be "wax in the hands of flatterers." Even Carl Schurz, the face of Liberalism to many Americans, found the Greeley nomination disappointing. Greeley was not the man Schurz had hoped for.[31] In short, whatever Greeley's appeal and however widely his ideas in the *Tribune* spread, his nomination elicited scorn in *Harper's* and elsewhere.[32] Greeley made a natural target for Nast's pencil.

Greeley first appeared in January. In "What I Know about Horace Greeley," Nast introduced what would become his stock phrase for the editor.[33] On the left side of the two-panel drawing, Greeley bails out Jefferson Davis, while on the right side he throws "Tammany Mud" at the president. The left side of the cartoon reminded readers of Greeley's public opposition to the confinement of former Confederate president Jefferson Davis at Fortress Monroe, Virginia. Greeley believed passionately in the rule of law and in the value of the Constitution. Citing those fundamental concerns, he called repeatedly for Davis's release and tried to assert his influence through back channels to help Davis. In May 1867, when a Richmond court set Davis's bail at $100,000, Greeley personally guaranteed 25 percent.[34]

Greeley's support for Davis and his civil rights won him few friends and a great deal of criticism. In a letter reproduced in the *New York Times*, reader J. Willson Jr. demanded an explanation for Greeley's actions. Greeley replied, "[I] would bail Davis, or you, or any other culprit that the Government would shamefully keep in jail more than a year, resisting and denying his just and legal demand that he be arraigned and tried, or let go." Such a vigorous defense failed to prevent serious damage to Greeley's reputation. He acknowledged as much when he insisted that many men offered to guarantee Davis's bail. His name and that of other northerners appeared primarily for political and public relations reasons. It was a necessary show of unity, he said. "They would not have required me to face this deluge of mud if they had not believed it necessary."[35] Nast played on the percep-

THE TRAITOR. THE PATRIOT.

WHAT I KNOW ABOUT HORACE GREELEY.

"What I Know about Horace Greeley," Harper's Weekly, *January 20, 1872.*

tion of Greeley as an ally of secessionists, a man whose loyalty could not be trusted.[36]

Nast continued to mock Greeley and the Liberals. In February, Greeley the editor appeared to offer Greeley the farmer, or "Cincinnatus," the presidential nomination of both Democratic and Republican parties. Senators Schurz and Reuben Fenton, of New York, looked on. In March, an awkward Greeley in his long, rumpled coat, joined Sumner, Schurz, and others in "The 'Liberal' Conspirators (Who You Know, Are Honorable Men)."[37]

Writing to Nast that month, N. P. Chipman complimented the cartoonist's style. Better still, Chipman reported that Grant enjoyed them, too. Chipman quoted the president, who said, "You are not only a genius but one of the greatest wits in the country." Chipman reported with pleasure the discomfort of Nast's enemies as well. "Did you see what Greeley said of you the other day?" Chipman asked. "He spoke of you as the 'blackguard of the paper, paid to defame.'" His amusement aside, Chipman understood that Nast's cartoons had real power. "It is a perilous thing to furnish ammunition to so dangerous a gunner as you are," he wrote later that spring.[38]

In the months to come, Nast returned again and again to certain themes in his treatment of Greeley. For example, Nast supplied a nearly endless

number of versions of a pamphlet, "What I Know about . . . ," often tucked in Greeley's coat pocket. The idea originated in Greeley's 1871 book *What I Know of Farming*. There, after admitting to a limited "practical knowledge of agriculture" and "a smattering [knowledge], if even that" of science, Greeley nevertheless laid out a long catalog of farming precepts based on his "invincible willingness to be made wiser" about the earth and its fruits.[39] This encapsulated Nast's overall critique: that Greeley never let a little ignorance get in the way of his desire to comment. So Nast used the "What I Know About" label repeatedly. "What H- G- Knows about Bailing" captioned a cartoon about the sinking ship of the Liberals; "What I Don't Know" appeared a week later; and "What I Know about Telling the Truth" appeared on a cover attacking the Liberals for their ingratitude to Grant.[40]

Nast's "What I Know About . . ." formulation appeared in another form that year. New York political operative Thurlow Weed borrowed the phrase for the title of his pamphlet, "'What I Know About' Horace Greeley's Secession, War and Diplomatic Record," published in 1872. The pamphlet, which took the form of a letter written to New York Republican political activist Thomas Acton, purported to be "a calm review of Mr. Greeley's teachings and movements preceding and during the Secession and Rebellion." It blamed Greeley for "the millions of treasure and the rivers of blood" lost in the Civil War. Quoting Greeley's columns in the *New York Tribune*, Weed offered a scathing attack on Greeley's presidential ambitions, cloaked in the mantle of history. The efficacy of the blow rested largely on Greeley's own words, but the nod to Nast's cartoons linked Weed to a longer, broader stream of anti-Greeley campaign materials that appeared in 1872. It demonstrated, too, that Nast's cartoons occupied central ground in the nomination and election battles. They worked cooperatively with editorials, letters, speeches, and appeals to the public—just as they had done during the Tweed campaign.[41]

The "What I Know" device worked so well it attracted imitators. In May, rival cartoonist C. S. Reinhart produced a drawing called "The Farmer Candidate En Route," in which Greeley rides a huge hog, "Pig Iron," to Cincinnati. In his pocket is a pamphlet titled "What I Don't Know." Nast used the device to suggest true superiority in other people. On May 11, for example, Grant appeared with a pocket pamphlet boasting, "What I Know About Telling the Truth." Doubtless that little touch struck Liberals as ironic, since part of their conflict with the president centered on Grant's dishonesty in office.[42]

In late spring, Nast's cartoons displayed another recurrent theme: the

Liberal willingness to do "Any Thing to Beat Grant." On May 4, *Harper's* published a complicated full-page image playing off a quote from *Othello*. Nast's main point was that as bad as Tammany corruption had been, its aim had been merely to steal from the people. Sumner, Schurz, and Greeley, he charged, intended to "filch" Columbia's good name. Tucked into this cartoon was the slogan: "1864 Anything to Beat Lincoln" paired with "1872 Anything to Beat Grant." A week later the device appeared again. In "A 'Liberal' Surrender—Any Thing to Beat Grant," the Liberals surrender a fort to the Democrats, turning their artillery on Grant.[43]

Political cartooning relies on a pointed combination of humor and gravity. Nast understood that combination well, and his cartoons in 1872 often demonstrated that his willingness to poke fun never erased the deadly seriousness of politics. On May 25, he drew Columbia despairing over the prospect of Horace Greeley as a presidential candidate. It was "Adding Insult to Injury," in Nast's formulation, and proof that the Liberals would do "Anything to Make Our Republic Look Ridiculous."[44] In August, the cry became "Any Thing to Get In" and "Any Thing to Get Chestnuts." The repetition of phrases Nast considered provocative echoed previous work. During his anti-Tweed campaign, for example, the question "What are you going to do about it?," the "it" being Tammany Hall's corruption, appeared again and again.

In June, once the Liberal nominee was selected, Nast and Curtis turned their attention to the Republican convention in Philadelphia. Greeley continued to figure in Nast's cartoons, of course; "Horrors Greeley" appeared in two drawings late in June. But Grant appeared as often. In the month's first issue, Columbia prepared for the coming election by painting the White House with the pro-Grant slogan "One Good Term Deserves Another." The next issue showed Grant admonishing Greeley to "Drop 'Em" as the nominee tried to steal the president's boots. Columbia appeared again on the next week's cover, this time rallying Union soldiers to fight for Grant.[45]

Grant won renomination at Philadelphia. But the real story in June was Charles Sumner. For months, Sumner flirted with the Liberals. He and Schurz argued against the renomination of President Grant, urged party members to look for other candidates, launched investigations into the administration, and otherwise sought to demonstrate the need for a change of direction in the executive leadership. But Sumner never really joined the Liberals. For Schurz, if Sumner had attended the Cincinnati convention, it would have been an affirmation—both of his ideas and of his position as a loyal Republican who simply could not accept Grant as the party's nomi-

ADDING INSULT TO INJURY.
Any thing to make our Republic look Ridiculous.

"Adding Insult to Injury," Harper's Weekly, *May 25, 1872.*

nee. But Sumner stayed away. As Curtis noted approvingly, "Mr. Sumner declared himself a Republican, and insisted that he could do nothing to help the Democrats into power."

Instead of going to Cincinnati, Sumner delivered a long attack on President Grant. Even Curtis, who had defended Sumner to Nast so vehemently, found the speech offensive. Sumner described the president, who "has given us peace and security," in the bleakest terms. Grant was "a monster of indolence, ignorance, lawlessness, and incapacity, whose influence is pernicious in the highest degree." Curtis found the speech particularly galling in its failure to "present accurately a single fact." Instead, Curtis charged, Sumner had transformed a personal antipathy to the president into a claim to the moral high ground. But the majority of Republicans recognized the Grant administration as a success, and they voted for the president. "Had there been any doubt of the renomination of the President before it was delivered," Curtis insisted, "there could have been none afterward." Sumner had ensured exactly the outcome he sought to prevent.[46]

In a full-page cartoon positioned six pages after Curtis's screed, Nast poked fun at Sumner's failure. Sumner, dressed in classical garb stretched tight across his rounded belly, pulls back the string of a longbow, aiming his arrow at Grant. The string breaks, because, as the caption reads, he has "Pulled the Long-Bow Once Too Often." On the next page, Uncle Sam shakes the president's hand as Columbia sweeps up broken arrows at their feet. Grant has been "Vindicated!"[47]

As June drew to a close, attention turned to the third convention in three months. In Baltimore on July 9 and 10, the Democrats finally met to choose their nominee. It must have seemed an auspicious moment, with the Republicans divided and men like Sumner the subject of editorial criticism and cartoon mockery in Republican papers like *Harper's Weekly*.

Two weeks before the Democratic convention, *Harper's* published a small Nast cartoon showing Horace Greeley as "The Connecting Link Between 'Honest Republicans' and 'Honest Democrats.'" In the next week's issue, "Chips from Chappaqua" quoted a series of Greeley's most anti-Democratic statements. The "Posy for the Baltimore Convention" began with Greeley's description of Democrats as men who "[choose] to live by pugilism or gambling or harlotry," moved on to Greeley's distillation of the Democratic "creed" as "love rum and hate niggers," and ended with Greeley's plea that the nation be spared from the horror of a Democratic Party that was "rebel at the core."[48]

Although Nast insisted on editorial independence, he was not above ac-

THE LAST SHOT OF THE HONORABLE SENATOR FROM MASSACHUSETTS.—HE PULLED THE LONG-BOW ONCE TOO OFTEN.

"The Last Shot of the Honorable Senator from Massachusetts,"
Harper's Weekly, *June 22, 1872.*

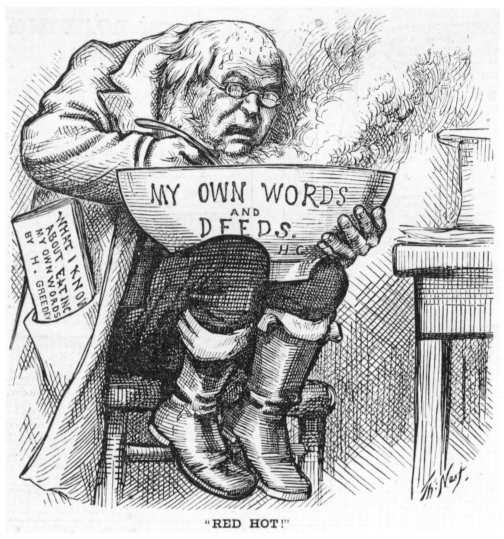

"RED HOT!"

"Red Hot!," Harper's Weekly, *July 13, 1872.*

cepting suggestions. Ben Perley Poore, of the *Boston Journal*, and Richard J. Hinton, a journalist in Washington, D.C., and a member of the congressional and national Republican committees, approached Nast with material regarding Horace Greeley. The two writers intended to use Greeley's public statements against his current political positions. They compiled a list of "choice extracts" from his attacks on the Democrats over the years. The document ran to almost 200 pages. Off to Nast it went in the mail, with a "request for a cartoon." Inspired, Nast replied with a drawing that showed a sweating Greeley drinking from a huge, steaming bowl of his statements

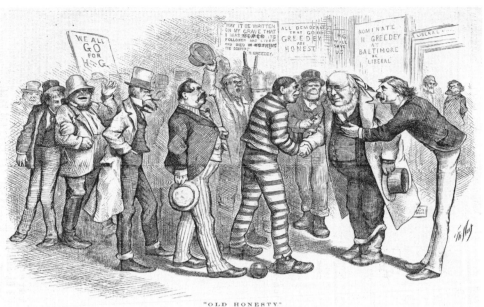

"*Old Honesty*," Harper's Weekly, July 20, 1872.

from the *Tribune*. "He was," J. B. Pond wrote, "thus made to sup sorrow of his own making."[49]

When the Democrats nominated Greeley, Nast dug deeper into the thick file of Greeley's anti-Democratic statements. On July 20, *Harper's* published "Old Honesty," in which Greeley is introduced to the Democratic Party as he had described it. Here were the "blacklegs, pugilists, keepers of dens, criminals, shoulder-hitters, rowdies, burglars, etc., etc.," — in short, "all the scum and dregs of the community." And Greeley was now their candidate for president. In his editorials, Curtis took a slightly different tack. Still sympathetic to the Liberals' critique, Curtis pointed out that Schurz's original intent was to find a candidate who would represent serious reform. Greeley was obviously not that man. Schurz knew it, and accepted the nomination, Curtis wrote, merely in order to "beat Grant anyhow, and hope for something better."[50]

With the nominations in place, Nast opened up with both barrels. In late July, "The Death-Bed Marriage" ridiculed the alliance between Democrats and Greeley and linked the ticket to the Ku Klux Klan, Roman Catholicism, and Tammany Hall. A week later Greeley starred in a cartoon that echoed "Compromise with the South." With Schurz and Sumner behind him, Greeley "Clasps Hands Over the Bloody Chasm." The same issue showed

Greeley and the Democrats trying to swallow one another in a futile circle. Eight pages after that, readers found Sumner terrifying women and children by crying, "Here Comes Nepotism!" as U. S. Grant rounds a corner.[51]

Nast's continued criticism reflected Sumner's continued influence in the election. The senator wielded a particular influence among African American voters due in part to his long-standing opposition to slavery and in part to his celebrity. Caned by Preston Brooks for his "Crime Against Kansas" speech, Sumner could claim to be a hero of the freedmen. So when he wrote a public letter urging black voters to choose Greeley and arguing that the Greeley coalition would better support civil rights than Grant, Sumner attracted a great deal of attention. When Sumner endorsed Greeley, writing that the "surest trust of the colored people" lay with the editor, he reflected Greeley's campaign persona and slogans. The nominee was, his supporters said, a symbol of "virtue over corruption, reform over reaction, reconciliation over revenge, generosity over greed."[52]

Curtis, for one, was simply flabbergasted. He wrote privately to Nast, "Nothing in our political history has seemed to me so sad as Mr. Sumner's letter." Yet even as late as August, Curtis tried to soften Nast's commentary. "You are your own master," he acknowledged, "and your name is signed to your work." The trouble came when people assumed, as they naturally did, that Curtis had a hand in Nast's cartoons. His editor's chair made him "responsible" for images that upset him, "the more because of my friendship and my difference." Worse, the cartoons suggested that Curtis's editorials, in which "perfect respect may be preserved," did not really represent his views. Nast's cartooning, he wrote, "covers the expressions of the most sincere regard with an appearance of insincerity." Curtis asked Nast again to cease his attacks on Sumner and to leave the senator out of any future cartoons.[53]

Nast ignored this request. He knew that the Harper organization supported his work, and he could always cry foul on Curtis. For example, on the cover of the August 17 issue, Nast asked whether Sumner would, in the service of his desire to "abolish the hate," lay flowers on the grave of the man who caned him, "Bully Brooks." "Will the Senator from Massachusetts Do This, To Make His Words Good?" Or was he a hypocrite? It was a harsh blow, making direct reference to the most painful episode in Sumner's life. Ironically, in the same issue Curtis wrote a long essay denouncing Sumner's endorsement of Greeley. By supporting Greeley, Curtis argued, Sumner had renounced "the work of his life" and forfeited much of the respect he had garnered in a lifetime of service. Curtis dismissed the endorsement

and Sumner's claims that the Democrats would protect African American rights as so much foolishness harnessed in the service of Sumner's "hostility to the President." Apparently, it was perfectly fine to criticize Sumner, so long as it was Curtis doing the criticizing.[54]

As August gave way to September, the race for the presidency became ever more heated. Nast's pencil had been working hard since the summer of 1871, almost without relief, and though the cartoonist's mind seethed with ideas, the campaign strained his physical capacities. In later years, Nast suffered from chronic pain in his hand and shoulder. Some of that pain probably originated in periods like this, when he worked harder and harder as the months passed. In September alone, twelve of Nast's cartoons appeared in the *Weekly*, including the cover of every issue.

That month Nast's drawings returned to another theme in the attack on Greeley. The Liberal nominee had long cultivated an air of distance from the hurly-burly of politics and industry. Though hip-deep in both, Greeley preferred to think of himself as a man tied to the land and to philosophy. Partly in the service of that self-image, and partly through sheer eccentricity, he tended to dress peculiarly. His beard trimmed carefully around his chin, with wire-rimmed glasses perched on his nose, Greeley often wore a long, white coat and a white hat.

Pro-Greeley campaign materials celebrated the editor's eccentric clothing. His coat and hat became trademarks, lauded in the *Campaign Songster*. Fans celebrated his unique look at rallies with handheld masks with cutout eyes and real hair attached with glue.[55] Nast, of course, turned the "White Coat Statesman" and "Old White Coat Philosopher" into a joke. On September 7, Nast offered readers "The Whited Sepulchre," in which Greeley is pictured draping his famed white coat and hat over a monument prominently labeled "Ku-Klux." The clear reference to Nast's "Patience on a Monument" linked Greeley to violence against freedpeople. The inscriptions, including references to slavery, to Tammany Hall, and to Seymour's slogan "This is a White Man's Government," left no doubt about Nast's view of Greeley. It was in the pocket of this coat that Nast so often tucked his references to what Greeley knew. On September 14, it was "What I Know About Wilkes Booth." The same issue carried a cartoon in which a wolf labeled "Tammany KKK" wears the white coat and hat. More cartoons followed, all mocking Greeley both for his lack of sartorial splendor and for his alliance with the Democrats.[56]

By October, Nast was still hammering away at Greeley on all counts. He was a tool of Tammany Hall. He was an ally of the former Confederates.

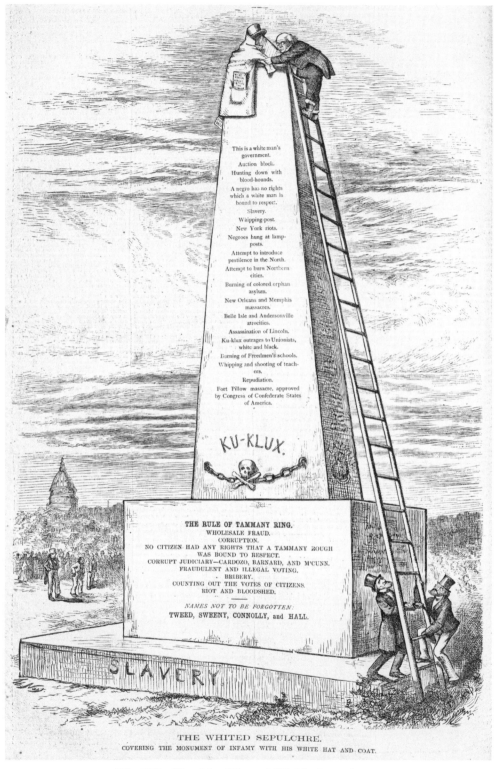

"The Whited Sepulchre," Harper's Weekly, *September 7, 1872.*

He represented the failure of emancipation and a threat to freedmen. His campaign relied not on principle or reform but merely on opposition to President Grant. As November approached, Nast worked furiously to keep pace with editorials in *Harper's*. The inveterate anti-Catholic Eugene Lawrence provided a September editorial attacking Greeley and Schurz. "The blood of murdered Republicans already cries out against [Schurz's] visionary schemes," Lawrence thundered, and Missouri echoed with "the groans and tears of his victims."[57]

Curtis's commentary was more measured, as always. When Sumner retreated to Europe to escape the campaign and for his health, for example, Nast viciously caricatured the senator. Curtis, on the other hand, responded with relief. Sumner's departure allowed the editor to remind readers that the man had been an American hero, no matter how misguided his recent choices. By October, victory for Grant seemed certain to Curtis, but he told readers not to celebrate — yet. "Once more into the breach," he urged them, "nor leave it until the whole wall crumbles." Just before the election, Curtis outlined his view of the situation in the South. There, he wrote, Democrats hoped that if they could take back the executive branch, they could undo the changes imposed on the South since the war. "The first step toward radical and final pacification in the Southern States," Curtis insisted, "is the universal conviction that the Republican ascendancy will be maintained," a view that typically emphasized party power over any particular presidential nominee. Nast defended Grant because of his deep admiration for the former general. Curtis stood for a continuation of Republican policy and the maintenance of Republican power in the South. Grant's reelection served that purpose, he believed, so he supported it.[58]

At least one late-October cartoon attracted the notice of its chief beneficiary. Nast's friend Norton Parker Chipman wrote from Washington of a recent visit to the president. "He asked me if I had seen the last *Harper's*," Chipman told Nast, then "he went into the bedroom and brought out your 'Tidal Wave.'" Not only did Grant affirm his interest in the cartoons, he also expressed his concern for Nast's health. The cartoon campaign was so powerful and so unrelenting that he worried Nast would "break down." "He felt your services had been so great and your genius so unprecedented that he was looking weekly to see you fall off in power," Chipman reported. It never happened, and the president marveled. No praise could have been more welcome.[59]

The last two issues of *Harper's Weekly* published before the election carried a total of eight Nast cartoons. Greeley's paper, the *Tribune*, had

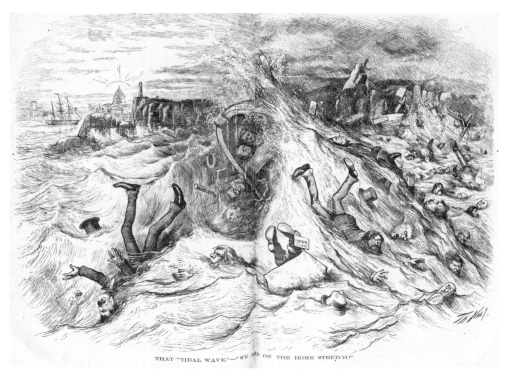

THAT "TIDAL WAVE."—"WE ARE ON THE HOME STRETCH!"

"That 'Tidal Wave,'" Harper's Weekly, *October 26, 1872.*

declared that the editor was entering the "home stretch." Nast took the phrase and ran with it. On November 2 he showed Greeley on a stretcher, being carried back to his farm in Chappaqua, New York. On the cover of the next week's edition, "Home Stretched" showed Greeley jousting with Grant. Greeley's mount, a Democratic donkey, has bucked him off, and the presidential candidate is sprawled on the ground, face first, his broken lance by his body. Clearly, Nast agreed with Curtis that the race was over. In other cartoons he continued to link Greeley with Boss Tweed, and to laugh at the Liberals.[60]

By the sixteenth, *Harper's* was celebrating Grant's decisive victory. Winning more than 55 percent of the vote, and all of the northern states, Grant crushed Greeley. A comic essay in the *Weekly* cast Liberals as characters from Greek and Roman mythology. Carl Schurz became Mars, the war god, "exceedingly boastful and vainglorious." Horace Greeley, lampooned by Nast using the "what I know" device, was transformed into Minerva, the goddess of wisdom. Charles Sumner was Jupiter, whose speech made the "senate of the gods . . . tremble." Written by "Apollo," the piece described visiting a Liberal mass meeting in front of Tammany Hall. There

he found Nast, whom he swept up into the air and carried off to draw his "Opera Bouffe." The accompanying Nast illustration gleefully made the jokes visual.[61]

A series of derisive and triumphant cartoons followed. Nast drew Columbia mocking the Liberals, Grant and Uncle Sam shaking hands across "the Bloodless (Sar)Chasm," and Grant insisting that on the subject of civil service reform there would be "No Surrender." Unable to resist the impulse to make Grant's victory personal, Nast drew himself in a faux-tragic cartoon. In "Our Artist's Occupation Gone," he stands dejected while behind him Americans rejoice at Grant's victory. "It's all very funny to you," reads the caption, "but what am I to do now?"[62]

Horace Greeley died on November 29. He had been ill during the last months of the campaign, and had retreated from the contest to nurse his dying wife, Molly, in October. After her death on October 30, he watched the election fall apart. He was "terribly beaten," he wrote, "the worst beaten man who ever ran for high office." He had been worn down by the attacks on his record, his personality, and his opinions. In *Harper's*, Greeley's passing initially merited only a brief mention, but Curtis provided a long and generous remembrance the following week.[63]

Greeley's supporters blamed Nast for making the editor's last months a misery. The cartoons had, they suggested, so viciously distorted Greeley's personality, record, and beliefs that the editor could no longer stand the strain. According to Paine, Nast defended himself by asserting that he had exercised restraint when he learned of Greeley's illness. He "sent over to the *Tribune* office for the facts," but when they responded that reports of Greeley's ill health were "a lie" and that Nast could "do your worst," he returned to the fray.[64]

Writing to N. P. Chipman, Nast appeared to be unremorseful. "Do you see how I am catching from all the papers that want to revenge themselves, since Greeley's death?" he asked. "Some of them seem to think I ought to feel like a murderer." But he did not. "I have about the same estimate of Greeley dead, as alive," he insisted to Chipman. He had predicted Greeley's death the previous summer, writing to Chipman that if the editor won, "it is my firm conviction that [he] should very soon die in office." Thus, whether he was willing to moderate his cartoons a bit as Paine says or not, Nast knew that Greeley was in ill health, and doubted the older man's ability to withstand the campaign or survive the presidency. That knowledge failed to stop Nast's pencil, nor did Nast think it ought to have.[65]

Attacks on Nast demonstrated his central role in the fight. In the com-

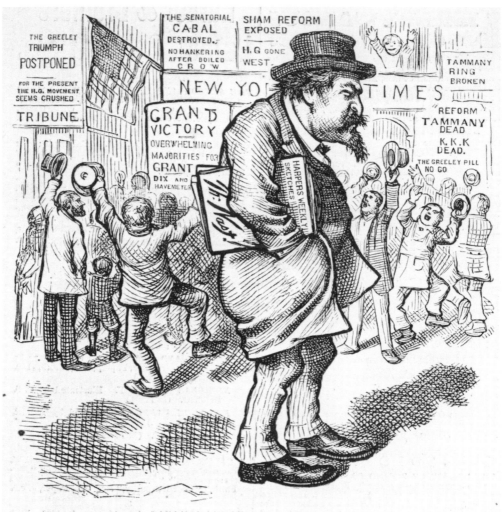

OUR ARTIST'S OCCUPATION GONE.

TH: NAST. "It's all very funny to you; but what am I to do now?"

"Our Artist's Occupation Gone," Harper's Weekly, *November 23, 1872.*

petitive world of New York's political cartoonists, Nast had climbed to the top. But other men knew that his position only made him a convenient target. Throughout the campaign he had been opposed by Matt Morgan, working for *Frank Leslie's Illustrated News.* Morgan could be outrageously provocative, and he sometimes addressed topics calibrated to undermine Nast's positions. He contrasted the dimensions of the Tweed frauds with those laid at Grant's door, forging a link Nast must have abhorred. He emphasized Sumner's lifelong work on behalf of slaves and freedmen, and

asked whether it could really be true that men like Sumner and Schurz would support a foolish hypocrite like Grant. He rejected Nast's conviction that Grant was an honorable man, a war hero who deserved the nation's support. In short, he provided a counterpoint.[66]

Papers that supported Greeley took the same approach. They attacked Nast, Curtis, and *Harper's*, as well as Grant. Some cartoonists played both sides. For example, Frank Bellew worked with Nast at *Harper's* but also drew for the *Fifth Avenue Journal*. Though Frank Luther Mott characterized the journal as a "society journal" in his *History of American Magazines*, Bellew produced a series of political cartoons for the short-lived paper. His scathing illustration of Curtis and Nast cooking up a huge bowl of mud to fling at Greeley showed Nast spitting into the mix. "Don't spit in it," Curtis protests; "it is not gentlemanly." Bellew's antipathy for his *Harper's* editor appeared in other forms, too. Bellew drew Curtis as one of the "Men of the Day (After To-Morrow)," a "Sweet Thing in Reform." He wears a dress, sensible ladies' heels, and black net gloves. In his right hand he clutches a needlework sampler titled "Civil Service Reform." The contrast between the dainty dress with its large bustle and Curtis's fluffy gray facial hair provided the humor, but of course the political point was to mock the editor and his crusade for civil service reform as effeminate.[67]

The attacks, however, seemed only to invigorate Nast. Paine's acknowledgment that the cartoons "went too far" suggests that Nast may have felt some regret for his personal attacks on Greeley. But the power of his work could not be denied, and Nast was proud of his success.

The results of the election had several dimensions. Before it, Nast enjoyed a national reputation for his attack on Boss Tweed. But with his work for Grant in 1872, he cemented his place within the Republican Party. In 1868, he supported the will of the party as a whole. Brilliant, inventive, and pugnacious, he nevertheless took political positions similar to those of many of his peers and colleagues. His 1871 cartoons delighted Republicans by destroying a powerful Democratic political ring and thus elicited only praise. In 1872 things were different. He disagreed with Curtis on principle and in practice. He found himself on one side of a bitter party split, defending a sitting president while attacking a senator with genuine credentials as an American hero. The election helped to show Nast's fundamental political ideals, his loyalties and values. So he emerged from the contest with an enhanced reputation and stronger ties than ever to the Grant administration. He had also demonstrated his range as an artist, his political acumen, and his value to *Harper's Weekly*.[68]

Throughout the year, Nast worked from a central insight to spin off a variety of interpretations of the same joke. But he also dipped frequently into history, literature, and popular imagery. His private life, complete with evening readings from Shakespeare with Sallie, contributed analogies and connections he exploited as cartoon ideas. For example, in early May, Nast quoted from *Richard III*, *Hamlet*, and *Julius Caesar* to attack the Liberals. Later in the same issue, he turned to *Othello* to compare Tammany Hall Democrats to Schurz, Sumner, and Greeley. At the end of the month, he drew Grant as William Tell, and a few weeks after that he returned again to Shakespeare, quoting from *The Merchant of Venice*. A cartoon published in early August presented Greeley and Tweed daring readers to determine which of them was Diogenes (the Greek Cynic philosopher) and which his "Honest Man." At the end of the campaign, in his "Apollo," Nast played on the words "lyre" and "liar" to poke fun at Schurz ally Whitelaw Reid, who, as the god of the sun, is playing the instrument. All this helped to demonstrate Nast's active and wide-ranging imagination and his ability to connect culture to politics with his pencil.[69]

The controversy over Grant's renomination forced Republicans to choose sides. It also demanded that prominent supporters of the president justify their loyalty to him. Nast's loyalty originated partly in his belief that Grant was like himself. In a "chalk talk" lecture in the 1880s, Nast commented twice on the price paid by a caricaturist. Unable to provide the "flattery" upon which, according to Nast, social interactions relied, the cartoonist rarely became "a popular society man." Instead, "the lot of the caricaturist can hardly be considered a happy one." Required to "present people to themselves in a very unfavorable light," the cartoonist confronted "resentment" at every turn. Purity of motive made no difference. Nast viewed his own work as honorable, perceptive, and useful. Others disagreed. Thus, when Nast confronted President Grant's critics, he brought with him a gut-level understanding of the chasm between one's intentions and what the public perceives them to be. The president had to make hard choices. Criticism was part of the price he paid, but this was no proof that he was a bad leader.[70]

When he denied Grant's failings and denigrated men like Schurz and Sumner, Nast willfully refused to see the merit in the Liberals' position. They had legitimate grievances against the president, and their views on presidential power and Reconstruction deserved better consideration than Nast gave them. But to ask a political cartoonist to be objective is a waste of time. Part of the conflict between Nast and Curtis lay in the nature of politi-

cal art. Nast could not, without gutting his own artistic voice, seek a middle ground. His power lay in exaggeration, hyperbole, and making people laugh. So at a crucial moment in Republican politics, when the party had to choose a way forward, Nast's work delivered precisely the kind of hard-hitting commentary that would be least likely to encourage compromise.

George William Curtis saw this clearly. His calls for Nast to hold back, to moderate, originated in part from his sense that what made cartoons succeed was not the same thing that made parties survive. Curtis wanted to control Nast, and by extension all of *Harper's Weekly*'s political content. He also wanted to support the Republicans. That meant, he thought, serious engagement with dissent. The two men failed to understand one another in 1872, and they would clash again when the next presidential election occurred.

CHAPTER EIGHT

Redpath and Wealth

By early 1873 Nast's position among Republicans could not have been higher. Their adoration "became something near idolatry," Paine says. But for Nast, the previous few months had been both exhilarating and trying. As his star rose, Nast experienced all the pressures of success. Invitations arrived for social and political events, and professional opportunities abounded. James Parton, despite mourning his wife, took time to write Nast a congratulatory note. "Apply at once for the Paris consulship," he urged Nast, "and *please don't* get it!"[1] Samuel Clemens, an old friend, wrote that the "pictures were simply marvelous."[2] Nast reveled in his fame. But he had been working nonstop for two years. He was exhausted.

Thomas Nast was compensated on a per-cartoon basis in 1871 and 1872. As a result, the more he submitted to *Harper's* the more he stood to earn. By the end of the year, more than 140 Nast cartoons, including 32 that appeared on covers, were published. According to Paine, Nast earned $18,000 in 1872, including the $1,200 he received in royalties from *Nast's Almanac*, published by Harper and Brothers. The bulk of the income came from his cartoons and represented an enormous sum.[3] The pace strained Nast's imagination and his body, though. Cartooning was physically as well as mentally taxing. Nast also sketched constantly. So his hands, arms, and shoulders, as well as his brain, felt the burden of his work. By January 1873, he described himself to a friend as having fallen into a "slough of despond." He wrote, "[I am] almost on the point of giving it up in despair for it seems as if I could not scratch up a particle of imagination or capacity to do anything. . . . I feel so stupid and listless."[4]

On top of his work for the *Weekly*, Nast produced drawings for books. *Harper's Weekly* was just part of the Harper brothers' publishing empire. So when Harper and Brothers decided to offer the public a new printing of Charles Dickens's *Pickwick Papers*, it turned to the famous illustrator already in their employ. His fifty-two drawings in the new edition helped make the volume, part of a series, particularly appealing. But the combination of illustrating books and his manic pace on the election cartoons

added strain to an already busy schedule. In late January, he was almost finished with the drawings.[5]

Frank Bellew experienced a similar postelection fatigue. He fell ill and was unable to work. When he needed money, Nast sent him twenty-five dollars. Nast's need for rest prompted expressions of concern from friends and colleagues. Clemens suggested that Nast might join him on a trip to England in May. Curtis wrote in February, encouraging Nast to rest and hoping that "when spring comes perhaps I shall see you, with the other bulbs and flowers!" Parton was more blunt: Nast needed "rest and change" and should take Horace Greeley's death as a warning. "It was forty years work and no play that destroyed him," Parton argued, and Nast should put aside concerns about things like his mortgage and worry instead about his health. Turning the biblical injunction on its head, Parton appealed to Sallie—"'Husbands, obey your wives'"—and urged her to force Nast to rest.[6]

Nast's fatigue might have been lifted by the spectacle of the inauguration. As guests of Norton Parker Chipman, he and Sallie traveled to Washington to attend parties and see Grant take the oath of office for the second time. But it was cold, the city was crowded, and the president was in a gloomy mood. The Credit Mobilier scandal had been brewing since the previous fall, but by the inaugural it had become a national disgrace. Not only had the Union Pacific Railroad Company subverted the rules regarding federal contracting through the invented Credit Mobilier company, but congressmen involved in policymaking related to railroads accepted discounted stock. An investigation showed that they also tried to cover up their involvement, adding to the embarrassment. Chipman wrote on January 26 that it was "an exhibition of idiocy and cowardice!"[7]

Nast hardly commented on the scandal. On January 30 he wrote to Chipman that the "affair makes me sick," but he lacked the "heart to touch it, as yet."[8] Because of his exhaustion, he contributed nothing to the Weekly in February and early March. On March 15, a cartoon finally appeared, treading a fine line. Newspapermen deserved praise for breaking the news, but Justice suggested in the image that no one could claim to be "without stain." In the next week's edition, Nast caricatured the two principal malefactors—James Brooks and Oakes Ames—as cherubs. But he largely restrained his pencil, due in part to fatigue and in part to his friends and colleagues' influence. The Weekly asked Nast to wait, at first, until more details were available. Later, Chipman urged restraint. "The whole subject offers a rich theme for your pencil, but I doubt the wisdom of availing yourself of it," he wrote. The scandal inspired "regret rather than censure," and

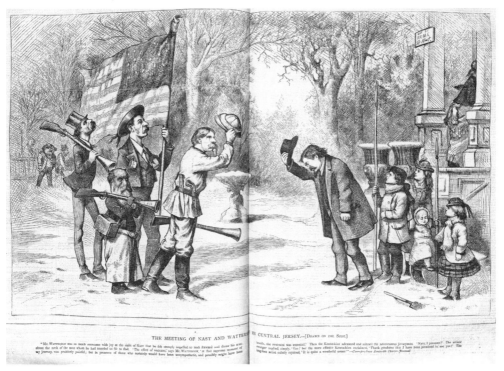

"The Meeting of Nast and Watterson," Harper's Weekly, *March 29, 1873.*

while Nast could probably strike a killing blow, the costs outweighed the benefits.[9]

But Nast paid little attention to Credit Mobilier. He produced a much more spirited drawing in response to questions about his absence earlier in the year. With tongue firmly in cheek, a *Harper's* essay asserted, "Tom Nast Not Dead!" and explained that he was only lost, like Dr. Livingston in Africa, in the "wilds of New Jersey." Rumors that he was "at the court of the Sandwich Islands" or held in the "dungeons of the Inquisition at Rome" proved unfounded. Instead, as Nast's drawing titled "The Meeting of Nast and Watterson in Central Jersey" showed, an expedition from the *Louisville Courier-Journal* discovered Nast safe at home, working on the *Pickwick* illustrations and unaware of all the speculation. "Mr. Nast, I presume?" asks the expedition's leader, *Courier* editor Henry Watterson, to which Nast replies, "You bet!" Despite the sarcasm in the *Harper's* essay and Nast's drawing, he really did want to retreat from politics for a while.[10]

Travel offered Nast a way to escape the pressure. A persistent "catarrh" bothered Nast. If left unchecked, he believed, it "is pretty sure to go into consumption after a while." A doctor suggested that Nast spend six months

in Switzerland, but the family could not afford the trip, nor was Nast willing to leave his wife and children for so long.[11] Instead, he decided on a spring journey to England and Cornwall, writing to Norton Parker Chipman in March that he "ought to stay six months, but do not think that I can possibly do so *alone*." Despite the enormous income generated by his 1872 work at *Harper's*, Nast needed money. He wanted Sallie to join him in England, but she said they could not afford it. Chipman had offered to find a buyer for Nast's painting *Sherman's March*, and Nast responded gratefully. "If it should possibly find a customer, it would be a very great help to me in the present stress circumstances." He had hoped to sell it for $5,000 but said he would take a lower price, "for the sake of helping myself back to health with the money."[12]

He left New York in April, traveling with a letter of introduction from President Grant. None of his cartoons appeared in *Harper's* for more than five months. In London and Cornwall, he visited old friends whom he had not seen since his visit to Europe in 1860. The most significant outcome of the trip, however, related to Nast's encounter with James Redpath while in transit. Redpath owned the Boston Lyceum Bureau, an agency that supplied speakers and entertainers to lyceums around the country, and he wanted to represent Nast.[13]

A native of Berwick-upon-Tweed, Redpath and his parents immigrated to the United States only three years after Nast. Almost from their landing, Redpath forged a fantastically varied career for himself. Horace Greeley noticed the antislavery articles written by "Berwick," the nineteen-year-old Redpath, and hired the young man to write for the *New York Tribune*. Three years later, Redpath left New York for Kansas, where he joined enthusiastically the Free-Soil movement and founded a Free-Soil newspaper. Redpath's antislavery convictions deepened after a chance meeting with the revolutionary abolitionist John Brown, who impressed Redpath as a visionary. A series of visits to the South in the 1850s produced a volume on slavery, *The Roving Editor, or, Talks with Slaves in the Southern United States*. The same year he proclaimed himself a roving editor, Redpath and a colleague responded to the Pikes Peak gold rush by publishing a guide for prospective miners. His interest in mining and slavery naturally led to a visit to Haiti. This, in turn, led to his appointment as commissioner of emigration for Haiti, for which Redpath opened offices in New York and Boston, and the publication of yet another book, his *Guide to Hayti*. By the time Redpath was all of twenty-seven years old in 1860, he had published

three books, traveled widely, acted as the official representative of a Caribbean nation, and established firm—some might say fanatical—antislavery credentials.[14]

During the war, publishing claimed most of Redpath's attention. His "Books for the Times" series featured a variety of original and reprinted works, many authored by prominent antislavery writers. Journalism still beckoned, though. In 1864, Redpath returned to reporting as a war correspondent. His strange career took yet another turn when at the end of the war he became superintendent of education for the schools of Charleston, South Carolina. It was in 1868 that Redpath began the work that would lead to his acquaintance with Thomas Nast.

In that year, Redpath organized the Boston Lyceum Bureau, which later bore his name. He recruited speakers, booked venues, and otherwise worked to satisfy the public demand for semi-intellectual entertainment. The bureau represented politicians, authors, and other men and women whose public personae might attract a crowd. These included Charles Sumner, Mark Twain, and Ralph Waldo Emerson.[15]

Redpath liked to take chances. The variety of his work in his twenties demonstrated his appetite for change, challenge, and innovation. The staid world of the lyceum might, at first, seem a departure for him. But in fact he entered that world as an innovator, too. Before Redpath established his bureau, lyceum boards across the country hired speakers through individual contracts. Fees paid to lecturers encompassed only the travel expenses and a small cash payment. Often, this amounted to less than fifty dollars. Speakers organized their own schedules and made their own travel arrangements. Since tickets to listen to Sumner, Twain, or Emerson might cost anywhere from twenty-five cents to five dollars, and since auditoriums held several hundred to several thousand people at once, local lyceum boards earned a healthy income. Redpath saw the potential for a lucrative business, and he took it on with characteristic vigor.

The Boston Lyceum Bureau reimagined the lecture tour. The bureau organized an itinerary, complete with venues scheduled in geographic order and payment contracts arranged in advance. Speakers no longer had to correspond with every little town they intended to lecture in because their lyceum agent oversaw bookings. A personal representative of the firm chaperoned the most important clients, smoothing out the usual travel wrinkles, including late trains, bad coffee, and crooked theater managers. Most important, however, fees changed. Lecturers now received a portion

of the ticket sales, amounting to as much as $500 per appearance. In later years, stars such as Henry Ward Beecher could earn $1,000 for a single night's work. Redpath's agency took 10 percent for its trouble.[16]

Redpath wanted Nast. But repeated requests met with denial. Nast refused "even to consider the subject." Finally, Redpath resorted to trickery. Hearing a rumor that Nast had quarreled with the Harpers, and finding that Nast intended to visit England for a vacation, Redpath booked passage on the same ship. He presented a letter of introduction from satirist "Josh Billings" as the ship left harbor. Nast was cornered, and he joked, "Well, you have got me where I cannot run away; but it's no use—I won't lecture." But this time Nast could not avoid hearing of the many advantages of lecturing for the lyceum. Very quickly, he was convinced.[17]

Nast agreed to 100 nights of lecturing. Redpath, for his part, promised Nast $10,000, at least. This was an enormous amount of money, more than Nast earned in a year of working for the Harpers. The offer also fed Nast's growing appetite for recognition. Many men of Nast's acquaintance lectured, and he must have known how lucrative the work could be. Temperance activist John B. Gough earned $40,000 in the 1871–72 season, and other speakers collected similar fees. Nast could observe someone even closer to home, however.

George William Curtis, Nast's editor at *Harper's Weekly*, had been lecturing for many years, both before and after the advent of the Boston Lyceum Bureau. Curtis earned $400 or $500 a night. More, he won public recognition for his "higher conception of purity, dignity and sweetness" and his "clear, bell-like, silvery" voice. With lecturing came membership in an elite club of public intellectuals. For these men—and a smaller group of women—lecturing represented a form of public service. They fed the American appetite for elevated discourse, discussion of current affairs, and explanations of philosophy, art, and politics. Lecturing also linked speakers to a world of activism embodied in the temperance, abolition, and woman suffrage movements. Lecturing could be a path to political influence, and a way to reach an ever wider audience. No wonder Nast found it seductive.[18]

Accepting Redpath's offer also promised Nast access to a small group of interesting, influential people. At *Frank Leslie's Illustrated News*, the young Nast observed New York's writers, artists, and politicians visit the offices to speak with Leslie. There, Nast learned about informal connections and the quasi-social interactions that constituted networking. Later, as a member of the social circle created by Sallie Edwards Nast's parents, the cartoonist observed the multiple intersections of intellectualism, journalism, and family.

Redpath's agency offered a similar environment. Often, speakers dropped by the parlor at the bureau to discuss their most recent excursions and enjoy the company of other clients. Redpath created not just a service but in effect a club, and now he invited Nast to join. The personal, and often amusing, quality of this club is evident in a letter written by client Mark Twain. Responding to the delivery of a pet donkey for one of his children, Twain wrote the bureau, "Much obliged . . . for the jackass. Tell Redpath I shall not want him now."[19]

Nast feared lecturing, but he told Redpath that if Sallie could be convinced, the deal would be done. Redpath promptly left England, sailed back to New York, and convinced Sallie. With his usual speed, he then commenced booking lecture halls. Sallie's role in Nast's lecturing career bears a special note here. Although there is almost no direct evidence of her participation in Nast's work, or her political views, Redpath's application to her suggests the value Nast placed on her opinion. More, Redpath's curious personal history echoes the world from which Sallie sprang. An English immigrant, deeply involved in American politics, Redpath reflected many of the values the Edwardses espoused. The same family that sheltered Harriet Jacobs's daughter for a time—albeit in the home of the despised Fanny Fern—raised a daughter who responded warmly to Redpath. Likewise, Nast's complex but deeply sympathetic response to the struggles of the freedmen suggests the link between Redpath's career as an abolitionist and the willingness of both Nasts to sign on to his agency.[20]

By the time Nast returned from Europe in June, a new kind of work confronted him. The bureau organized for Nast a schedule of what it dubbed "chalk talks" (for the drawings he did on a chalkboard per audience members' requests after each lecture), six nights a week, and he would be paid between $200 and $500 per night.[21] Redpath informed Nast that he had already confirmed more than $13,000 worth of engagements. "There is every reason to believe that you will be under the painful necessity of drawing twenty thousand dollars out of the pockets of your countrymen," he gushed. With Sallie's cousin James Parton, the Nasts spent the rest of the summer writing a speech and rehearsing its delivery. Parton had spent the 1870–71 season lecturing, so he brought useful experience to the work. In turn, helping Nast to compose a lecture provided Parton some distraction from his wife's death.

Even with the lecture carefully written and approved by a veteran lecturer, Nast's fear remained powerful. Redpath was now offering almost half again as much pay, though. Redpath solicited invitations for Nast, and

found himself overwhelmed by replies. Audiences clamored to hear from the cartoonist. Redpath increased Nast's anxiety when he wrote that he had already booked more than $20,000 worth of engagements. Nast should "get [himself] in the best physical condition," Redpath urged, "and practice all the time to strengthen your voice."[22]

Lecturing proved both a triumph and a nightmare. Nast's stage fright nearly paralyzed him. Bubbly and even childlike in private life, Nast was terrified by the idea of speaking to a large crowd. He was "personally shy, and would sooner go on a forlorn hope than face an audience," wrote one of Redpath's employees. Nast confronted Redpath the first night, in Peabody, Massachusetts. "Now Redpath," he insisted, "you got me into this scrape and you will have to go on the platform with me." Redpath agreed, and spent the lecture sitting quietly on a chair behind Nast. He recalled that Nast was so nervous "he dug his nails into the reading desk."[23]

On October 8, Nast wrote to Sallie about the experience. The audiences "seem pleased," but he was not. "All eyes are on me to see how I do it," he complained, "the silence is [dreadful while] I draw." On the other hand, the "interest that the people show in me is beyond description," and "the pleasure they manifest is very loud." Neither public interest nor audience pleasure mitigated the pain of public speaking, though. "The suffering I go through I can't not express in writing," Nast wrote. He hoped rain prompted a cancellation, but it did not. "As long as you at home don't get sick, or I," he complained, "there is no backing out."[24]

Nast tried to convince Redpath to release him from the tour, even begging, but the promoter refused. In November, he urged a Christmas break. "I want so much to be home that night," Nast wrote to Redpath, "and it would be a miserable night for a lecture I should think." Underestimating his popularity, Nast continued, "Who would want to be bored Christmas Eve?"[25] No reply survives. Nast wrote to Sallie that her letters provided the only moments of happiness. Nast's letters reveal not only his distress but also his tendency to overdramatize. The pay Redpath issued was "blood money," while lecturing was a "horrible dream." He had become, as he signed himself, "your poor traveling circus boy."[26]

Nast hated traveling alone, hated climbing onto the stage, hated the isolation and nervousness he experienced while on the road. The young, observant Nast who had charmingly chronicled the foibles of his fussy, overdressed neighbor on the train to Washington in 1861 was gone. A man for whom home and family were paramount took his place. "Love to you [and] all the children and the most of it for you," he wrote to Sallie, his "dearest

darling love." In addition, Nast seems to have been incapacitated by his stage fright. Alone on the road, there was no one to help him conquer it, and he suffered in solitude. Even Nast's children sensed the tension. "Do you hate lecturing yet[?]" asked Thomas Nast Jr. "Mother is getting lonesome."[27]

On the other hand, the tour was a smashing success. Audiences loved his drawings and paid handsomely to watch him create them. The evenings began with Nast giving a brief lecture, accompanied by drawings that he created on the spot. Sometimes he used crayons on paper. In later years, he seems to have used oil paint. After each lecture, the audience was invited to request drawings, which he produced in chalk on a board wheeled onto the stage. Observers noted that audience members were captivated not only by Nast's skill but by the speed with which he produced complex images. Thus Nast captured three essential elements of entertainment: audience participation, immediate gratification, and the sense that the product was fleeting.[28]

At a lecture in New York in November 1873, he began with a joke. After acknowledging the applause of the crowd at Steinway Hall, Nast observed that "man is a laughing animal." While Australia harbored the "laughing jackass," Nast continued, "it is not necessary to go as far" to find the human kind. He then drew a fat, laughing man on the blackboard. Jokes about the ancestry of man and ape followed, with references to Tammany Hall–associated jurists George Barnard and Albert Cardozo, then jokes about "Caesarism" and Andrew Johnson. Nast spoke about his history, talking about the war and his pleasure in caricaturing men like General Benjamin Butler. He dwelled at length on the Tweed campaign.

Tweed provided ample fodder to illustrate the method behind caricature and to make a few crowd-pleasing jokes. Best of all, it reminded the audience of Nast's most famous exploit. The artist quickly sketched Tweed's head. "Look at the head and you will see that its general outline is suggestive of a moneybag," he pointed out. With a few strokes, the Boss's features dissolved and Nast demonstrated his point. "The next thing," he continued, "is simply to place a dollar mark upon it." The addition of "a darker mark here" and "a curve there" completed Tweed's new features. Where Tweed had been now stood "The Brains."[29] Audiences loved it. Nast went on to describe the Ring's attempts to bribe him and to punish Harper and Brothers. Neither he nor the Harpers "wavered." "They had enlisted 'for the war,' and they fought it through." The New York Times reported "loud and continued applause" for that line. To end the Tweed portion of his chalk talk,

Nast returned to an iconic image from the crusade. Punning with the word "suits," Nast reminded his audience of the Ring's affinity for elegant clothing. These days they wore a different suit: the stripes worn by convicts. A quick sketch showed the Ring in prison gear, the image not only delighting the audience members but also reminding them of Nast's connection to Tweed's downfall.[30]

Nast offered his audiences a personal history, too. "I believe I am the first person in America who accepted caricaturing as a profession for life," he reported. "My original intention was to become an historical painter," but a performance by actor William Evans Burton—whose portrait Nast later painted—convinced the young artist of the "power of humor." A caricature of Burton as his most famous character, "Toodles," followed.[31] As he would with his biographer many years later, Nast altered his personal history at times. He told the audience that he got his first job when he was only fourteen years old. Drawing himself begging Frank Leslie—"a well-known proprietor of an illustrated weekly paper"—for a job, Nast emphasized his youth and joked that his drawing skills needed work. Despite these shortcomings, Nast recalled, "I got the situation at the magnificent stipend of $5 per week." The *Times* reported laughter from the audience, whether at Nast's self-deprecation or at his salary, it did not specify.[32]

All of Nast's most amusing qualities—his talent for mimicry, his humility, his ability to laugh loud and long—helped to endear him to audiences. At Lewiston, Maine, that first season, his approach emphasized "what a jolly, fun-loving people we Americans are, and how readily we can laugh down pretension, humbug, and imposition."[33] He cannot have spent every moment on the lecture circuit miserable. In Denver, Colorado, in 1889, Nast posed for a photograph looking as though he had no cares. He sported a dapper hat, tilted over his forehead to mimic the angle of his head, a plaid suit, and a polished cane. Pants pressed, pockets full—of chalk?—Nast appears happily amused and entirely at ease.[34]

According to Redpath and his assistants, Nast overcame his stage fright fairly quickly. Within weeks of his terrifying night in Peabody, they reported, Nast faced the full house at Steinway Hall "as jauntily as if he had been a veteran comedian." In Philadelphia, he even cracked jokes. Drawing the outline of a simple house on the chalkboard, Nast tossed over his shoulder the comment, "I can draw a house." Since the theater was completely full, this pun fell upon an appreciative audience, and the laughter must have buoyed Nast's confidence.[35]

Redpath may have shared with Nast stories of other speakers and their

foibles to boost his confidence. Henry Ward Beecher, one of the greatest orators of the century, required several cups of coffee before every performance. His agent, J. B. Pond, took special care to ensure the presence of good coffee in every stop. Nast might have taken comfort from the thought that he was not so different from this giant of the lyceum circuit. Like Beecher, Nast needed some coddling to balance the physical demands of the stage. He complained in 1885 to an associate about "the exertion of working so rapidly." At the end of a performance, he wrote, "I am wet with perspiration . . . and most large halls are drafty." Nast sometimes caught colds in the unheated lecture halls, and in later years, he preferred to lecture when it was warm.[36]

Other lecturers insisted that public speaking could restore health. After a miserable circuit in intense heat, Mark Twain wrote in 1895: "Lecturing is gymnastics, chest-expander, medicine, mind-healer, blues destroyer, all in one." After the tour, he said, "[I was] twice as well as I was when I started out." He had gained nine pounds, he wrote, in only twenty-eight days. For Nast, however, nine pounds would have been an unwelcome addition. According to J. B. Pond, Twain was not always so brave. Before his first lecture in the 1870s, Twain "dreaded failure . . . as he had no experience in addressing audiences," so he found a ringer. A lady of his acquaintance agreed that whenever he looked in her direction and stroked his beard, she would burst into applause. Twain hoped the audience would follow, and he in turn could encourage an enthusiastic response. His speech was a success, of course, and before long Twain forgot all about his lady friend and their arrangement. But she remembered. Thus, despite the fact that it was not an obvious moment for applause, when Twain turned in her direction and stroked his mustache, she clapped enthusiastically. No matter. The audience, by now, was ready to applaud anything, and it followed her lead. Perhaps Nast found comfort in the idea that even a raconteur of Twain's gifts felt it necessary to resort to subterfuge. Nast, like Twain, found audiences needed no encouragement.[37]

The financial rewards helped to allay any lingering pain. Nast spent seven months traveling for Redpath in 1873, and in that time he made $40,000. Nast might have earned more, but he cancelled more than $5,000 worth of tour dates because he was so homesick. Convinced that honor demanded it, Nast paid the bureau its 10 percent of the cancelled lectures from his own pocket. At the end of the season, Nast withdrew from the lecture circuit. Redpath tried to convince him to sign on for another tour, but Nast refused. The money was spectacular, but the stress was equally so. Still, the income

generated by lecturing would become the foundation of Nast's personal wealth.[38]

Cartooning was Nast's passion. It gave him the opportunity to dip his pencil into any subject that caught his attention. Gifted with a vivid imagination, inspired by human foibles and grand themes, Nast was perfectly suited for the life of a political cartoonist. And although he had not become a political cartoonist in order to become rich, the work rewarded him handsomely.

The path to wealth proved steep. In 1859, Nast had abandoned his job at *Frank Leslie's Illustrated News*, which paid him $360 annually, in favor of freelance work. Nast enjoyed an income closer to $1,100 in 1860.[39] At the turn of the next decade, Nast's income attracted public comment. Publisher Charles Shepherd sent Nast a newspaper clipping that claimed the cartoonist enjoyed a net worth of $75,000. Teasingly, Shepherd asked, "Do you speak to common folks now?" Within a few years, the joke would fall flat, as Nast's income spiraled upward and the artist's personal wealth followed.[40]

Nast's 1871 income totaled approximately $8,000, of which $5,000 was pay from the Harpers for his cartoons against Tweed. Much of the rest came from the income from the first *Nast's Illustrated Almanac*. The *Almanac* was a spinoff, a way for *Harper's* to capitalize on Nast's celebrity and for Nast to diversify his offerings to the public. It drew upon Nast's wide circle of friends and contained the work of many fellow humorists. The last bit of Nast's 1871 income came from book illustration.[41] Though Nast worked constantly on book illustrations, they did not always fulfill his expectations in terms of the amount of income they generated. He complained to N. P. Chipman that his recent work on a slim volume called *Miss Columbia's Public School* had been more trouble than it was worth. "I got up the whole thing at my own risk," he wrote, spending almost $500 on engravings. Even with sales near 10,000 copies, Nast only made back his investment and "barely [kept] the publishers from a loss." With future sales the book might turn a profit, he wrote, "but I don't think it will." A friend had suggested that Nast publish some *Harper's* cartoons for money, but he feared the same result.[42]

In 1872, a year of feverish election cartooning, Nast earned closer to $18,000.[43] Much of his 1872 income originated in per-page fees for the election cartoons. Nast produced as many as three cartoons a week during this period. Money earned for work on *Almanac*s and outside illustration—$1,200 from the *Almanac* in 1872 alone—again added to the pile.[44]

Nast's finances thus catapulted from respectable to impressive in the space of a year.

But Nast sought more. Exhausted and depressed after the rigors of the election, Nast worried about his future income. Friends in Washington even began a subscription campaign to provide the artist with $10,000, but Nast refused the effort.[45] Instead, he sought a more reliable relationship with his employer. An annual contract from *Harper's* would provide stability and free Nast from any financial concerns. Surviving financial records reveal nothing about negotiations surrounding Nast's employment in 1873, but there is reason to believe that James Redpath helped the cartoonist achieve his goal.

A few weeks after Nast's departure for Britain, the *Boston Globe* published a "gossipy private letter" from Redpath. Nast was a genius, the agent asserted, whose work was "sacred." He was like Thomas Carlyle, better than *Punch*, unparalleled in America or England. He "has tempting offers, both financial and otherwise" to remain in England. Why should the artist return? "His share of the spoils of the last campaign," Redpath argued, "was fame—plus a thoroughly tired out body and mind." Who profited from the attack on Tweed and the presidential triumph? "Publishers and politicians," who received "great offices and rich gifts." Nast, on the other hand, "was not even decently paid for his work." Nast never asked for more. Instead, he "says nothing." Redpath drew out of him, in "hundreds of talks," the truth: "He has been almost broken down in health and with hard work—with nothing more gratifying than a popular reputation to show for it."[46]

The *New York Times* replied four days later. Far from poor and broken, Nast enjoyed a substantial income, the paper argued. His wealth reflected the excellent pay *Harper's* offered. If he were to read Redpath's statements, Nast himself would "repudiate and ridicule" them. Far from failing to honor its artist, the *Times* continued, *Harper's Weekly* deserved credit for "originally bringing him into notice." In fact, the *Weekly's* vast audience and power in the marketplace "placed [Nast] in the enviable position which he today occupies." As Nast's income shows—the *Times* had a point.[47]

Redpath fired back. Nast's money came from "the severest toil that any artist in America has ever subjected himself to." More, Redpath continued, his published comments represented "the truth financial, the truth physical, the truth mental, and nothing but the truth." It was Nast who built *Harper's* reputation with his "potent pencil" and Redpath reminded readers that the *Weekly* had not always been a Republican paper. In an astonishing claim, Redpath asserted that Nast "liberated and endowed with a political

soul" a paper "then in bondage to the slave power." Nast made the paper what it was, and his work deserved more acclaim than that of "all its other contributors combined."[48]

The subject of all this argument remained in England until June, blissfully above the fray. He submitted nothing to *Harper's*, and no one could predict when his work might resume. By July, engagements totaling at least thirteen thousand already filled the calendar, and advance bookings suggested that Nast could earn as much or more lecturing as he ever won from the Harpers. Nast waited, sending nothing to Franklin Square. Finally, the Harpers submitted to the inevitable. Fletcher Harper offered his most famous employee $150 per image, plus $5,000 annually to guarantee that Nast worked only for the *Weekly*.[49] Having gotten his way, Nast returned to work in September with his first cartoon in five months.[50]

Beginning in 1873, then, Nast enjoyed both steady income from his work for *Harper's* and the promise of a substantial increase from lecturing. He was, for the first time, really a man of means. Those means found expression partly through the purchase and furnishing of a home. Purchased before he won his annual contract, the house would become Nast's showplace, where he demonstrated his success for all to see. It had been the subtle, and then not-so-subtle, threats of the Tweed Ring in 1871 that convinced Nast to move Sallie and the children out of New York City. Initially, the move promised to be temporary. The Nasts kept their Harlem house and lived in a boardinghouse for several months. As the attacks on the Ring increased in tempo and fervor, however, the safety of New Jersey must have seemed ever more appealing. Sallie's fourth pregnancy added to the argument. In December 1872, the Nasts' third daughter joined the family, prompting Nast to write to Fletcher Harper, "We had a 'glorious fourth' on the fifth." With four children, an increasingly demanding career, and more money than ever before, Nast began to look for a permanent home.[51]

Morristown, New Jersey, seemed a likely prospect. Morristown was home to George Washington in the winters of 1777 and 1779. Long a sleepy village whose residents were mostly prosperous farmers and old New Jersey families, the town became a refuge for the rich in the second half of the nineteenth century. Just as Nast was moving into his new home, millionaires such as Hamilton McKown Twombly and Otto Kahn built palatial estates nearby. A railroad line to Manhattan, nicknamed the Millionaire's Express, stopped in Morristown. The majority of Morristown's residents, though, were of the upper middle class. Educated, genteel, and Protestant, they represented the social and cultural world to which Nast had long as-

pired. The *Boston Daily Globe* described the village as "blue-bloody, if not as blue-stocking as Boston," and complimented its residents as "very respectable, and yet not wholly stupid."[52]

Many of the most prominent men and women of Nast's time visited Morristown. Western writer Bret Harte visited the Grand View House, a hotel operated by his sister's husband. He wrote that Morristown was "a capital place for children. The air, without being at all bracing, is pure and sweet; the scenery pretty & pastoral."[53] With the Nast family growing toward its ultimate number of seven, that pure and sweet air was doubtless a welcome change from the worry and congestion of New York.

In 1871, the Nast house in Harlem sat in the midst of an outbreak of malaria while Nast struggled to recover from a throat infection.[54] Quiet Morristown seemed a perfect refuge. There would be no threat of riots, deadly infection, or Tweed's thugs here. The Nasts found a six-year-old house on the corner of Boyken Street and Macculloch Avenue and bought it in 1872 from David and Sarah Rockwell. The house in Harlem carried a mortgage, and even with its sale the Nasts had to borrow part of the $21,250 purchase price for the Morristown house. It was the financial strain imposed by the house that pushed Nast to insist on an annual contract and to agree to lecture with Redpath. Thanks to the success of the tour, however, and Redpath's intervention with the Harpers, the burden of a mortgage very quickly subsided. Within two years, the house reflected the Nasts' new prosperity, inside and out.[55]

Built in the Second Empire style, it rose two and a half stories on a generous lot. Three large windows glinted in the sun on each side, and dormers above provided still more light. A deep porch invited lazy afternoons and lemonade, while decorative iron railings ornamented the edges of the roofline. Spacious and inviting, the house represented a blank canvas for Nast. He set to work transforming it into a fantasy of his own imagining: the Villa Fontana.

By 1876, the house reflected Nast's love of beauty. In the study, he installed a floor containing eight types of wood. The floor competed with a marble fireplace, mirror, carved mahogany mantelpiece, and various porcelain knickknacks. But that was not enough. Above the fireplace hung a pirate shield boasting a skull. Paintings, decorative plates, and objets d'art decorated the walls. Even the sunflower-motif andirons, wood box, and fireplace guard offered a visual feast.[56]

Nothing was too good for Villa Fontana. Nast obtained an entire staircase, and possibly the intricate floor of the study as well, at the 1876 Cen-

Thomas Nast's home, Morristown, N.J. Courtesy of the photographer, Mary Carroll.

tennial Exhibit in Philadelphia. He also ordered a "Rustickwork" fence and matching gazebo. A large fountain stood as a counterpoint to the gazebo and provided a gentle sound to enliven the grounds. Visitors might sit on the porch in summer, surrounded by palm trees and climbing vines that Nast trained to grow up and around the porch posts.

Inside the house untold curiosities waited. Nast loved to collect objects, both for inspiration and decoration. Nothing was too bizarre—for example, a "beheading knife" from the Philippines and another from Borneo. Photographs were everywhere. Not only did Nast keep photographs of friends, family, and prominent Americans, he also collected images of famous authors, cats and dogs (more of the former than the latter), children, and famous statues. He displayed paper currency from four different countries, including China.[57] Weapons abounded. A sixteenth-century German suit of armor stood guard over a wide-ranging collection of Philippine, Somali, Carib, and Australian bows and arrows; war clubs of the Penobscot and Zulu peoples; otter lances from the Arctic; war lances from Fiji; a Sioux war bonnet decorated with white eagle feathers; and daggers, pistols, and swords from all over the world dating from at least four different centuries. These emblems of war kept company with porcelainware, bronze statuary,

medals, and a variety of utilitarian items—clocks, cake plates, snuff boxes, and the like.[58]

Many homes of the era contained decorative objects in glorious profusion. But Nast's home teetered on the edge of the bizarre, even for its time. Within, Nast's children found endless opportunity for imagination, often with their father as chief instigator. When he described his children as "the liveliest, wildest little rowdies," Nast identified not only their childish high spirits but also the freewheeling imaginative spark he provided.[59] The artist could, meanwhile, find at every turn something to ignite his own creative energies. His home had become a domestic lodestone, a muse, and a reflection of its owner all at the same time. Best of all, it was a work in progress. So long as Nast had money, he continued to buy. And the house was nearly bursting with stuff.

Nast's artistic style fed his collecting habit, and his collecting habit kept his pencil busy. Complex, object-filled backgrounds suited Nast's penchant for making more than one point at a time. Nast especially loved to use the symbols of historic events. So suits of armor, dripping daggers, and remnants of ancient worlds offered the artist a treasury of possible models. Anything Nast needed to draw, he could find just steps away. Just as his Irish thug required a pipe, filthy boots, and a ragged coat, so did his Columbia require variously a sword, a helmet, or a skull. The less martial items might appear in Christmas drawings, as did in 1886 a Japanese vase that former president Grant gave the Nasts.[60] Objets provided personal inspiration as well. They reminded Nast of his success and helped reinforce the impression of strength and insight.

American politics required thick skin and a pugnacious temperament. Nast had both, and his home reflected his self-image. A truth-teller, a critic of the overblown ego, and a judge of the value of policy, the political cartoonist wielded his pencil like a sword on behalf of the nation. Thus the full suit of armor standing in the hallway served not only as a model but also as a symbol of Nast's mission. He was "'the avenger'—a mailed knight with gleaming battle axe to carve out the way of reform." Likewise, for a self-educated man, a house full of interesting things attested to his curiosity and taste. His political instincts reflected a mind filled with questions, and the Villa Fontana did, too.[61]

But the Morristown house revealed more than Nast's interest in exotic objets. His collection's significance, indeed, was far greater than its hodgepodge nature might suggest. Nast's artistic process emerged full-blown in his home. Speculation about the influence Nast's childhood had on his

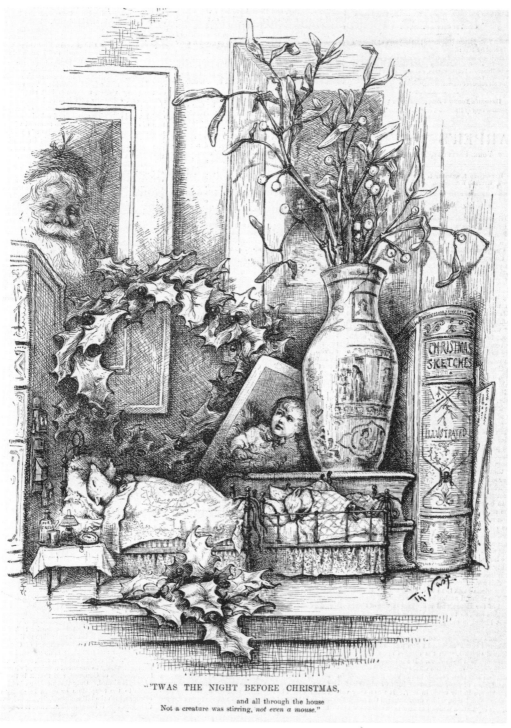

"'TWAS THE NIGHT BEFORE CHRISTMAS,
and all through the house
Not a creature was stirring, *not even a mouse.*"

"'Twas the Night Before Christmas," Harper's Weekly, *December 25, 1886.*

work, for example, would be impossible without an examination of the Morristown house. Nast worked from life. This assertion may seem too simple, but it is not at all obvious. Nast drew inspiration from a number of sources: Shakespeare, ancient history, and the natural world. But he drew what he could see, quite literally. Is it possible, then, that the people who surrounded Nast during his childhood—gaudily dressed Bowery B'hoys and thuggish Democratic politicians, street urchins and immigrant grocers—could have failed to catch his eye? Nast's home confirmed the influence of his environment.

Nast's work occupied a cultural space between high and low art. Trained as a fine artist, Nast abandoned paint for a pencil and the drafting room of illustrated newspapers. His work addressed popular culture, politics, and international affairs, but it incorporated allegorical, mythical, and religious themes. For many of the consumers of Nast's work, it served as weekly entertainment, yet Nast and his colleagues perceived political cartoons as an essential and powerful component of the national discourse on governance and society. The role Nast played was, therefore, a complex one, so knowing how he worked matters.

Had Nast, for example, worked under the supervision of an editor, he would have been far less significant to American politics. He resisted George William Curtis's attempts to control him for exactly this reason. Nast wanted independence. He intended to assert his authority as a political thinker in his own right. Both of these goals dovetailed with an artistic process based on observation. Because his work derived from the world as he saw it—literally and imaginatively—*only* Nast could conjure new ideas. Likewise, the rich detail of Nast's drawings required models. Home, collecting, travel, and personal history provided a visual library from which Nast could draw. The result was a cartoon world unique to Nast, and one that he defended. The Morristown house, then, revealed as much about Nast as his childhood. And it shaped him, too. Together, they contributed to— and in the case of the Morristown house, represented—the maturation of his work.

CHAPTER NINE

Access and Authority

If the Morristown house cemented Nast's status as a mature cartoonist—secure in his annual contract, lauded by his political party, and happy in his family life—it also served as a dividing line of sorts. From 1873 forward, Nast enjoyed a position of access and authority from which he could comment on practically any topic he liked. So in the years following Grant's re-election, Nast addressed a variety of topics. Unsurprisingly, given the financial crisis of 1873, fiscal policy and the economic status of the nation caught his eye. Anti-Catholic, sometimes antipapal, cartoons appeared often. Nast's Christmas drawings, popularized during the war, became a staple. Still intensely partisan, he often worked on many projects at once. Illustration, *Nast's Almanac*, and lecturing had all contributed to Nast's prosperity. They also made his working life more complicated. But the mid-1870s were the halcyon days of Nast's career, and his work shows that his curious mind sought ideas everywhere.

Because no single crusade occupied Nast's pencil, the period between the fall of 1873 and the presidential election of 1876 offers a chance to examine Nast's work on a thematic basis. He worked on a variety of concepts, and his work featured many of his most common artistic techniques. Fiscal policy, anti-Catholicism, Santa Claus, and the defense of Grant against charges of "Caesarism" all moved Nast to draw. An examination of each of these topics shows how widely Nast observed American culture and politics. It also helps to demonstrate the extent to which his influence had grown since his first successes in the 1860s.

The economic crisis in 1873 began with the failure of the bank Jay Cooke and Company in September. A major financing source for railroads, and a backer of the new Northern Pacific Railroad, Cooke's firm was, in modern parlance, "too big to fail." But fail it did. And that failure triggered a cascade of economic distress, including a massive increase in unemployment, the failure of railroad companies, and trouble on Wall Street.[1] President Grant, whatever his strengths as a leader of men, seemed unable to manage the crisis. For Nast, the initial question was who to blame. On October 11,

Nast drew Uncle Sam warning bankers about their use of Treasury dollars. In another cartoon that week, he portrayed the Wall Street panic as a "general 'bust up' in the 'street,'" with various industries colliding catastrophically. The following week Grant had to pull Columbia from the rubble of Wall Street.[2]

Fiscal policy, one aspect of the federal response to the crisis, attracted Nast's commentary. An effort to expand the money supply in response to the panic led Congress to pass the inflation bill in 1874. President Grant, who believed the nation's currency should be backed by gold, vetoed the bill. Republicans were divided between those who favored the bill for its potential to enhance economic activity among farmers, especially in the West, and those who worried about its effect on the United States' ability to do business overseas. Nast, as always, supported the president. He celebrated Grant's veto of the bill, then likened inflation to lying.[3]

Republican advocates of the greenback objected to Nast's work. According to Paine, John Logan of Illinois complained that Nast lacked the knowledge and influence to critique the government. N. P. Chipman replied in terms calculated to soothe and amuse. "It is a distinction to be caricatured by Nast," Chipman pointed out, and "just think what it would be to be indicated by a tag." Chipman referred to Nast's dismissive treatment of B. Gratz Brown, whose run for the vice presidency Nast reduced to a joke by portraying Brown as a tag on Horace Greeley's characteristic long overcoat. In other words, Chipman told Logan, it was better to be Nast's target than to be so insignificant as to be ignored.[4]

The inflation cartoons generated so much heat that *Harper's* felt obliged to defend its cartoonist. *Harper's* argued that cartooning was an entirely legitimate avenue for political criticism. "Its object," the paper insisted, "is not merely to raise a laugh, but to tell a serious truth humorously." The objections of certain men to Nast's caricatures of them only demonstrated their ignorance of the medium. If Nast believed that inflation "would be a national disaster," then he must express that view. Drawing a picture of inflation was impossible, so he had chosen "its most noted champions to symbolize it." His mockery was not personal but political. It related not to animus but to the nature of his art. Other papers had used "every legitimate weapon" to defend inflation. Nast had the right to use his pencil to criticize it, and his targets "should not petulantly complain."[5]

Nast's reply was altogether more definitive. He drew himself bowing to men he had offended in his fiscal policy cartoons. Though he bends low and doffs his hat, Nast's bow is anything but conciliatory. Quoting Shake-

OUT OF THE RUINS.

U. S. G. *(Chief of U. S. Police).* "I am glad to see that you are not seriously hurt. The Houses in this 'Street' have been Shaky and on false Bases for a long Time. and you've had a very Narrow Escape."

"Out of the Ruins," Harper's Weekly, *October 18, 1873.*

speare, as he loved to do, Nast invoked the battlefield insult Cassius flings at Octavius in *Julius Caesar*: "Peevish School-boys, Worthless of Such Honor." The cover of *Harper's Weekly* on July 4 caricatured Senators Logan and Oliver P. Morton, but the most powerful blow appeared in a two-page drawing toward the back of this issue. Columbia, her head bowed in prayer, thanks God that Congress—so ineffectual and yet so problematic—had finally adjourned. Neither image offered conciliation to Nast's opponents.[6]

Attacks on fiscal policy continued in 1875 and 1876 with a new symbol of congressional wrongheadedness: the rag baby. In September 1875, Nast dropped the rag baby onto Senator A. G. Thurman of Ohio's doorstep.[7] The baby represented both the tensions among Democrats about fiscal policy— hard-money advocates versus soft-money supporters—and the unreal, even surreal, nature of the marketplace. For Nast, paper money could not represent value. It was a symbol, like the rag baby. Congress could no more declare paper money "real" than they could declare a rag baby alive.

Nast made his point best in an illustration for David Wells's *Robinson Crusoe's Money*. Published by the Harpers in 1876, this little book used the story of Crusoe to satirize recent fiscal policy and to argue for hard money. *Harper's Weekly* promoted the book in the March 11 issue, and reprinted the Nast illustration that accompanied this section of Wells's text:

> A disease among the cattle having deprived the islanders of their usual supply of milk, a large public meeting was called to consider the matter. . . . After an eloquent address from the chairman, abusing the "Lacteal Association" for not issuing more tickets at a time when the demand for milk was imperative, it was unanimously resolved that the association should at once increase their supply of tickets, under pain of forfeiting their charter. The demand was at once complied with; and every happy father carried home an abundant supply of milk tickets, which were served out to the babies that night in place of milk. But the babies had lived long enough to know the difference between milk and paper, and refused, with great uproar and disturbance, to accept the sham for the reality.

In Nast's illustration, a hand offers the rag baby a ticket labeled "This is milk, by act of Con[gress]." On the wall behind the baby are various signs showing objects with the labels; for example, "This is a cow by the act of the artist."[8] Things could only be what they were. Currency must be gold-based because gold held intrinsic value. Paper, or greenbacks, offered no such value, so its use as currency could not be legitimate. As *Harper's* put

MILK TICKETS FOR BABIES, IN PLACE OF MILK.

"Milk Tickets for Babies," Harper's Weekly, *March 11, 1876.*

it, money could not be "sorry, worthless stuff." Currency must be able to "become useful, acquire value, become an object of exchange, and constitute a standard in the regulation of prices."[9] The rag baby not only helped make Nast's point about paper money having no value but also served to underline Democratic disagreement. He revived it for the 1876 presidential election to attack Samuel Tilden.[10]

While Nast expended a great deal of energy commenting on economic questions big and small, his understanding of them was thin. As later events would show, Nast never boasted a sophisticated sense of the stock market or investment strategy. In October 1871, he wrote to N. P. Chipman about the challenge of earning and managing money. "I shall probably never be able to make any more money than I do now," he wrote, because "I am now in my prime and never can turn out any more work than I do now." Given the strain of the campaign against Tweed, in fact, he worried that he would work less in the year to come. In addition, Nast apparently had already lost money in bad investments. He said he "didn't mind it much," but now that he was thirty, "the chances of receiving such losses are smaller." "I know so little about investing money," he complained, "and yet ought to make the most of what I have." In a transparent pitch for Chipman's advice, he indicated that what he really needed was guidance from "a friend that is better trusted."[11]

Nast's essential conservatism regarding money appeared again when he briefly engaged the question of communism among working men. In a cartoon in which Nast portrayed communism as a skeleton, he lauded the New York Ironmoulder's Union, which had rejected communist ideas at a recent meeting. An accompanying article called communism "a foreign product" that could never "flourish" in the United States. Nast's sense that labor and capital shared a common interest appeared again in a small cartoon on the back page of that issue. "The American Twins," labor and capital, joined in "The Real Union," thus excluding communist ideas. He reinforced the point a month later, calling communism a "Foreign and Poisonous Weed."[12]

If he knew himself to be no expert on financial issues, Nast had no such qualms about his understanding of Catholicism. So while his commentary on fiscal policy filtered in through the years between 1873 and 1876, his attacks on the Roman Catholic Church and his certainty that it posed a threat to democracy never wavered. Nast brought a wealth of personal experience to his view of the church, and the cartoons that mocked it were perhaps the most vicious of all his cartoons.

Paine's biography suggests that Nast was raised Catholic, but he had a great deal of personal experience with Catholic immigrants as well. In the 1840s and 1850s, the vast majority of the Irish, as well as a substantial proportion of the Germans, in his neighborhood were Catholic. Nast's early work experience reinforced his interest in, and disdain for, the Irish.[13]

Illustrated journalism brought Nast into direct contact with the public discussion about the place of the Irish in American life. Papers like *Frank Leslie's Illustrated News* loved to cover sensational stories involving murders, corruption, illegal boxing matches, and barroom brawls.[14] More often than not, the Irish were the major players, simply by virtue of their demographic dominance. City residents had a special interest in gang activity, so the presence of notorious Irish gangs in New York naturally drew newspaper attention.[15] The role of the Irish in New York's politics was also a closely examined topic. For decades, illustrated magazines and newspapers' portrayal of political corruption reflected the view that the Irish were the most important—and most dangerous—voting bloc in the city. Prominent New Yorkers "held Democrats politically responsible for the Irish, whose high crime rate was considered proof of their racial degeneracy."[16]

If the workplace reinforced Nast's personal interest in the Irish, an existing cartoon tradition provided a template for their portrayal. Informed by British cartooning traditions, Nast drew the Irish with ape-like features. Noting the power of journalistic artists, L. Perry Curtis Jr. has written that cartoons "served more than the negative function of exposing the vices of men and the absurdities of party politics." They were a vector for "certain values and ideals" that reflected not only those of the paper or magazine's managers but also those of the community.[17]

Nast's version of the Irish was, indeed, a reflection of his community's view of them. The existing stereotype of the Irish held that they were "servile, uneducated, unaccustomed to self-government or the rule of law itself, prone to take liberty as an excuse [to] cast off inhibition," and "a substantial danger to a self-governing republic."[18] Made visual, the Irish appeared as dirty, ragged, boorish louts. They were pictured drunk, wearing a tall hat, carrying a pipe, and stomping all over the land of liberty in their thick workman's shoes. But it was their faces that best reflected stereotypes about them.[19]

In British cartoons and caricatures, the Irishman had an elongated upper lip and the sloping facial structure and jutting lower jaw suggestive of a gorilla. He had thick, fleshy lips and coarse skin, often dotted with unruly hairs or moles. Rotten teeth were featured prominently, and facial

hair was unkempt. *Punch* explained this choice of features when it opined that the apparent evolutionary gap between black men and gorillas (a difference assumed to be self-evident) was bridged by the Irishman. The Irish were "a climbing animal, and may sometimes be seen ascending a ladder laden with a hod of bricks."[20] Irish posture in cartoons reinforced the simian analogy; Irish men were shown stooped, sometimes humpbacked, and often holding a single arm aloft in a gesture of wild exultation, and they often appeared to be dancing with glee at crime, violence, and drink. But of all these qualities, their violent tendencies were the most common and the most dangerous. A British cartoon by George Cruikshank, published in 1845 to illustrate a history of the 1798 Irish rebellion, shows a crowd of Irish men murdering an old man and his granddaughter. Some of the men grin as they pierce their victims with pikes. So out of control are they that they are even moved to murder the man's dog.[21] Nast echoed this emphasis on violence in a cartoon that shows a scowling Irish thug perched atop a keg of gunpowder, brandishing a lighted torch with which he has already lit the fuse.[22]

Nast's Irish images reflected the existing cartoon conventions almost exactly. Two of these are among his best-known cartoons. "This Is a White Man's Government," which appeared in *Harper's* on September 5, 1868, shows the three pillars of the Democratic Party: former Confederates, northern capitalists, and Irish thugs. They stand over a black veteran, preventing him from reaching the ballot box. The Irishman, who stands on the left, his arm lifting a cudgel labeled "A Vote," demonstrates Nast's adoption of simian iconography. The man's nose is turned up, his jaw is huge and square. His wild eyes promise violence and mayhem, while his ragged pants and workman's boots suggest his poverty. A scene from the Draft Riots peeks out from the left background, where the burning Colored Orphan Asylum appears shrouded in black smoke.[23] A second image, "The Ignorant Vote—Honors Are Easy," in which Nast was comparing the black and Irish votes, shows an enormous scale balancing a black man in one pan with an Irishman in the other. Again, the Irish man has a turned up nose, lantern jaw, heavy sideburns, and thick stubble. Although neither tips the scale, the facial expressions of each man are telling indications of Nast's position. The black man, barefoot, his thick lips and teeth exaggerated in size, smiles broadly. His Irish counterpart seems to growl. It is the Irish, the picture seems to suggest, who are more dangerous. Both groups may be ignorant, but the black citizen is the lesser threat to the American polity.[24]

After violence, the greatest threat the Irish were believed to pose to

American life was their commitment to Roman Catholicism. While some scholars have interpreted Nast's opposition to the Catholic Church as anti-clericalism rather than anti-Catholicism, Nast's attacks on Catholic influence in schools, government, or society were unequivocal.[25] Nast scholar Kendall Mattern interprets Nast's opposition as the response of a liberal to the reactionary public pronouncements of Pope Pius IX. In his "Syllabus of Errors," Pius stated that the pope has no obligation to embrace "progress, liberalism, and contemporary civilization."[26] Doubtless, this raised Nast's ire. Still, Nast's violent dislike of the Irish and their connection to Roman Catholicism suggests a more obvious source of his anger. In either case, Catholicism and the Irish were inextricably linked in Nast's mind and work.

Both fiscal policy and the role of Catholicism in American life operated within an essentially political framework. But by the 1870s, Nast's work touched on much more than the political. His Santa Claus drawings, powerful enough to remain popular in the twenty-first century, grew from a *Harper's Weekly* Christmas tradition into a small business of their own. For Nast, they not only became a second legacy but a way to celebrate the family life he so cherished.

By the time Thomas Nast had children of his own, Christmas had become the ultimate family holiday. It had not always been so. From a season of misrule characterized by drink, of the inversion of social roles in which working men taunted their social superiors, and of a powerful sense of God's judgment, the holiday had been transformed into a private moment devoted to the heart and home, and particularly to children. The process had taken the better part of a half century, but it reflected the rise of the middle-class ideal of the home that Nast adopted enthusiastically. He loved the idea of the roaring fire, the sleepy children, and Santa Claus's visit in the depths of the night.[27]

Personal, familial, illustrative, and emotional, Nast's drawings of Santa Claus occupy a cultural space separate from his political cartoons. They also reveal a great deal both about the values that motivated Nast and the social context in which he worked. For a man who entered the United States as a Bavarian (possibly Catholic) immigrant, the enthusiastic embrace of all things middle-class offers a striking sense of the power of social norms.

Nast began to draw Santa during the Civil War. Beginning in 1863, his illustrations emphasized Santa's sentimental and patriotic role. The first Santa illustration appeared in *Harper's* on January 3, 1863. Santa appears in a Union camp, distributing gifts and spreading cheer. As with all his Christmas illustrations, Nast underlined the presence of children—in this

case two boys in the foreground who appear fascinated by a jack-in-the-box. Santa's devotion to the Union cause cannot be mistaken; he wears a star-covered jacket and striped trousers, echoing the American flag (which helpfully flies just above him, for those who missed the reference).[28]

In the same issue, Nast asserted the centrality of family to the war effort, and again Santa appeared. On the left, as mother prays for the safe return of her husband, Santa creeps in through the chimney to bring Christmas cheer. On the right, father sits at his lonely campfire, staring at a family portrait while Santa drives his sleigh above, distributing presents as he goes.[29] In other drawings, during the war and later, Nast returned to the same themes.[30]

By the 1870s, Nast's Christmas drawings had become a staple of *Harper's* seasonal fare. They tended to be large, complex drawings with a profoundly sentimental core. "The Same Old Christmas Story Over Again," for example, offered a double-paged swirl of illustrations of classic stories around the peaceful faces of two sleeping children. It was a drawing and a puzzle, challenging readers to find in the intricate lines of the engraving tiny references to other tales, "half hidden amidst clustering locks or in the folds of the bedclothes."[31]

From its inception, *Harper's Weekly* served a dual purpose. It provided political news and commentary on national and international events, but it also offered readers sentimental fiction, humor, and cultural news. For example, *Harper's* routinely reviewed and published drawings of the exhibitions of the National Academy of Design. A long-running column, "Humors of the Day," specialized in jokes about housewives, country bumpkins, and foolish immigrants. In an 1877 column, this joke appeared: a rural paper receives a question regarding "how long cows should be milked." Answer? "Why, the same as short cows, of course." Another joke began with "a great drinker" at the dinner table. When offered grapes for dessert, he declines, saying, "Thank you, I don't take my wine in *pills*."[32]

Nast's Christmas drawings fit into this second purpose for *Harper's*. When he was a young illustrator, they made him a more valuable employee and padded his income. Paid per page, he needed to find ways to induce *Harper's* to buy more of his work. But Nast's Christmas drawings benefitted from the same penetrating eye as his political work. He touched an emotional nerve with readers, and gave them beautiful, detailed renderings of the joys and bittersweet sorrows of the holiday season. So even when Nast's political work catapulted him to fame and fortune, and even when his an-

"*Santa Claus in Camp,*" Harper's Weekly, *January 3, 1863.*

"The Same Old Christmas Story Over Again," Harper's Weekly, *January 4, 1873.*

nual contract freed him from concerns about a per-page pay rate, he continued to enjoy his Christmas work.

Santa occupied a central place in Nast's Christmas imagination. Santa was rotund, white-haired, bearded, and always smiling. He smoked a long pipe and wore a fur hat. He echoed, in short, the Pelze-Nicol of Nast's childhood memories. In Bavaria, he told his biographer, children waited for Pelze-Nicol to bring them "toys and cakes, or switches, according as the parents made report."[33] His 1874 cover, "Christmas Eve—Santa Claus Waiting for the Children to Get to Sleep," provided a typical representation. In this image, Santa is perched on the chimney with his bag of toys. "Ho! Ho! My fleet coursers! You've brought me too soon," ran an accompanying poem. Santa's round belly and smiling cheeks reinforced Nast's immersion in the new, family-oriented culture of Christmas. "The glory and honor that's most to my mind," says Santa in the poem, was to be "in the hearts of the children enshrined." Like Santa, Nast considered Christmas a holiday devoted to childish delight, pleasure, and innocence.[34]

Christmas cartoons also allowed Nast to indulge his love of detail. Unlike Nast's political cartoons, which he had to conceive and then draw in a short

"Here We Are Again!," Harper's Weekly, *January 5, 1878.*

period of time in response to the events of the moment, Christmas drawings might percolate all year in the artist's imagination. His home provided inspiration, too. Its busy decorative scheme, crammed with objects ancient and bizarre, helped spark Nast's creative energies. In the first issue of 1878, for example, he joked that Santa had arrived a bit late. Meeting the New Year at the hearth, St. Nick is surprised to find that he is so far behind. The drawing fairly bursts with intricately drawn detail. Plates adorn the wall on either side of the hearth, and among the vases on the mantel are bits of evergreen for the season. Two cats and a dog snooze by the fire, and next to them are a mounted toy soldier, dolls, drums, blocks, and a picnic set. A fully set buffet to the right of the hearth complements the small Christmas tree to the left. Even the hearth itself is carved and/or painted with details. In short, no surface in the drawing is left unadorned.[35]

The Christmas images became a cherished part of Nast's professional life. They helped to expand his reach from the realm of politics into the social life of Americans. His biographer, who grew up in the Midwest, recalled sitting with a copy of *Harper's Weekly* in front of his own hearth at age five trying to discover whether Santa considered him a good boy or a bad one.

Readers of *Nast's Almanac* doubtless enjoyed the holiday images he offered them. In later years, the Nast family reused some images for Christmas cards. In a culture that increasingly embraced sentimental evocations of the family, Nast's Christmas drawings provided a perfect view of the idealized home. Children slept peacefully, a fire roared in the hearth, and prosperity brought loads of Christmas booty for everyone.[36]

Throughout his career, Nast was accused of harming the political process with his cartoons. Indeed, the clash over that question eventually soured his relationship with Curtis and the Harper family. But they were only the nearest critics. From across the political and social spectrum, observers attacked Nast when they disagreed with him and when they thought he had gone too far. Christmas drawings failed to muzzle the critics, but they helped to soften Nast's public image. They brought it back into harmony with his personality—driven and often devilish but also compassionate, family-oriented, and traditional.

Nast's Christmas drawings have proved the most enduring of all his work. Historians might dispute this judgment, since they continue to value Nast's work for its visual impact and utility in teaching nineteenth-century politics. But the staying power of Santa as Nast drew him is evident in surprising places. The famous Coca-Cola Santa Claus, which has remained popular since his introduction in 1931, mimics Nast's rendering almost perfectly. In 1979, the silverware and china maker Reed and Barton introduced a Christmas plate bearing Nast's image of Santa in profile. A Duncan Royale figurine based on a Nast drawing of Santa was being offered for an astonishing $1,500 in 2009. From 2002 until 2004, Wedgwood produced salad plates based on Nast's drawings, and Williams-Sonoma sold them at Christmas time. A book of Santa paper dolls by Tom Tierney featured two Nast drawings dating from 1863 and 1874.[37] Even the Library of Congress participates in the nostalgia for Nast's Santa Claus. Its "Christmas Coloring Book," available for purchase in the gift shop, boasts Nast's chubby 1890 Santa on the cover and two of his illustrations inside.[38] In short, Nast's Santa lives on, in a variety of venues. He influences American representations of St. Nick more than 100 years after his death, and the sweet, loving qualities that endeared him to children in the 1870s continue to appeal to modern sensibilities.

Themes like fiscal policy and anti-Catholicism dominated the cartoons Nast produced in the 1870s, and Santa offered an escape into fantasy every year. But Nast often digressed into smaller-scale, more local, or more nar-

rowly focused topics as well. These images reflect Nast's wide reading of the news. They also demonstrate his expansive imagination. If something caught his eye and suggested an amusing drawing, Nast let his pencil have its way. The last few pages of *Harper's Weekly*, which were devoted to advertising and often featured one or two very small cartoons, offered the perfect space for such drawings. Nast's campaign on behalf of the military offers an example.

Nast's patriotism included a devotion to the armed services. His wartime and postwar work emphasized service members' heroism—in terms of both their bravery and masculinity. After the war, shrinking federal budgets and the nation's fluctuating military needs led to a series of changes in military funding. At every stage, Nast supported the army and navy, arguing that they formed an essential component of national security.

In a May 1874 cartoon, Nast portrayed the military as a skeletal figure, starved of the funding it needed and deserved. His warning took on a more urgent tone in June. A nation that failed to maintain its military, Nast cautioned, could not expect effective fighting in future conflicts. Conflict in the West prompted further complaints. The army could hardly be expected to protect settlers and industry from Indians when it was a "mere shadow," Nast suggested in an August cartoon.[39]

Nast's support of the military was apparently well known and appreciated, because in December 1877, a veteran of the western fighting proposed to thank Nast with a testimonial and a gift. Colonel Guy Henry circulated a call to members of the army and navy to contribute twenty-five cents each. They would honor a man whose work demonstrated "to the country how the Army has been and is being treated." Two years later, Nast joined representatives of the army and navy in New York for the presentation of a decorative silver vase. In his dedication, General Thomas L. Crittenden praised Nast's "magic pencil." In a letter to Nast, William T. Sherman, who was unable to attend the event, echoed Nast's cartoon "The Ass and the Charger," noting that promises made in wartime often fall away once peace has been restored. But, Sherman wrote, however easily promises were abandoned, "when the danger is past, and peace reigns supreme," Nast never failed in his support for the army and navy. The subject of all this attention enjoyed it immensely. He liked to be recognized for his work, and it was especially satisfying to receive thanks from men whose work had been the object of his admiration for many years.[40]

Another example of Nast's roaming political interests appeared in

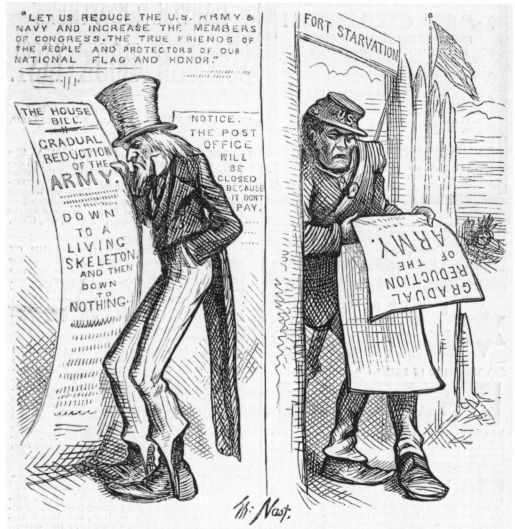

OUR LIVING SKELETON STANDING ARMY.

UNCLE SAM. "It's no wonder I have the reputation of being a mean Yankee."

U. S. SOLDIER. "Oh! why don't they put me out of this sham existence, and so end my sufferings?"

"Our Living Skeleton Standing Army," Harper's Weekly, *June 27, 1874.*

November 1873. In a small cartoon, "You Are Getting Too Big for Your Cradle," Uncle Sam admonishes Boston for annexing Charlestown, West Roxbury, and Brookline. Boston is pictured swollen with those acquisitions, outgrowing its "Cradle of Liberty."

In March a year later, Nast produced a flurry of pro-temperance images. The first, demonstrating Nast's love of historical imagery and Shakespearian language, appeared in early March. Joan of Arc, clad in armor and lifting her sword to the sky, stands triumphant atop the defeated dragon/bottle. "Do what thou canst to save our honor," he says. "Drive them from the country and be immortalized." Nast attacked again two weeks later, this time portraying the bar, staffed by a skeleton serving liquor, as the source of all social evil. In another image, a bottle of rum is in prison for "Manslaughter in the Greatest Degree," serving a sentence of hard labor. Though the temperance movement was one of the most widespread and powerful social movements of Nast's lifetime, and though he adhered to the most conventional view of appropriate middle-class family life, Nast only occasionally touched on the issue. He was more likely to portray drunken Irishmen in the course of an attack on the Irish community than to attack drinking for its own sake. But these cartoons suggest the depth of his commitment to the ideals embodied in temperance activism.[41]

Criticism of a new dog law, and of the behavior of police officers toward dogs, prompted two cartoons in July 1874. Copying the style of English painter Edwin Landseer's work with dogs, Nast offered sympathy to New York's dogs and criticism of the police. A short accompanying editorial blamed the police for "brutal and unnecessary clubbing" and other "flagrant abuses," justifying Nast's cartoon comment. These cartoons often provided useful concepts for Nast's larger themes. The dog cartoons, for instance, appeared during Nast's attacks on those fiddling with fiscal policy. So it comes as no surprise that he used the muzzling ordinance as a springboard to portray Senator Logan as a muzzled dog with a watering can labeled "inflation" tied to his tail.[42]

Consider a few more examples of the topics Nast addressed. Nast amused himself at the expense of the New England Woman Suffrage Association in January 1874.[43] In February, he eulogized the late operatic soprano Euphrosyne Parepa-Rosa with a full-page illustration.[44] In 1875, a rise in postal rates caught Nast's attention.[45] He protested vigorously both the increase and the retention of Congress's franking privilege.[46] In short, he tackled anything and everything that caught his eye. Although the 1870s were a

period of intense partisan cartooning for Nast, his work reflected his interest in and knowledge of the arts, society, and the family, as well as local, state, national and international politics.

Meanwhile, as Nast busied himself consolidating his celebrity, lecturing, and working on illustration projects, President Grant faced renewed attacks, this time focusing the question of whether he intended to seek another term. Convinced that he would, newspaper editors and political opponents initiated a campaign accusing the president of Caesarism, or wanting to install himself as an American emperor. James Gordon Bennett Jr., the editor of the *New York Herald*, aroused Nast's special attention on this front. In a series of cartoons, Bennett served as a symbol both of the foolishness of Caesarism and of the disproportionate power the press wielded.

Nast's most famous cartoon on the subject appeared in November 1874, just before the midterm elections. "The Third-Term Panic," described in great detail by historian Mark Summers, ridiculed the plethora of newspapermen who sensationalized the election in order to sway voters. It also introduced the elephant as Nast's symbol for the Republican Party. The press, Nast asserted in the cartoon, corrupted the electoral process. It drummed up unwarranted fear among voters, selling papers by exploiting public suspicions. Nast understood the important role journalists and editors played in politics. But by the mid-1870s, Nast perceived danger in editors' intruding into party politics, and his cartoons attacked the press and especially the editors of influential newspapers.[47]

Morton Keller argues that Nast began to see the press in this light during the election of 1872. Newspapers played a central role in the candidacy of Horace Greeley, a newspaper editor himself, and their increasing ability to make or break political careers gave them undue power over parties and officeholders. Even editors who espoused no particular party loyalty could damage political discourse when they elevated commercial success above principle by running sensational stories to sell papers. So when the outcome of the 1874 midterm elections seemed to hinge on the supposed desire of Grant for a third term and, by extension, on the idea that a corrupt Republican administration was making a power grab, Nast responded with an attack on the men he believed responsible for the Caesarism scare: editors.[48]

Bennett attracted the lion's share of Nast's ire. The editor of the *New York Herald* cut a flamboyant swath through New York society in the 1870s and 1880s. His paper reflected his personality: he was pugnacious, commercially

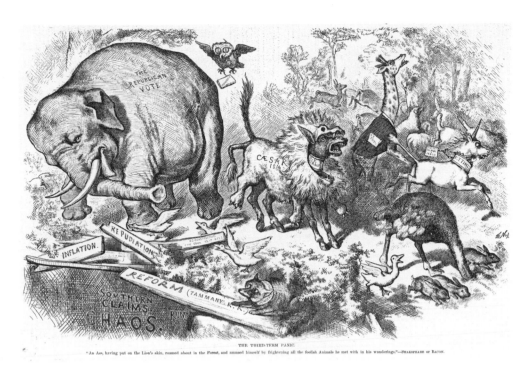

"The Third-Term Panic," Harper's Weekly, November 7, 1874.

savvy, and idiosyncratic. According to at least one historian, Bennett's emphasis on Caesarism reflected primarily business interests. He needed a hot-button issue to sell papers. The idea that President Grant might seek a third term might be just the thing. But whatever Bennett's motivation, the issue stirred a lot of American hearts. Corruption in the Grant administration and the increasing tug of war between the Democratic and Republican parties leant special power to the Caesarism scare. So the same controversy that Bennett relied on to sell papers captured Nast's attention not only because it might actually sway voters but also because Nast considered it an offensive lie.[49]

So he attacked. In October 1873, for example, Nast drew Bennett haunted by the ghost of Caesarism, a toga-clad jackass. "What do you see?" it asks, and answers, "You see an ass-head of your own; do you?" In another illustration that month, President Grant stands on the beach to insist that he could not "proclaim" himself Caesar just as he could not "compel the Atlantic Ocean to recede." At the end of the month, a Nast cartoon emphasized the way that the press could control national political discourse. Bennett appears here as a "herald," blowing his horn and bragging to Grant about his power. Two weeks later, Nast himself appeared playing a harp (that is,

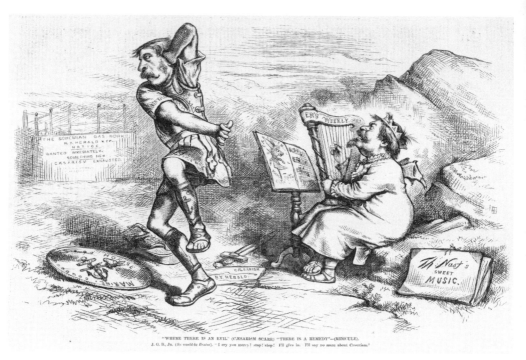

"*Where There Is Evil There Is a Remedy,*" Harper's Weekly, *November 8, 1873.*

Harper's Weekly), to drive home the point. Bennett begs him to stop playing "Th Nast's Sweet Music" and promises to "say no more about Caesarism."[50]

The idea that Grant wanted a third term seemed ridiculous to Nast. Or, at least, he enjoyed ridiculing it. As the midterm elections approached, he became increasingly pointed in his attacks. On an October 1874 cover he made the point by showing Grant bowed under "a world of care and responsibility." Tacked onto the globe he struggles under are an array of troubles, including "hard times," "Indian troubles," "Cuba," and the "White Leagues," as well as various other problems in the South. Meanwhile, the press, drawn as a pack of aggressive but tiny dogs, nip at the president's heels. "And they say he wants a third term," the caption reads.[51]

In late October, Nast put a juvenile Bennett atop the "Third Term Hobby-horse," where he tells Whitelaw Reid (editor of the *Tribune*), "You must take a back seat. I was on first." A ball at their feet demonstrates Nast's view that they played with "public men" as if politics were a game. As usual, Nast skirted hypocrisy. His own work employed ridicule as a weapon against politicians, and he reveled in the fun of mocking both the foolish and the great. But of course that was different. Bennett, Reid, and others attacked a

great man, President Grant, merely to sell papers. Nast honorably defended the president and party against them, he might have argued. Since he was on the side of the angels, or at least political seriousness, he could have as much fun as he pleased.[52]

The Republicans were in trouble, though. Nast fought so hard against the third-term "hoax" in part because it was an easy target. Other complaints lodged against the administration proved harder to dismiss. A series of scandals, starting with Credit Mobilier, pushed voters away from the Republicans. As one historian put it, it appeared as though there was "hardly a department of the national government but was alive with fraud." Even Nast had to take Grant to task for reappointing Alexander Shepherd, the embattled governor of the District of Columbia. Accused of profiting from his improvements to the city, Shepherd vigorously denied any wrongdoing. In a controversial July cover cartoon Nast drew a disgusted Columbia telling Grant, "Don't Let Us Have Any More of This Nonsense. It Is a Good Trait to Stand by One's Friends, But—."[53]

The *Tribune* pounced on Nast's critique, crowing that Nast had finally "abandoned" Grant and welcoming him to the ranks of "independent" journalists. On his current course, one wag noted, Nast would caricature "every prominent man in the country, no matter what his politics or style of religion." *Harper's* defended Nast. His cartoon only proved his claims of public-spiritedness. "He will not hesitate to use his pencil," editor William Curtis wrote, "in the cause of what he believes to be truth and justice and liberty and sound principles of government and pure administration." He shared with truly independent papers the "candor and courage" required to safeguard the nation. Like Nast's attack on Bennett's playing with politics, there was a whiff of falsity in Curtis's defense. The editor disliked Nast's caricatures. He considered cartooning a crude tool unsuited to the serious business of politics. But even crude tools could be useful at times. And in this case, faced with a scandal-ridden administration and the potential for major losses in November, Curtis embraced Nast as the standard-bearer of all that was good.[54]

Whatever Nast's powers, he could not save the Republicans in the election. Voters recoiled from the scandals of the administration, a reinvigorated Democratic Party managed to mobilize its voters, and the third-term accusation, however ridiculous to Nast, convinced some Americans to vote Democratic or stay home. The Republicans sustained devastating losses. More importantly, the fissures in the party, so visible in the election of

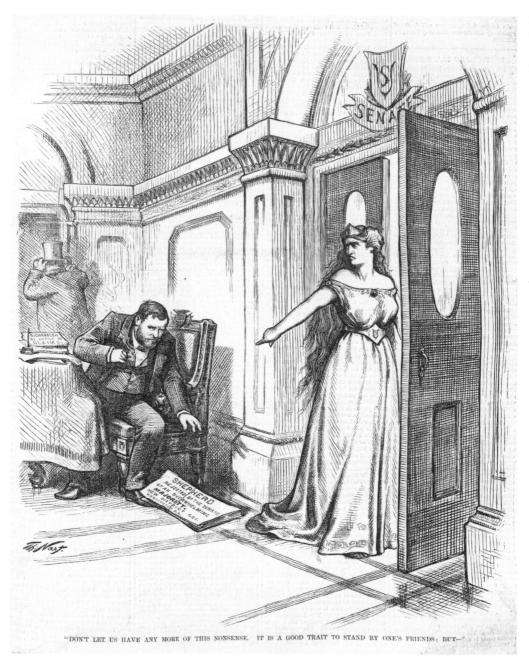

"DON'T LET US HAVE ANY MORE OF THIS NONSENSE. IT IS A GOOD TRAIT TO STAND BY ONE'S FRIENDS; BUT—"

"Don't Let Us Have Any More of This Nonsense," Harper's Weekly, *July 18, 1874.*

1872, widened. Nast reused his "Third-Term Panic" concept to warn Republicans of their peril. The elephant had been chased toward ruin by the braying press, and had now fallen into the trap. Bennett, "The Man Who Laughs," was to blame. As for the triumphant Democrats, Nast invited them to "Gnaw Away!" at the nation's problems. His implication, essentially a defense of Grant as well as the Republican congressional leadership, was that the country's problems were more serious and challenging than the Democrats realized.[55]

Conflict with Curtis

"I cannot do it. I cannot outrage my convictions."
—THOMAS NAST, quoted in Paine, *Thomas Nast*

"My feeling is that the country feels that there has been
rather too much bayonet."—GEORGE WILLIAM CURTIS,
quoted in Keller, *Art and Politics of Thomas Nast*

By 1876, Thomas Nast had every reason to rest on his laurels. His personal income was substantial, his fame was widespread, and his position at *Harper's Weekly* seemed unassailable. No one could have predicted that by the end of 1877 Nast's ongoing conflict with editor George William Curtis would become a public clash, destroying Nast's relationship with the magazine and with the Harper family. Nast continued to work for *Harper's* for another ten years, but the teamwork that characterized the paper in the 1860s and early 1870s was absent, and the ill feeling meant that Nast no longer communicated easily with the Harpers or Curtis. Nast withdrew more and more to his home in Morristown, and his attempts to secure a contract with another magazine or to collaborate with publishers and authors were frustrated by a mystifying series of rejections. After 1877, Nast's star was on the wane, and he was increasingly bitter about his inability to recapture the magic he had experienced during his glory years at *Harper's*.

A long time forming, the fight between Nast and Curtis had its roots in both personal and professional differences. The two men agreed on many things. They both valued honor in public life, decried hypocrisy and avarice, and believed that American government could be both highly moral and impressively efficient. The corruption of government, whether on the local level or the national, aroused both men to indignant fury. They agreed, as well, on the need for civil service reform, although Curtis fought harder for the latter. Differences eventually overwhelmed similarities, however.

At the root of the clash was that Curtis believed public life should be genteel. He found Nast's cartoons offensive for two reasons. First, they at-

tacked public men in personal ways. Caricature took a man's face and body and exaggerated his flaws until he appeared ridiculous. The black and white dichotomy of the cartoon universe cast men either as angels or devils, with hardly any room for the kind of complexity that Curtis saw in a public servant like Senator Charles Sumner. Second, Curtis objected to Nast specifically. The cartoonist's editorial independence challenged Curtis's role as political editor of the weekly. Curtis felt that his editorials ought to set the paper's policy. Nast should then cartoon in conjunction with that policy. In essence, Nast's work should reinforce what Curtis wrote, not contradict—and certainly not reject—it.[1]

For many years Nast and Curtis maintained a kind of polite standoff. Fletcher Harper protected Nast and guaranteed his editorial independence. Curtis remained political editor, and his essays expressed the paper's positions with force and elegance. In the wake of Rutherford B. Hayes's controversial election in 1876, Curtis disagreed with Nast over the new president's southern policy. Nast wanted to attack the withdrawal of federal troops from the South as an abandonment of the freed slaves. Curtis wanted to approve the president's policy so that Hayes could use his political capital for other policies, notably an attack on the spoils system. Working behind the scenes, Curtis convinced the younger Harpers to support his position. The struggle provided a tense undercurrent to the more public discussion of the election and its outcome. It was only with the death of Harper, in 1877, that Curtis found he could assert his power. After that, Nast's relationship with *Harper's Weekly* never recovered.

As the election of 1876 approached, "Caesarism" persisted. Democratic control of the House made the contest for the White House even fiercer than usual. More, the success of the Democrats in 1874 showed the potential value of the third-term question. So it kept coming up, and Nast kept attacking those who fretted about Grant's plans. He delighted, for example, in suggesting that James Gordon Bennett Jr. of the *New York Herald*, motivated entirely by a personal animosity for Grant, was acting blindly, ignoring the facts. In "Homo-Phobia," he hammered home the point with a series of slogans on the wall behind Bennett, pictured seated behind his desk. Grant appears on a plaque with "Our Target" printed above him; the goal, "Let Us Find Fault," is printed on the wall next to it; and the words "Our Motto 'Get Even'" appear above Bennett's desk. Miss Minerva, as Bennett's mother, worries that he is troubled by "too much brain work," to which her friend Miss Hygiene replies scathingly, "Brain! Oh, dear no! That will never trouble him." Instead, the "dyspepsia" of Caesarism is at fault.[2]

President Grant rejected the idea of a third term in May 1875. He would not seek nomination, he insisted, and would only accept it if circumstances demanded a personal sacrifice for the good of the nation. In fact, he expressed surprise that the Republicans had permitted the Democrats to "force upon them . . . an issue which can not add strength to the party, no matter how met." Writing at that time, Curtis acknowledged the president's point, and argued against the idea that Grant was conspiratorial. "There is nothing more absurd," Curtis insisted, "than the portrayal of General Grant as a dark, designing man, nourishing deadly ambition, and resolved to overthrow our liberties."[3]

But in December, when Grant issued his seventh message to Congress without reference to a third term, Curtis had a different opinion. The conflict simmering between editor and cartoonist flared briefly as Nast and Curtis diverged yet again. In "The Blighting Effect of the President's Message," Nast mocked editors disappointed by Grant's silence on the coming election.[4] But Curtis was one such editor. His column that week called Grant's silence on the issue an "evasion." The *New York Times* picked up the dissonance immediately. One of the editors in Nast's cartoon has his back turned to the reader. Was it supposed to be Curtis? The *Times* thought so. Other papers repeated the charge, spreading the notion that "there was a lack of political unity in Franklin Square."[5] This cannot have eased Curtis's concerns about Nast's editorial independence.

Much of Nast's energy in the weeks leading up to the Republican convention was expended in mocking Grant's enemies. Despite abundant evidence of official corruption at the White House, Nast portrayed investigations as motivated by personal animosity and fruitless.[6] When it came to the charge of Caesarism, the fact that Nast was correct, there would be no third term, little consoled him for the loss of the man Nast considered America's greatest hero. Still loyal to the Republicans, Nast was nonetheless bitter about the way that Grant had been treated. He felt that Grant's subordinates had betrayed the president by their malfeasance, and that the party had failed to support its most senior representative.

Moreover, Nast had imbued Grant, in his own mind and in his work, with an aura of idealized honorable rectitude. Whoever the party nominated at Cincinnati, in Nast's eyes, would be a man far less than Grant.[7] Given the personal, visceral nature of political cartooning as Nast practiced it, this meant that the candidate could not look forward to the kind of powerful defense Nast had marshaled for Lincoln and Grant.

Rutherford B. Hayes hardly inspired passionate diatribes or personal

sacrifice. His nomination was a compromise calculated to appease feuding groups of Republicans who could not agree on the direction of the party, and while Hayes was a perfectly respectable Republican, he was not a man whose record brought forth hordes of supporters or detractors.[8] In addition, it seems that Hayes joined Curtis and other Republicans in an attempt to silence Nast in 1872. The attempt failed, but if Nast was aware of it, his support for Hayes could not have been wholehearted.[9]

Still, Nast was a Republican through and through. Since his political awakening during the Civil War, he had never wavered in his support of the party. He had even predicted Hayes's nomination, albeit for vice president. On the June 24, 1876, cover illustration of *Harper's*, Nast drew himself holding a chalk slate, offering Hamilton Fish for president with Hayes as his running mate. Although he was wrong about the presidential nominee, and Hamilton Fish failed to win nomination for any office, Nast enjoyed having predicted Hayes's ascendancy. So Hayes could look forward not to the level of passionate defense Grant received, perhaps, but at least to a goodly portion of cartoon bile on his behalf and against the Democrats.[10]

Yet Nast never drew Hayes. Hardly a single major political figure escaped Nast's pencil, but he pointedly avoided representing Hayes. A single sketch, believed to be Nast's, currently held in woodblock form at the Metropolitan Museum of Art, is probably of Hayes, but there is no attribution, no caption, and no context.[11] Nast's failure to draw *any* major political figure was odd; ignoring a presidential candidate was unprecedented. Nast had taken artistic stands in the past, notably his refusal to mock Grant in cartoons. Grant appeared in cartoons, but usually as an honorable foil against which other figures appeared as hypocrites or criminals. Similarly, in 1880, Nast insisted on treating the Democrat General Winfield Scott Hancock gently, asserting that Hancock's war service had been so exemplary as to insulate him from public mockery. Hayes had been a brigadier general for the Union, but Nast did not idolize Hayes as he did Grant.[12]

One explanation of the absence of Hayes from Nast's work lies in Hayes's relationship with Curtis. In an 1876 letter to Judge W. M. Dickson, Hayes referred to Curtis as one of America's "great political writers" and speculated that no one could achieve Curtis's level of expertise. This letter, which Dickson passed on to Curtis, elicited a promising response. Curtis outlined which Republicans supported and which ones opposed Hayes's nomination, suggesting that if a compromise could be found, Hayes might become the party's nominee. Good feeling between the two men continued, later prompting Hayes to invite Curtis to provide guidance on appointments in

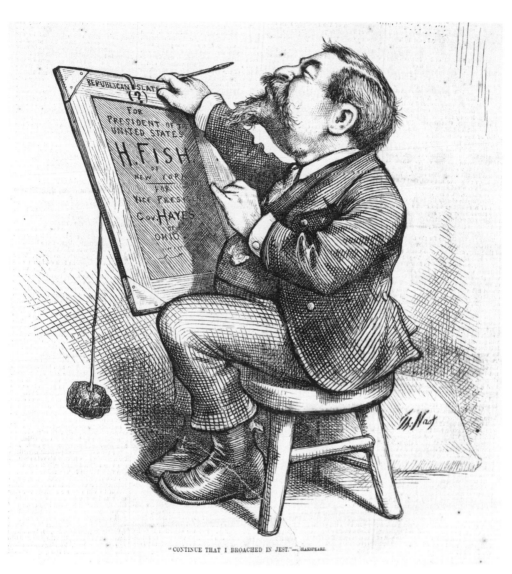

"CONTINUE THAT I BROACHED IN JEST."— SHAKSPEARE.

"Continue That I Broached in Jest," Harper's Weekly, *June 24, 1876.*

civil service reform for an upcoming speech. In 1879, Hayes and his wife attended a New Year's Day address by Curtis at the Academy of Music in New York, an event Hayes recorded with compliments in his diary. Given the growing hostility between Nast and Curtis in 1876, Nast may have perceived the friendly relations between Hayes and Curtis as yet another example of Curtis cultivating political friendships when he ought to be objective. Failing to portray the candidate might have been a ploy to needle Curtis, or it simply reflected Nast's antipathy to Hayes.[13]

In 1876, however, there was no explanation of the absence of Hayes from Nast's work. Because Nast continued to support the party platform and to attack the Democrats as viciously as ever, the absence of Hayes from his drawings drew little public comment. He reserved special venom for Democratic presidential candidate Samuel J. Tilden's war record, showing two veterans asking, "Whose side were you on?" and Tilden stammering, "I—I was—busy in court with a *Railroad Case!*"[14]

Some of Nast's attacks on the Democrats went so far that they seemed implicitly to criticize the Republicans as well. Nast built on the terms of the 1876 party platform. In stirring language, the party "sacredly pledged" itself to protect the rights of the freed slaves.[15] Reminding the public of the depredations of the Redemption governments, the White Leagues (inheritors of the white supremacist tradition of the Ku Klux Klan), and southern Democrats, Nast asserted a highly idealized role for Republicans. A late summer eruption of racial violence in South Carolina only reinforced Nast's partisan approach.[16]

Just months before Americans went to the polls, South Carolina's social fabric began to unravel. In July, a white militia attacked a group of black militiamen in Hamburg. Black South Carolinians fought back against the steady stream of harassment at Cainhoy, but whites responded with more violence across the state. Thus race became even more central to the election both in South Carolina and on the national stage. Nast commented repeatedly, for example on September 2, 1876, when he drew a grieving black man standing over the bodies of his family. He asks, "Is *This* a Republican Form of Government?" Government by the Democrats meant racial violence and the tyranny of the vigilante, Nast cried, and all right-thinking voters must resist. The Republicans, in particular, ought to honor the "sacred pledge" of their platform by protecting southern Republicans.[17]

Ultimately, the election proved a mess. Neither Hayes nor Tilden won a clear majority, and three contested states (South Carolina, Florida, and Louisiana) could not determine the winner for some time. Congress attempted unsuccessfully to find a solution. An electoral commission was formed to determine the winner, but its deliberations took place against a backdrop of partisan, and often bitter, disagreement. Its fifteen members voted along party lines, awarding Hayes the White House. Outraged by their loss, some Democrats threatened filibuster or even violence. Fresh negotiations began, motivated in part by the hope that Hayes could still be inaugurated in early March. The result—the Compromise of 1877—balanced Hayes's victory with formalizing the end of Reconstruction. As president,

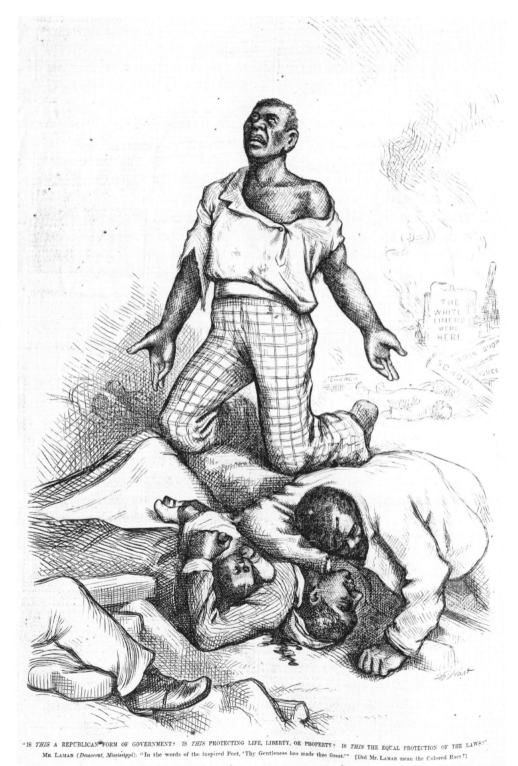

"IS *THIS* A REPUBLICAN FORM OF GOVERNMENT? IS *THIS* PROTECTING LIFE, LIBERTY, OR PROPERTY? IS *THIS* THE EQUAL PROTECTION OF THE LAWS?"

MR. LAMAR (*Democrat, Mississippi*). "In the words of the inspired Poet, 'Thy Gentleness has made thee Great.'" [Did Mr. LAMAR mean the Colored Race?]

"Is This *a Republican Form of Government?,"* Harper's Weekly, *September 2, 1876.*

Hayes would permit "home rule," which really meant abandoning southern blacks and accepting the changes of the Redemption movement. It was a compromise with much to recommend it on the national stage. For Nast, though, it heralded the beginning of the fiercest period of his conflict with Curtis.[18]

This period is important to Nast's life story for two reasons. First, the fight marked a turning point in Nast's career. He was famous, wealthy, and accomplished. As Roger Fischer has argued, Nast was the first cartoonist to enjoy not only a "mass-circulation" audience but also a "continuing audience for which to develop sustained themes."[19] It seemed he would continue to influence American politics forever. Yet after he lost his battle with Curtis, Nast's fortunes, both political and personal, began to decline. More and more, his style seemed dated, his primary concerns out of step with his audience, and his personality a little too pugnacious for his employers. His partnership with *Harper's*, so long an element of his success, started to seem like a straightjacket. Later, he sought a place outside of the weekly but failed to find one. Second, this conflict points to what is essential to a political cartoonist's work: editorial freedom. As long as Nast felt he could comment in any way he liked on any issue which aroused his ire, his work was fiery and effective. He hated the sense that his drawings might be rejected; thus after 1877 he submitted fewer drawings and the periods of profound inspiration occurred less often. This episode illuminates the ways that Nast's independence fueled his inspiration.

The battle between Nast and Curtis began in the late 1860s. Both men supported congressional Reconstruction, but they differed about the appropriate role for cartoons in political discourse. Curtis objected early on to Nast's approach when Nast caricatured Charles Sumner. Later, when Nast took positions that differed from Curtis, the editor tried to convince the Harpers to muzzle their cartoonist. At the very least, Curtis thought, he ought to be made to work within the editorial boundaries Curtis established. If, as editor, he could not determine the paper's stance, what was his role? Between 1868 and 1872, Curtis repeatedly complained to Nast and Fletcher Harper about the effects of Nast's cartoons. In every case, Harper supported his cartoonist while reassuring Curtis that nothing could be more important to the weekly than his editorials. It was a delicate balance, but one that Harper managed gracefully.

Nast's drawings in the late fall of 1876 and early winter of 1877 showing the Democratic/southern violence that Tilden supporters threatened appeared as usual in places of prominence in the paper. The cover, the first

full page after the inside double-page editorials, and the next to last page, where smaller versions of lesser drawings appeared, all remained Nast's territory. On March 5, Rutherford B. Hayes publicly took the oath of office. This should have been a great moment for Nast, and he was indeed pleased at the outcome. He continued to caricature Tilden, mocking his attempts to thwart the Republicans and his ire at having lost. Then, not quite suddenly, Nast's cartoons became less pointed, less timely. They shifted to focus on foreign affairs, on smaller issues, and on allegorical farewells to Grant.[20]

At the same time, Hayes enacted the program for which he is best known today: the removal of federal troops from the South.[21] As Hayes envisioned it, this was a "peace policy" based on the notion that North and South were brothers rather than enemies. In order for North and South to reconcile, Hayes argued in his inaugural, the government had to abandon coercion.[22] This action, which essentially abandoned the freedmen to fend for themselves against local whites, was exactly the kind of thing that normally would have moved Nast to venomous creativity. Curiously, his pencil was almost silent. His only comment was an oblique reference to the removal of Russian troops from Alaska, in which "Caucasian" bears comment on their freedom to do as they please.

What could explain Nast's silence on the new southern policy? It wasn't as if Harper's itself was silent. Indeed, Curtis's editorials reinforced the president on every point. Far from denouncing southern violence, which he had done throughout the fall, Curtis now seemed to believe that southern whites held the interests of their black neighbors close to their hearts. Who better, Curtis asked, to determine the civic order of the South than the educated, landowning class of gentlemen who had the greatest stake in the region's success?[23] In addition, Republicans, who had been increasingly divided on a variety of fronts for years, were further weakened by the election controversy. Curtis, who was devoted to civil service reform and to the continued power of the Republican Party, feared the results of any further strain on party unity and power. He was sincere in his editorials about the South, but more important, he knew that in supporting the president he was working to preserve what he thought mattered most.

Gradually, public comment on Nast's silence became a steady rumble. It was not a secret that Nast and Curtis often disagreed. They had done so publicly with regard to Carl Schurz and the corruption of the Grant administration, as the Nation reminded its readers. Perhaps, the Nation asserted, Curtis was finally exerting himself to establish editorial "harmony." The Semi-Weekly Observer noted Nast's silence, as did the Daily Graphic.[24]

Commentators even took sides in some cases. The *Chicago Inter-Ocean* reprinted a *New York Post* comment on Nast and Curtis's disagreement, adding, "Nast and George William Curtis are rival editors on the same journal, *Harper's Weekly*. . . . Nast hits the nail on the head every time he strikes, because of his great singleness of purpose. Curtis strikes wildly, hurting nobody, not even the enemy."[25] Comments like these, which Nast preserved in his scrapbooks and Albert Bigelow Paine included in his biography of Nast, helped to buoy the cartoonist and assure him that he need not back down.

The public did not know that Nast had been forcibly silenced. The euphoria that accompanied Hayes's inauguration had hardly worn off when two of the younger members of the Harper family, Fletcher Harper's nephews Joseph W. "Joe Brooklyn" Harper Jr. and John Henry Harper, rose to take over the weekly. Although they had worked for *Harper's* most of their adult lives, and had been raised on the stories of Nast's fight with the Tweed Ring, neither of these young men had the same attitude about the paper as their predecessor.

For Fletcher Harper, *Harper's Weekly* was not only a business enterprise; it was a labor of love. Like many of the founders of illustrated magazines, especially Frank Leslie, Harper was involved in every aspect of his product throughout his tenure. He attracted talented contributors and then allowed them a great deal of editorial freedom. This was as true of Nast as it was of Curtis. In fact, B. R. Cowen of the Department of the Interior complained in an 1872 letter to Rutherford B. Hayes that "Nast seems to be allowed *carte blanche* in his cartoons as Curtis is in his editorials."[26] Fletcher Harper's nephews, on the other hand, were concerned more with the commercial viability of the newspaper than with its content, so they were reasonably open to Curtis's argument that he, as political editor, should determine editorial policy.[27]

There was a personal element to their susceptibility to Curtis's arguments as well. In making a choice between Curtis and Nast, Joe Brooklyn and John Henry Harper relied on their personal, as well as business, knowledge of both men. Curtis and Nast could hardly have been more different. Curtis was an elegant, studied intellectual. Little given to emotional outbursts, Curtis cultivated a wide circle of influential friends with whom he carried on extensive correspondence on public affairs and questions of political philosophy. He was committed to social and civic reform, especially to the rights of women and to the alleviation of urban blight.[28] Married to a sister of charity reformer, Josephine Shaw Lowell, Curtis was steeped both personally and publicly in the politics of social reform. He was the personi-

fication of the "best men" of the Gilded Age who devoted themselves to the improvement of American life and government. In this capacity, Curtis was deeply involved in the internal debates of the Republican Party, participating in conventions and back-room deals throughout his career.

Nast, on the other hand, was very much the clown. Given to dapper ensembles, including a silver-headed cane (which he carried under his arm) and carefully shaped fedoras, Nast enjoyed dressing up.[29] In several photographs taken by his friend Napoleon Sarony, Nast appears in costume. In one, he is wearing a wide ruff and appears to be wrapped in a blanket. Nast enjoyed games, especially with children, and was frequently boyish.[30] John Henry Harper remembered one occasion in which he arrived home from the *Harper's Weekly* building in Franklin Square to find his house in an uproar. From upstairs came crashes and bangs suggesting that a herd of elephants was rampaging through the parlors. Upon inquiry, he was informed by the butler that Mr. Nast had come to call. Finding Harper still at work, Nast had begun to play hide and seek with the children, and they were currently racing through the upstairs, heedless of anything in their path.[31]

Because of his abbreviated education and his struggle with English, Nast could not carry on the kind of correspondence Curtis so enjoyed. Uncomfortable with intellectuals, Nast gravitated instead toward men with rougher personalities, like Grant and Mark Twain. Curtis traveled the nation, delivering lectures on social, philosophical, and political themes. Rhetorically powerful and even witty at times, Curtis was at ease with the richest, best-educated, and most influential men of his time. The class difference between Nast and Curtis alone was enormous. In addition, although Nast regularly editorialized about the Republican Party, and his comments were often remarked upon, he was never personally involved in the party's internal politics.[32]

The most famous example of Nast's comments being remarked upon was the reference to *Harper's Weekly* by Roscoe Conkling, the "King of Spoils," at the New York State Republican convention in 1877. Rising after a long, righteous civil service reform speech by Curtis, Conkling began to attack Curtis's ideas and suggested that Curtis was slightly effeminate, perhaps not quite the man to dictate Republican ideals. As he spoke, Conkling looked down at Curtis, indicating clearly to whom his remarks were directed. The final blow was his reference to *Harper's Weekly*, "that journal made famous . . . by the pencil—of Thomas Nast!"[33]

As much as they disagreed, however, it was the two men's similarities that made it possible for them to work together for as long as they did.

Thomas Nast. Courtesy of the Rutherford B. Hayes Presidential Center, Fremont, Ohio.

Both professed a deep devotion to the causes upheld by the Republican Party and sympathized with the plight of black Americans in the South and elsewhere. For both, honesty and moral uprightness were powerful forces in politics, and ought to be rewarded. They agreed that corruption should be fought at every turn, especially when its victims were the powerless: women, orphans, former slaves, or immigrants.

Faced with a conflict between these two men, each believing that his work was the reason for *Harper's* success as a medium for public discourse, the Harpers had to decide whom to support. Nast was clearly at a disadvantage in terms of his access to the Harpers. Based in Morristown, Nast communicated with the company via telegrams and letters unless he chose to board the train for a day in New York. Thus removed from the daily operations at Franklin Square, he did not have the kind of sustained contact with the new editors that Curtis enjoyed. Both Nast and Curtis had watched the younger Harpers grow to maturity, but Curtis had more access to them now.

Curtis made the most of that access. He renewed his objections to Nast's editorial independence on several levels, outlining a theory of editorship in which he, as the effective creator of the magazine's positions, should control the content of all contributions. These were arguments Curtis had been making since at least 1872, and they highlighted both his sincere desire for *Harper's* to be the best magazine possible and his personal discomfort with cartooning as a political tool.

What Curtis wanted was for Nast to draw cartoons that reinforced, but never deviated from, *Harper's* editorial position. He also wanted Nast to refrain from caricaturing prominent Republicans, many of whom were Curtis's friends. Curtis believed that the paper reflected on his personal honor as well as his political positions, so he was very much aggrieved whenever the paper took a stand that he personally did not support. Nast had fewer restrictions, for a variety of reasons.[34]

First, he had fewer friendships with prominent Republicans than Curtis, so there were fewer friends to offend. Nast refrained from attacking men he admired, like Grant, Hancock, and other Civil War figures, but he rarely pulled any punches. Nast visited Washington many times, but he never lived there, so he did not cultivate a regular circle of friends with whom to socialize. In letters home, it is clear that when in Washington he enjoyed an active social life, but this was more an outgrowth of his celebrity than a reflection of his personal relationships.[35] "I do not think any caricaturist has ever become a popular society man," he would tell audiences at his chalk

talks. "If he is a truthful character delineator, his ability cannot recommend him to a circle where flattery is an indispensable article and the taffy must be passed around without vitriol."[36]

Second, unlike Curtis, Nast did not believe that caricature was inherently insulting. In this, Nast and Fletcher Harper agreed.[37] Curtis repeatedly argued that cartoon images of prominent public servants were disrespectful. The purpose of caricature was to exaggerate and to mock, Curtis believed, and no amount of political content erased that essential nature. Other editors agreed. The *Nation*, editorializing in 1871, praised Nast's work against the Tweed Ring. His cartoons deserved attention, the magazine wrote, in part because they never stooped to be "weak, or paltry, or vulgar." Nast's restraint impressed readers, the editorial went on, because Nast was the man "whose pencil caricatures were teeming every week for so long." In other words, a caricaturist highlighted minor characteristics in a vulgar way to mock without purpose. Nast's Tweed work transcended this problem.[38]

Nast could hardly be expected to embrace this view of caricature, as it would invalidate his great talent. Instead, he accepted the fact that men rarely enjoyed caricatures of themselves and argued that politicians and public servants must embrace increased scrutiny. Caricatures, he explained, point out that politicians and public figures "have become people of importance or they would not be thus represented." Thus satire reflected "distinction" and fame. Even when politicians were portrayed in an unflattering way, Nast argued, they preferred such attention to "oblivion and the silence that consigns him to a back seat as if he was too small to be seen or heard." Sliding into cynicism, the cartoonist went even further: "The love of publicity seems to be pretty deeply implanted in the human breast," Nast wrote, "and if he can't have fame, he will accept notoriety." Thus, by implication, Curtis was fighting to protect public men from attention they actually craved. Nast acknowledged that caricature could be crude, mean, or even cruel, but these were the hallmarks of the amateur. A true caricature reflected the faults of the subject and commented upon them in a constructive way. It was an "encouragement and compliment," according to Nast. Regarded in this light, Nast argued, caricatures were more valuable than some formal portraits. Portraits of Lincoln, Grant, and William T. Sherman, Nast told his chalk talk audiences, were often much more insulting than any well-drawn caricature.[39]

Indeed, in Nast's defense, Curtis's position seemed naive in light of the vicious sniping and personal attacks characteristic of Washington politics. In his memoirs, Carl Schurz provided a taste of the kind of parlor

talk Washington thrived on. Describing Republican congressman Thaddeus Stevens, Schurz noted his elongated face "topped with an ample dark brown wig which was at the first glance recognized as such." In an atmosphere replete with political, personal, racial, religious, and regional attacks, Nast must have found Curtis's opinion about caricature bizarre.[40]

The third reason that Nast had fewer restrictions was that he simply did not see *Harper's Weekly* as his personal organ. If Curtis's positions differed from his, so be it. Nast trusted readers to know who contributed what. There is no indication in any of Nast's papers that he ever felt embarrassed by the editorials in *Harper's*. Unlike Curtis, Nast could easily dine with a man whom the paper had mocked, secure in the knowledge that his own sympathies were as public as they could be.

Finally, Nast sought guidance from the Harpers on how to handle his conflict with Curtis. In 1872, still new to his fame and therefore open to the opinions of men he considered more experienced, Nast brought Curtis's letter about Sumner to the Harper offices and asked them what he should do. He recounted the meeting in a letter to his wife, Sallie. One of them (likely either Fletcher or Joe Brooklyn) addressed Curtis's complaint about his dinner plans: "He must not eat the bread of Sumner!" According to Nast, they also resented Curtis's presentation of the paper as a reflection of his own ideas, rather than theirs, and pointedly observed that should Curtis resign, the paper would go on without him. Curtis "knew which side his bread was buttered on," Fletcher Harper said. "I do think they would rather have Curtis go than have the *Weekly* not show its strength," Nast observed to Sallie. The message to Nast was clear: it was Curtis who was mistaken, not only to fraternize with his subjects but also in his perception of his own value at the paper. Nast was to continue as usual, and to placate Curtis as much as was reasonable.[41]

Curtis's discomfort with Nast, and with political cartooning in general, was too deep for him to accept defeat. Even after Fletcher Harper, communicating through his nephew Joe Brooklyn, took an opposing view, Curtis persisted. Joe Harper wrote, "My uncle hardly agrees with you as to the policy of allowing [Schurz] to escape without being made to appear ridiculous to the party he would ruin by persistent misrepresentation of its leaders."[42] This was sufficiently bold that Curtis might have finally given in, but still he did not. He continued to complain about Nast's work and to present an alternate vision of how the paper ought to operate. That vision was closely linked to both what he thought of political cartooning and what he hoped to achieve with his editorials.[43]

Curtis preferred to attack ideas rather than men, and he believed that public servants were usually honorable, especially if they were Republicans. Public affairs were too serious to be treated with the flippancy that Curtis perceived in caricature, and distracting public attention with humorous treatments of important issues only wasted a valuable resource.[44] The public's interest in the weekly's commentary was squandered when the paper stooped to satire. In Curtis's view, the reader should be educated about the facts and exhorted to take the correct stand. In this way, readership could be translated into activism on behalf of any cause the paper espoused.

Curtis did not deny the power of political cartoons. That was their chief fault. Editorial writing could be harshly critical, he believed, without making personal attacks. "Perfect respect may be preserved," he wrote. Moreover, written comments could be easily retracted. Cartoons and caricature, however, left an indelible imprint on the minds of readers. No matter what the editorials said, or even what Nast later drew, the initial impression would remain with the reader. This restricted the paper's ability to change its mind.

Recurring conflict between the two men before 1877 had never substantially changed the way Nast worked. Over time, however, his behavior toward Curtis changed from polite solicitousness to a chilly silence. In an 1868 letter, for example, Nast gently teased Curtis that whenever Fletcher Harper seemed doubtful about a drawing, Nast replied, "'Mr. Curtis has approved of this,' and then, he condescendingly observes, 'Oh, well then you can go on with it.'" Enclosed with the letter were "some sketches for [Curtis's] approval."[45] By 1877 these kinds of communications had long since ceased.

Curtis continued to plead his case. He never deviated from his view of the relationship between cartoons and editorials, expressing the same ideas years later. "The pictures," Curtis wrote to John Henry Harper in 1882, "should be judged by the simplest test of their accord with [the editorial] articles. If they are not harmonious, then however good they may be, they should not appear." Curtis suggested, modestly, that editorial positions should determine the content of the paper as a whole, but he avoided the central point: it was Curtis who would identify the correct political position. All other contributors would then have to fall into line.[46]

Faced with two men whom they had known all their lives, less interested in the editorial end of the weekly than in its business operations, and under constant pressure from Curtis, the Harpers gave in.[47] The Harpers' change in attitude toward Nast began when Joe Brooklyn asked Nast whether he

intended to comment on President Hayes's southern policy. Readers had been writing to both the paper and Nast begging for something on the subject for weeks. Nast replied that he was "ready to give them something when you say the word!"[48]

The problem was that Harper wanted Nast to comment without criticizing. The "general disposition," he said, was to "stand back and give the President's policy a chance." That this was Curtis's opinion need not be mentioned. "Will you let me put that in the form of a cartoon?" Nast asked. "Yes, if you keep Hayes out of it," was the reply. Fletcher Harper would have seen a trap. He was too aware of his cartoonist's explosive temper and tendency to reveal uncomfortable truths. In keeping with that assessment, Nast drew a picture that presented exactly the position in which he found himself at the weekly.

Nast adhered to Joe Brooklyn's restrictions precisely. Hayes did not appear in the cartoon, nor did it criticize the southern policy. There, compliance ended, however. Nast drew himself clearly restrained, held back by Uncle Sam from expressing his true opinion. The dictate of "Gen. Disposition" hung on a wall behind them, pointing to the same message Nast built into the caption: "Our artist must keep cool, and sit down, and see how it works."

The cartoon appeared on the cover of the weekly on May 5, 1877. If Curtis had triumphed by silencing Nast, it would be reasonable to expect that the drawing would not be published, or that, at the very least, would appear at the back of the paper. There is no evidence to explain why Nast's revelatory image commanded the most prominent position in the paper, but it seems likely that the deal he struck with Harper was that as long as he followed the prohibitions laid down on content, the cover would be his. If that were the case, Harper must have felt betrayed by Nast's cartoon.

Harper asked Nast, "Is that fellow choking you intended for me or Mr. Curtis?" According to Nast's biographer, Nast replied, "Neither. It doesn't represent an individual, but a policy. Policy always strangles individuals."[49] In Nast's recollection of this exchange, his language is uncharacteristically stilted. It is possible that in reviewing the conflict over the years, Nast constructed an imaginary exchange in which he expressed his feelings eloquently and fully. Whether Nast said precisely those words or not, they encapsulate the crucial fault lines between *Harper's* and Nast.

First, they clearly acknowledged that there was now an editorial policy in place at the weekly. Instead of the open door for contributors that Fletcher Harper had insisted upon, the paper would now impose ideas upon its

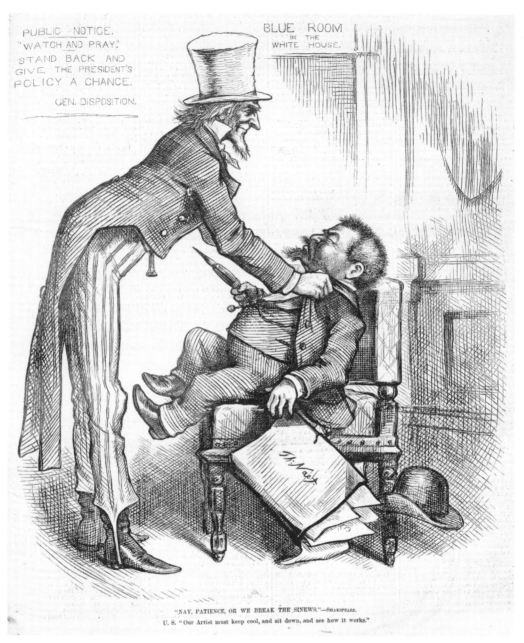

"Nay, Patience, or We Break the Sinews," Harper's Weekly, May 5, 1877.

employees. This was a significant change, especially for an artist. In 1882, Curtis wrote, "I do not mean that any artist should draw pictures to help what he disapproves, but only that he should not throw the great force of the pictures against the course of the paper." This was Curtis's public position all along, but now Nast was not free to simply submit drawings, confident that they would be printed immediately.

Immediacy was an important part of Nast's livelihood. Nast's drawing of the imaginary Hamilton Fish/Rutherford B. Hayes slate demonstrated an essential quality of political cartoons: their timeliness. If they were not used right away, they became obsolete. For Nast, this had never been a concern so long as Fletcher Harper was alive. Every drawing he sent the paper was either used right away or saved for the next issue. This meant that Nast was producing multiple drawings every week.[50]

Nast's talent could be mercurial. He described it as similar to a sudden sickness or fit. He would wake in the middle of the night with the vision of the perfect drawing, for example, and rush to get it down on paper.[51] Files of Nast's materials, while often thin, contain many little scraps of paper—envelopes, ticket stubs, menus, and train schedules—covered with sketches, caption ideas, and rough drafts of famous images (Tweed's head as a money bag, for example). They attest to the sudden urge to work that seized Nast at various moments.[52]

So how could Nast, whose work and career had been built on the freedom to draw at will and the expectation that he would see his product printed immediately, accept what was now to be a collaborative process? If he needed Curtis's approval for topics, he would have to work quite differently. On the other hand, if he continued to produce drawings as he saw fit, perhaps they would disappear into Franklin Square never to appear in the *Weekly*. In Nast's eyes, either option would stifle both his creativity and his individuality. Hence, "policy always strangles individuals." If Nast hoped that his drawing would arouse public support in his behalf, he was disappointed. Although there had been much comment on his silence, and letters of support did arrive at both Nast's home and Franklin Square, *Harper's* subscribers failed to muster a serious demand for Nast's cartoons to reappear.

One reason for this is that, for the first time in years, Nast was detached from public opinion. Recall the importance of proximity in the Tweed crusade. In Morristown, in contrast, Nast was out of touch with American politics. The central quality of his work had always been its ability to touch the raw nerves of readers. Or, at least, Republican readers. But since his move

to Morristown in 1872, Nast's world had been shrinking. Increasingly, he remained at home with his family and had only occasional visitors. When not at home, he was touring with James Redpath's Lyceum Board.

Nast's chalk talks brought him into contact with the public for months at a time, but in this setting he was in the business not of hearing public opinion but rather of sharing his opinions with the public. The audience's role was largely laudatory. Even had Nast been inclined to interact more with his audience, his crippling shyness prevented it. Writing home to Sallie, for example, he complained that the silence of the audience was "dreadfull" and "the suffering I go through I can't not express." He even "begged" Redpath to let him cancel the tour.[53] These kinds of complaints, repeated over the years, indicated that the more enthusiastic the crowd, the more intimidated Nast became. He could hardly stand each evening's performance, and rushed home on any excuse.

In addition to the organization of his lectures and his shyness limiting his discussions of current affairs, for the most part, Nast's lectures were focused on the art of caricature itself and on the Tweed Ring. While it is possible that he deviated from the script enough to discuss current events, the tone of his remarks suggests that he intended to provide a walk down memory lane. The audience would be gently reminded of the triumphs and amusements of the past, not exhorted to action now. Thus, even for those attendees who might have asked questions or met the artist privately, a discussion of current events would have been a deviation from the spirit of the evening.[54]

It would be a mistake, therefore, to assume that touring provided any meaningful interaction with the public. Before the move to Morristown in 1872, the Nast family lived in Harlem. Making his way to work at Franklin Square, taking the train to Washington, D.C., with Fletcher Harper and Civil War colonel N. P. Chipman, Nast was constantly exposed not only to the views of ordinary New Yorkers but to the personalities and machinations of national politicians. George William Curtis lived on Staten Island, socialized with a very refined group of families, and often wrote in the most elevated terms. Yet Curtis wrote about major national issues and hoped both to educate and persuade his audience. For Nast, it was emotion which was central. He needed to touch the reader—in either a serious or humorous way. Thus, Curtis's separation from the masses made his writing more admirable and refined, while Nast's isolation sapped his power.

By 1877, Nast had retreated to a more circumscribed social world.[55] He was a natural homebody who loved nothing more than playing with his

children and tinkering with his house. Morristown itself had always been a well-to-do suburb, but in the late 1870s it was becoming a playground of the ultrarich. Ordinary folks were few and far between in this atmosphere.[56] But Nast still believed he was connected to the public, no matter how terrified he was standing on a lecture platform. There was no doubt in his mind that once he showed the readers of *Harper's* exactly why he had failed to comment on Hayes's southern policy, Curtis would be forced to give way. But the fact was that, in being so far removed from public discourse, Nast failed to see the change in public opinion on the subject of race in the South.[57]

Northerners, exhausted by the war and Reconstruction, sought reconciliation with the South and freedom from the burden of responsibility for black Americans. Northern politicians like President Hayes had been early supporters of Reconstruction and the civil rights of former slaves but had come to see the harsh attempts of Congress to force equality on the South as counterproductive. Others were weary of the continuing sectional bitterness Reconstruction generated. Still others remained committed to the idea of equality for black men and women but were simply too tired to continue the seemingly endless, expensive, violent process required to ensure that equality.

The passage of time had weakened many northerners' commitment to racial equality and industrial progress in the South. In addition, many of those most committed to the cause of the freedpeople had died or were too old for activism. By 1877, for example, Charles Sumner and many other of the early abolitionists were lost to death or disability. Their heirs, committed to a variety of social causes, no longer felt the burning passion for racial justice that had animated their mothers and fathers. Women's rights, urban decay, temperance, and civil service reform all siphoned off men and women whose dedication might have helped to shore up northern public opinion in regard to the plight of blacks in the South.[58]

Curtis had been an abolitionist. Writing to his best friend, Charles Eliot Norton, in March of 1862, he argued that the North must be prepared for "a war of conquest and subjugation."[59] By September, he asserted that the war had divided the nation into those for slavery and those against. "The fence is knocked over," he wrote to Norton, "and straddling is impossible."[60] Curtis's convictions were deep, and his commitment to the end of slavery and the rights of freed slaves was as passionate as his later dedication to civil service reform. Yet Curtis was like his contemporaries. As the failures of Reconstruction mounted, he grew frustrated. By 1877, Curtis resembled

his northern neighbors and the offspring of the radical generation. If Reconstruction could not be accomplished, the energies of reformers ought to be focused elsewhere.

Of course, there were still outspoken men and women who, like Nast, found the southern policy unacceptable. Wendell Phillips and William Lloyd Garrison are but two examples.[61] But their numbers were not as great as Nast thought, and their support for Nast was largely moral rather than practical. Confronting an editor with whom he disagreed, Nast needed to access the power of his public, but it failed him. For the rest of the summer, his drawings returned to foreign affairs, civil service reform, and a few rather lukewarm attacks on the Democratic Party.

Nast might have appeased Curtis by adopting a conciliatory pose in his work, but, over the years, Nast had developed a style of commentary that depended on simple, graphic evocations of the battle between good and evil. Concepts like reconciliation and compromise were antithetical to Nast's political and artistic approach. Whether the target was hypocrisy, treason, or corruption, Nast established a moral universe in which the "righteous" was juxtaposed with the "tyranny of evil men."[62] To have created cartoons that compromised between what Nast considered morally right—the protection of Republican governments in the South and support for the uplift of the freedmen—and what he saw as morally wrong would have muted the power of his work. What would be the point of producing cartoons that had no power to embarrass wrongdoers, influence public opinion, or force action?

In addition to personality and policy, professionalization played a role in the tension between editor and artist. The confrontation between Nast and Curtis had clearly evolved over many years. So different in personality and political style, they had never seen eye-to-eye on the place of drawings at *Harper's*, yet neither had won the point. Why did it take so long for Curtis to win? Two of the factors which helped to resolve the dispute in 1877 have already been discussed. Without Fletcher Harper, Nast was at a disadvantage in the Harper offices. In addition, Nast's alienation from the majority of the northern public made him unaware that he could expect little support against Curtis from readers. The final contributing factor, however, was one which affected not only Nast but contributors and editors in newspapers all over the nation.

As we have seen, illustrated newspapers like *Harper's* were an invention of the 1850s.[63] Riding a wave of journalistic entrepreneurship, men like Frank Leslie and Fletcher Harper created papers that brought news

to the public in an exciting new format. Timeliness, sensation, and variety were the hallmarks of these publications. For as long as men like Leslie and Harper remained in charge, the papers usually retained a loosely organized command structure. They owned the paper, and their editors were employees.

By the late 1870s, however, newspapers were increasingly becoming the domain of powerful editors, whose views shaped content, style, and tone. Many of these men were famously talented and created powerful space for writers, poets, and statesmen to share their talents and views. In other cases, editors changed the direction of a paper, moving it away from an emphasis on political commentary, for example, and toward a greater focus on home life. In addition, editors were no longer the first among equal contributors; they were now in charge of a productive literary hierarchy. Editors had become business professionals.[64]

At *Harper's*, then, it was Curtis who benefited from this change. Not only was Fletcher Harper no longer available to protect Nast; not only were his heirs willing to support Curtis's views on cartooning; but now Curtis could make a credible argument that he should determine the political content of all contributions, whether from Nast or anyone else. If Curtis's power had increased through professionalization, Nast had changed from contributor to employee.[65]

In fact, rather than pointing out that organization and leadership were essential components of effective editorial policy, Curtis could have argued his position from a purely business standpoint. A postwar boom in magazine publishing increased the number of magazines from 700 in 1865 to 1,200 in 1870. By 1880, the number had grown to 2,400 and by 1885, to an incredible 3,300. From his vantage point, Curtis could have argued that he had to make *Harper's* more appealing to readers who had more and more choices with every passing day.[66]

Curtis had been waiting for just such a moment, and he did not hesitate to seize it. The publication of Nast's inflammatory drawing "Patience or We Break the Sinews" was a turning point at which Nast's public might have rallied around its hero. Without that support, however, Nast was relegated to a position of relative powerlessness. He could still claim editorial independence, but the reality was that his work had to conform to Curtis's editorial policy.

Lest there should be any ambiguity about his new authority, Curtis found another opportunity to assert it. When in midsummer Nast submitted a drawing that showed American diplomat James Russell Lowell reciting a

poem to the bloated and corrupt governments of Europe, Curtis rejected it. Why he rejected it is unclear, but it was now obvious to Nast that he could never assume that his drawings would be published.[67]

Angry, disappointed, and increasingly bitter, Nast withdrew from his work for four months. Concerned friends wrote to Nast at Morristown. James Parton, for example, sent a sympathetic but resigned note. Curtis was right to assert his leadership, Parton wrote, because "there cannot be two captains to one ship." On the other hand, he acknowledged that Nast could never work under that authority. It would "paralyze your arm in another than the physical sense." The two men were like "a nightingale and a falcon," who could never expect to achieve "any harmony." Perhaps sensing that he was not being very encouraging, Parton ended his letter with the opinion that Curtis's future editorship would be limited and not very successful. Still, there was no minimizing the fact that Nast's happy relationships at *Harper's* had come to an end.[68]

Eventually, Nast began to draw again for the magazine. When it was time for him to renew his contract for 1878 he signed it, in spite of the troubles of 1877. But his close relationship with the Harper family and his sense of complacency about his position at the magazine were shattered. Nast and Curtis butted heads periodically for the next ten years, until the end of 1886, when Nast returned his contract for 1887 to Franklin Square unsigned.

Curtis's success in changing *Harper's* editorial policy was a massive blow for Nast. Political cartoons were powerful expressions of the public's interest in, and sometimes contempt for, politics and politicians. Nast's creative portrayal of the hypocrisies and heroics, triumphs and failures of the nation's life made his cartoons far more important than their physical characteristics would suggest. Likewise, Nast's loss of control over the content of his work was a blow to his personal and professional confidence.

After 1877, nothing would ever be the same. Nast's final years with *Harper's* saw two presidential contests, a series of lesser crusades, and episodic conflict over Nast's freedom to cartoon as he liked. At first, the wealth that lecturing, drawing, and investing produced cushioned Nast's fall. Later, when financial reverses erased his prosperity, Nast looked back at his career with increasing bitterness.

The End of an Era

Between 1877 and 1884 Nast's presence at Franklin Square was intermittent and punctuated by illness and clashes over rejected cartoons. He continued to work, submitting cartoons on a variety of issues.[1] But during these years, Nast's fame and talent began to decline. Pain that had developed in his drawing hand in 1873 during his chalk talk tours persisted.[2] His connection to the public and to the staff at *Harper's Weekly* suffered, too. By the early 1880s, Nast's career had begun its decline in earnest. The presidential election of 1884 only increased the speed.

Nast's absence from *Harper's Weekly* in mid-1877 attracted substantial comment in the press. This heartened the cartoonist and helped him to return to work. Roscoe Conkling's attack on Curtis at the Republican state convention, where he lauded *Harper's* as the magazine "made famous by the pencil of Thomas Nast," brought a moment's satisfaction. In November, *Harper's* published Nast's cartoon criticizing the president's southern policy as a capitulation to the Democrats. The drawing was beautiful—the democratic tiger's fur produced in careful detail, his tongue sliding across his cheek to illustrate his satisfaction at having eaten the Republican lamb—and it attracted reassuring letters and public notice. One paper likened Nast to the warrior Grant and called Curtis a "fly on the chariot wheel."[3]

By 1878, Nast's contributions to *Harper's* reflected the aftermath of the contested election of 1876. They returned to a much broader, more unpredictable set of policy concerns. The gold-versus-silver debate captured his attention in 1878, along with less crucial events like the triumph of the Columbia College crew team at the Henley Royal Regatta.[4] He received invitations to lecture, but he hated to travel alone, so he declined.[5] Instead, Nast took his wife and children to Europe to enjoy the Paris Exposition.

Nast's relative quiescence in this period is partly related to the unexpected pregnancy of Sallie Nast. Their youngest son, Cyril, was born on August 28, 1879. He enchanted Nast, who used Cyril as the model for his Christmas drawings of 1879. The family's total assets, including the Mor-

ristown house and more than $60,000 in government bonds, reached $125,000 that year. Nast was a wealthy man, but not always a happy one.[6]

Dissatisfied with his position at *Harper's*, he hoped to start his own weekly magazine. When that proved impossible, he diversified his investments, removing money from the safety of his bonds and buying shares in mining and other speculative ventures. Nothing could really distract Nast from his primary trouble, though. As the presidential campaign of 1880 began, Nast confronted his nemesis again. This time, Nast and Curtis clashed over the Republican *and* Democratic nominees.

In some ways, the election of 1876 poisoned American politics. While Nast and his family visited the Paris Exposition, an enormous scandal had broken, exposing the details of the frauds perpetrated during the presidential election. A series of encoded cables, published in the *New York Tribune*, showed clearly that allies of the Democratic candidate had offered cash for votes. The enquiries of the Potter Committee eventually tossed mud onto both parties, revealing the depth and complexity of the maneuvering for supremacy even before the electoral crisis. Historian Mark Summers argues that paranoia about corruption warped the entire political process in the postwar period. It was certainly visible in 1878 and 1879, when Nast returned to a nation whose politics echoed with accusations and counter-accusations.[7]

Relations between Nast and Curtis remained tense. From Nast's point of view, and that of many other Americans, the president's approach to national unity failed to achieve any Republican objectives. On November 30, *Harper's* published "Our Patient Artist." It was a commentary on his previous cartoon, "Nay, Patience, or We Break the Sinews." In the earlier drawing, Uncle Sam holds the cartoonist in place, demanding patience for the president's policies. In the new cartoon, Uncle Sam flees the scene while Nast—collapsed through the seat of the chair but with his arm raised— appears "defiant" to the last.[8] Clearly, Nast believed that his assessment of the Compromise of 1877—that it amounted to the nation's abandonment of the freedpeople—had been correct. That confidence suggested that the clashes between editor and cartoonist would continue as the two parties selected nominees for 1880.

On the Democratic side, the withdrawal of a sick and scandal-tainted Samuel J. Tilden left room for the nomination of General Winfield Scott Hancock. On the Republican side, Ohioan James Garfield was the party's choice. Nast was no fan of Garfield, whose service at Shiloh and Chicka-

"Our Patient Artist," Harpers Weekly, *November 30, 1878.*

mauga would normally have elicited Nast's enthusiasm, because of the Credit Mobilier scandal of 1873. But, if Nast were to back Hancock, he would have to contradict his previous work.[9]

Nast's distaste for hypocrisy was widely known. Any national figure whose politics were inconsistent could expect a very public rebuke from Nast. And on this one point, Curtis's complaints about political cartoons came back to haunt Nast. It was true, as Curtis argued in 1877, that cartoons were never forgotten. So Nast could hardly endorse Garfield as the great hope of the Republican Party. To do so would be to repudiate his own position of only seven years before.[10]

The nomination of General Hancock complicated Nast's problems. Hancock was a friend. He was a "splendid soldier, a thorough gentleman, an upright and loveable man." But how could Nast, the most devoted of Republicans, in conscience, support Hancock? Asked by some mischievous soul, "I hear you are very fond of General Hancock?" Nast replied, "The man, yes; his party, no." Nast attempted to honor his friend with a cartoon that suggested that the Democrats had finally chosen a great man to lead them. *Harper's* rejected it.[11]

Yet again, the conflict between Nast and *Harper's* centered on Nast's editorial independence. Nast insisted that his consistency and integrity were essential to his popularity. If he violated his central commitment to honor in government, why should his audience pay any attention to his cartoons? In the end, Nast offered a compromise. He supported the party platform and attacked the Democrats—in general—in his drawings, but he did not specifically attack Hancock. It was almost exactly the same approach he took with Hayes, but for different reasons. Democratic papers, especially *Puck*, mocked Nast for his dilemma.[12]

In response, *Harper's* supplanted the artist's work with that of a variety of younger men. The *Brooklyn Times* suggested that *Harper's Weekly* employ the artist/owner of *Puck*, Joseph Keppler, instead of Nast.[13] The public complained, and Nast's rivals were removed. Still, Nast's commentary on the 1880 campaign lacked passion. Nast's frustration with his professional position, his ambivalence about both candidates, and his conflict with Curtis sapped his strength. Curtis made the situation worse by writing in an editorial that whatever Nast's cartoons might say, the writing in *Harper's* reflected the paper's opinions. In other words, pay no attention to Mr. Nast. He does not represent the paper, only his own views. In Fletcher Harper's opinion, both Curtis and Nast were equal contributors and the paper had

room for both men's opinions; but the younger Harpers elevated Curtis and denigrated Nast.[14]

Garfield's victory brought the conflict between the two men to a temporary close. His assassination, on July 2, 1881, and subsequent death in September reminded Nast of the death of Lincoln. In a series devoted to the president, Nast echoed the nation's prayers, then its grief. The presidency of Chester Arthur, a New Yorker and associate of Roscoe Conkling, provided no respite for Nast's troubles. Paine described Nast's drawings in 1882 as "somewhat less positive," and blamed the Harpers and Curtis. With their critical gaze constantly over his shoulder, Nast was "circumscribed" by the "uncertainty as to the acceptance of his work." Nast felt paralyzed, and his work suffered. Increasingly, private life offered a respite from the frustrations of work.[15]

By 1883, Thomas Nast was a wealthy man. His salary at *Harper's Weekly*, combined with lecturing fees, payments for illustrated books, and the proceeds from his annual almanac for Harper and Brothers amounted to a substantial income. Nast owned the house in Morristown, and as his financial security grew, he began to enjoy both spending his money and investing it. In 1883, he invested $30,000 (the proceeds from selling his Harlem home) with Grant and Ward, an investment company in which President Grant's son was a partner, and the returns provided him a steady stream of income.

The new source of income prompted Nast to reconsider his long association with *Harper's Weekly*. In mid-March 1883, Nast wrote to John W. Harper to complain about the magazine's rejection of his drawings, even when they were not controversial. When cartoons appeared, they were "invariably . . . the smallest." He concluded that "for some reason unknown to me, my drawings are no longer of use to you." He wanted to terminate the long-standing contract, effective April 1.

John Harper's response pinpointed the problem. Reading between the lines of Nast's letter, Harper responded that no "one member of the firm" had rejected Nast's work. Instead, it was a group decision, taken in the course of discussing "business matters." Subtly, Harper suggested that Nast's absence from the Franklin Square offices had left him without a voice on the paper. In addition, he suggested that when the two men had discussed Nast's cartoons in the past, Nast seemed to understand why the paper chose not to use them. Harper managed to convey a whiff of betrayal. In closing, reiterating the fundamental difference between Harpers

and Nast, he wrote, "You ought to remember that we have to consider these matters from a business standpoint, as well as from their artistic merits." Finally, Harper suggested that Nast wait and reconsider his decision. Nast did so, but submitted no further drawings after late March 1883.[16]

The Harpers' emphasis on business over content was precisely the problem. To Nast, political cartooning was not about making money. It was an art form designed to express viewpoints and sway public opinion. A great political cartoonist required the freedom to express ideas, even when they were critical. The absence of that freedom diminished Nast's art. Obviously, Nast had no illusions that *Harper's Weekly* could continue without making a profit. But he believed that if the Harpers and Curtis dulled the edge of his cartoons, or rejected the controversial ones, the result would be *less* profit, not more.

In May of 1883, Nast and his family left for England, where he visited a variety of acquaintances. Former president Grant provided introductory letters, and Nast called upon a number of painters and intellectuals. He enjoyed a concert at Buckingham Palace, saving the elaborate program as a souvenir, and accepted entirely too many (as his complaints about his digestive problems suggest) invitations to dinner. In the end, his body rebelled. Nast returned home in early summer, and Sallie took him directly to Saratoga, where the healing mineral springs helped to cleanse his system.

Back in Morristown that summer, Nast opened his home to friends. Foremost among these was former president Grant. Entertaining General Grant allowed Nast to indulge in both of his favorite social activities with one of his favorite men. He could discuss his recent trip and listen to similar stories from Grant. The former president also presented the Nasts with a pair of Japanese vases he had bought during his travels. (One of these is pictured on the cover of the December 25, 1886, issue of *Harper's*, discussed in chapter 8.) The Grants brought their son and daughter-in-law to dinner that night as well. Grant and Nast discussed world affairs, including what Grant called "the decay of the Latin races." Given Nast's interest in and experience with the Italian unification movement, this must have spurred a lively discussion.[17]

Socializing with the Grants seems to have struck just the right balance for Nast between hobnobbing with high society, which he disdained, and spending time with close friends and family. Asked what he would like to eat at Nast's, Grant said, "If you knew how tired I am of little birds, you would give me corned beef and cabbage." Obligingly, Sallie presented the president with this quintessentially Irish American meal. To entertain a

former U.S. president was to be socially privileged, but neither man really fit into elite society. Grant's rough edges had been smoothed by years in public life but were still apparent and corresponded to Nast's. The cartoonist's unreserved adoration and unflinching defense of the general against every critic surely made Grant feel at home with the Nasts.[18]

After a reciprocal dinner at the home of the former president's son Fred Grant, the Nasts left Morristown again, this time to relive their honeymoon. Married twenty-two years, the Nasts retraced their steps, even staying in the same hotel. Having revisited Niagara Falls, the couple moved on to Montreal. There, Nast contracted such a bad cold that the couple abandoned plans to visit Quebec and returned home. Pneumonia followed the cold, leaving Nast "weak and prostrated."

More than six months passed between Nast's last cartoon for *Harper's Weekly* and his return to Morristown from Montreal. Readers complained that their artist had disappeared. A presidential campaign loomed. *Harper's* tried other artists, but none attracted as much attention as Nast had. In September, the Harpers began to woo their famous cartoonist back. Before the honeymoon trip, Nast had met with J. Henry Harper, prompting the younger man to write a masterful note the next day. Harper appealed to Nast's loyalty to the paper and the party—he emphasized the coming presidential campaign—and complained that no other artist brought Nast's talent and experience to the paper. The combination of flattery and exhortation sent Nast north with something to think about.

By October, though, Nast was quite ill. His illness provided a perfect opportunity for the Harpers to persuade him to return to the paper. Visits to his bedside accompanied pleasant notes. All recalled for Nast the longstanding personal relationship he had with the Harper family. Joseph W. Harper Jr., "Joe Brooklyn," wrote on October 30 to ask if he could visit. He enclosed a letter from a *Harper's Weekly* reader in Illinois. Where was Nast, the reader asked, and why was he silent? By the winter, Nast succumbed to the Harpers' charm campaign. He reassured them that when he felt better his pencil would again work for the *Weekly*. He could provide nothing, however, until he recovered his strength. On December 27, *Harper's* informed its readers that Nast intended to return to the paper as soon as possible.

Nast remained weak. Winter in New Jersey provided no relief. Eventually, Nast accepted an invitation to travel to Florida. The trip, a junket arranged by a Florida land company, offered both warmer air and exalted company: the company's chairman, the Earl of Huntington, his son, Lord

Hastings, and a group of "investors and pleasure seekers."[19] Better still, reporters there clamored for an interview with Nast. The flattering attention reminded Nast that *Harper's Weekly* gave him a unique platform. By the time he returned to Morristown in February, his health was restored and his pencil was ready. Joe Harper met his return with a teasing note, asking, "Where's my alligator?" *Harper's Weekly* needed Nast, the younger man asserted. A "strong and incisive" first cartoon could set the tone for the entire presidential campaign, and *Harper's* eagerly anticipated its arrival.[20]

Even Curtis, so often at odds with his most famous colleague, was moved enough to send a little note. He was happy to hear of Nast's return to health, and he looked forward to "the old and ever new fight." They would work to ensure the best possible outcome, "side by side."[21] As difficult as it was to imagine in 1877, this was precisely what would happen in 1884.

The last great battle waged by Nast and *Harper's Weekly* was against Republican presidential candidate James G. Blaine. Opposition to Blaine united Nast and Curtis, rejuvenated Nast's artistic impulses, and pushed *Harper's Weekly* back into its position as the nation's premier—if controversial—Republican magazine.

Neither Nast nor the Harpers predicted the controversy 1884 would bring. The election brought to the fore two issues. The first was the dissent within the Republican Party. Opposition to Blaine's nomination cast Curtis, the Harpers, and Nast outside the fold for the entire election and sparked a nationwide discussion about party loyalty. The second issue involved ethics in government. This encompassed not only civil service reform and Blaine's personal ethics but also broader questions about the character of candidates. What this meant for Curtis and *Harper's Weekly* was that they were faced with the choice between an upstanding Democratic candidate and a corrupt Republican.

Nast returned to cartooning on March 1, 1884, with a cover illustration portraying victims of recent floods in the Midwest. The following week, however, he began the presidential campaign with a cover aimed directly at the Republican nomination process. "The Sacred Elephant," it argued, "is sure to win, if it is only kept pure and clean, and has not too heavy a load to carry."[22]

For the first time in a long while, Curtis and Nast agreed on the Republican candidate; both men found Blaine wanting. The campaign would become the most contentious of Nast's career. Ironically, given Curtis's attacks on Nast in the past, it began with a quiet Nast and a crusading Curtis.

Curtis's objection to Blaine was related to his long-standing political as-

THE SACRED ELEPHANT.

THIS ANIMAL IS SURE TO WIN, IF IT IS ONLY KEPT PURE AND CLEAN, AND HAS *NOT TOO HEAVY A LOAD TO CARRY.*

"*The Sacred Elephant,*" Harper's Weekly, *March 8, 1884.*

pirations. The best evidence for this lies in his correspondence with his best friend, Charles Eliot Norton. Over the years, Curtis sought leadership positions within the Republican Party at a variety of levels. Some he achieved, but electoral success eluded him. It was clear, by the 1880s, that his position as editor at *Harper's* was his greatest opportunity to comment on (and shape) national politics.[23]

Curtis was ambivalent about *Harper's*, though. He had little respect for the Harpers themselves, occasionally deriding them in letters to Norton. On the other hand, he knew the power of his "pulpit." When Norton offered him the editorship of a new paper, Curtis declined regretfully, citing his editorial freedom at *Harper's* and the breadth of his audience there. It seems clear from his letters that Curtis had an amazing amount of latitude at *Harper's*. He traveled constantly, lecturing on a variety of subjects. Earning a comfortable income, he visited friends and family, retreated to his country house on Staten Island, and generally stayed out of the *Harper's* offices as much as he possibly could. Still, his voice animated the paper politically. He reached more than 200,000 people every week, a feat few political figures could match.[24]

Over time, Curtis's ability to reach the public had become increasingly important to his power within Republican circles. Like fellow editor E. L. Godkin of the *Nation* and Senator Carl Schurz, Curtis became more and more disillusioned with the results of partisan politics. In general, he espoused a set of ideas that he felt were crucial to American prosperity. These included low tariffs, adherence to the gold standard, and—most important—civil service reform. But in large measure, the party system was built on the spoils system. So long as that remained, and so long as party loyalty took precedence over policy, Curtis's passionate push for civil service reform would come to nothing.[25]

So Curtis began to question whether the party system was itself detrimental to government and the future of democracy in America. More specifically, he was outspoken in his opposition to certain candidates for the Republican Party's presidential ticket. Curtis was somewhat sympathetic to the Liberal Republicans in 1872 and disliked the corruption of the Grant administration. Despite his firm defense of party loyalty, he understood the reasons for Liberal disaffection. By 1880, his disappointment with the pace of reform was acute. He hoped to push the party toward a much more active reform agenda. In the wake of Garfield's assassination, the struggle for power among various factions within the Republican Party became ever more confusing, with so many competing factions, so many contradictory

issues, so many men changing sides. To Curtis's chagrin in 1884, James G. Blaine was the presumptive nominee. If nineteenth-century corruption boasted many gods, Blaine's place in that pantheon could not be denied. He represented precisely the kind of politics Curtis deplored.[26]

James G. Blaine, born in 1830 in Pennsylvania, was a former congressman, Speaker of the House of Representatives, senator, and secretary of state (briefly, under James Garfield). His long tenure in public life, his commitment to Republicanism, and his ability to rally large numbers of both party workers and voters all suggest he was an excellent candidate. Despite his credentials, Blaine was anathema to reformers. In 1876, Blaine was accused of using his position as Speaker of the House to manipulate railroad land grants and then pocket the proceeds. Public hearings at which Blaine read aloud telegrams and secret notes to a railroad company contractor, known as the "Mulligan letters," only added to the conviction that he was engaged in blatant corruption. Both Curtis and Nast believed that Blaine was not the person to lead either "the party of Lincoln" or the nation. For Curtis Blaine's nomination was a test of his political power. If Curtis was a leader within the party, if his voice counted for anything, then surely he could stop this man from becoming the representative of the Republican agenda.[27]

At the Republican Convention in Chicago, Nast also tried to find a better man. He agreed with J. Henry Harper that President Chester Arthur should run again. But Arthur declined. If nominated, he would accept, he told the two New Yorkers, but his health and the demands of the office precluded a real run for the nomination. The president suffered from kidney disease, and his death in 1886 confirmed his assertion in 1884 that he might not survive another term. According to Paine, Arthur also confessed to Nast and Harper that he was ashamed of his collaboration with Republican bosses Roscoe Conkling and Tom Platt during the 1880 presidential election. That relationship, captured in a Nast cartoon in 1881, played directly into the convention debates about corruption and reputation.[28]

In the end, Curtis could not influence the nomination. It was Blaine's turn, and most Republicans felt that the scandal was not that important. Like Curtis, many Republicans felt they simply could not back Blaine, so they looked to the other candidate.

The Democratic front-runner, New York governor Grover Cleveland, inspired widespread admiration. A reformer whose personal integrity was considered as impressive as his girth, Cleveland was the kind of man Curtis had hoped to see in the White House. Curtis wrote of Cleveland that he was

CONKLING & PLATT

OUT-"SHINING" EVERYBODY IN HUMILIATION AT ALBANY.
NEW YORK: "I did not engage you, Vice-President ARTHUR, to do this kind of work."

"Out-'Shining' Everybody in Humiliation at Albany," Harper's Weekly, *July 16, 1881.*

so "clean and independent" that "he is denounced as not being a Democrat by the Democrats themselves."[29]

Curtis's challenge was to establish a position for himself outside of either party. He and the other Free, or Independent, Republicans (or Mugwumps, to Republican loyalists)—an impressive group including minister Henry Ward Beecher, editor E. L. Godkin, and former senator, secretary of the Interior, and diplomat Carl Schurz—needed a philosophy that could justify abandoning the Republicans. Once that philosophy was established, Curtis needed help explaining it to his audience. For once, the simplicity and emotional appeal of political cartoons was an asset. In fact, it was a positive necessity. Curtis and his allies were pilloried across the nation for their stand against Blaine. Nast's cartoons could make Blaine so ridiculous, though, that citizens might think twice.[30]

In his 1968 study of Nast, Morton Keller points out that Nast, unlike Curtis or Godkin, had little to gain and no personal investment in bringing down Blaine. While Keller is correct that Nast never sought political office, like Curtis, and that he never tried to control internal party dynamics, it is inaccurate to say that Nast had no stake. For one, Nast believed that his integrity was his chief asset. Thus, to change his position on Blaine would be to destroy his political base and thus his bond with his fans—the same argument he made in 1880 with regard to Hancock and Garfield. In addition, Nast's investment in his cartoons was intensely personal, in the sense that their power derived from his passionate emotional approach.[31]

Nast's opposition to Blaine emerged long before the 1884 campaign. In an 1878 cartoon, he attacked the hypocrisy of anti-Chinese sentiment. Americans hate the black man, Uncle Sam says, "because he is a citizen," while they hate the Chinese man "because he will not become one." Blaine supported Chinese exclusion, and Nast's antipathy for him was immediate.[32] In a series of cartoons, Nast portrayed Blaine as a fussily pompous blowhard. Blaine, like Sumner before him, saw the damage Nast's cartoons could do.[33]

In a letter to Nast in 1880, Blaine complained that he had been "totally and inexcusably misrepresented." "I have always had a strong belief in your sense of right and justice," he wrote, "and I leave you to do what seems meet and proper in your eyes." Any examination of Nast's cartoons or any personal knowledge of his character would have disabused Blaine of the notion that Nast would recant. Nast almost never apologized, and he rarely changed his mind once it was made up. Blaine was a hypocrite, Nast thought, and a self-righteous one at that.[34]

THE CIVILIZATION OF BLAINE.

JOHN CONFUCIUS. "Am I not a Man and a Brother?"

"The Civilization of Blaine," Harper's Weekly, *March 8, 1879.*

After what Curtis called "essentially a Blaine convention," *Harper's Weekly* publicly denounced the Republican candidate. Curtis had been a delegate to the convention and had acquiesced to Blaine's nomination after fighting for another candidate. Because of his official role, Curtis hesitated to oppose Blaine openly. As the convention shifted away from and then toward Blaine, Curtis was unsure what he should do. In the end, he cast a vote for Blaine because he believed that party unity was vital. When he returned to New York, he found that many Republican newspapers had already expressed their opposition to the nomination—and many criticized his role in it.

Curtis's insistence that the *Weekly* be his personal mouthpiece worked against him in this case. He believed that the political views expressed in the paper could be separated from his public image. Now, when his official vote had been for Blaine and he failed to comment on it in an editorial, the paper's opposition to Blaine made Curtis look like a hypocrite and a coward. He would vote for the nomination but not support the ticket. He would express his views at the convention but not in the paper. Curtis had placed himself in an untenable position.

Curtis, Nast, and the two younger Harpers lunched together to find a solution. Curtis wanted to wait to comment on Blaine's nomination, but Nast, as always, preferred to strike. "Speaking for myself," he argued, "I positively refuse to support Blaine, either directly or indirectly, even if the Democrats should nominate the Devil himself." The Harpers agreed, and asked Curtis to write an editorial. "Make it as strong as you like, Mr. Curtis," said John W. Harper. "Make it stronger than you like, Mr. Curtis," said Nast. Curtis gave in, and in the June 14 edition, the paper rejected Blaine. "Fidelity to Republican principle requires indifference to present Republican success," Curtis wrote.[35]

Nast's first contribution was a small cartoon showing the Republican elephant's back broken by the "Magnetic Blaine," who is pictured as an enormous magnet.[36] A larger, more violent and pointed attack appeared the following week. "Death Before Dishonor" likened Blaine to Appius Claudius and the Free Republicans to Virginius. It was better for Republicans to leave the party and preserve their honor, Nast argued, than to sully the party by supporting an unsuitable candidate. As Paine later put it, the Free Republicans were putting "Nation before Party."[37]

The paper's campaign against Blaine was ugly, personally, professionally, and politically. Nast's fans wrote bitter letters complaining about his defec-

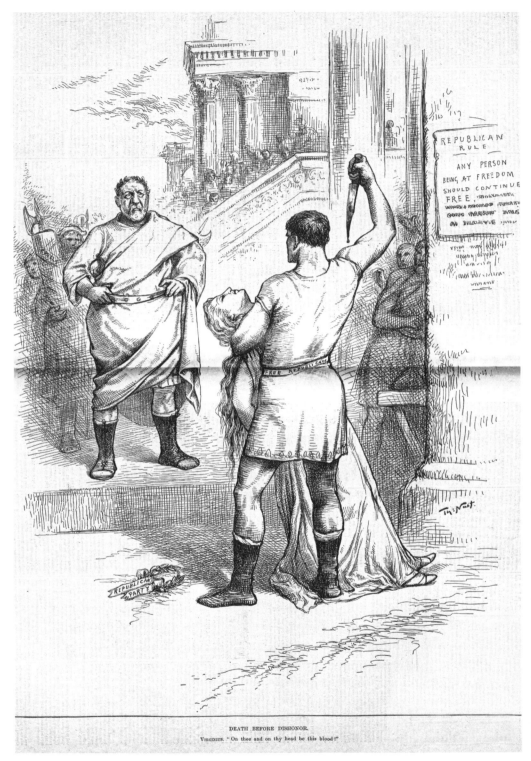

"Death Before Dishonor," Harper's Weekly, *June 21, 1884.*

tion, and rival papers mocked both Nast and Curtis as turncoats. In *Judge*, a bit of verse summed up the reaction:

Poor, poor T. Nast,
Thy day is past—
Thy bolt is shot, thy die is cast-
Thy pencil point
Is out of joint
Thy pictures lately disappoint.[38]

In a series of illustrations using new color reproduction methods, *Judge* cartoonist Grant Hamilton caricatured Curtis as an organ-grinder with Nast, the trained "Mugwumps' Monkey," in tow.[39]

Nast's tendency to establish categories of criticism and then return to them over and over appeared to great effect in this campaign. The artist mobilized a variety of arguments against Blaine and his supporters. Most prominent were that Blaine was fundamentally corrupt and incapable of following through on political commitments and that his supporters in the press were foolish. Blaine's "Plumed Knight" persona appeared as well.[40] With this framework in place, Nast added visual elements to increase the humor. Chief among these was the canvas bag, which reflected an ever-changing set of titles for Blaine's congressional memoirs.[41] Nast also responded to news as it emerged. When the last of the Mulligan letters appeared in *Harper's Weekly*, Nast inserted excerpts of them into cartoons.[42] Likewise, late in the campaign, Nast linked Blaine to financier and speculator Jay Gould.[43] Taken together, the cartoons painted a damning portrait of a corrupt politician with neither principles nor intelligent supporters.

Readers of *Harper's Weekly* understood corruption. The paper that crushed Boss Tweed called upon a rich store of images to demonstrate Blaine's problematic character. Early in the campaign, a series of Nast cartoons linked Blaine to New York's political bosses.[44] In a July issue, *Harper's* also republished all of Nast's Blaine cartoons from 1879 to 1882.[45] By the end of July, however, the attacks became more specific. Blaine attempted to win the votes of Irish immigrants, Nast charged, in part by attacking England's policies toward the Irish and simultaneously trying to pacify the English.[46] With the Irish cartoons, where Nast associated Blaine with undesirable voters, he may have helped the candidate more than they hurt him, however. Mark Summers argues that Nast's anti-Irish attacks on Blaine reinforced the idea that the Mugwumps represented the old nativist ideas

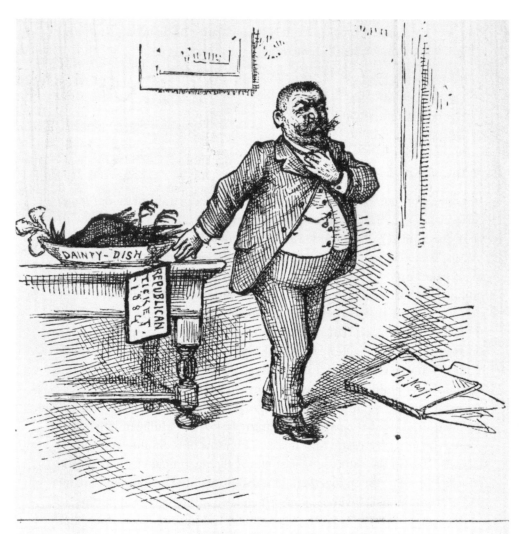

PLUMED CROW.

"Plumed Crow," Harper's Weekly, June 21, 1884.

of the Know-Nothings, which may have pushed some Irish voters toward Blaine.[47]

When Cleveland won, Nast joined Curtis in a sustained celebration. In a cover illustration, Columbia presents the new administration with a declaration of the election's meaning: "The Republic Has Been Saved to *Free* Institutions. Honest Men of Both Parties Won the Victory." Nast acknowledged the vitriol of the campaign, and the personal cost, but asserted its value by celebrating the Mugwumps: "All Honor to Independent Republi-

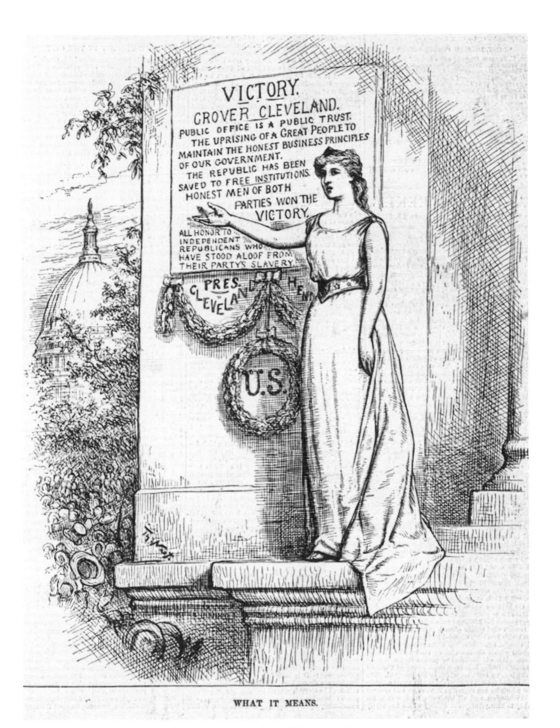

"What It Means," Harper's Weekly, *November 15, 1884.*

cans Who Have Stood Aloof from Their Party's Slavery."[48] The cartoon's title, "What It Means," denied the reality for Nast, however. Cleveland's administration might very well succeed in governing with honor, but Nast, Curtis, and *Harper's Weekly*, to say nothing of the Republican Party, found that the election left permanent scars.

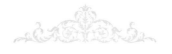

CHAPTER TWELVE

Nast's Weekly and Guayaquil

In the aftermath of the election of 1884, Nast was exhausted. He took some pleasure in a visit from his friend Mark Twain, who was in Morristown for a stop in his lecture tour with George Washington Cable. The lecturers dined with the Nast family, enjoying fresh oysters. Twain enjoyed them so much, in fact, that Nast offered him seconds. "Don't care if I do," replied the humorist. Thirds? "Come to think of it, I believe I will." Eventually, five servings were consumed. "Look here, Nast," Twain remonstrated, "I didn't know you had an oyster ranch in your cellar." He could eat no more, he admitted. Spying some pretty apples, though, he asked, "Are there any more apples in this house? Cause if there is, I'd like one." In his thank-you note, Cable mocked the hard work of touring: "Our wives at home can hardly keep back the tears for thinking of their 'poor husbands, working so hard.' (Don't you tell)." It was the kind of entertaining Nast loved best.[1]

Entertaining friends offered a pleasant respite from personal and professional worries. Nast's passionate contributions during the election masked a private drama of disastrous proportions. One day in early May 1884, Nast opened the newspaper to find that Grant and Ward, the firm in which Nast had invested most of his fortune, had failed. He lost everything but his Morristown home. Ferdinand Ward, it emerged, had been a crook all along. The company had no holdings. It was a giant Ponzi scheme. Former president Grant, whose son was the Grant in Grant and Ward and who had invested heavily in the firm, was devastated and broken—financially and personally. The president struggled to make right his debts, but nothing could really save him from the consequences of the failure. Grant, like Nast, had been essentially innocent when it came to investment. The cartoonist commented on the scandal with "The Tape That Entangles Both Large and Small," a drawing that showed three men entangled in ticker tape.[2] Though Nast did not yet know it, his financial troubles had only just begun.[3]

In order to increase his income in the wake of the Grant and Ward failure, Nast embarked on a new lecture tour in late 1884, traveling with a speaker and his son, Thomas Nast Jr. The speaker provided the audience

with narration while Nast drew the pictures. This helped to alleviate Nast's terrible stage fright and freed him from having to write a speech. To Nast's disappointment, although the tour was a success, it was less remunerative than those of 1873.[4] He returned to Morristown, produced a cartoon on Cleveland's struggle to institute reforms in national government, and tried to relax.

But politics continued to inspire. Nast's tendency to become over-wrought and extreme during presidential elections showed in his postelection cartoons as well. In late November, he had Cleveland brokering a peace between black and white men in the South. In the last issue of the year, his Christmas spirit again overrode caution. On the cover of *Harper's Weekly* Nast posed a pair of southern men, one black and one white, beating their swords into ploughshares. "Proclaim Liberty," the caption optimistically directed.[5] In the New Year's issue of *Harper's*, Nast wished for a bright future for president-elect Cleveland.[6] Curtis and the Harpers failed to share Nast's optimism, however. The same issue contained an editorial about the divisions within the Republican Party. Blaine's loss had "done nothing to repair the breach" caused by the "bitter" disagreements among Republicans. Facing a substantial loss in revenue thanks to their stand in 1884, and still widely criticized, Curtis and the Harpers looked with concern upon the coming year.[7]

Nast's optimism continued into the early spring of 1885. Cleveland's inauguration prompted Nast to speculate on the end of the abusive spoils system and the advent of a new level of civil service reform. In one cartoon, he showed Cleveland overseeing "Ft. Honesty" and wielding the club of reform. In another, the president was shown "dusting" out the corrupt officials and keeping only the best men—among whom the White House cook apparently numbered.[8] By late spring, however, Nast's attention began to fracture. The health of his greatest hero, the man whom he admired above all others, was failing.

Nast probably knew more about Ulysses S. Grant's battle with throat cancer, which was diagnosed in October 1884, than most Americans. Nast's personal relationship with Grant afforded him greater access to information, but his friendship with Mark Twain helped, too. For some time, Grant had been working on his memoirs. These volumes, which he strove to complete before his death, represented the best hope for financial security for his family. On February 21, 1885, Twain brokered a publication deal for Grant. Nast's friendship with both men put him solidly within the circle of people hoping for Grant's return to health.[9]

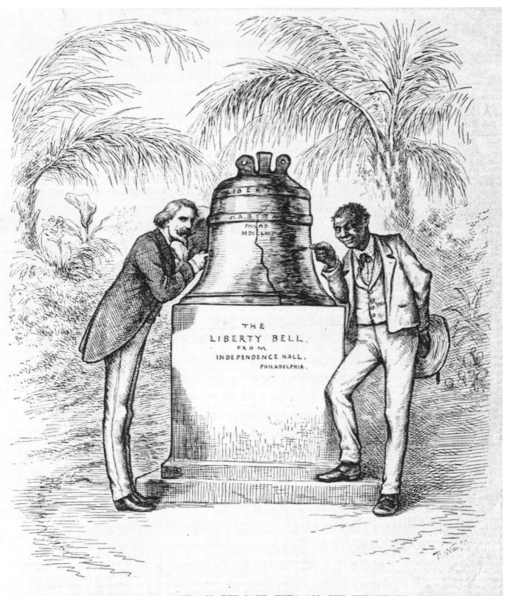

"Proclaim Liberty Throughout All the Land," Harper's Weekly, *January 24, 1885.*

General Grant's death, on July 23, 1885, was a devastating loss for Nast. In Nast's eyes, there was no man greater than Grant. His suffering a slow death by cancer only confirmed his heroism. Nast's memorial to Grant appeared in *Harper's Weekly* on August 1, 1885. Columbia stands veiled, her back to the reader, mourning "The Hero of Our Age."[10] If Nast needed a sign that the great men of his generation were passing, none was more powerful than this. His increasing dissatisfaction with the Harpers, his painful drawing arm, his unsteady finances, all pointed to decline. He felt, Paine wrote, "lonely and left behind."[11]

Despite Nast's rapprochement with *Harper's* during the campaign of 1884, the underlying conflict had not been resolved. Nast could not work under Curtis's editorial control, and the Harpers refused to intervene. In 1886, *Harper's* published a total of 188 Nast drawings. That number exceeded that published by the *Weekly* in any single year between 1876 and 1885.[12] Often, as many as four drawings appeared in a single issue. After January of 1887, when three drawings were published in the first issue, two in the second, and one in the third, Nast's cartoons simply stopped. No further drawings from his pencil appeared that year, and he returned his annual contract unsigned. What happened?

There are three possibilities. First, Nast may have had another clash with either Curtis or the Harpers over editorial control. His last six cartoons, however, offer no clue about any offense he might have caused. He caricatured Grover Cleveland, but that was normal. His other drawings focused on international affairs and topics of general interest. If Nast offended the Harpers, there is no sign of it in the work, nor is there reference to it in the surviving correspondence. Though Paine denies any open break between Nast and *Harper's*, he comments that "the editorial conditions were such that [Nast] did not consider it advisable to continue his contributions."[13]

That Nast resumed his work for *Harper's* in 1895, three years after Curtis died, suggests that his differences with the editor could not be overcome. In addition, when Curtis died, Nast was publishing his own paper, *Nast's Weekly*, so it would be unlikely that he would draw for *Harper's* as well. But by 1895, Nast's paper had failed, and he would have needed the work. Thus, in the summer of that year, *Harper's* began to publish Nast's drawings. A total of fourteen appeared in 1895. In 1896, eight appeared. This was far fewer than Nast produced when he was in his prime, but it demonstrated that the cartoonist still had the same fiery approach to politics and that he had returned to his Republican Party affiliation.[14]

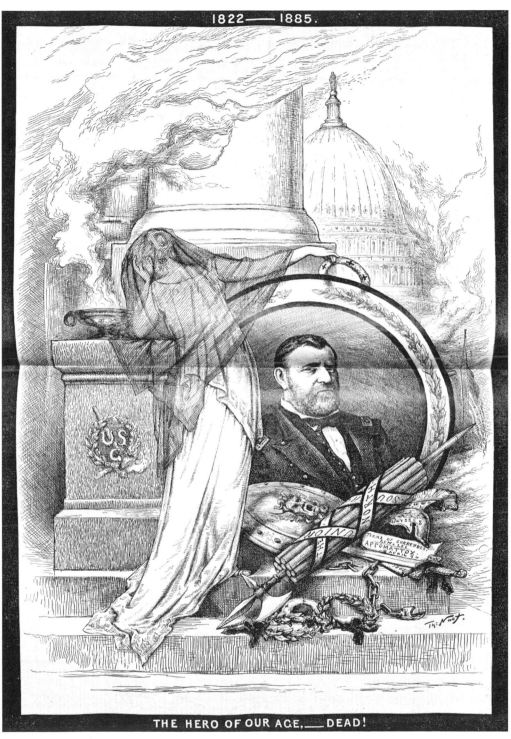

The second possible explanation for Nast leaving *Harper's* is that Nast's drawing arm was painful. The recurring pain he had begun to experience might easily have made itself felt after three years of intense work. Almost 200 drawings a year in *Harper's* meant that Nast drew an average of 4 per week, a task requiring that he read the news, discuss and consider it, then conceive a drawing. Once the idea struck, Nast had to sketch, refine, clarify and perfect. It is not hard to imagine that he could have overtaxed his body in the effort.

A final possibility is that Nast may have had a period of relative stagnation. In quick succession, Nast's finances sustained a terrible blow, his greatest hero died, and the party to which he had dedicated his life and art splintered. The effect of these developments on his work cannot be underestimated. In 1878 and 1879, Nast chafed against the restrictions imposed on him by Curtis. Without freedom to draw as he liked, he could not bring passion to his work. Without passion, his work was stale and predictable. After the campaign of 1880, Nast's ennui worsened. His wealth and satisfying home life coupled with anger at the Harpers and Curtis may have led Nast to abandon his work. Why strain his painful arm, after all, when money was rolling in from investments? Perhaps it was time to retire?

The dream of a pleasant retirement died as Nast's investments failed. After *Harper's*, Nast's career entered a downward spiral. He sought a variety of sources of income, but none was as lucrative as his work for the *Weekly*. The paper suffered, too.

Whatever his reasons for departing, Nast's absence was a blow to *Harper's Weekly*. Paine's chapter on this portion of Nast's life is titled "At the End of Power." According to *Louisville Courier-Journal* editor Henry Watterson, whom Paine quoted, "In quitting *Harper's Weekly*, Nast lost his forum; in losing him, *Harper's Weekly* lost its political importance."[15] The former is true to a certain extent, the latter unlikely. Readers may have missed Nast's cartoons, but *Harper's Weekly* remained influential.[16] However, *Harper's Weekly* would never again boast a more powerful collaboration than that between a famous, influential, and highly regarded editorialist and the nation's most important political cartoonist.

Nast continued to seek freelance work, churning out cartoons for a variety of magazines and newspapers. The work wore on his health and rarely provided enough income to balance its cost. Selling paintings proved equally difficult. In 1893 Nast approached Colonel William Church with a proposal for a painting to adorn a Sven Ericsson monument. Nothing came of the project.[17] He also proposed a painting or mural—the subject is un-

known—to librarian of Congress A. R. Spofford. Although Spofford was complimentary and encouraging, there is no sign that anything came of Nast's proposal.[18]

In May 1887, Nast invested what savings he had in a silver mine in Colorado.[19] After a period of travel within the United States with his wife, he set out with his son Thomas in September to supervise the mines. The playful side of his personality, coupled with his optimism, led him to believe that he could profit from the massive extractive industries of the West. To guarantee success, Nast arranged for his son to study assaying and to manage the mine. Three months into the adventure, Nast hoped to find himself a rich man again.

There was no silver. The entire operation was a bust, and possibly a scam. Nast had a minor nervous breakdown and returned to Denver to recuperate. From there—probably desperate for money to repay the $3,000 he'd invested in the mine—Nast began a lecture tour through the far West. Audiences responded enthusiastically, and Nast basked in a friendly welcome wherever he went. His ill health, however, continued to bother him.[20]

Money was now more of a problem than ever, and lecturing had begun to fail as a solution. It was less lucrative, and Nast was less capable of weathering the travel required. Freelance positions, with the *Daily Graphic*, for example, felt like hack work. He needed the money, but the quality of these papers was disappointing. Nast's frustration is understandable. Readers of the *Daily Graphic* would have seen that his pencil was not as precise as it had been. He recycled ideas and caricatures and seemed frustrated. More and more, Nast believed that what he really needed was a paper of his own. Some money remained, and he intended to use it to make one last attempt at financial, artistic, and journalistic success.[21]

For several years, Nast watched as the world of political cartooning expanded and his own preeminence eroded. New artists began to capture the public imagination. Of these men, Joseph Keppler represented the most disturbing example for Nast. Keppler's father supported the Revolutions of 1848 in Austria. In their aftermath, the senior Keppler removed his family to the United States, leaving his son Joseph behind in Vienna. There, Joseph Keppler studied art from 1851 until 1855. He lived in Italy for a time and then in 1867 moved to the United States. Keppler's first journalistic endeavor was a German-language newspaper in St. Louis. When the venture failed, Keppler joined the staff of *Frank Leslie's Illustrated News*, where Leslie hoped he would offer Nast some competition. In 1876, the young artist founded *Puck* in New York.[22] This time, he found success. Ironically, not only did

the bearded and mustachioed Keppler resemble Nast, but he also chose as the headquarters of his new illustrated paper 13 William Street.[23]

Keppler was two years older than Nast, and his entry into American political cartooning occurred at the moment when Nast's celebrity blossomed, so the men's differing style was not a product of generational differences. Using color and demonstrating a far more relaxed, agile, and mobile style, Keppler's work began to eclipse Nast's in appeal. Compared to his work, Nast's black and white drawings, with their reliance on cross-hatching, seemed dated and old-fashioned. But the most telling difference between the two men's work was that Keppler controlled every detail of his drawings. No editor controlled the content of *Puck*. No one could change the political stance of his paper. Keppler was editor, artist, owner, and publisher.[24] But Keppler was not the only political cartoonist who had such freedom. A consortium of cartoonists—former employees of *Puck*—founded *The Judge*, for example, and then later bought *Frank Leslie's Illustrated News*. Nast could not avoid the conclusion that magazine ownership guaranteed editorial liberty.

To Nast, this seemed the ultimate dream. After the years of conflict with Curtis, the struggle to assert his independence within the Harper company, and his ultimate failure, Nast could see the immense value of ownership.[25] With his own paper, he would determine the political positions to be taken. His talent would undergird the paper's popularity with the public. His hand would control everything about the paper, from the advertisements to the masthead. The editor Nast hired might write the editorials, but they reflected Nast's views. This time, Nast would run the shop and the editor would be the employee.

Nast imagined a paper in which profitability took a back seat to ideas, values, and honesty. *Nast's Weekly* would tell hard truths and would "do more good than any church or library or college ever founded," he said. Profit might not come, "perhaps not for years," but the readership would build because quality is its own sales pitch. In Nast's view, Americans expected nothing less. Unfortunately, Nast's approach to the business of running a magazine failed to attract the wealthy investors he hoped would "endow" his paper. Instead, he launched the paper with his personal fortune, depleted as it was.[26]

Despite Nast's long-standing interest in owning his own paper, *Nast's Weekly* emerged more by accident than design. The *New York Gazette*'s three editors offered Nast cartooning work in March 1892. He accepted, but the paper was failing. Nast received no pay for his work. Within months,

the editors struck a deal with Nast, exchanging the *Gazette* for the payroll debt. Nast now owned his own paper—but one without liquid assets. Nast needed cash.

Nast found the money in a second mortgage, and re-christened the *Gazette Thomas Nast's Weekly* (commonly known as *Nast's Weekly*). The inaugural edition appeared on newsstands on September 17, 1892. Nast designed the masthead, which featured an illustration of an owl sitting on an artist's palette. The owl, which clearly represents Nast, has a beard and mustache, wears a joker's cap, and clutches a pencil and paintbrush in its talons. The owl, in heraldry, symbolizes both vigilance and perception. It sees in the dark and can swivel its head to see in almost any direction. By giving the owl his facial features, Nast asserted his ability not only to observe politics but also to expose pretension and hypocrisy. The owl's place on an artist's palette and its pencil and brush assert Nast's vision of himself as a talented artist and his artistic freedom. This paper, the centrally placed mascot argues, is the property and expression of an artist. Here, there will be no conflicts between the cartoons and the editorials.[27]

Initially, *Nast's Weekly* boasted sixteen pages of jokes, news, editorials, cartoons, and advertisements. Nast produced all the cartoons. Editor Morrison Renshaw, Nast, and Thomas Nast Jr. collaborated on the editorials. The younger Thomas Nast appeared on the masthead as publisher. From the *Gazette* Nast inherited few readers, but he hoped to use the presidential election campaign of 1892 to revive circulation. Indeed, once Nast's name was attached to the paper, the Republican Party promised a guaranteed circulation of 100,000 copies. Nast supported the Republican candidate, Benjamin Harrison. The presidential campaign cartoons, however, went badly. Nast's cartoons were sketchy and incomplete. They lacked the vigor of previous years and failed to capture public attention. Moreover, despite the guarantee of circulation, advertisers were wary about the new paper, and ad revenue dropped precipitously after the first few months.[28]

Another problem was getting the paper into the hands of readers. Newspapers and magazines appeared on newsstands through the delivery services of a local distribution company. According to Nast, that company was controlled by a resurgent Tammany Hall. Nast was already Tammany's greatest public enemy. In the first issues of *Nast's Weekly*, he enhanced that reputation by attacking the police. Writing about a corruption scandal, Nast antagonized Tammany and the police still further. As a result, his paper was banned by the police. There is no evidence to suggest that the distribution company was in league with the police and Tammany Hall, but clearly Nast

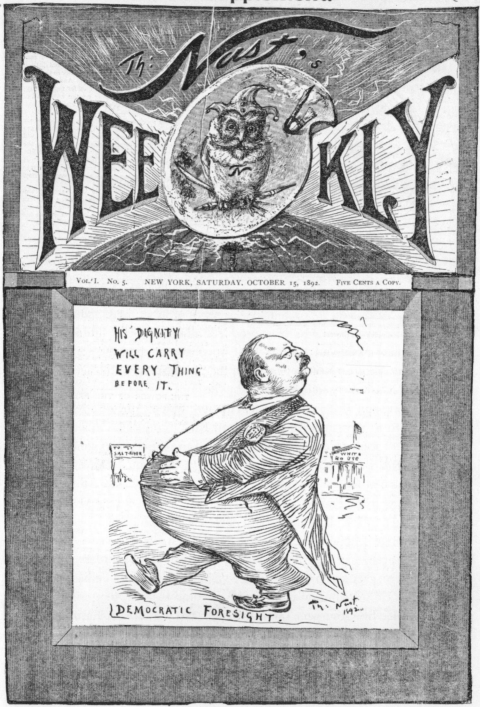

The cover of Thomas Nast's Weekly, *October 15, 1892.*
Courtesy of the University of Minnesota Libraries.

thought so. He believed that his old enemies had yet again reached out to destroy him.[29]

Nast's Weekly lasted only seven months, and by the end, it was a shadow of its former self. In the final issue of the paper, on page seven, Nast announced the dissolution of Henry E. Dixey's Opera Company. "The fact is," he wrote, "though a man may play well his part, he may play a losing game."[30] This was as true for Thomas Nast as it was for Henry Dixey. *Nast's Weekly* had dwindled to eight pages. Its advertisements, numbering forty-seven in the best issue (November 5), were down to only twelve by March 4, 1893. The eleven drawings in that issue were all reprinted from previous issues. Even the cover was a copy, repeated from the December 3 issue. There was no announcement of its failure, only the cessation of publication. The last of Nast's fortune was gone with it.

Private painting commissions arrived, but they were few. In 1894, Nast painted the surrender of Lee, titled *Peace in Union. The Surrender at Appomattox, April 9, 1865.* Hung in Ulysses S. Grant's hometown, Galena, Illinois, the painting attracted some positive attention. "So many southerners have been pleased with it," Nast wrote to Henry Watterson of the *Louisville Courier-Journal.* Nast hoped Watterson could help place a copy in Washington, since "it is too bad it is to be buried in Galena."[31] In May that year, Shakespeare again inspired Nast. *The Immortal Light of Genius,* a painting commissioned by English actor Sir Henry Irving, showed a bust of Shakespeare illuminated by a shaft of sunlight coming through a window. The painting eventually traveled to Stratford-upon-Avon to adorn the bard's memorial. Before it departed, Nast displayed the painting at a gallery on Broadway and invited friends and potential clients to see it.[32] A final painting, of the actor William E. Burton as Timothy Toodle from the play *The Toodles,* decorated The Players Club of New York in 1899. There is no record of the payment Nast received for these paintings. In any case, it was not enough.

Still, Nast was a famous political artist. Perhaps his work could grace the seat of government. Writing again to Henry Watterson in Louisville, Nast complained, "How is it that an artist of my reputation which is national, can not be represented at the National Capital?"[33] In 1898 he approached A. R. Spofford, of the Library of Congress, with a proposal. As librarian of Congress until 1897, Spofford had been responsible for expanding the library from a service for members of Congress to a true national repository. Before his tenure in Washington, Spofford edited the *Cincinnati Commercial* and participated in Republican politics. Nast offered to provide the

library with a set of historical paintings, to be purchased by the federal government by an act of Congress. The paintings would be both "educational and practical," Nast argued, and would be more useful than the current decorations at the library.[34] Whatever Spofford's reaction, Congress failed to act.

Painting took up a great deal of time, anyway, and the rate of production was so much slower that Nast could never expect to make a living at it.[35] He could still find freelance work, but for the most part the pay was poor. Small papers that were struggling to survive could ill afford hiring a star cartoonist. Most were either just starting publication or on the verge of bankruptcy. Worse, most papers, old and new, had a supervisory editor. Having tasted freedom, even for just seven months, Nast could not work under the control of another man for long.[36]

As if the parade of failure and tragedy that had dogged his heels since 1884 was not enough, Nast endured yet another loss in 1899. His eldest daughter, Julia, died in New York. Julia was born on July 1, 1862, the year Nast joined the *Harper's Weekly* staff and exhibited three paintings at the National Academy of Design. She was Thomas and Sallie's first-born, a child whose growth to maturity fascinated Nast and provided many images for his Christmas drawings. Accounts of her death vary. According to one, she died of kidney disease in a New York City boardinghouse,[37] where she was living while working as a nurse. Another account in the diary of a Morristown man, however, says that Julia killed herself.[38] If she did, then her death must have been especially difficult to bear.

By 1901, Nast's financial state was extremely precarious. He still worked, but publishers and editors were generally unenthusiastic about his cartoons. Some members of the public believed that Nast was dead, and the similarity of Thomas Nast Jr.'s signature to that of his father helped to reinforce their mistake. In October 1901, Nast sent a grumpy little drawing to the *Bridgeport Standard*, complaining of its reference to him as "the late Thomas Nast." "I Still Live" the heading trumpeted, though he signed the drawing "The Ghost of Th: Nast."[39] A teasing signature softened the petulance in his comment. That relaxed approach typified Nast's response to the recurring references to his death. "What is the use to cry about it?" he asked Paine. "The paper is right—I'm dead enough to the public." If he did not cry, it still wounded his spirit. "I feel like a caged animal," he said, "so helpless."[40]

Helpless or not, he needed to earn some money. The Morristown house, so long a refuge from the world and a showplace for his interests, was ex-

pensive to maintain. Even before the failure of *Nast's Weekly*, friends advised that he ought to sell the house. He refused but mortgaged it to remain solvent. In addition, he felt that his friends, especially those to whom he had been generous when he was flush, had abandoned him. Worse, his success at *Harper's* made him a target for sniping. To defend his artistic and political achievements had been easy before. Now, not only was Nast poor and increasingly desperate for work; his fall from his position as America's premier cartoonist was humiliating.[41]

When Nast was a young man, his tenacity rewarded him beyond his wildest dreams and made him both rich and famous. But now he was a tired sixty-one-year-old. He might have decades of experience, but his hands were painful and he no longer had the endurance he once had. And what he produced looked rougher. His illustrations lacked the smooth lines and polished shadows of his best political cartoons.[42] Freelancing under such conditions promised little financial security. Nast needed a salary, and hoped that his many contacts in the federal government could help. A particular target for that hope was John Hay.

Hay, born in 1838 and educated in law at Brown University, became Abraham Lincoln's private secretary in 1861. From that position, Hay, a prolific writer, recorded his observations of the president during the Civil War in diaries, poems, articles, and letters. He was acquainted with numerous Washingtonians, from the powerful to the insignificant. He had a long diplomatic career, including posts in Paris, Vienna, and Madrid, worked as a writer for the *New York Tribune*, served under President Rutherford B. Hayes as assistant secretary of state, and wrote a laudatory biography of Lincoln. In 1898, President William McKinley asked Hay to return to government service as secretary of state. When Theodore Roosevelt assumed the presidency in the wake of McKinley's assassination, Hay remained in his job. By then, Thomas Nast had been acquainted with him for more than thirty years. It was to Hay that Nast turned for help obtaining a position within the Department of State.[43]

There was reason to believe that Hay could help. Although most of the men holding ambassadorial positions were educated, experienced government officials from the upper classes, a fair proportion represented the artistic and literary classes.[44] Author Bret Harte, the midcentury's foremost observer of the American West, turned to a consular post when his money ran out. Like Nast, his career had begun with stunning highs and degenerated to depressing lows. Hailed as the greatest new voice in American literature when he was only in his twenties, Harte fielded a flurry of editorial

and literary job offers. The most lucrative was the editor's chair at a new magazine intended for launch from Chicago at a salary of $10,000.[45] Harte was invited by the owners of the magazine to a dinner in his honor, hiding the ten thousand dollar check under his plate at the table. He never showed up. Years of hard drinking and squabbles with collaborators (such as Mark Twain) and employers led to a serious financial crisis by 1877. Traveling to Washington, D.C., Harte finagled a position as consul general in Crenfeld, on the Rhine. The job paid $2,500 a year.[46] He later transferred to Glasgow, Scotland, and retained his consular post until 1885. The money he earned helped to support his wife and children until his death.[47]

Nast's chances for obtaining a position in the diplomatic corps were enhanced by the man in the Oval Office. Nast admired Theodore Roosevelt, and he had shown that admiration in his political cartoons. As New York City's police commissioner Roosevelt had campaigned against open saloons on Sunday, an endeavor Nast approved of. And since Irish Democrats and Tammany bosses opposed Roosevelt, Nast naturally sided with the future president. In addition, striding through the streets of the city, his large teeth snapping and his wire-rimmed glasses flashing as he tossed his enormous head, Roosevelt provided material enough for ten caricaturists. Nast applauded him through letters and cartoons, and Roosevelt replied gratefully.

The appointment, when it came, was not for a comfortable position in western Europe. Instead, Hay offered the consular post at Guayaquil, Ecuador. The salary was $4,000 a year. Hay apologized for the offer, saying that although the president was eager to find Nast a post, there were few openings. If Nast preferred, he could wait for another opening. But, Hay wrote, "our service is so edifying and preservative that few die and nobody resigns." This was an ironic comment in light of the notoriously unhealthy climate of Guayaquil.

Nast accepted the post. He needed the money and he felt that diplomatic service might be an honorable retirement for a man so closely associated with Republican politics. He had been compiling notes for Paine's biography, and he hurried to complete them before he left. Despite his acceptance, he traveled to Washington in hopes that there might be some better place. England or Germany would be pleasanter and more suited to his age and health. There was nothing. He left for Ecuador on July 1, 1902.[48]

The most common illness foreign visitors to Guayaquil contracted was yellow fever. At first, Nast seemed heartily immune. Like the New York of his childhood, Guayaquil was prone to fire. Just before his arrival, on

July 18, it had burned. Nast explored the town, perhaps remembering the many fires in his childhood neighborhood. In letters to Sallie, the majority written on tiny little scraps of paper that make them nearly illegible today, he sketched the local people, described the boring rounds of social calls required of diplomatic folk, and commented on the local politics and culture.[49]

In general, he was not complimentary. Nast was always critical; it was part and parcel of his profession. But in Guayaquil his tendency to criticize was unleavened by family life or his usual good humor. "The fire, the yellow fever and the dirt do not help to clear one's mind," he wrote. The night air was purportedly dangerous, but there was no glass in the windows. "There are shades, we can shut them, but the air goes through them," he continued. The nearby ocean was also cause for complaint: "When the tide is out the smell is in; when it comes back again, it washes the smell away." The people were little better. "Oh, what a place this is for gossip," he grumbled; "it runs wild, like the rats." One of the few things Nast really enjoyed was the tropical fruit. He seems to have eaten little besides melon, banana, pineapple, and papaya.[50]

Despite his early avoidance of yellow fever, Nast knew that it was a serious danger. To Sallie, he wrote that he had hung up a photograph of her and their grandchildren. "As I look at it and see all laughing, I laugh too," he wrote, "but my greatest happiness is that you are not here." He would gamble his own health for the sake of their finances, but Sallie was too precious for him to risk her safety.

Between the lines of Nast's letter lurks a terrible sense of bitterness. His complaints that everything was dirty and that the people of Ecuador were worthy of little more than the mud of the streets they walked on reflected not only his artist's eye for detail but also his failing optimism. This job was a dead end, and it was clearer than ever that his life had taken a desperate turn. "I do long to have a stillness such as we have in Morristown," he wrote to Sallie.[51] He tried to work, sketching the locals for Sallie and creating at least one cartoon for the local paper, *La Nación*. He painted a little, but the moist air kept the paint from drying quickly. Mostly, he hoped for a better post, telling Sallie that he would "make a good record" in Guayaquil.

On September 15, Nast wrote to Sallie, "I think I am too old to catch the fever." The weather was bad, though, damp and cloudy. Locals referred to it as "fever weather," Nast said, and were paranoid. Any sickness was instantly diagnosed as yellow fever, and the city would become a hotbed of rumor and panic. Nast was both fatalistic and upbeat. "What a blessing to

be old," he wrote. "One is going to the next world soon, anyway, so one is exempt. For the first time I feel glad that I am old." Despite Nast's dismissal of local concerns, the reality was that yellow fever was raging in the city. He knew that the wealthier residents had already left because of the fever. Mail boats bypassed the city. Foreigners were especially susceptible, including Germans.

The first German of Nast's acquaintance to die was a man who frequented the Union Club. His secretary also took sick. Then a German man on Nast's hall in the boardinghouse fell ill. Although he tried to keep it a secret, Nast found out. He poured disinfectant in the hallway, which alerted the manager. The man was removed. Nast noted the progression of the disease toward him: "First our club, then on our floor. It is coming very near."

Nast's last letter to Sallie was written November 30. On Monday, December 1, he began to feel ill. His throat was infected; he felt nauseated and feverish. Robert Jones, the American vice consul, wrote that Nast initially thought he was having a "bilious attack." Jones visited Nast on Wednesday and found him dressed but reclining in a hammock. Jones insisted he see a doctor, who pronounced the problem to be Nast's liver. On Saturday, a second doctor arrived, and declared that Nast had yellow fever. A third doctor confirmed the diagnosis.

Both physicians warned Nast that "his condition was very serious," but Nast insisted that "he felt much better and would soon be all right." This was Nast the optimist, cheerful in the midst of the most serious of events. His capacity for friendship was evident, too. All night on Saturday, Jones and the British vice consul, Mr. Ashton, cared for Nast. They cabled Sallie several times to inform her of the latest news. There was nothing good to report. In the middle of the night, Nast suddenly lost consciousness and struggled to breathe for the next few hours. Jones and Ashton watched and waited, able to do little. They were with him when he died, at 11:35 on Sunday morning, December 7. Jones cabled Sallie immediately.[52]

Within six hours, Jones buried Nast and "assumed charge" of the consulate. The funeral attracted most of the diplomatic community as well as the governor and many other local dignitaries. Jones informed the State Department of Nast's death that day, including a detailed account of his illness in code. On December 10, Third Assistant Secretary of State Herbert H. D. Peirce replied to Jones with a terse note expressing the department's condolences to Nast's family, which he asked Jones to relay.[53]

The State Department forwarded Jones's telegram to Sallie so that she could read his account of her husband's death. The accompanying note

read: "Madam: The Department is in receipt of a dispatch from the Vice Consul General of the United States at Guayaquil, Ecuador, reporting the death of your husband, Thomas Nast, Esquire, late Consul General at that post, a copy of which communication is transmitted herewith for your consideration."[54] Understandably, Sallie and her children found this cold.

The State Department's note proved a sensitive subject for some years to come. In 1904, C. M. Fairbanks, a friend of Nast's, lunched with Albert Bigelow Paine. Paine reiterated what Fairbanks already knew from Sallie: the State Department never officially thanked her for her husband's service, nor had it offered any official condolences. Fairbanks then wrote to Hay. "I am sure," he gently insisted, "you would not have withheld from Mrs. Nast the consolation of such a message as she felt she might receive from your Department." She felt the omission, he wrote, "sorely."[55]

Hay received other appeals on behalf of Mrs. Nast. In March, family friend J. W. R. Crawford wrote to ask Hay about the long-dormant proposal for the Library of Congress to buy Nast's historical paintings. This idea had been floated as early as 1872, when Nast wrote to Sallie about a meeting with Hay to discuss "painting a picture for the Capital."[56] The price in 1902 was $25,000. Appealing to Hay's long acquaintance with Nast, Crawford wrote, "As a personal friend of the late Mr. Nast may we call upon you . . . ?" The deal was not only a worthwhile recognition of Nast's "services to the Nation," Crawford wrote, but also an act of "relief" for Sallie. Thomas Nast, Crawford reminded Hay, "gave his life for the country as bravely as any soldier of them all." Surely, Crawford added, President Roosevelt would wish to recognize him, and to help Mrs. Nast.[57]

Nothing came of it. Mrs. Nast was, however, in dire need of "relief." Without Nast's income and with the expenses of her household, Sallie had terrible money problems. The longest communication Sallie received from the State Department, in the end, was the inventory of Nast's possessions. It was a sad catalog. His clothes and gun, pencils and paints were all noted, as was the possibility that some of the items could be sold locally rather than shipped back to New Jersey. The guns and some other materials stayed in Ecuador.[58] Nast's body also remained in Ecuador until Sallie could afford to move it. Nast is now interred in Woodlawn Cemetery in the Bronx.

Legacy

Nast's death left his family bereft. For Sallie, the void was not only emotional but also financial. With the loss of much of Nast's fortune in the Grant and Ward debacle and the remainder sunk into the Colorado silver mine and *Thomas Nast's Weekly*, Sallie had nothing left but her home and Nast's collection of drawings, letters, and mementos.[1] Nast's position in Guayaquil had not even lasted a year, and the income it would have provided had been the sole reason for Nast's willingness to travel so far. After more than forty years, Sallie was back to a financial position not so very different from the one she occupied in 1860. One bright spot was supplied by hopes for a forthcoming biography of Nast. Its author was a first-time biographer but a longtime admirer of Nast's.

Born in Massachusetts, Albert Bigelow Paine grew up in Iowa and Illinois. The child of a farmer and store keeper, Paine was both literate and literary from an early age. His family subscribed to an astonishing array of newspapers and magazines. His parents read local and national newspapers, Christian essays, and humorous magazines. The children subscribed to two magazines, both full of imaginative stories, articles, and drawings. Paine began to write poetry as a young man, despite his more prosaic job selling photographic supplies in Kansas City. By 1895, spurred in part by his failed marriage, Paine moved to New York to pursue writing full time.[2]

One of Paine's first endeavors in New York was a weekly literary magazine. He and three friends founded the paper, but it failed within three weeks. Paine consoled himself by writing a humorous book about his troubles. Titled *The Bread Line*, after the most famous of New York's "outdoor" charities, the book appeared for sale in 1901. In an act simultaneously admirable and presumptuous, Paine mailed copies to his two heroes: Thomas Nast and Mark Twain. Twain replied with a pleasant note, but nothing more.[3] Nast was altogether more enthusiastic.

Nast and Paine were both members of the Players Club. Encountering the young Paine on the stairs one day, Nast stopped him to compliment the

book. "You probably intended that book 'The Bread Line' as humor, but to me it is tragedy. I started a paper once myself," Nast said. Paine's experience was similar to Nast's, but with a few important differences. For one, Paine had had no reputation to lose, nor much money invested in his paper. In addition, he had never had the national party connections that Nast hoped to parlay to increase sales. Paine could laugh at his folly, while Nast looked upon his experience with bitterness.

In 1901, Paine was forty years old. When *The Bread Line* appeared, he was the same age that Nast's deceased daughter Julia would have been. Albert and his second wife, Dora, were the loving parents of two daughters, and they eventually welcomed a third. Although Paine was not yet rich, his writing career was clearly headed for success, and his genial manner had already earned him a wide circle of friends and acquaintances. *The Bread Line* had been a moderate success. *St. Nicholas* magazine hired Paine as the children's editor, and he wrote a number of charming stories for the magazine. Trained in photography when very young, Paine remained interested in taking pictures and enjoyed various forms of art, including cartoons. In short, Paine was a talented and appealing young family man who loved literature and the visual arts. His shy stammer only added to the impression of sensitivity. It is easy to imagine how appealing he was to Nast.

Paine was hardly perfect. He could, in fact, be as disingenuous as Nast. For example, in later years, Paine claimed that his final acceptance of Nast's offer—to write a biography of him—was the result of a happy coincidence. As a boy, Paine had enjoyed the Christmas drawings in *Harper's Weekly*. He remembered them vividly, and many years later would assert that while he understood what fiction was, he believed utterly in Santa Claus because he knew that *Harper's* was a *news*paper, and therefore whatever it printed must be true. According to Paine, he was talking with Nast at the Players Club when the cartoonist said, "If you should do this book about me, I would like to have in it some of my Santa Claus pictures." Paine claimed that it was only then that he realized that the drawings that had so enchanted him as a child were Nast's, and, on the spot, he agreed to the book.

Of course, this account begs the question of why Paine sent *The Bread Line* to Nast in the first place—if he was unaware of Nast's body of work. Nast's origination of the modern Santa Claus was no secret. In fact, Nast was the illustrator not only of *Harper's* annual Christmas editions but also of special Christmas issues and children's books. More likely, Paine sought to insert drama into the story of his agreement to become Nast's biographer. Also, he hoped to blunt the impression that he had sought out the as-

signment in any mercenary way. In Paine's version, the cartoonist and his biographer found a common ground in shared experience.

Having agreed, before the fire at the Players Club, to become Nast's biographer, Paine was very much at sea. He had only written fiction and poetry and had no idea what he was doing. However, his first impulses proved sound. He sat with Nast, recording impressions, memories, and ideas. He visited Morristown, spending many days poring over old drawings, talking with Sallie and Nast's friends, and discussing the politics of Nast's era with its cartoonist. As Nast prepared to leave for Guayaquil, Paine sifted through Nast's papers, letters, and sketches, selecting materials he would use in the book.[4]

Paine's theory of biography, developed in the course of writing and publishing his first two, was founded firmly on the principle that the biographer must know and like his subject. Paine would later refuse to write a biography of Calvin Coolidge, arguing that he could not possibly get to know the man and understand him—much less actually write a book about him—in the six weeks provided by Coolidge's staff. With Nast's biography, Paine selected a man he admired, then set about describing his life in glowing terms. Paine was aware of Nast's flaws, but he believed that biographies ought to recognize faults but focus on achievement. That emphasis on achievement provoked much positive comment, but at least one reader objected.[5]

When *Thomas Nast: His Period and His Pictures* appeared in 1904, it drew instant criticism from one of Nast's Civil War colleagues. Writing to the *New York Times Review of Books*, Arthur Lumley began by attacking Paine's assertion that Nast "practically created" Santa Claus.[6] But this was only an introduction to the real point, which was that Nast was "an indifferent draughtsman" and that his special talent was only for "crude" cartooning. Not only did Nast copy Lumley's work and that of A. R. Waud, Lumley asserted, but he also "had no personal experience of the rough army life and its perils and privations."[7]

Paine responded the following week. Writing in an overly cordial tone, he began by addressing Lumley's Santa Claus argument. He moved quickly on to Lumley's attacks on Nast. First, he argued, Nast only reworked sketches by other artists in his earliest employment with *Harper's*, and had never denied this. Second, Nast's trips to the front were documented by military passes, letters, and other ephemera in Paine's possession.[8] Third, and somewhat contradictory to his other two points, Nast's work was almost entirely "imaginative" and "allegorical." Thus, Nast could not have copied it from

Lumley or Waud's sketches. As for Lumley's attacks on Nast's style, Paine subtly insulted the older man. Yes, he wrote, Nast had little formal training, and essentially none after the age of sixteen. But, considering the impact of his life's work, this was a good thing, not a mark against him. Essentially, Paine had said that Lumley, for all his art education, was a hack compared to Nast. In closing, Paine offered Lumley a compliment and an insult at the same time: Lumley's work was familiar to him and of great quality—unlike his memory.[9]

The controversy did not end there. Lumley, furious now, wrote back to say that it was during Nast's employment at the *New York Illustrated News* that he had copied Lumley's drawings. But Lumley contradicted his own story. He asserted that no one had ever seen Nast in an army camp but then said that A. R. Waud had taken Nast for a "few weeks of camp life" and later laughed about "Tommy's" fears. After insulting Nast's artistic ability and suggesting that his work for Garibaldi had been inferior both in absolute and relative terms, Lumley came back to the war. Nast's name had been excluded from the memorial to war correspondents at Gapland, Maryland, he said, because Nast was not at the front. Nast spent the war at his home in Morristown, New Jersey. Apparently unable to stop his righteous anger from rolling right over a variety of subjects, Lumley attacked Nast's work in the 1880s, the quality of *Nast's Weekly*, the painting Nast made of the Seventh Regiment leaving New York, and his Tweed drawings. Those, he said with supercilious glee, now hung in a saloon!

At this point, Paine was unwilling to remain polite. He pointed out, cuttingly, that the Nast family purchased their Morristown home in 1871 and therefore could not have lived there during the war. But Lumley's letters were essentially an attack on Nast as a person worthy of a biography, and Paine recognized that this was Lumley's weakness. Nast was a national and local hero. He was a man whose influence, character, and talent were disputed by no one but Lumley. The factual errors in Lumley's letters were incidental when compared to his obvious effort to diminish Nast and aggrandize himself. Lumley, Paine charged, was a member of "that small but venomous coterie who, comprehending neither [Nast's] genius nor his success, hated him accordingly, and never missed an opportunity of stabbing him from behind." The *Times* ended the discussion with an endorsement of Nast, comparing him to James Gillray, George Cruikshank, and Paul Gavarni.[10]

Did Nast travel to the front? Paine unequivocally asserted that Nast had, indeed, visited the front on several occasions. Nast's letters from Pennsyl-

vania in July 1863 demonstrate that he attempted to sketch Gettysburg and came under Confederate fire in Carlisle. Given his experiences with Garibaldi, there is no reason to suppose that Nast's fear of camps or combat kept him away from the front. Still, Nast was a newly married man at the time. By 1862 the Nasts were the parents of their first daughter and spent much of their time at home. Indeed, he and Sallie were such homebodies that their friends called them "old grannies."[11] So while Nast clearly traveled during some periods of the war, he had incentives to stay home whenever possible.

If Arthur Lumley's were the only allegations that Nast attached his name to the work of others, it would be easy to dismiss him. But A. R. Waud's complaints reinforce the picture of Nast as a plagiarist. There is no question that Nast worked on Waud's drawings. In the late 1850s and early 1860s, the process of transforming a sketch into an illustration required not only an artist but a room full of engravers to bring the image into printable form. In that complex work environment, several men could refine any drawing. Perhaps Nast felt that his contributions to Waud's rough sketches merited applying his signature. Waud and Lumley disagreed. They believed him to have simply stolen other men's work and presented it to the public as his own. Nast's work was synthetic, however. He borrowed images, jokes, quotes, and situations from a variety of sources, including Shakespeare, classical drama, antebellum political lithography, and popular sayings. As Nast's personal style developed, his facility for "borrowing" became more sophisticated. Nast's youth, inexperience, and, most of all, ambition led him to appropriate other cartoonists' work. Nast wanted to succeed, and his personal style was still in embryo. As he moved from a jack-of-all-trades in the engraving room to a position as a salaried illustrator, he crossed the fine line between altering other artists' work and appropriating it.

Artistically, Nast hardly needed direct war experience. The images he created for *Harper's* reflected the emotional reality of the war for the Union home front. The power of Nast's work lay not in its fidelity to reality but in its penetration into Union hearts and minds. Fletcher Harper liked Nast and allowed him the freedom to re-create events largely from his imagination. Nast never denied this. Rather, he pointed to it as an example of the mutually respectful and affectionate relationship between himself and Harper. So while it is likely that Nast did visit Union camps, at least a few times, those visits were not the stuff of which his illustrations were made. Instead, they were a combination of his store of visual experiences—those images he could reproduce from memory, such as a camp full of soldiers—

and his talent for touching the most powerful emotions of the reading pub-
lic. Paine shared Nast's talent in the sense that he knew how to portray
someone sympathetically. In Paine's account, Nast emerges as a complex,
funny, passionate man. He had weaknesses, but they were balanced by his
strengths, and any reader would come away understanding why people so
loved him despite his faults.[12]

Perhaps it was this quality in the biography, published by Macmillan in
1904, that attracted Nast's old friend Mark Twain's attention. Twain sought
a biographer, and he selected Paine on the strength of his work for Nast.
Paine spent the next five years working, playing, and passing the time
with Twain. Not only did he write an enormous biography of the writer,
but Twain named Paine (with Twain's daughter) coexecutor of his literary
estate. From that post, and his position as children's editor at *St. Nicholas*,
Paine continued to produce books until his death in 1937. In all, he wrote
more than forty, including several biographies — an impressive accomplish-
ment for any man. For his last biography, of Joan of Arc, Paine was named
a chevalier of the French Legion of Honor. So the Nast biography was a
beginning, a first foray into a new field of writing, but it helped to cata-
pult Paine into the ranks of the literary elite. In the process, he became a
rich man.

Paine's financial success did not benefit Sallie Nast, however. She re-
ceived nothing from the book except a positive testament to her husband's
legacy. Forced to seek some revenue source, Sallie auctioned Nast's posses-
sions through the Merwin-Clayton Auction house in New York. The first
sale, in April 1906, was restricted to Nast's "library, correspondence, and
original cartoons." The second, in February of 1907, disbursed another
large selection of Nast's drawings and cartoons. The third auction, in April
of the same year, sold the family's collected ephemera, the various curios
and objets d'art that had cluttered the Morristown house. The last of Nast's
possessions left the family's control at the final sale, in March of 1908. There
is reason to believe that Sallie did not consult all of her children about the
objects for sale. Cyril Nast, the younger of their two sons, purchased a num-
ber of items at the second auction. Surely, had the entire family collabo-
rated on the catalog, he could have selected in advance those that he wished
to keep.[13]

Nast's possessions did not fetch a very high price, and the auctions could
not relieve Sallie's financial distress. She died in New Rochelle, New York,
at the home of her son Cyril in October 1932.[14] Nast's children carried on

his legacy in various ways. Thomas Nast Jr. enjoyed a relatively success-ful career as an artist—and his signature was almost a copy of his father's. During the Second World War, Nast painted camouflage for the U.S. Army. He died in New Rochelle in 1943.[15] Cyril, Edith, and Mabel Nast all outlived their brother. Cyril carried on the family legacy by using Nast's Christmas drawings to illustrate his annual holiday cards.[16]

Nast's legacy lay in far more than Christmas cards, however. He was widely praised, and his contribution to American political cartooning has been unequaled. Today, Nast's position as the father of American political cartooning goes unchallenged. His work is widely available in monographs, compilations, and on the internet. However, the complexity that character-ized Nast's life, work, and ideas has been diminished with time.

With the advent of the internet, Nast's vast body of work became far easier to catalog. HarpWeek.com, a website that has made *Harper's Weekly* available to the public, has embraced Nast as its primary celebrity. The site features a "Cartoon of the Day" that provides a brief explanation of the cartoon and places it in historical context. Before HarpWeek, many of Nast's lesser known drawings were hidden in the back pages of dusty bound volumes. HarpWeek made Nast's work searchable, so that any sub-scriber interested in cartoons containing references to Carl Schurz, for ex-ample, need only enter his name, and the pertinent cartoons pop up, listed in chronological order.

Other websites devoted to Nast testify to his continued popularity. ThomasNast.com is the home site of the Thomas Nast Society, operated from the Morristown Free Public Library in Morristown, New Jersey. The society has been working on a CD-ROM that will contain Nast's entire body of work—including his illustrations, Almanac drawings, paintings, and sketches.

Nast's public legacy, as opposed to his legacy among historians, might have been a disappointment to him. He is famous primarily for three things. The first would have pleased him: the destruction of the Tweed Ring. The second was his "invention" of the Democratic donkey and Republican ele-phant. It is likely Nast would have declined this honor, since he knew he had not invented the donkey. It was widely used before the Civil War, some-times in explicit references to Democrats as jackasses, sometimes simply to connote thickheaded obstinacy. The elephant was a symbol he might have claimed as his own, but it was a minor element in his richly symbolic car-toon world, and one wonders how important he would have considered it.

The last element of his legacy is his collection of Santa Claus drawings, of which Nast was especially proud. Their success reinforced his devotion to two of the most important parts of his life: family and children.

Among academics, Nast has become a source for useful illustrations and hardly anything more. It is not unusual to see his cartoons in books about the nineteenth century with little accompanying explanation and no mention of the artist's views. Teachers love his drawings, understandably. They are a great way to illustrate the issues that were important to nineteenth-century Americans. Yet, again, Nast himself is largely absent. His work must speak for itself, because his personality, politics, and artistic goals are largely ignored.

Historians who have written about Nast pay slightly more attention, but even they rarely look deeply into his life or ideas. In many cases, he is dismissed as a bully, a man so negative he had almost nothing nice to say about anyone. This is a disservice to Nast, who had many positive things to say. In fact, the venom he directed at the Tweed Ring and the Irish, for example, was counterbalanced by his heartfelt defense of Grant and the freedpeople.

Art historians have been kinder to Nast. Perhaps they bring Nast more fully into their writing than do other scholars because they accept more fully the fact that the artist's views are essential to understanding his work. Still, art historical treatments of Nast are few for two reasons. First, there is simply less written about art history than American history. Second, political cartooning receives only a minor share of art historical attention in general, and most of that is directed toward the great European cartoonists: Honoré Daumier, George Cruikshank, John Tenniel, and even Francisco Goya. The best of art historical scholarship has linked Nast both to European traditions and to fine art.

Today, the disconnection between art history and traditional historical research extends to the treatment of the politics of Nast's work and its art content. Those elements of greatest interest to historians of America—his Republican Party loyalty, his views on race, gender, and immigration, his adoration of Grant and vilification of Tweed—are largely absent from art historical examinations of his work. There, he emerges distinct from his politics.

Were Nast free to select his own legacy, it would be very different. Primarily, he would emphasize the power of his work. It reached a massive audience, it influenced elections from the presidential level to the level of New York alderman, and it reflected the social and political reality of nineteenth-century America in both its best and its worst moments. Nast

would choose to be remembered as a Republican, a man loyal to the legacy of Abraham Lincoln and opposed utterly to the vigilantism, social decay, and cultural stagnation of the antebellum and Jim Crow South. In his defense of his editorial and political freedom, Nast demonstrated that he believed his voice equal to the intellectuals and journalists of his time. Nast would want us to remember that it was he who chose the subjects for his satire. He was a political commentator in his own right, not simply the tool of a larger organization. Finally, Nast would want later generations to take him seriously as an artist. Nast never abandoned fine art entirely, and at the end of his life it reemerged as a primary interest. Nast's mind was open to art in a variety of forms. Daggers and suits of armor, paintings, sculpture, and artifacts all interested him, and no national or geographic boundary disqualified an item from classification as art. Likewise, Nast's own cartoons, full of imagery, symbolism, subtlety, and wit, would be a sad omission from the history of art in America.

If historians were to honor this legacy, how would our view of Nast change? To begin, it would no longer be reasonable to accept a political cartoon as a simple image. This would not disqualify scholars' use of cartoons. Quite the contrary. Cartoons would be richer than ever as sources because there would be so much more to say. They would constitute an entire world of interpretation on par with newspaper text, letters, diaries, and other primary sources. We would ask, "What did the artist mean to imply here, and does he represent the nation's opinion, or only his own?" Examining Nast, and other cartoonists, as political authors and thinkers widens the field of useful evidence available to historians.

Moreover, cartoons straddle the problematic boundary between the elite and the street. Consumed by the rich and poor, the educated and illiterate, the male and female, cartoons were a form of popular political expression that illuminated the interactions between classes, genders, races, and immigrant groups. Like all historical evidence, cartoons are imperfect. How can we really understand Nast's use of text, for example? Did illiterate Irish laborers "read" his drawings in the literal sense, or only symbolically? These are challenging and exciting questions, demanding from historians a much more serious approach to nineteenth-century print culture.

NOTES

Abbreviations

AC	Accession number
CCF	Caricature and Cartoon File, Print Room, New-York Historical Society, New York, N.Y.
CEN	Charles Eliot Norton
FLIN	*Frank Leslie's Illustrated News*
GA	File code
GWC	George William Curtis
GWCP	George William Curtis Papers, bMS AM 1124, Houghton Library, Harvard University, Cambridge, Mass.
HM	Huntington Library, Manuscript Division, San Marino, Calif.
HW	*Harper's Weekly*
JTNS	*Journal of the Thomas Nast Society*
LOC	Library of Congress, Washington, D.C.
MCNY	Museum of the City of New York
MFPL	Morristown Free Public Library, Morristown, N.J.
NPC	Norton Parker Chipman
NPCCW	Norton Parker Chipman Collected Works, 1803–1924, vol. 2, California History Section, California State Library, Sacramento
NYHS	New-York Historical Society, New York, N.Y.
NYIN	*New York Illustrated News*
NYT	*New York Times*
RBHPL	Rutherford B. Hayes Presidential Library and Center, Freemont, Ohio
SEN	Sarah Edwards Nast
TN	Thomas Nast
TNC	Thomas Nast Collection
TND	Thomas Nast Diary, 1860–1861, Thomas Nast Papers, Box 1, GA-33, Rutherford B. Hayes Presidential Library and Center, Freemont, Ohio
TNP	Thomas Nast Papers

Chapter One

1. Paine, *Thomas Nast*.

2. For example, "Caricaturists," *Louisville Courier-Journal*, Sunday, December 11, 1887; "Caricature in the United States," *Harper's New Monthly Magazine*, 25–42; and "American Caricaturists," unknown publication, in TNC, MFPL. In 1976, cartoonist Draper Hill, whose biography of James Gillray is the definitive work on that cartoonist, began to write a biography of Thomas Nast. It has never been finished, but in an unpublished chapter, Hill repeats some of Paine's details, along with confirming material from James Parton. See Draper Hill, "Tommy on Top," 88–90, unpublished essay, TNP, RBHPL, GA-33, Box 1.

3. Alice Caulkins, "Thomas Nast: A Chronology," *JTNS* 10, no. 1 (1996): 119–23.

4. Paine, *Thomas Nast*, 6.

5. The last reference to Nast's birth family in the Paine biography appears on page 68. Nast's sister is mentioned only in the very beginning of the book, on page 5.

6. Paine, *Thomas Nast*, 13.

7. Ibid., 8. Paine notes that the wife of the ship's captain treated Nast with "wine and quinine," suggesting malaria. There is no evidence that Nast suffered the recurring fevers of some malaria patients, however, so it is possible that he simply had a fever and the woman gave him the medicine she had on hand.

8. Caulkins, "Thomas Nast," 119.

9. Paine, *Thomas Nast*, 13.

10. Company Six was the company of William M. Tweed, who was later called "Boss" Tweed. Briefly, in 1850, Tweed led the company. Its truck was decorated with the head of a tiger, a symbol Tweed suggested and that he later adapted as the symbol of Tammany Hall. See Paine, *Thomas Nast*, 12–14; and Bales, *Tiger in the Streets*, 28, 33, 45.

11. See Tolzmann, *German-American Experience*, 191–93, 397–98; and Furer, *Germans in America*, 39–43.

12. A number of German-speaking artists lived in New York in this period, offering Nast with thriving community to join. See Ernst, *Immigrant Life*, 214–15; Table 27 shows immigrant artists.

13. "Thomas Nast," *HW*, May 11, 1867, 293.

14. Cummings, *Historic Annals*; Clarke, *History of the National Academy of Design*.

15. Paine, *Thomas Nast*, 16–17.

16. The use of printed images in private homes is well-known, but illustrated newspapers were printed on fairly inexpensive paper, in comparison to the high quality of Currier & Ives prints. It is initially difficult to imagine the paper surviving the process of cutting and pasting, and the rigors of nineteenth-century life. Readers nonetheless cut out drawings they liked and pasted them up. Frank Leslie even made special accommodations for this by warning readers to examine the paper thoroughly before cutting in order to catch any important text (which might be on the back of a picture and thus lost if it was cut out too soon), and by usually

printing "stories and miscellaneous materials" on the back of an illustration. See Gambee, *Frank Leslie*, 50.

17. Mott, *History of American Magazines*, 2:44; Gambee, *Frank Leslie*, 4–39.

18. Mott, *History of American Magazines*, 2:453. Gambee, *Frank Leslie*, 4, suggests that Leslie did not intend his paper to be "sensational" in a prurient sense, like the Penny Press, but that his personality lent itself to coverage of what we now call human interest, and he learned early that crime stories were hot sellers. It must have been early, indeed, as the second issue of the paper, January 5, 1856, contained the following headlines: "A Female Found Dead," "Accidental Death," "Suicide of an Artist," "Christmas at Five Points," "Diabolic Murder in New Haven," and "Juvenile Fracas."

19. *Leslie's* began publication in December 1855, just after Nast's fifteenth birthday. Nast likely obtained the job sometime in early 1856, therefore, before his next birthday.

20. Paine, *Thomas Nast*, 18–19. According to Budd Gambee, *Frank Leslie*, Frank Leslie got his first job in almost exactly the same way as Nast. Although at the time Leslie was an adult, he apparently talked his way into a job with almost no qualifications save talent and ambition. Paine does not mention this, and perhaps did not know it. Alternatively, Paine may be silent because Nast tended to emphasize his work for *Harper's Weekly* rather than *Frank Leslie's*. But it suggests that Leslie might have been more sympathetic to the young German applicant than he admitted to James Parton.

21. See Greenfield, *Nationalism*; Smith, *National Identity*; Anderson, *Imagined Communities*; and Hobsbawm, *Nations and Nationalism*.

22. Lower Manhattan's wooden homes and businesses suffered repeated fires in the first half of the nineteenth century. See Homberger, *Historical Atlas*, 56, 78–79.

23. Paine, *Thomas Nast*, 15.

24. A photocopied newspaper article in the collection of Nast materials at the Morristown Free Public Library states that the Nast family intended to live in New York City but "ultimately, this plan was changed and a home was made in the middle West." This is the only reference to the Nast family in later years, and it is incomplete in that the newspaper is identified and no date is given. In the spring of 1860, while in England, Nast repaid a loan by the boxer John Heenan by giving him a draft for $100 from Nast's mother. This was in case the *New York Illustrated News* failed to pay Heenan money it owed Nast. Heenan tore up the draft, but the story indicates that not only was Nast's mother still in New York at that time; she was in possession of his savings or of family money on which Nast felt he could draw. See Paine, *Thomas Nast*, 44. In a diary Nast kept while touring Germany, he describes his visits with family members in Landau. Nast seems to have been hoping that an elderly aunt would make him her heir. He was unsure, however, that she actually had any money, or if she did, how much. In the end, he found that the endless round of afternoon visits and beer hall nights was tedious, and he moved on. The only hint that his emotions were engaged was in his visit to his father's old band hall, where he was moved to think that his father had walked through the same gates. See TND, December 21–24, 1860, entries.

25. Hills, "Cultural Racism," 104. In 1865, Hippolyte Taine published a description of the philosophy of art in which he linked the "moral temperature" of any given time period to the lives of its artists, and suggested the intimate relationship between artist and art. See Taine, "The Philosophy of Art," 370–83. Most important here, however, is not how to interpret Nast's work in light of his persona but rather the absence of a crucial element of that persona in his life story.

26. Paine, *Thomas Nast*, 6, writes that Nast observed a nasty incident "at a Catholic Church," but he does not specify whether Nast was there as a congregant. On page 12 he relates the story of the poster on Sunday and on page 14 the confessional story.

27. Ibid., 9.

28. Homberger, *Historical Atlas*; and for Nast's version of the move, see Paine, *Thomas Nast*, 10.

29. Furer, *Germans in America*, 42.

30. For example, Nast identified the man next door as a crayon-maker for artists (Paine, *Thomas Nast*, 10), and an engraving at the MCNY shows a window-shade-maker in this area. Also at the MCNY, an engraving shows a row of shops on William Street between Fulton and John Streets, in 1845. Here, we see shops selling "Paris Fancy Goods," "Saddlery Hardware," and dry goods, a lamp manufacturer, and a paint store for artists. In the early nineteenth century, Delmonico's Restaurant opened on William Street between Beaver Street and Mill Street. It burned in 1835 but was reconstructed and reopened in 1837, where it remained until 1890. See Margot Gayle, "New York's Changing Scene," in *Sunday News Magazine*, March 25, 1979, n.p., in William Street File, MCNY.

31. Paine, *Thomas Nast*, 10.

32. William Street actually had several informal names in addition to its final one. It began as Shoemaker's Lane, and was famous for the horrible smells produced from the tanning process. Later, it was called Smith Street, King George Street, and William Street, the last named for William III of England. In 1744 the street was officially named William Street to minimize confusion. See "New Doings in Shoemaker's Lane," a pamphlet of the National City Bank of New York, in William Street File, MCNY.

33. Among the newspapers on Park Row and William Street and in Franklin Square were the *Staats-Zeitung und Herald*, the *New York World*, the *New York Sun*, the *New York Tribune*, the *New York Times*, the *Evening Journal*, and the *New York Herald*. *Harper's Weekly* and the Harper publishing business were located there after 1853. See Robert C. Boardman, "Newspaper Row Loses Last Paper," September 14, 1954, in William Street File, MCNY. This article is likely from the *New York Times*, but there is no attribution in the clipping.

34. This store, founded by A. T. Stewart in 1848, was also known as the Marble Palace. It occupied a corner lot at Broadway and Chambers Street. In 1862, Stewart moved his store to Broadway and Ninth Avenue.

35. Paine, *Thomas Nast*, 12–13.

36. Anbinder, *Five Points*, 43–45.

37. Ibid., 45–48.

38. In 1855, according to the U.S. Census, there were 1,987 German bakers in New York. Other occupations, in descending order of frequency, were tailor (6,709), servant (4,493), "food dealer" (3,045), clerk (2,249), cabinetmaker (2,153), and laborer (1,870). Over 45,000 Germans worked in New York, representing 47 percent of the total immigrant population. By contrast, although the Irish were employed at a slightly higher rate (50 percent, which was the highest recorded for any immigrant group in the census), the number of Irish laborers was 17,426, out of a total of 19,783 in New York. Irish domestic servants numbered 23,386 to the city's 29,470. This distinction between a German propensity for artisanal work with higher pay and greater opportunity for the accumulation of wealth and the Irish dominance of laboring and service work was doubtless visible on the streets, where the marks of a man or woman's work were usually visible in his or her dress and workplace. So not only might Nast have witnessed the variety of immigrant experiences, but he could hardly have missed the lesson that some immigrants were blessed with far greater advantages than others. Perhaps it was this comparison that initially tinted his memories rosy, since in contrast to the lives of many Irish immigrants, his family's experience was relatively easy. See Ernst, *Immigrant Life*, 213, Table 26; 214–15, Table 27; and 219.

39. Hawgood, *Tragedy of German-America*, 55–58, gives the number of German immigrants for 1854 as 215,000. Billigmeier, *Americans from Germany*, 79, says that the total number was 230,000.

40. See Wittke, *Refugees of Revolution*, 3.

41. Harris, "Arrival of the Europamude," 1–3. Harris gives the total number of German emigrants between 1845 and 1854 as one million. Of these, he estimates that 670,800 arrived in the United States between 1850 and 1854, demonstrating the delay between 1848 and the arrival of the wave of German immigrants. However, it is important to note that most of those immigrants were not refugees of the Revolution of 1848. Harris describes them using the term "Europamude," which translates as people who were "tired of Europe" and frustrated by its reliance on tradition. These immigrants rejected the traditionalism against which the Forty-eighters fought, but they rejected it in favor not of Liberal political values but of a generalized embrace of the new (ibid., 2). See also Hamerow, "Two Worlds of the Forty-Eighters," 19–21.

42. Wittke, *Refugees of Revolution*, 24; James M. Bergquist, "The Forty-Eighters: Catalysts of German-American Politics," in Trommler and Shore, *German-American Encounter*, 22–36; H. B. Johnson, "Adjustment to the United States," in Zucker, *Forty-Eighters*, 43–78.

43. Tolzmann, *German-American Experience*, 228–31.

44. William Street's seeming gentility did not totally exclude the violence and dangers of the neighborhood. In 1856, just after Nast began work for Frank Leslie, the newspaper reported a "Shocking Murder" on William Street. A German dance hall, operated from number 231, was the scene of an altercation on New Year's Day. When Martin Karnes was ejected from the hall, he returned after a short interval and provoked a knife fight with the man who opened the door to his knock, William Ruff. Karnes's knife cut Ruff's throat, killing him. Not only did this mur-

der occur on Nast's street, it was reported by his employer. See *FLIN* 1, no. 5 (January 12, 1856).

45. For an example of the crime in Nast's neighborhood, see *FLIN*. For example, in the February 25, 1856, edition: "Successful Burglary and Robbery," "Charge of Gambling," and "Charge of False Pretenses," in the section "Police Intelligence." *HW*, not content merely to report crime, mixed the news in its May 23, 1857, issue with bizarre descriptions of Chinese culture, reporting on its cover that the consumption of opium was becoming epidemic in New York because of imports from Asia. See pp. 321–22.

46. On the poor and criminal on surrounding streets, see Anbinder, *Five Points*, 72–105. Lithographic and newspaper references at the MCNY show a wide variety of street scenes on and around William Street, ranging from prosperity and respectability to vile crime. The origin and intent of the image often predicts its content, rather than the reality of the business and social life occurring in that place and time.

47. Paine, *Thomas Nast*, 11–12, refers to both of these locations.

48. The company known as the "Big Six" derived from a previously dissolved fire company called Engine Company Number Six. The company was re-formed in 1849 under the leadership of a group of local men, including John C. Reilly and William M. Tweed, but its first location is unclear. The Hester Street house was occupied in 1854, when Nast was fourteen years old. The neighborhood served by the Engine Company was bounded by the river (and South Street) to the east, Grand Street to the north, Catherine Street to the south, and Bowery, or Fourth Avenue, to the west. The station likely stayed within those bounds from 1849 until the organization of municipal fire companies in 1865, and was never very far from Nast's home on William Street. Paine, *Thomas Nast*, 11, says the engine company was "less than a dozen blocks away."

49. See Anbinder, *Five Points*, 48–50 and chaps. 3 and 4.

50. In 1834–35, residents of Five Points and surrounding streets rioted three times, first, in reaction to an election controversy; second, against the abolitionist sentiments of local activists, targeting African Americans living on the Lower East Side; and third, in an expression of the tension between local native-born Americans and immigrant Catholics. In later years, violence was a constant threat during political interactions, for example in 1845, when a gang of thugs broke into a Tammany Hall meeting and forced the revision of a resolution on Texas. Riots could also occur over cultural events, as in 1849, when the dueling Shakespeare interpretations of Macready and Forrest led to riots during which the Park Theatre burned down. On the 1849 riot, see Levine, *Spirit of 1848*. On the 1834–35 riots, see Anbinder, *Five Points*, 27 and 141–44. Anbinder's discussion of street crime and the perils of drink can be found throughout, but especially on pages 20–27, and 72–105. Nativist political and social sentiments were continually expressed in political debates and party publications as well. See Gronowicz, *Race and Class Politics*, 109–12.

51. *NYT*, December 2, 1902.

52. Regarding child workers, including newsboys, see Anbinder, *Five Points*, 129–33. Frank Leslie referenced these children in his second issue of *FLIN*. Com-

plaining about blocked streets, he pointed to the crowds of "thousands of girls and boys employed in the innumerable manufacturing establishments lying between Spruce and John Streets." See *FLIN*, January 5, 1856.

53. Paine, *Thomas Nast*, 18; Parton, *Caricature and Other Comic Art*, 318–34, esp. 326–27.

54. On the depression of 1854 in New York, see Anbinder, *Five Points*, 133–35; and Paine, *Thomas Nast*, 28.

Chapter Two

1. Joseph Thomas Nast, as a musician with a large band, may have read sheet music, which would imply a level of education that might also include literacy. Mrs. Nast is a complete mystery in this regard. No letters exist from Thomas Nast to his father, mother, or sister, and there is no record of him receiving letters from them, either. When he was in Germany in 1860, Nast visited family in Landau and kept a diary for his own use and Sallie's interest, but he made no mention of any literary artifacts (letters, diaries, family Bibles, or other written materials). If the Nast family moved west after the 1860s, and they were illiterate, their absence in Nast's life after 1861 makes more sense, but there is no conclusive information on this subject. According to Tolzmann, there were 5,000 German-language periodicals published between 1732 and the late twentieth century, the largest number published by any non-English group in American history. Tolzmann calculates that in 1872, 80 percent of the periodicals published in a language other then English in the United States were in German. Many of these were published in states, particularly Ohio and Indiana, where massive German immigration meant an enormous reading public. In 1890 there were 727 German-language periodicals in America, many in the Midwest. See Tolzmann, *German-American Experience*, 228–31 and 397.

2. Gambee, *Frank Leslie*, 50.

3. On New York's ascendancy and the content of illustrated magazines, see Mott, *History of American Magazines*, 2:103–7.

4. Exman, *Brothers Harper*, esp. 1 37.

5. Ibid., 48–59, esp. 53–54.

6. See Marzio, *Democratic Art*; Pierce and Slautterback, *Boston Lithography*; and LeBeau, *Currier and Ives*.

7. Paine, *Thomas Nast*, 19–20; Mott, *History of American Magazines*, 2:44; Gambee, *Frank Leslie*, 47. Gambee points out that Frank Leslie did not introduce the multiple-block method to the United States but that his was the first successful use of it in the service of illustrated journalism. It is because of his success that Leslie is so closely associated with the process. When calculating the time required to produce an illustration, it is also important to note the curious dating of Leslie's paper. Issues bore a date that reflected the week to come rather than the week just past. So, for example, the January 12 issue, in which a New Year's Day murder was reported, arrived on newsstands on January 5. Thus the illustrations in the January 12 issues reflected the news of the last week of December and first week of January, and each issue took only about one week to create. See Gambee, *Frank Leslie*, 56.

8. See prints 16533, 16534, and 16535 at the Metropolitan Museum of Art, American Prints, Nineteenth Century, MM85208 and SP3599.

9. An excellent example of this is the January 20, 1872, issue of *FLIN*. On the cover is a full-page depiction of the murder of Colonel Fisk, complete with the stunned onlooker, his billowing cape, and the cloud of smoke surrounding the fired gun. A subtitle identifies the "scene of the tragedy" as the Grand Central Hotel. See Mott, *History of American Magazines*, 2:454. See also Pearson, "*Frank Leslie's Illustrated News* and *Harper's Weekly*," 81–111.

10. The Harpers began their business on Front Street, near the docks, then moved to Pearl, then to 82 Cliff Street, and finally to Franklin Square (in 1853), after a fire destroyed the Cliff Street building. All of these addresses were within ten blocks of Thomas Nast's home on William Street. See Exman, *Brothers Harper*, 5, 12, and 353–62; and Exman, *House of Harper*, 37–47.

11. Nast tried to tear down the poster while playing hooky from church, in an impressive combination of wicked behavior. See Paine, *Thomas Nast*, 12.

12. Pearson, "*Frank Leslie's Illustrated News* and *Harper's Weekly*"; Paine, *Thomas Nast*, 21.

13. Thomas Butler Gunn, as quoted in Warren, *Fanny Fern*, 171.

14. "In and About the City: Death of Charles I. Pfaff, Something about the Proprietor of the Once Famous 'Bohemia,'" *NYT*, April 26, 1890.

15. Paine, *Thomas Nast*, 22.

16. Nast's "The Political Death of the Bogus Caesar," *HW*, March 13, 1869, is based on Gérôme's *The Death of Caesar* (1867); another example is "Napoleon 'Dead Men's Clothes Soon Wear Out,'" *HW*, September 10, 1870, based on Paul Delaroche's *Napoleon in Fontainebleau, le 31 mars 1814* (1845).

17. *FLIN*, December 15, 1856.

18. "The Irish Fiasco at the Astor House," *FLIN*, December 22, 1856, 22.

19. Paine, *Thomas Nast*, 22.

20. Gerome's painting *The Death of Caesar*, 1867, and Nast's "The Political Death of the Bogus Caesar," *HW*, March 13, 1869; another example of Nast's use of paintings is "Napoleon 'Dead Men's Clothes Soon Wear Out,'" *HW*, September 10, 1870, based on *Napoleon in Fontainebleau, le 31 mars 1814*, 1845, by Paul Delaroche.

21. *FLIN*, December 15, 1856.

22. Gambee, *Frank Leslie*, 40.

23. Pearson, "*Frank Leslie's Illustrated News* and *Harper's Weekly*," 83–86.

24. See Gambee, *Frank Leslie*, 46–48; and Pearson, "*Frank Leslie's Illustrated News* and *Harper's Weekly*," 89, regarding the way artists' work was often altered in the engraving room.

25. Paine, *Thomas Nast*, 24.

26. On the formation of the municipal police, see Ernst, *Immigrant Life*, 22.

27. It is likely that Nast's family was in the Fourth Ward since Paine indicated that the house was near Frankfort. If they were farther down, closer to Beekman Place, they might have been in the Second Ward. See "Lloyd's Mammoth Map of the Business Portion of New York City, 1867," in *Manhattan Maps, 1527–1995*, at MCNY.

28. Ernst, *Immigrant Life*, 223, Table 35, based on the New York State Census of 1855. In the Sixth Ward, just across Frankfort from Nast's home, the numbers were 13,010 aliens, 2,263 naturalized citizens, and 686 native-born citizens. The Sixth was Tammany's home ward and the ward of Boss Tweed. It was the only ward in the city with a greater number of alien voters than the Fourth.

29. Welch, *Concept of Political Culture*, 3–5.

30. See Sperber, *European Revolutions*, and Kelly, *Transatlantic Persuasion*.

31. See Trefousse, *Carl Schurz*.

32. A plaque at Castle Gardens, Battery Park, notes the reception there of Kossuth, among others, by the city, and a statue at 112th Street and Riverside Drive commemorates his visit as well. For Nast's experience, see Paine, *Thomas Nast*, 14.

33. According to M. A. Hackett ("Thomas Nast," 3), Kaufmann fought in the streets for the Revolution of 1848 and emigrated to America in 1850. He could, therefore, have been as powerful a Liberal influence on Nast as anyone in the boy's life.

34. Scisco, *Political Nativism*, 217.

35. Nadel, "Forty-Eighters," 53. Nadel asserts the power of these men in the elections of local officials, especially Mayor Fernando Wood.

36. Translation of this phrase is difficult. Blaetter (in which the "ae" stands in for an "ä"), translates literally as blade, folio, leaf, or sheet. The use of a racial epithet in connection with this word, and in reference to journalists, suggests that sheet or folio is the correct translation. Still, the meaning is not entirely clear. It is unmistakably derisive, however, and denotes a bitter disagreement over the place of Republicans, nativists, and slavery in German American political discourse. In contrast to this evidence of disagreement, in other parts of the country, Germans were associated with a single political leaning. For example, in Arkansas and Missouri, German immigrants were closely associated with abolitionist sentiment. See Valencius, *Health of the Country*, 37.

37. Zucker, *Forty-Eighters*, 22, 83, 100–101.

38. Foner, *Free Soil*, 226–27, 259 n. 71. There is a spirited disagreement over the contention made in the early part of the twentieth century that German votes were Lincoln's margin of victory. This only serves to demonstrate the centrality of German political participation in America.

39. See, for example, "This Is a White Man's Government," *HW*, September 5, 1868; or "Old Honesty," *HW*, July 20, 1872.

40. Anbinder, *Five Points*, 145–50.

41. Ibid., 154–58. In 1842, the Maclay Act created the city-run public school system, bypassing the Protestant Public School Society.

42. Hackett, "Thomas Nast," 4.

43. See Keller, *Art and Politics of Thomas Nast*, 159–75. The most famous example of Nast's anti-Catholic cartoons is "The American River Ganges," which appeared in *HW* on September 30, 1871. It shows the children of the United States standing, helpless, on a riverbank while crocodiles (drawn as Catholic priests) emerge to eat them. Tweed and the Tammany Hall gang look on while an Irish tough menaces a young mother.

44. Curtis, *Apes and Angels*, 58–59.

45. Morton Keller, analyzing Nast's anti-Catholic and anti-Irish cartoons of the 1870s, attributes Nast's views to his Radical Republicanism. This is hard to accept. Nast's experiences with the Irish were of too long duration and his observation of anti-Catholic sentiments too varied for his views to have been formed within the narrow confines of Radical Republicanism. In addition, the Irish role in the Draft Riots of 1863, and in local politics, helped to reinforce long-standing stereotypes reflected by Nast and other artists. Keller also bases his analysis on the mistaken assertion that Nast was raised as a "German Protestant," an assertion for which there is no evidence. See Keller, *Art and Politics of Thomas Nast*, 159.

46. Curtis, *Apes and Angels*, 58. See also Anbinder, *Five Points*, esp. 7–13, 163.

47. Irish violence against African Americans also reflected the support of some Irish immigrants for both slavery and white supremacy. These sentiments, expressed in Irish newspapers and by Irish politicians, reinforced the connection between Nast's Liberal political leanings and his awareness of the Irish as a political force. See Anbinder, *Five Points*, 303–14.

48. Paine, *Thomas Nast*, 9–11. On one occasion in grammar school, Nast successfully fought back against schoolyard bullying. Still, the streets of New York teemed with danger for a small boy. Nast learned this in school and observed it in his neighborhood.

49. One way in which this ideal was expressed was by transfiguring the meaning of the word "citizen." It came to mean, popularly, those voters who descended from English and Dutch settlers and who were therefore more authentically American than newer arrivals. See Gronowicz, *Race and Class Politics*, 137. Writing in 1901, Louis Dow Scisco argued that nativists in New York City were more sincerely committed to nativist ideology than those in any other part of New York State. See Scisco, *Political Nativism*, 203.

50. In 1844, John Harper, of the Harper Brothers publishing house, headed the first of the secret societies formed on nativist principles, the American Brotherhood, quickly renamed the Order of United Americans (OUA). John Harper's brother, James, was then mayor of New York. It was their youngest brother, Fletcher, who would found *Harper's Weekly* in 1857; he was Thomas Nast's boss until 1877. By the time Nast was in close contact with the Harper family, however, Fletcher and his brothers embraced abolitionism and the Republican Party. See Curran, *Xenophobia and Immigration*, 44–45.

51. The hysteria of some native-born Americans was only made worse by the swell of immigration in the 1830s. While in the 1820s, fewer than 6,000 German immigrants arrived in the United States, comprising less than 5 percent of total immigration, the numbers jumped massively in the next decades. From 1830 to 1899, Germans made up at least 15 percent, and as much as 34 percent, of the total American immigrant population. In the 1840s, almost 400,000 Germans arrived in America, while in the 1850s the number was almost a million. When you add to these numbers the tide of Irish immigration that accompanied the potato famine, it is easy to imagine the tension among citizens who believed in the link between

their birth in the United States and their political and social primacy. See Tolz-
mann, *German-American Experience*, app. 6, 447.

52. Higham, *Strangers in the Land*, 8–9.

53. The problem of finding oneself an outsider could also be true for Catholics
of different ethnic or national origin. German Catholics, for example, often wor-
shipped at different churches than their Irish neighbors. This was true not only in
Nast's neighborhood but also in outer boroughs such as Queens, where Newtown
St. Mary's parish was German and Our Lady of Sorrows parish was Irish. See San-
jek, *Future of Us All*, 22.

54. Curran, *Xenophobia and Immigration*; Anbinder, *Nativism and Slavery*, 103–
26.

55. Examples of Nast's anti-Catholic drawings in *HW* include "The Promised
Land," October 1, 1870, and "Church & State," February 19, 1870.

Chapter Three

1. Sarah Edwards's mother, Sarah Leach Edwards, was the sister of Parton's
mother, Ann Dearling Parton. Parton's father, Peter Parton, a miller in Canterbury,
England, died in 1826, and Ann Parton emigrated with her four children. Sarah
Leach Edwards lived in Philadelphia at that time with her husband and family. See
Flower, *James Parton*, 7–8.

2. S. C. Jochem, "Dearest Sallie: Sarah Nast, the Woman Who Inspired Thomas
Nast," *JTNS* 13, no. 1 (1999): 26–36.

3. Jeffrey Eger, "Young Thomas Nast's First Book: A Tale of Two Stories," *JTNS*
10, no. 1 (1996): 54. The author of the text caption was probably Jesse Haney, which
reinforces the possibility that it is a repeated conversation from the Edwards home.
It is tempting to interpret the "young lady at our elbow" as Sallie, who would spend
her entire married life aiding Nast in his work, often supplying captions and quotes
for his drawings.

4. In some cases, Nast used drawings as a substitute for text. For example, in
their honeymoon letters to Sallie's family, Sallie wrote the text and Nast added
drawings. In this way, Nast could avoid the problem of his written English (and his
terrible handwriting) by relying on his talent and Sallie's social graces. See Thomas
and Sallie Nast, 1861, TNC, MFPL.

5. SEN to TN, 1859, TNP, HM no. 27771.

6. Ibid.

7. Fanny Fern was a pseudonym for Sara Parton. Her name at birth was Grata
Payson Sara Willis, later Sara Payson Willis. She was also known, at various times,
as Sara Willis Eldredge and Sara Farrington, during her first two marriages.

8. Parton, *Life and Times of Aaron Burr*; Flower, *James Parton*, 39–41.

9. Parton, *Caricature*, 327.

10. Flower, *James Parton*, 18–19. Nast's support of international copyright law
is most clear in his visit to Washington in 1871, when he observed the Senate pro-
ceedings on copyright law. He also petitioned Charles Sumner on the subject. See

Charles Sumner to Thomas Nast, February 8 (no year), in the Charles Sumner Papers, Library of Congress Manuscript Division, Washington, D.C. This letter must have been written before 1872, the year Nast moved to Morristown, New Jersey, because it is addressed to his home at 125th Street, New York City.

11. See, for example, Parton, *Caricature*, in which he wrote about stereotypical images of women in caricature and cartoon: "When women have enjoyed these [equal education, rights, and opportunity] for so much as a single century in any country, the foibles at which men have laughed for so many ages will probably no longer be remarked, for they are either the follies of ignorance or the vices resulting from a previous condition of servitude" (190).

12. Warren, *Fanny Fern*, 155.

13. Ibid., 187.

14. Ibid., passim.

15. Ibid., 191.

16. SEN to Thomas Butler Gunn, quoted in ibid., 192.

17. Ibid., 151.

18. Ibid., 187.

19. Ibid., 222–30.

20. This was Parton's 1877 work, *Caricature*.

21. Ibid., 327. While Parton's friendship with Nast seems to have been a strong and long-lasting one, it did not prevent Parton from making a curious error in his book. He states that Nast was eighteen when the Civil War began, but he was actually nineteen. See ibid., 326.

22. Defining "class" in nineteenth-century America is notoriously complex. Here, class is intended to convey not simply economic difference—though the Edwards family enjoyed greater financial security than the Nasts—but also educational and social distinctions. The Edwardses' status as immigrants from England and their interest in politics, abolition, activism, and literature echo the emergent social authority of what Americans would understand as the "middle" class. Today, we can detect the many fault lines in any class hierarchy, but there is no question that from the perspective of nineteenth-century New York, Sallie Edwards came from a family at least one step above Thomas Nast.

23. TN to SEN, September 29, 1860, TNP, RBHPL, AC 12167, GA-33, Box 1.

24. TND.

25. Ibid.

26. TND, February 1860 entries. The pages of this document sometimes show dates, but the text is so muddled that determining the date of any given statement is a challenge. The voyage began February 16, 1860, but the document transitions to a description of England without a clear date.

27. Ibid.

28. "Yankee" Sullivan's legal name was Frank Ambrose, and although his nickname belies it, he was born in Ireland and emigrated to America by way of a prison transport to Australia. He used the name Jim Sullivan to avoid recapture while on a trip to England. In the first famous prizefight in America, Sullivan fought Tom Hyer on February 7, 1849. The *New York Illustrated Times* provided an illustration of

the fight, showing the boxers, ring, and spectators. See Anbinder, *Five Points*, 156, 194, 201–6.

29. Warren, *Fanny Fern*, 242.

30. Nast contributed to *The Little Pig Monthly*, *Nick Nax*, *Phunny Phellow*, *Yankee Notions*, *Vanity Fair*, and the *Comic Monthly*, whose editor was Jesse Haney. Nast provided illustrations for a children's book based on a story in *Little Pig Monthly*, *The Woful History of Hamunbakun*. See Jeffrey Eger, "Young Thomas Nast's First Book: A Tale of Two Stories," *JTNS* 10, no. 1 (1996): 45–74. Regarding the *Comic Monthly*, see S. C. Jochem, "Dearest Sallie: Sarah Nast, the Woman Who Inspired Thomas Nast," *JTNS* 13, no. 1 (1999): 26.

31. Paine, *Thomas Nast*, 34–36. Paine treats Nast's dual employment as entirely normal, and it was consistent with Nast's work in New York, where he held a salaried position as well as did freelance work. Only in later years, with *Harper's Weekly*, did Nast work for only one publication, but even then his Christmas work appeared separately, albeit published through Harper and Brothers.

32. See Nast's expense report, TN Box 1—Original Sketches—Foreign Travel, TNC, RBHPL, GA-33. Nast traveled by train from London to see Heenan, and he detailed his departure and arrival times, expenses, and sketch production for the *New York Illustrated News* on its stationery.

33. Mushkat, *Fernando Wood*, 91. John Morrissey also participated in the Fernando Wood campaign, fighting for Tammany Hall. He eventually became a powerful political operative in New York. Other examples of boxers who fought for political figures include "Yankee" Sullivan, who was finally arrested in San Francisco in 1856 when local leaders tired of his work stuffing ballot boxes for a price. Other boxers arrested at the same time included Chris Lilly, Dutch Charlie Duane, and James Cusick. Tom Hyer opened a bar in New York after he retired from boxing. He cultivated the business of the Bowery Bhoys, and adopted nativist political opinions. See Gorn, *Manly Art*, 123–28.

34. TND, London.

35. TN to Lexow, editor of the *NYIN*, March 19, 1860, TNC, C1135, Box 1, Folder 3, Princeton University Archives, Princeton University Library, Princeton, N.J.

36. Nast commemorated his visit to Heenan's English headquarters in a drawing published by the *New York Illustrated News*. See Paine, *Thomas Nast*, 38–39. Nast illustrated his meeting with Sayers for the *New York Illustrated News* as well.

37. Burnham, *Bad Habits*, 158; "A Gambling Scene at Pike's Peak," *FLIN*, January 9, 1864, reprinted in Burnham, *Bad Habits*, Figure 1.1; TN to Lexow, editor of the *NYIN*, March 19, 1860, TNC, C1135, Box 1, Folder 3, Princeton University Archives, Princeton University Library, Princeton, N.J.

38. Gorn, *Manly Art*, chap. 5 and 148–78.

39. See Paine, *Thomas Nast*, 44. Gorn, *Manly Art*, chap. 5 and 152–55, describes the fight itself, which lasted two and a half hours and ended when constables and fans rushed the ring. See *NYIN*, May 5, 1860. The cover illustration is by Nast, as are many within.

40. TND.

41. Ibid. The May 24 entry reads "Go to Italy," but the diary records Nast's de-

parture from London on May 27. His travels took him from London to Paris, then to Lyons and Turin, and finally to Genoa on June 1.

42. Paine, *Thomas Nast*, 47–48.

43. Nast left Italy in October. From October until December, he visited Germany. Nast returned to England in January and embarked from Liverpool for New York on January 19. See TND, January 20, 1861, entry.

44. Paine, *Thomas Nast*, 45. Never content to say just one thing when he could say four, Paine also called Garibaldi a "Sir Galahad of modern times, forever seeking the golden grail of freedom," and "a world's hero, . . . [offering] his sword in that cause which of all the gifts of earth he held most dear."

45. Ibid., 48–49.

46. Many other journalists found Garibaldi appealing, and there is some evidence that his reputation as the hero of the Risorgimento emerged as much from the conscious work of journalists as from actual events. See Riall, *Garibaldi*.

47. Nast kept the report from his January 1869 phrenological analysis conducted by "Fowler and Wells, New York" all his life. It includes many generalized injunctions, characteristic of astrology, such as: "You should become more an individual, be more master of your own position, and live more for yourself, not selfishly, but as if you had duties to perform, and as if young men were looking to you for example." Other sections are curiously specific: "You could not go, [*sic*] into an old cathedral, or synagogue, no matter who worshipped in it, if it had the marks of a thousand years upon it, without taking off your hat, as though you stood on holy ground." Some of the predictions seem prophetic, such as: "You have an excellent eye for proportions and outlines" and "You may not be quick to anger but when excited you are very severe." The document's survival, in several versions, in Nast archives, suggests that Thomas or Sallie may have found some of the descriptions accurate. One version, in Sallie Nast's handwriting, is in TNC, RBHPL, AC 12167, GA-33, Box 1.

48. Nast helped to produce illustrations of the war in Nicaragua at *Frank Leslie's Illustrated News* in 1856 and 1857 but had never observed war himself until his travels in Italy.

49. Jeffrey Eger, "Thomas Nast and the New York Illustrated News, Part III: Thomas Nast in Italy with Garibaldi," *JTNS* 12, no. 1 (1998): 66–68, with sketches on 75–111.

50. TN to Sallie Edwards, September 29, 1860, a transcription in Sallie's hand, TNP, RBHPL, AC 12167, GA-33, Box 1.

51. TND, December 16 and 18, 1860, entries.

52. Paine, *Thomas Nast*, 66.

53. TND, December 18, 1860, entry.

54. TND, December 20, 1860, entry.

55. TND, December 21, 1860, entry.

56. TND, December 23–24, 1860, entries.

57. Ibid. Paine, *Thomas Nast*, 66, says the "little fortune" was forty dollars.

58. TND, December 31, 1860, and January 1, 1861, entries.

59. TND, January 6, 1861, entry.

60. Paine, *Thomas Nast*, 67.

61. Written on his way to catch his ship for home, this is the last statement in Nast's diary. The last date recorded is January 20, but the handwriting and the fact that the statement is separate from other notes suggest that it was written another day.

62. One reason why Nast might not have seen the English papers was that he had a strange accident while traveling to Liverpool. His diary is extremely confused, both in its language and because his handwriting is almost impossible to decipher. At some point, though, there was an accident with the train, and Nast woke with a head injury. He was unable to focus for a couple of days, and only really felt better two days later, on January 20, 1861. See TND, January 20, 1861, entry.

63. Paine, *Thomas Nast*, 68.

64. Thomas and Sallie Nast, 1861, TNC, MFPL.

65. Quote, Paine, *Thomas Nast*, 68. There is no denying that some marriages in the nineteenth century were founded on a partnership basis. Given Sallie Nast's assistance with his later work, one might hope that this was the case with the Nasts, but it does not seem to have been so. Nast did not express openly his opinions about women's issues in print, but his cartoons make clear his distaste for the idea of women voters and women in business or public life. His letters are short and usually lack philosophical discussions, but there are hints that he preferred to have a traditionally gendered relationship with women. See, for example, TN to SEN, February 5, 1872, in which he wrote, "Miss Gail Hamilton did not like it, because I talked to Mrs. Aimes more, and she afterwards told me so, but the reason was I did not talk with her more was she was to strong minded, and the other was not" (TNP, HM no. 27760). The next day he wrote: "Yesterday afternoon I made call with Mrs. Chipman on ladies, and it seems very strange they are as much interested in my pictures as the men folks" (TNP, HM no. 27761).

66. Paine, *Thomas Nast*, 121–22.

67. For example, TN to SEN, February 6, 1872, from Washington, TNP, HM no. 27761. See also ibid., February 13, 1872, TNP, HM no. 27765. Not only would Sallie later help Nast produce his drawings, but she became the face and body of all women in his work. Most often he drew her as Columbia, or Liberty, in Greek dress and wielding a torch, sword, laurel wreath, or the Constitution.

Chapter Four

1. "Compromise with the South," *HW*, September 3, 1864.

2. Nast's facility with portraiture was legendary. In 1865, he won a contest in *Mrs. Grundy* magazine. The contest called for a caricature containing as many recognizable faces as possible. Nast's drawing provided over 100 faces, and won him $100 and his illustration on the cover of the magazine.

3. Rumors claimed that Lincoln had so feared violence from southern sympathizers that he adopted Scottish dress. Caricatures of this embarrassing story, including four drawings showing Lincoln in a plaid cap and cape, peering out of doorways, mocked Lincoln's supposed cowardice. Nast did not relate this story to

Paine, and his claim that he drew as best he could in the dark suggests that he chose to represent the scene as realistically as possible. See CCF, 1861-42, and Bunker, *From Rail-Splitter to Icon*, 92–95. David Herbert Donald (*Lincoln*, 278–79) tells the story in his biography and suggests that Lincoln's coat, thrown over his shoulders, and an unfamiliar Kossuth hat (a wide-brimmed felt hat) were the reason observers saw a Scottish costume.

4. Paine, *Thomas Nast*, 76.

5. Nast's exact pay at *Harper's* is unknown, but he had been offered fifty dollars a week to leave the *News* for *Frank Leslie's*. Leslie lowered the salary to thirty dollars because of financial problems. It is safe to assume, then, that Nast was earning more than thirty dollars at *Harper's Weekly*. Paine (*Thomas Nast*, 120) says that Nast was paid per illustration at first, around thirty dollars for a double page. Nast could therefore earn more than his usual salary if he worked especially fast, but it could also mean he would have dry spells while traveling or gathering sketches. In 1868, *Harper's* raised Nast's rate to $150 per double page. Perhaps it was Nast's ability to produce drawings quickly that prompted Fletcher Harper to offer Nast an annual contract in later years. Under that system, Nast would be paid a flat rate, whether he produced one drawing a week or ten. See Paine, *Thomas Nast*, 82, 120.

6. An earlier illustration, printed on July 29, 1861, also bore Nast's signature. This time, it was the full "Th: Nast" of later years. The title of the drawing, however, acknowledged Waud's ownership: "Commencement of the Action at Bull's Run. Sherman's Battery of Rifled Cannon Engaging the Enemy's First Masked Battery. Sketched on the spot by A.R. Waud, Esq." Waud is visible in this drawing, standing to the left with his sketch pad in hand, watching the action in apparent disregard for any possible danger. In later years, he learned to duck. See Ray, *Alfred R. Waud*.

7. Paine does not specify where Nast was at this time, but Philip Sheridan was not in the East. He was in Kentucky in October of 1862, and at Chickamauga in September of 1863. He commanded the Third Division, Twentieth Corps, of the Army of the Cumberland from January 1863 until October of that year, fighting in Kentucky and Tennessee. It was only in March of 1864 that Sheridan moved east as the commander of Grant's cavalry. Nast may have traveled to Tennessee, a trip scarcely more alien than the one to South Carolina. It is also possible that Paine mistook the dates and that Nast traveled to Sheridan's camps in early 1864. Finally, it is possible that the entire Sheridan story is a fabrication or a mistaken memory. Paine (*Thomas Nast*, 90) asserts that Sheridan liked Nast.

8. Ibid., 90–91.

9. TN to SEN, July 3, 1863, TNP, RBHPL, AC 12167, GA-33, Box 1.

10. In letters to Sallie, Nast spells the general's name "Stahl," which is a common spelling in other documents as well. Julius Stahel was a Hungarian immigrant and in July 1863 had only just arrived in Harrisburg to assume command of cavalry in the Department of the Susquehanna.

11. It is possible that Nast was traveling to Gettysburg without Fletcher Harper's knowledge. When Winslow Homer went to the Peninsular Campaign in 1861, on the orders of Harper, he carried with him a letter of introduction on *Harper's*

Weekly letterhead. "Commanding Generals and other persons," it said, "will confer a favor by granting to Mr. Homer such facilities as the interests of the service will permit for the discharge of his duties as our artist-correspondent." There is no trace of such a letter for Nast, and he obviously lacked it when he really needed it. See Exman, *House of Harper*, 95.

12. Paine, *Thomas Nast*, 88–92. For Nast's correspondence with Sallie during his confinement, see TNP, HM nos. 27750–27752 and 27756. Photographer Mathew Brady shared the road to Gettysburg with Nast.

13. Fletcher Harper's affection for Nast, and his willingness to allow Nast as much freedom as he needed, was well known. See Paine, *Thomas Nast*, 94, 122; and Exman, *House of Harper*, 83–92.

14. Paine, *Thomas Nast*, 90, 96; Harper, *House of Harper*.

15. A. G. Christen and J. A. Christen, "Adalbert J. Volck (1828–1912): Confederate Dentist, Artist, and Lincoln Satirist," *Journal of Historical Dentistry* 49, no. 1 (March 2001): 17–23. See also Anderson, *Work of Adalbert Johann Volck*.

16. Mott, *History of American Magazines*, 2:8–9. Mott points to the *Southern Literary Messenger*, which published until 1864, and *De Bow's Review*, which perished in 1862, as examples of prewar papers that failed because of shortages of material, money, or labor. The *Southern Presbyterian Review* survived, as did the *Southern Cultivator*, but both were shortened and experienced financial troubles. Mott argues that no paper founded during the war survived and offers the *Magnolia Weekly*, which only lasted six months, as an example. He points out, however, that the South had never been a publishing center and that the majority of the periodicals consumed were therefore of northern origin. This suggests another reason why Nast's illustrations might have aroused special ire. Over the course of the war, as southern fortunes waxed and waned, Nast's illustrations became ever more stridently pro-Union.

17. Paine, *Thomas Nast*, 86, 89; Exman, *House of Harper*, 86; Harper, *House of Harper*. The Harper publishing company's papers are held at Columbia University, but there is no correspondence from readers related to Thomas Nast among them. Eugene Exman's papers, relating especially to his book above and to his earlier work, *The Brothers Harper*, are also at Columbia but also do not contain the letters regarding Nast. No letters survive regarding other writers or artists, and *Harper's Weekly* almost never published letters from readers. It is reasonable to assume, therefore, that the paper simply did not retain correspondence unless it was business related.

18. In the Gilder Lehrman Collection, NYHS, the drawings are catalogued as responses to Nast.

19. See especially, Nast's Christmas and New Year's drawings of 1863: "The War in the West," *HW*, January 17, 1863; "The Result of War," *HW*, July 18, 1863; and "New Year's Day," *HW*, January 2, 1864.

20. See, for example, Currier & Ives's "An Heir to the Throne, or the Next Republican Candidate" (CCF, 1860-20) and "The Republican Party Going to the Right House" (CCF, 1860-30), the latter of which shows Lincoln leading a string of "crazy"

people into an asylum. They include activists on behalf of women's rights, free love, Mormonism, emancipation, and communism, as well as a few criminals and Bowery "Bohoys" for good measure. See also note 25, below.

21. Marzio, *Democratic Art*.

22. LeBeau, *Currier & Ives: America Imagined*, esp. 69–108 and 149–291. LeBeau says that Currier & Ives printed as many as 100,000 copies of popular political prints, such as "Why Don't You Take It?"; see 86, 264. He also argues that while families might hang printed images in the parlor, political prints were rarely used for that purpose, and suggests instead that they were mostly consumed by local political headquarters. The sheer numbers involved seem to suggest that this was not the case, however. See ibid., 264.

23. TN to SEN, July 1, 1863, TNP, HM no. 27750.

24. Examples of this tendency include his honeymoon letter from Niagara Falls, in TNC, MFPL; his letters and sketches back to the *New York Illustrated News* and to Sarah Edwards from England, in TNC, RBHPL; and the innumerable sketches of street life from Guayaquil, Ecuador, in the same collection. Letters at the Houghton Library at Harvard and in the Princeton University Library Department of Rare Books and Special Collections also contain quick sketches.

25. *HW*, January 3, 1863. Note that editions of *Harper's Weekly*, like *Frank Leslie's Illustrated News*, appeared on newsstands dated for the week to come. Thus, this edition of the paper would have been available for purchase just after Christmas 1862. Paine says that an image from this edition, of Santa distributing gifts to soldiers in camp, was Nast's first "semi-allegorical" drawing. Thus, the January 3 issue represents Nast's departure from informative war illustration and into imaginative sentimental drawings. See Paine, *Thomas Nast*, 84–85.

26. "The War in the Border States," *HW*, January 17, 1863.

27. "Emancipation," *HW*, January 24, 1863.

28. See, for example, "Miscegenation," CCF, 1864-1, which sold for twenty-five cents, or five for one dollar; and "The Miscegenation Ball," CCF, 1864-5.

29. Paludan, *People's Contest*, 225, quoting the *North American Review*. For a longer discussion of the ebb and flow of northern commitment to (and fear of) black emancipation, see ibid., 198–230.

30. Mayer, *All on Fire*, 559.

31. See Cook, *Armies of the Streets*; Spann, *Gotham at War*; Quigley, *Second Founding*; and Bernstein, *New York City Draft Riots*.

32. TN to SEN, July 1, 1863, TNP, HM no. 27750. See also Paine, *Thomas Nast*, 90–91.

33. TN to SEN, July 4, 1863, HM no. 27751-52. Nast says at the end, "These 2 days are the toughest I have spent for many a day," implying that he was detained on July 2. General Couch was a graduate of the U.S. Military Academy (class of 1846, three years after U.S. Grant graduated), a veteran of the Mexican War, and a naturalist. His son Robert joined the Union army and probably died at Cold Harbor. There is no evidence that he and Nast were friendly during or after the war. Given Nast's interest in soldiers, and popularity with them, this suggests that Nast's interactions with Couch in 1863 were more negative than the circumstances required.

The most recent biographical work on Couch is Gambone, *Major-General Darius Couch*. It is also possible that local politics played a part in both Nast's interest in Pennsylvania and Couch's intransigence. Harrisburg was the publication site of the main Democratic newspaper for western Pennsylvania, and with Lee's army so close, Couch must have worried about the local population. If Nast hoped to observe the conflicts among regular people, as he had done in Philadelphia and would do later in New York, Harrisburg was a prime location. Likewise, if Couch believed that southern partisans and spies were in Pennsylvania, a pair of unidentified men with a Confederate signal flag in their possession would be instantly suspicious. See Neely, *Union Divided*, 129.

34. TN to SEN, July 4, 1863, TNP, HM no. 27751-2.

35. Nast left no indication of how the battlefield affected him. Perhaps his experiences in Italy made it possible for him to look at carnage without emotion. He had, after all, drawn a scene in Italy in which wounded soldiers were burned alive. But it seems more likely that Nast's silence is a sign of how moved he was. For a man who never hesitated to trumpet his patriotic emotions, and who liked to cast himself in heroic guise, to be completely silent about something so horrible is telling. Oral historians suggest as a matter of methodology that interviewers must pay attention to silences, and in this case Nast's silence is suggestive.

36. TN to SEN, TNP, HM no. 27756. "Darlings" (plural) is a reference to Nast's wife and his baby daughter, Julia. This letter is undated, but it is marked "Saturday." Since Nast's confinement on July 4 was also a Saturday, he probably wrote from Carlisle on July 11. This would make his return to New York possible on July 12 at the earliest.

37. Of the approximately 140,000 Irish men who fought for the Union, as many as 30 percent were residents of New York City. With a total population around 800,000, New York was home to 200,000 Irish citizens. See Spann, "Union Green," 193, 195.

38. The historiography of the Draft Riots is rich. Some of the best examples include Bernstein, *New York City Draft Riots*; Cook, *Armies of the Streets*; McKay, *Civil War and New York City*, esp. 195–215; and Spann, *Gotham at War*.

39. McKay, *Civil War and New York City*, 196–97. See also Spann, *Gotham at War*, 96–97.

40. Anbinder, *Five Points*, 306, 312; Spann, "Union Green," 202–3. Earlier, some Irish immigrants found African American spouses, an occurrence that generated both positive and negative reactions. See Hodges, "'Desirable Companions.'"

41. Headley, *Great Riots of New York*, 106–7.

42. Bernstein, *New York City Draft Riots*, 18–19.

43. Paine, *Thomas Nast*, 92.

44. Spann, "Union Green," 202–5; McKay, *Civil War and New York City*, 197–207; Cook, *Armies of the Streets*, 77–95.

45. See Cook, *Armies of the Streets*, 91. Even Republicans living on Staten Island were not safe from mob violence. See Waugh, *Unsentimental Reformer*, 74–75.

46. Paine, *Thomas Nast*, 93.

47. Paine explicitly made this connection when he wrote, "It would have been

madness to attempt any interference with the inflamed and drunken mobs, which were not unlike those of the French Revolution" (*Thomas Nast*, 93).

48. TN to SEN, July 4, 1863, TNP, HM no. 27751.

49. Nast's home after 1863 was on Eighty-ninth Street at the East River. In 1864 Nast moved again, removing his family entirely from the city by choosing a home on 125th Street in Harlem. At that time, Harlem was a rural village, bisected by a stream. New Yorkers liked to take carriage rides through its streets on the weekends. See Paine, *Thomas Nast*, 120.

50. Curtis, *Apes and Angels*.

51. See "The War in the West," *HW*, January 17, 1863; "The Result of War," *HW*, July 18, 1863; "New Year's Day," *HW*, January 2, 1864; and "The Union Christmas Dinner," *HW*, December 31, 1864.

52. Spann, "Union Green."

53. Mott, *History of American Magazines*, 2:474–75. Fletcher Harper was initially critical of Lincoln and argued that slavery was "a matter which concerns the southern states exclusively." But over time, especially after Curtis became political editor in 1862, *Harper's* allegiance moved solidly behind both Lincoln and the Republican Party. Curtis, who had been a supporter of Republican presidential nominee John C. Fremont and of Lincoln, contributed essays to *Harper's Weekly* from its inception. When he assumed the political editorship in 1862, he began a career that was to last until his death. At *Harper's*, each edition featured a political essay by Curtis on the inside page. As political editor, he was charged with determining the paper's position on major national political issues. Two managing editors, John Bonner (1858–63) and Henry Mills Alden (1863–69), worked at *Harper's* during the Civil War, but no mention of either man appears in Nast's papers, in Curtis's letters to Nast, in Fletcher Harper or John Henry Harper's accounts of the political positions the paper took in these years, or in secondary accounts of the politics of *Harper's Weekly*. It can safely be assumed, therefore, that political positions were determined by Fletcher Harper and George William Curtis. See Exman, *House of Harper*, 81, 93.

54. Mott, *History of American Magazines*, 2:475; Keller, *Art and Politics of Thomas Nast*, 41.

55. A copy of the poster is in the collection of the Gilder Lehrman Society. Morton Keller (*Art and Politics of Thomas Nast*, 41) says that the Republicans printed "hundreds of thousands" of the poster, while Paine (*Thomas Nast*, 98) claims "millions." Frank Luther Mott (*History of American Magazines*, 475), who would be an ideal objective source, does not supply a number. Given the fact that *Harper's* sold out its first edition (approximately 100,000 copies) and ran a second edition, Keller's numbers seem very viable. Paine's are almost certainly exaggerated.

56. Paine, *Thomas Nast*, 98.

57. Ibid., 69. Paine's quote has been reproduced by many authors (Mott, *History of American Magazines*, 475; Keller, *Art and Politics of Thomas Nast*, 13; and Nevins and Weitenkampf, *Century of Political Cartoons*, 104), but where a source is provided, it is always Paine himself.

58. Paine, *Thomas Nast*, 106. Paine goes on to attribute the same sentiments to

"many Northern generals and statesmen of that time." It is not coincidental that in 1904 Paine would emphasize both Grant and Lincoln's view of Nast. While Lincoln was the nation's fallen hero, Grant's death was even more heroic. Battling cancer in his throat and tongue, Grant drove himself to finish his memoirs in order to leave a legacy—both financial and historical—for his family. The unprecedented success of the memoirs meant that for many Americans, U.S. Grant was the single most emblematic figure of the war. For Grant to identify Nast as its greatest civilian would have been the highest praise imaginable. See McFeely, *Grant*, and Perry, *Grant and Twain*.

59. Fischer, "Nast, Keppler and the Mass Market," 29.

60. Fischer, *Them Damned Pictures*, 29.

61. "Clement Vallandigham Speech on the Civil War," in Schlesinger, *History of U.S. Political Parties*, 909–13.

62. "The Lincoln Catechism," in Schlesinger, *History of U.S. Political Parties*, 914.

63. Paludan, *People's Contest*, 231–59; Donald, *Lincoln*, 493–545.

64. Unlike today's national journals, *Harper's Weekly* did not have a clear policy on endorsement. In theory, only George William Curtis could endorse a candidate, but Fletcher Harper allowed Nast to operate independently. Harper considered Curtis and Nast contributors, and therefore Nast was free to endorse a candidate in his drawings, even if Curtis had not done so. Later, when Curtis and Nast disagreed about the second nomination of Grant and about the nomination of James G. Blaine, this policy would become unworkable.

65. Mott, *History of American Magazines*, 475–76.

66. Examples in the collection of the New-York Historical Society show recognizable faces as early as 1848, though recognizable faces appeared in political art long before that. In an 1848 print, John C. Calhoun points to a printing press in the sky and commands its silence: "Sun of intellectual light and liberty, stand ye still, in masterly inactivity, that the nation of Carolina may continue to hold negroes & plant cotton till the day of Judgment!" (CCF, 1848-28). In the 1860 file, newspaper editors, especially Horace Greeley of the *Tribune*, appear in number 13, and Stephen Douglas is lampooned in number 15. Greeley appears again, in numbers 18, 20, and 30, this time with Lincoln and Charles Sumner of Massachusetts. Other examples are too numerous to mention but can be observed by perusing any collection of cartoons, such as Nevins and Weitnekampf, *Century of Political Cartoons*. On likeness, Gombrich (*Art and Illusion*, 345) argues that "configurations of clues" can be more telling than a simple "replica."

67. Gombrich, *Uses of Images*, 194 and 203, Figures 269 and 282.

68. See Selz's preface to Blaisdell and Selz, *American Presidency*, 11–20. An extended examination of this history is provided by Philippe, *Political Graphics*.

69. Hill, *Mr. Gillray*, 3–4; Gombrich, *Art and Illusion*, 333–44.

70. Paine, *Thomas Nast*, 94.

71. Keller, *Art and Politics of Thomas Nast*, 9.

72. See, for example, Vinson, *Thomas Nast*, 6–7; and Gould, *Masters of Caricature*, 93. Some scholars entirely ignore the question of appeal by agreeing with the reader to assume that the popularity of all satire rests on the public's desire to laugh

at itself and its leaders. From this position, it remains only to examine the distinguishing characteristics of each artist. See, for example, Lucie-Smith, *Art of Caricature*.

73. Fisher, Gerberg, and Wolin, ed., *Art in Cartooning*, 11. The editors represent the Cartoonists Guild.

74. Keller, *Art and Politics of Thomas Nast*, 41; Blaisdell and Selz, *American Presidency*, 96; Nevins and Weitenkampf, *Century of Political Cartoons*, 104.

75. Nevin and Weitenkampf (*Century of Political Cartoons*, 104) point this out but dismiss similar treatments as lacking Nast's "touch of genius." The idea was not only popular before Nast but repeated often after him. In parliamentary elections of 1900, a Conservative slogan admonished, "Remember! To Vote for a Liberal Is a Vote to the Boer." See Manchester, *Last Lion*, 330.

76. CCF, 1864-6, no artist or publisher name.

77. CCF, 1864-11. This cartoon is signed "Harley," an artist unknown to the author and the NYHS staff. The cartoon's subtitle reads, "18th Ward, Philadelphia, October 11." October 11 was the date of a series of state elections that were considered predictors of the outcome of the presidential election; they were closely watched by both the public and national political leaders. See Donald, *Lincoln*, 543.

78. CCF, 1864-18. 1864-12 is a similar image from Currier & Ives. Prang was most famous for his series of color lithographs of the war, printed between 1886 and 1888. See Holzer, *Prang's Civil War Pictures*.

79. CCF, 1864-65. Examples of drawings mocking Lincoln's fondness for telling humorous stories include 1864-28, "The Commander in Chief Conciliating the Soldier's Votes on the Battle Field," in which he requests a funny song while soldiers lay wounded; 1864-27, "Abraham's Dream," in which Lincoln cries, "This don't remind me of any joke!" as he is driven from the White House; and 1864-25, "Running the Machine," in which Lincoln tells his cabinet, "All this reminds me of a most capital joke." Gary Bunker identifies "The Commander in Chief" cartoon as a Democratic campaign print from the presidential election intended not so much to point out Lincoln's irritating sense of humor but to highlight his insensitivity to the human carnage of Antietam. See Bunker, *From Rail-Splitter to Icon*, 130, 282–83; 352 n. 12 addresses the Antietam cartoon.

80. Gombrich, *Uses of Images*, 190–91.

81. Paine, who never hesitated to identify politicians in Nast's work and who had access to Nast if he needed confirmation of any detail, says that the man on the right is "a southerner." Blaisdell and Selz identify him as Jefferson Davis, and he does resemble the Confederate president. The likeness is not exact, however, and there are no identifying items of clothing. See Paine, *Thomas Nast*, 98; and Blaisdell and Selz, *American Presidency*, 96.

82. Gombrich, *Uses of Images*, 194–95. For a brief discussion of Hogarth's use of distortion, see Low, *British Cartoonists*, 9–10. Anthropologist William Fry points to a "suspension of physical rules" as a component of cartoon humor. In this he seems to refer to the same distortions that Gombrich calls the "suspension of disbelief," in essence, that cartoons rely on some obvious physical distortion to amuse the audience and engage its attention. See Fry, *Sweet Madness*, 28–29.

83. According to Paine (*Thomas Nast*, 98), the original version of "Compromise with the South" contained a number of smaller, bordered images, which Fletcher Harper cut out. Harper considered the central drawing powerful enough and enlarged it to fill the space. Thus, the illustration would have been even more similar to sentimental illustrations if Nast had been able to do as he originally intended.

Chapter Five

1. Lois Densky, Alice Caulkins, and Jeffrey Eger, "An Annotated Bibliography of Books Illustrated by or Containing Illustrations by Thomas Nast, 1860–1904," *JTNS* 1, no. 1 (1987): 10–33.

2. Paine, *Thomas Nast*, 109.

3. *FLIN*, June 11, 1864, 178–79.

4. *FLIN*, December 24, 1864, 210–11.

5. *HW*, May 13, 1865, 291.

6. The total number of drawings in the *Grand Caricaturama* remains unclear. The *JTNS* 10, no. 1 (1996): 121, claims thirty-three, while Paine claims sixty (*Thomas Nast*, 109). *Harper's Weekly*, in its brief comment on the ball, noted "nearly a hundred" (*HW*, April 14, 1866, 234). Nast, in a document written in Sallie Nast's hand, also says sixty, see "Caricature," TNC, RBHPL, AC 12167, GA-33, Box 1, Thomas Nast folder "Articles in the hand of Mrs. Nast."

7. Paine, *Thomas Nast*, 13, 109; "Max Maretzek Is Dead," *NYT*, May 15, 1897.

8. "Caricature," TNC, RBHPL, AC 12167, GA-33, Box 1, Thomas Nast folder "Articles in the hand of Mrs. Nast." There are two articles in this file, one hand-numbered at nineteen pages. This is the document to which this note refers. The other is not listed in the RBHPL Nast catalog.

9. Ibid.

10. *HW*, April 14, 1866, 234.

11. "Thanksgiving Day, November 24, 1864," *HW*, December 3, 1864; "The Union Christmas Dinner," *HW*, December 31, 1864; illustration Paine refers to as "Columbia Mourns," *HW*, April 29, 1865; "President Lincoln Entering Richmond, April 4, 1865," *HW*, February 24, 1866 (this image is unsigned, but Paine [*Thomas Nast*, 104] attributes it to Nast).

12. For the drawings illustrating "A Chronicle of Secession," see *HW*, between January and July. "President Lincoln Entering Richmond, April 4, 1865," *HW*, February 24, 1866. This drawing is unsigned, but Paine identifies it as Nast's work in *Thomas Nast*, 104.

13. "The Situation," *HW*, June 9, 1866.

14. "The Executive Power," *HW*, September 8, 1866.

15. "Plain Speaking," *HW*, October 20, 1866. Isaac N. Arnold, abolitionist and admirer and biographer of Abraham Lincoln, had been Lincoln's and then Johnson's auditor of the Treasury. He resigned in 1866 and issued a scathing letter to the president, which *Harper's* printed in part.

16. "Radical Riots and How It Works," *HW*, September 1, 1866; "Which Is the More Illegal?," *HW*, September 8, 1866.

17. "King Andy I," *HW*, November 3, 1866.

18. Paine, *Thomas Nast*, 123.

19. Simpson, *Reconstruction Presidents*, 68–73.

20. "Research Guide," *JTNS* 15, no. 1 (2001): n.p. Draper Hill claims that Nast contributed to more than ninety illustrated volumes between 1859 and his death. See *JTNS* 1, no. 1 (1987): 5.

21. Harrison, *Man Who Made Nasby*. See also Locke, *Struggles of Petroleum V. Nasby*.

22. Locke, "In Search of the Man of Sin," 759–60.

23. "Caricature," TNC, RBHPL, AC 12167, GA-33, Box 1, Thomas Nast folder "Articles in the hand of Mrs. Nast." There are two documents in Sallie Nast's handwriting in this folder. The one cited here runs to nineteen pages. The other is not listed in the RBHPL catalog. It contains about four pages of text, heavily edited. Here, the second document is cited as "four-page document."

24. Ibid.

25. "Thomas Nast," *HW*, May 11, 1867, 293–94.

26. Boime, "Thomas Nast and French Art." Boime acknowledges that Nast relied on widely available English cartoons (see 49 n. 34) for inspiration but argues that French cartoons and paintings influenced Nast's allegorical work.

27. Draper Hill, "Tommy on Top," 99, unpublished essay, TNC, RBHPL, GA-33, Box 1. See also Rogers, *Mightier than the Sword*, 178.

28. Simpson, *Sir John Tenniel*, 9–13.

29. "Caricature," TNC, RBHPL, AC 12167, GA-33, Box 1, Thomas Nast folder "Articles in the hand of Mrs. Nast," four-page document. Sallie's presence in Nast's work appears here as in so many places. Not only did she transcribe this document, but the vocabulary suggests her contribution as well. "Post-prandial," for example, is not a term Nast likely used himself.

30. Ibid.

31. Ibid.

32. "The Union Nominations," *HW*, June 25, 1864, 402.

33. "Marshall's Grant," *HW*, April 18, 1868, 243.

34. "Thanks to Grant," *HW*, February 6, 1864, cover.

35. "Our Arms Victorious," *HW*, June 25, 1865, 392–93; "Merry Christmas to All," *HW*, December 30, 1865, 824–25.

36. "Prometheus Bound," and "Scene," *HW*, March 2, 1867, 137; Shelley, *Prometheus Unbound*, 104.

37. Paine, *Thomas Nast*, 119–20.

38. "A Wild Goose Chase," *HW*, July 4, 1868; "Sickly Democrat," *HW*, July 11, 1868, 439; "Would You Marry Your Daughter to a Nigger?," *HW*, July 11, 1868.

39. McKay, *Civil War and New York City*, esp. 195–215; Spann, *Gotham at War*. On Nast's reaction to Seymour's riot speech, see Paine, *Thomas Nast*, 92–93.

40. "Letter of Acceptance from U.S. Grant," 114.

41. "Matched.(?)," *HW*, October 31, 1868.

42. The Lady Macbeth cartoon has no title. It appears in *HW*, September 5, 1868, 576; "One Vote Less," *HW*, August 8, 1868, 512; "The Lost Cause," *HW*, August 15,

1868, 528; "We'll Fight It Out on This Line If It Takes All Summer," *HW*, August 22, 1868.

43. "Keep the Ball Rolling," *HW*, September 19, 1968, 605; Paine, *Thomas Nast*, 126.

44. Carney, "Contested Image," 607–8. Forrest's role at Fort Pillow remains disputed, but Nast was relying on cultural perceptions rather than historical accuracy.

45. Stephen A. Douglas "Speech at Jonesboro, Illinois," in Gerber and Kraut, *American Immigration*, 182; Barnes, *History of the Thirty-Ninth Congress*, 389–92.

46. McKitrick, *Andrew Johnson*, 167; Harding, *There Is a River*, 311.

47. *Putnam's Magazine of Literature, Science, Art, and National Interests* 2, no. 11 (November 1868): 616–17.

48. "A Negro Regiment in Action," 168–69, and "Negroes as Soldiers," 174, both in *HW*, March 14, 1863. A Nast drawing of the attack by the Massachusetts Fifty-fourth on Fort Wagner portrays that terrible engagement with much of the same emotional content. See Duncan, *Blue-Eyed Child of Fortune*.

49. "'Marching on!' The Fifty-fifth Massachusetts Colored Regiment Singing John Brown's March in the Streets of Charleston, February 21, 1865," *HW*, March 18, 1865, 165; Holzer, "'Spirited and Authentic,'" 18.

50. "All the Difference in the World," *HW*, September 26, 1868, 616; Curtis, *Apes and Angels*. On Blair, see Foner, *Reconstruction*, 218–19. On minstrelsy, see Toll, *Blacking Up*; Boime, *Art of Exclusion*; and Dorman, "Shaping the Popular Image."

51. Baker, *Affairs of Party*, chap. 6; David R. Roediger, "Irish-American Workers and White Racial Formation in the Antebellum United States," in Gerber and Kraut, *American Immigration*, 173.

52. Nast's *Harper's Weekly* cartoons in October were "The Modern Samson" and "Seymour Says the Nomination 'Had Plunged Him into a Sea of Troubles,'" October 3, 1868; "Patience on a Monument" and "A Respectable Screen Covers a Multitude of Thieves," October 10, 1868; "Dignity and Impudence" and "Both Sides of the Question," October 24, 1868; and "Matched.(?)" and "The Democratic Hell-Broth," October 31, 1868.

53. For another interpretation of this image in regard to the black veteran, see Savage, *Standing Soldiers*, 175.

54. Paine, *Thomas Nast*, 129.

55. "The Political Death of the Bogus Caesar," *HW*, March 13, 1869. The dating of this image is imprecise for several reasons. As HarpWeek points out, the appearance of Representative Thaddeus Stevens on the far right suggests that the drawing was made before Stevens's death on August 11, 1868, likely in the spring of 1868, but published much later. See http://www.andrewjohnson.com/ListOfCartoons/ThePoliticalDeathOfBogusCaesar.htm.

56. "Testimonial to Thomas Nast," *HW*, May 15, 1869, 307. An illustration of the vase appears on page 314 of the same issue.

57. "Six Days with the Devil and One Day with God," *HW*, July 3, 1869; "Pacific Chivalry," *HW*, August 7, 1869; "One Good Row Deserves Another," *HW*, September 18, 1869; "Physical Education" and "Woman's Kingdom Is at Home," both *HW*, October 2, 1869.

Chapter Six

1. Paine, *Thomas Nast*, 181–82, 184.

2. Nast removed his family to New Jersey in early 1871, but did not purchase a house there until March of 1872. See Paine, *Thomas Nast*, 207.

3. Ibid., 10–12.

4. Ackerman, *Boss Tweed*; Mandelbaum, *Boss Tweed's New York*; Bales, *Tiger in the Streets*; Allen, *Tiger*, 82–85. According to various sources, Tweed joined the Big Six in 1848 or 1849, was suspended for three months in 1850, then returned to the company until he assumed a seat as alderman for the Seventh Ward in 1851. Thus his tenure with the Big Six provided ample opportunity for young Thomas Nast to observe the organization, admire its tiger logo, and see Tweed in action.

5. Werner, *Tammany Hall*; Bales, *Tiger in the Streets*; Mushkat, *Tammany*.

6. Werner, *Tammany Hall*, 107–10; Ackerman, *Boss Tweed*.

7. On voting, see Callow, "Vote Early and Often," in Callow, *City Boss in America*, 158–61. On Tweed's methods, see Callow, *Tweed Ring*, 22–32.

8. Callow, *Tweed Ring*, chap. 12, details examples of Ring tactics.

9. Ackerman, *Boss Tweed*, 2.

10. Tweed was the boss of the Irish vote, but he was not Irish himself. He was of Scottish ancestry, and the family name was taken from the River Tweed. William Tweed was of the third generation in America, however. See Ackerman, *Boss Tweed*, 18.

11. Immigration contributed to New York's complicated partisan politics for decades. Because many of the city's nativist elite—including the Harper brothers—were Republicans, the party struggled to appeal to immigrants. Even those who might otherwise have embraced the party, such as Free Soil German immigrants, mistrusted the nativist flavor of New York Republicanism. So Republican efforts to paint Tweed as exclusively the representative of the Irish both reflected Republican views and demonstrated some of the reasons that New Yorkers voted for him over a Republican. See Bernstein, *New York City Draft Riots*, 97, 188–90.

12. More than fifty buildings burned during the riots, including the most famous casualty, the Colored Orphan's Asylum. Others included police stations, the provost marshal's office, and "an entire block of dwellings on Broadway." See Barnes, *Draft Riots*, 6.

13. Exman, *Brothers Harper*, 197–98. Tweed apparently hated serving in Congress. He preferred local office, thus the nativists hoped he might be a force for their views in local politics. In the years following his return from Washington, he held several positions in New York, before losing a bid to become sheriff. He led Tammany starting in January 1863. See Ackerman, *Boss Tweed*, 19–23.

14. Bernstein, *New York City Draft Riots*, 198; Ackerman, *Boss Tweed*, 22–25.

15. Callow, *Tweed Ring*, 253–78. On the early opponents of Tweed, see 255. Jones editorial, "Tammany and the Presidency," *NYT*, July 8, 1871.

16. "The Democratic Scape-Goat," *HW*, September 11, 1869. This was not the first cartoon in which members of the Ring appeared. Almost a year before, in the October 10, 1868, edition, *Harper's* published "A Respectable Screen Covers a Multitude of Thieves." But the cartoons of that fall, especially "Patience on a Monu-

ment," focused on the presidential election and violence against freedmen in the South. Note that the magazine was forward dated. The September 11 edition appeared on stands the week before September 11, so Nast probably drew his image at the end of August or in the first few days of September. It is interesting to note that "Compromise with the South" appeared on September 3, 1864. The early autumn was a productive time for Nast.

17. "The Government of the City of New York," *HW*, February 9, 1867.

18. "Robinson Crusoe—The Footprint on the Land of Peace," *HW*, December 4, 1869.

19. "The Economical Council, Albany, New York," *HW*, December 25, 1869.

20. "The Greek Slave," *HW*, April 16, 1870. In the same issue, "Senator Tweed in a New Role" cast the Boss as Hamlet's mother, clutching the new charter of the city of New York.

21. The cartoon is approximately 11 by 17 inches and would have been the centerfold. Thus, a reader could tear the drawing out of the paper to hang it on a wall.

22. Ackerman, *Boss Tweed*, 100.

23. Warren, *Fanny Fern*, 279.

24. Democratic and some Republican newspapers attacked Jones and Jennings. Privately spread rumors matched public attacks in viciousness. One recurring rumor was that Tammany sympathizers would buy enough of the outstanding shares in *Times* stock to force Jones to stop his crusade. Jones publicly denied the charge, which helped. Later, Jones arranged for the shares to be purchased through a friendly intermediary.

25. Paine, *Thomas Nast*, 159.

26. See Kennedy, "Crisis and Progress," 191–200.

27. Cary, *George William Curtis*, 207–8.

28. Kennedy, "Crisis and Progress," 189–336.

29. "Editor's Easy Chair," *Harper's New Monthly Magazine*, December, 1873, 134, Paine, 179, for a discussion of the veracity of quotes attributed to Tweed, see Ackerman, 185.

30. Paine, *Thomas Nast*, 179.

31. Ibid., 78, 172. See also Nast scrapbook, New York Public Library.

32. Ackerman, *Boss Tweed*, 162–63.

33. *JTNS* 6, no. 1 (1992): 67.

34. See Keller, *Art and Politics of Thomas Nast*, 179.

35. In "The 'Brains,'" Tweed himself utters the phrase; see *HW*, October 21, 1871. On November 11, 1871, the Tammany Tiger repeats the phrase as he stands over a prostrate Columbia. In "To Whom It May Concern," Columbia responds, "Now you see what I did about it." See *HW*, December 2, 1871. Less than a year later, caricaturing Horace Greeley, Nast again poses the question: "'What Are You Going to Do About It,' If 'Old Honesty' Lets Him Loose Again?," *HW*, August 31, 1872.

36. The bottom half of this drawing appears in W. G. Rogers's treatment of the Tweed Ring crusade in *Mightier than the Sword*, 185. This drawing has prompted at least two copies, the first by *Detroit News* cartoonist and Nast enthusiast Draper Hill and the second by Drew Friedman in the *New York Times*. Friedman recycled

the pointing fingers and circular composition to point out modern leaders' failure to take responsibility for their decisions. See "Where Does the Buck Stop? Not Here," *NYT*, March 28, 2004.

37. *NYT*, August 31, 1871.

38. Mark Twain, "The Revised Catechism," *New York Tribune*, September 27, 1871; Arthur L. Vogelback, "Mark Twain and the Tammany Ring," *Proceedings of the Modern Language Association* 70, no. 1 (March 1955): 69–77.

39. "The Brains," *HW*, October 21, 1871.

40. Mercury was sometimes associated with merchants, thus his fallen caduceus may symbolize the danger to New York's economy posed by a corrupt city government.

41. Richard Samuel West argues that Keppler deserves credit for having "anticipated, and perhaps inspired," Nast. See West, *Satire on Stone*, 50.

42. Arthur Lumley, who worked with Nast during the war, also accused him of stealing his work in the *New York Times* in 1906.

43. *Puck*, St. Louis, October 22, 1871. Reprinted in West, *Satire on Stone*, 48, fig. 15.

44. Boime, "Thomas Nast and French Art," 12–14. Nast's "The Political Death of the Bogus Caesar" (1869) is copied almost exactly from Gérôme's *The Death of Caesar* (1867). Nast also used French painter Paul Delaroche's *Napoleon at Fontainebleau* (1846) as a model for his "Dead Men's Clothes Soon Wear Out" (1870).

45. Paine, *Thomas Nast*, 204–5.

46. "Our Mare Still Lives," *HW*, October 28, 1871, 1016.

47. "The Boss Still Has the Reins," *HW*, November 4, 1871, 1040.

48. See "The Tammany Tiger Loose," 1056; "Going through the Form of Universal Suffrage," 1060; "The Lion's Share," 1064; "Next!," 1065; "The Wearing of the Green," 1072; and "For the Relief, Much Thanks!," 1072, all *HW*, November 11, 1871.

49. Ackerman, *Boss Tweed*, 109, 196, 174–250; Paine, *Thomas Nast*, 141–200.

50. Ackerman, *Boss Tweed*, 1–8.

Chapter Seven

1. Paine, *Thomas Paine*, 184.

2. "Out of the Frying Pan into the Fire," *HW*, March 23, 1872, 231.

3. In 1872, the Liberals met first in Missouri in January, then later in Cincinnati, Ohio, in May. *Harper's Weekly* commented on their positions and activities throughout the year.

4. Harper, *House of Harper*, 302.

5. GWC, "The Eulogy," in *A Memorial of Charles Sumner*, published by the Massachusetts Legislature, Boston, 1874, 109. On Sumner, see David Herbert Donald's classic, *Charles Sumner and the Coming of the Civil War*.

6. Harper, *House of Harper*, 302; Paine, *Thomas Nast*, 216.

7. TN to SEN, January 29, 1872, TNP, HM no. 27758.

8. TN to NPC, April 22, 1872, NPCCW.

9. Paine, *Thomas Nast*, 214.

10. "Children Cry for It," *HW*, February 3, 1872. Other identifiable men pictured

are Senators Carl Schurz (Missouri), Lyman Trumbull (Illinois), and Reuben Fenton (New York); see also "Let Us Have Complete Restoration, While You Are About It," *HW*, December 28, 1872; "Apollo Amusing the Gods," *HW*, November 16, 1872; and "The Last Shot of the Honorable Senator from Massachusetts—He Pulled the Long-Bow Once Too Often," *HW*, June 22, 1872.

11. Pond, *Eccentricities of Genius*, 14–15. It is unclear exactly what Pond saw or did in Kansas, and his memory coincided not with the period of conflict known as "Bleeding Kansas" but with the earlier period of political conflict related to the admission of Kansas under either a proslavery or an antislavery state constitution. His account of Sumner cannot be confirmed, but it certainly reflected the senator as Nast perceived him.

12. Sumner to TN, February 8, 1872 and December 16, no year specified, Charles Sumner Papers, Manuscript Division, LOC.

13. TN to SEN, January 29, 1872, TNP, HM no. 27758.

14. TN to SEN, January 29, 1872, TNP, RBHPL, AC 12217, GA-33, Box 1.

15. Paine, *Thomas Nast*, 216–18.

16. GWC to TN, in Paine, *Thomas Nast*, 216–18. The same letter appears in Harper, *House of Harper*, 302.

17. "Senator Schurz," *HW*, January 27, 1872, 74.

18. Paine, *Thomas Nast*, 222. What Paine presents as a single long letter between Nast and the Harpers is actually a compilation of several letters over several days. Some of the quoted material in this section can be corroborated by the original letters. Other portions come from letters that no longer exist, and are quoted here using Paine as the source.

19. TN to SEN, February 2, 1872, TNP, HM no. 27759.

20. Paine, *Thomas Nast*, 224. For more on Chipman, see Hogge's biography, *Norton Parker Chipman*.

21. "Mephistopheles at Work for Destruction," *HW*, March 9, 1872; Paine, *Thomas Nast*, 230–31.

22. GWC, "The Cincinnati Convention," *HW*, February 17, 1872. Curtis made the same point a week later in "The First Response to the Cincinnati Call," *HW*, February 24, 1872.

23. GWC, "Shall the Republican Party Disband?," *HW*, April 13, 1872, 282; Williams, *Horace Greeley*, 298.

24. GWC, "Persons, Not Principles," *HW*, May 4, 1872, 346. Curtis here plays off the famous story about Lincoln in which the president is told that General Grant drinks too much whiskey. Lincoln replies that if that is the case, he will send whiskey to every Union commander in hopes of similar results. Curtis made similar points in "New York and Cincinnati," on the same page of the same issue.

25. GWC, "Flings and Sneers," *HW*, March 9, 1872, 186; "The 'Liberal' Conspirators (Who You All Know, Are Honorable Men)," *HW*, March 16, 1872.

26. "A Few Washington Sketches—in the Senate," *HW*, March 23, 1872.

27. GWC, "Charles Sumner and the Cincinnati Convention," *HW*, April 6, 1872, 266; "Will Robinson Crusoe (Sumner) Forsake His Man Friday?," *HW*, April 20, 1872; "What H- G- Knows about Bailing," *HW*, April 27, 1872.

28. TN to NPC, April 22, 1872, NPCCW.

29. Ingersoll, *Life of Horace Greeley*, 539.

30. Williams, *Horace Greeley*, 298.

31. Ibid., 301, details the many opponents of Greeley's nomination, including Lydia Maria Child, Hamilton Fish, and historian George Bancroft. Schurz tried to find another candidate in June, without success.

32. GWC, "The Cincinnati Candidate," *HW*, May 18, 1872, 386; see also Williams, *Horace Greeley*, 299, for reaction from other Republicans and from those who had been Liberals but melted away at the nomination, such as free-trade supporters.

33. "What I Know about Horace Greeley," *HW*, January 20, 1872.

34. Williams, *Horace Greeley*, 270–73.

35. Parton, *Life of Horace Greeley*, 497–98.

36. "What I Know about Horace Greeley," *HW*, January 20, 1872; "Horace Greeley and Jeff Davis," *NYT*, July 22, 1866.

37. "Cincinnatus," *HW*, February 10, 1872; "The 'Liberal' Conspirators," *HW*, March 16, 1872.

38. Paine, *Thomas Nast*, 234–35.

39. Greeley, *What I Know of Farming*, 7–8.

40. "What H- G- Knows about Bailing," *HW*, April 27, 1872; "'Liberal' Gratitude," *HW*, May 11, 1872. Nast's colleague C. S. Reinhart played off Nast's joke by including the phrase "What I Don't Know" in his "The Farmer Candidate En Route," *HW*, May 4, 1872.

41. Thurlow Weed, "What I Know About Horace Greeley's Secession, War and Diplomatic Record" (New York: James McGee, 1872), Thurlow Weed Papers, University of Rochester, New York.

42. C. S. Reinhart, "The Farmer Candidate En Route," *HW*, May 4, 1872, 360; "'Liberal' Gratitude," *HW*, May 11, 1872.

43. "It Is the Immediate Jewel of Her Soul," *HW*, May 4, 1872; "A 'Liberal' Surrender—Any Thing to Beat Grant.'" *HW*, May 11, 1872.

44. "Adding Insult to Injury," *HW*, May 25, 1872.

45. "Horrors Greeley" appears in "The Sage of Chappaqua" and in a series of images accompanying an essay by "Max Adeler" on page 517 of *HW*, June 29, 1872; "Decorating the White House," *HW*, June 1, 1872; "Drop 'Em," *HW*, June 8, 1872; "Stand by Your Guns, Men!," *HW*, June 15, 1872.

46. "Mr. Sumner's Speech," *HW*, June 22, 1872, 482.

47. "The Last Shot of the Honorable Senator from Massachusetts—He Pulled the Long-Bow Once Too Often" and "Vindicated!," *HW*, June 22, 1872.

48. "The Connecting Link Between 'Honest Republicans' and 'Honest Democrats,'" *HW*, June 29, 1872; "Chips from Chappaqua; Or, a Posy for the Baltimore Convention," *HW*, July 6, 1872, 523.

49. Pond, *Eccentricities of Genius*, 190–91. The cartoon is "Red Hot!," *HW*, July 13, 1872.

50. "'Old Honesty,'" *HW*, July 20, 1872; GWC, "Change, Not Reform," *HW*, July 20, 1872, 563.

51. "The Death-Bed Marriage," *HW*, July 27, 1872; "Baltimore 1861–1872," *HW*, August 3, 1872; "They Are Swallowing Each Other," *HW*, August 3, 1872; "The Battle Cry of Sumner," *HW*, August 3, 1872.

52. Williams, *Horace Greeley*, 303.

53. GWC to TN, August 7, 1872, in Harper, *House of Harper*, 303.

54. "Will the Senator from Massachusetts Do This, To Make His Words Good?," *HW*, August 17, 1872; GWC, "Mr. Sumner's Letter," *HW*, August 17, 1872, 634.

55. One such mask survives, in the collection of the Prints and Photographs Division of the New-York Historical Society.

56. "The Whited Sepulchre," *HW*, September 7, 1872; and "The Next in Order—Any Thing! Oh, Any Thing!" and "The Wolf in Sheep's Clothing," *HW*, September 14, 1872; Williams, *Horace Greeley*, 302. The coat and hat appeared in cartoons earlier in the year; for example, in "Something That Will Blow Over," *HW*, June 15, 1872, Greeley is wearing them, and in "The New Democratic Party Whip," *HW*, August 31, 1872, Whitelaw Reid is shown wearing them as he tries to whip into shape "The Liberal Reform Army."

57. "More Secession Conspiracy" and "'Old Honesty' among the Ruins of Tammany Hall," *HW*, October 5, 1872; "H.G. 'Let Us Clasp Hands Over the Bloody Chasm'" and "Who Are the Haters?," *HW*, October 19, 1872; Eugene Lawrence, "Mr. Carl Schurz and His Victims," *HW*, September 7, 1872, 693.

58. "'Good-By!' My Poor Brain Demands Rest," *HW*, September 21, 1872; GWC, "Senator Sumner," *HW*, September 21, 1872, 730; GWC, "Work! Work! Work!," *HW*, October 26, 1872, 827; GWC, "The South," *HW*, November 2, 1872.

59. Paine, *Thomas Nast*, 252; "'That Tidal Wave'—'We Are on the Home Stretch,'" *HW*, October 26, 1872.

60. "'We Are on the Home Stretch'—New York Tribune, October 9, 1872," *HW*, November 2, 1872; "'Home-Stretched!' November 5th His Borrowed Steed Will Home-stretch Him," *HW*, November 9, 1872. Boss Tweed appeared on the November 2 cover, "'Save Me from My Tobacco Partner! .'" "'The Pirates' under False Colors—Can They Capture the Ship of State?," *HW*, November 9, 1872, portrayed the Liberals as sailors of a pirate ship.

61. "Apollo Amusing the Gods," essay, *HW*, November 16, 1872, 898; "Apollo Amusing the Gods," *HW*, November 16, 1872, 896. The cartoon shows Whitelaw Reid as Apollo, playing his lyre (a pun on liar), labeled the *New York Tribune*, for the assembled Liberals. This edition probably appeared on newsstands five to seven days prior to its publication date as printed on the cover.

62. "The Insult Returned," "Clasping Hands Over the Bloodless (Sar)Chasm," and "Our Artist's Occupation Gone," *HW*, November 23, 1872; "No Surrender," *HW*, December 7, 1872.

63. Williams, *Horace Greeley*, 305–7; Paine, *Thomas Nast*, 264. Mention of Horace Greeley's passing appears in *HW*, December 14, 1872, 971. The weekly devoted two sentences to Greeley, while publishing below it an obituary four times as long for its former superintendant of the composing room, Mr. Henry Marsh. For Curtis's memorial, see "Horace Greeley," *HW*, December 21, 1872, 994.

64. Paine, *Thomas Nast*, 258–60.

65. TN to NPC, December 15 and July 19, 1872, NPCCW.

66. Matt Morgan's campaign cartoons in *FLIN* include "The Modern Moses to His People," August 24, 1872; "Too Thin, Massa Grant," September 14, 1872; "Grand Larceny vs. Petty Larceny," September 28, 1872; "The Modern Moses to His People," August 24, 1872; and "Which Shall it Be?," November 9, 1872. Morgan worked for the *London Illustrated News* when Nast was in England, and later covered the Risorgimento, just as Nast did for the newspaper. Whether the two men knew each other is unclear, but when Morgan came to New York in 1870 to work for *Leslie*, he became a natural rival for Nast, whose star was on the rise.

67. Paine, *Thomas Nast*, 250; "A Sweet Thing in Reform," CCF, "Men of the Day" folder, 1872; Mott, *History of American Magazines*, 3:102.

68. Paine, *Thomas Nast*, 254.

69. "Shakspeare on the 'Liberal' Campaign of Slander," *HW*, May 4, 1872 (misspelling in the original); "It Is the Immediate Jewel of Her Soul," *HW*, May 4, 1872; "William Tell Will Not Surrender or Bow to the Old Hat," *HW*, May 25, 1872; "Shylock, We Would Have Money and Votes," *HW*, July 6, 1872; "Diogenes Has Found the Honest Man—(Which Is Diogenes and Which Is the Honest Man?)," *HW*, August 3, 1872.

70. "Caricature," TNC, RBHPL, AC 12167, GA-33, Box 1, Thomas Nast folder "Articles in the hand of Mrs. Nast."

Chapter Eight

1. Paine, *Thomas Nast*, 264.

2. Mark Twain, *Mark Twain's Letters*, vol. 1, edited by Albert Bigelow Paine (New York: Harper and Brothers, 1917), 202.

3. Paine, *Thomas Nast*, 266.

4. Nast's 1872 covers March 9, 16, 23, and 30, May 4, 11, 18 and 25, August 10, 17, 24, and 31, and September 7, 14, 21, and 28. The months with three covers each are April, June, July, and November. By the end of 1872, Nast realized his value to *Harper's*. In 1873, with the help of James Redpath, the cartoonist forced Harper and Brothers to issue an annual contract. See TN to Messrs. Goodsell, August 7, 1873, RBHPL, AC 1646; and TN to NPC, January 30 and 12, 1873, NPCCW.

5. Dickens, *Posthumous Papers*. In 1873, a number of other illustrated volumes containing Nast drawings appeared. In some cases, these were reprints (for example Roswell Dwight Hitchcock's *New and Complete Analysis of the Bible* and Clarence Gordon's *Boarding-School Days*), but he also produced a small number of new drawings for William Taylor Adams's *Dikes and Ditches: or, Young America in Holland and Belgium* and a book of folk songs published by Scribner's. See *JTNS* 1, no. 1 (1987): 24. On the completion date of the *Pickwick* drawings, see TN to NPC, January 30, 1873, NPCCW.

6. Paine, *Thomas Nast*, 263–66.

7. Ibid., 270.

8. TN to NPC, January 30, 1873, NPCCW.

9. "Every Public Question with an Eye Only to the Public Good," *HW*, March 15,

1873; "The Cherubs of the Credit Mobilier," *HW*, March 22, 1873; Paine, *Thomas Nast*, 268–70. In the March 15 issue, the small cartoon "The Biggest Joke of the Season" appeared on the last page of the *Weekly*. It mocked New York mayor Fernando Wood for suggesting that Vice President Schuyler Colfax should be impeached, echoing the paper's judgment on Wood's "little comedy of indignant virtue."

10. "Tom Nast Not Dead!," *HW*, March 15, 1873, 202; "The Meeting of Nast and Watterson in Central Jersey," *HW*, March 29, 1873.

11. TN to NPC, January 30, 1873, NPCCW.

12. Ibid., March 14, 1873.

13. Ibid. Nast's hiatus from the *Weekly* began with the April 19 issue and ended October 4, when two Nast cartoons related to "Caesarism" appeared.

14. Boyd, "James Redpath." Redpath published *The Pine and the Palm*, a Boston periodical devoted to Haitian immigration by former slaves, from May 1861 until September 1862. In that journal, he advocated both emancipation in the United States and the creation of a powerful black nation in Haiti. See Kenneth J. Cooper, "The Pine and the Palm," The William Monroe Trotter Institute, University of Massachusetts, Boston, 2007, http://www.trotter.umb.edu/newsite/Publications/pubsonline/cooper_paper.html.

15. Pond, *Eccentricities of Genius*.

16. Ibid., 51, 539–42.

17. Ibid., 188–89; "Correspondence," *Boston Globe*, May 19, 1873, 2.

18. Pond, *Eccentricities of Genius*, 341–42 and 541–42.

19. Ibid., 232.

20. Redpath's national identity, like his hometown, rested on the borderland between English and Scots. Born in Berwick-upon-Tweed, he spent the first years of his life less than five miles from the Scottish border. He was, thus, nominally English, certainly British, and possibly Scottish.

21. Pond, *Eccentricities of Genius*, 189.

22. Paine, *Thomas Nast*, 276–80.

23. Pond, *Eccentricities of Genius*, 188–89.

24. TN to SEN, October 8, 1873, TNP, HM no. 27766.

25. TN to James Redpath, November 24, 1873, TNC, RBHPL, AC 1885.

26. TN to SEN, October 8, 1873, TNP, HM no. 27766.

27. Thomas Nast Jr. to TN, March 14, no year, TNC, RBHPL, AC 12217. In the letter, Nast Jr. says that baby Mabel, who was born in December 1871, has learned to say a few words, which helps to date this letter during the last months of Nast's first season on the lecture circuit.

28. Pond, *Eccentricities of Genius*, 189. Regarding the use of oil paints, see also flyers for Nast's "First Tour of the Pacific States," 1887–88, TNC, RBHPL, GA-33, Box 1, file A.

29. "Caricature," TNC, RBHPL, AC 12167, GA-33, Box 1, Thomas Nast folder "Articles in the hand of Mrs. Nast."

30. "Thomas Nast's Lecture," *NYT*, November 19, 1873.

31. Ibid. On Burton, see Keese, *William E. Burton*.

32. "Thomas Nast's Lecture," *NYT*, November 19, 1873. Nast could not have ob-

tained a job from Frank Leslie until the printer began his illustrated newspaper, in December 1855, when Nast was fifteen years old.

33. "Thomas Nast's Lecture," *NYT*, October 18, 1873.

34. Photograph appears in *JTNS* 6, no. 1 (1992): 28.

35. Pond, *Eccentricities of Genius*, 189.

36. TN to George Hathaway, February 23, 1885, TNC, RBHPL AC 1885.

37. Pond, *Eccentricities of Genius*, 199.

38. Ibid., 189; Paine, *Thomas Nast*, 284–85.

39. Draper Hill, "Thomas Nast: Illustrator and Points Beyond," *JTNS* 1, no. 1 (1987): 6.

40. Clipping, Thomas Nast scrapbook, New York Public Library, quoted in Draper Hill, "Thomas Nast: Illustrator and Points Beyond," *JTNS* 1, no. 1 (1987): 9.

41. Paine, *Thomas Nast*, 202. The *Almanac* included contributions from Mark Twain, Josh Billings, and Petroleum V. Nasby.

42. TN to NPC, November 26, 1871, NPCCW.

43. Paine, *Thomas Nast*, 206, 266.

44. Receipt for payment for the 1872 *Almanac*, Harper and Brothers Collection, HVFG, Nast II, Special Collections, Columbia University Library.

45. Paine, *Thomas Nast*, 266.

46. "Correspondence," *Boston Globe*, May 19, 1873, 2.

47. *NYT*, May 23, 1873.

48. "Correspondence," *Boston Globe*, May 26, 1873, 4.

49. TN to Messrs. Goodsell, August 7, 1873, TNC, RBHPL AC 1646.

50. Paine, *Thomas Nast*, 277–78.

51. Ibid., 206–7.

52. Foreman and Stimson, *Vanderbilts in the Gilded Age*, 108–9; Wiegley, *Morristown*; *Boston Daily Globe*, July 2, 187[8?], Manuscript no. 18, TNC, MFPL.

53. Scharnhorst, *Selected Letters of Bret Harte*, 69–70.

54. Nast wrote of repeated struggles with catarrh and of the malaria outbreak. See TN to NPC, November 12, 1872, and March 3, 1873, NPCCW.

55. The exact date of Nast's purchase of the house is unclear. Robert P. Guter, citing the records of the Morris County Clerk, dates the purchase on April 7, 1872. See Robert P. Guter, "Thomas Nast at Home: Creating Villa Fontana," *JTNS* 2, no. 1 (1988): 6, 15. However, letters from Nast to Chipman in 1872 and 1873 indicate that the Nasts purchased the house in August. See TN to NPC, July 15 and November 12, 1872, NPCCW.

56. Robert P. Guter, "Thomas Nast at Home: Creating Villa Fontana," *JTNS* 1, no. 1 (1988): 6–15.

57. Merwin-Clayton auction catalog, February 19, 1907, *JTNS* 11, no. 1 (1997).

58. Ibid., April 16, 17, and 18, 1907.

59. TN to NPC, January 4, 1870, NPCCW.

60. "'Twas the Night Before Christmas, When All Through the House Not a Creature Was Stirring, Not Even a Mouse," *HW*, December 25, 1886.

61. Paine, *Thomas Nast*, 526.

Chapter Nine

1. On the crisis as related to Cooke, see Lubetkin, *Jay Cooke's Gamble*.

2. "Keep the Money Where It Will Do the Most Good," *HW*, October 11, 1873; "The 'Long' and 'Short' of It Is a General 'Bust Up' in the 'Street,'" *HW*, October 11, 1873; "Out of the Ruins," *HW*, October 18, 1873.

3. "The Power of the Press," *HW*, May 9, 1874; "The Cradle of Liberty Out of Danger" and "A General Blow Up — Dead Asses Kicking a Live Lion," *HW*, May 16, 1874; "Public Opinion — April 22, 1874," *HW*, May 23, 1874; "Inflation Is 'As Easy As Lying,'" *HW*, May 23, 1874; "The Arab and His Camel," *HW*, May 30, 1874.

4. Paine, *Thomas Nast*, 293.

5. GWC, "Caricature in Controversy," *HW*, May 30, 1874, 450. Paine, *Thomas Nast*, 293, identifies this editorial as Curtis's work.

6. William Shakespeare, *Julius Caesar*, act 5, scene 1; "Peevish School-boys Worthless of Such Honor," *HW*, June 6, 1874. Senators John A. Logan of Illinois, Oliver P. Morton of Indiana, Simon Cameron of Pennsylvania, and Matthew Carpenter of Wisconsin appear in the cartoon. Carl Schurz and Reuben Fenton are among the men in the background. "An Inflation Opinion," cover, *HW*, July 4, 1874; "Let Us Be Thankful," *HW*, July 4, 1874, 560–61.

7. "That Irredeemable Rag Baby," *HW*, September 9, 1875. The rag baby represented the controversy over gold versus greenbacks. Paine (*Thomas Nast*, 314) links the rag baby directly to the inflation baby that Nast created during the storm over the inflation bill in 1874.

8. "Milk Tickets for Babies," *HW*, March 11, 1876; Wells, *Robinson Crusoe's Money*. Nast's illustration of the rag baby appears on page 97.

9. "Robinson Crusoe's Money," *HW*, March 11, 1876, 213–14.

10. The rag baby appeared again on October 9, 1875, in "'Holy Murder!!!' Governor Tilden and the Ohio Rag Baby" and on November 6, in "'The Two Rag Babies — Are They Dead? .'" The following year, the rag baby popped up in a tiny illustration at the back of *Harper's Weekly* on February 12, titled "Hush-a-bye (Rag) Baby, Be Still!," and on April 8, titled "The Haunted House." Nast used the rag baby to attack Tilden on August 5, in "Hen(dricks) Pecked," and on the cover of the August 26 issue, in "A Hard Summer for the Soft Rag Baby."

11. TN to NPC, October 9, 1871, NPCCW.

12. "The Emancipator of Labor and the Honest Working People," *HW*, February 7, 1874, accompanying article on page 122; "The American Twins," *HW*, February 7, 1874; "A Foreign and Poisonous Weed," *HW*, March 7, 1874. Another cartoon on this subject appeared at the end of March. "Between Two Evils," *HW*, March 28, 1874, placed Columbia between communism and Nast's stereotyped Irish thug.

13. On the Irish in New York, see Anbinder, *Five Points*; Diner, "'Most Irish City in the Union'"; Erie, *Rainbow's End*; and Knobel, *Paddy and the Republic*.

14. For an example of corruption, see the story on the murder of dentist Dr. Burdell, *Leslie's* first great success. As an indication of the sensationalism of *Leslie's* coverage, one lithograph depicted Burdell's "slashed heart." See Brown, *Beyond the Lines*, 26.

15. See illustrations of gangs in *FLIN*, July 18, 1857. Anbinder, *Five Points*, 280–89, describes the relationship between politics and gang activity in Five Points.

16. Gronowicz, *Race and Class Politics*, 153.

17. Curtis, *Apes and Angels*, 28.

18. Knobel, *Paddy and the Republic*, 55.

19. An example of Nast's emphasis on the dangers of drink and Irish voters is "The Greek Slave," *HW*, April 16, 1870.

20. Curtis, *Apes and Angels*, 29–108, quote on 100.

21. "Murder of George Crawford and his Granddaughter," *History of the Rebellion in Ireland in 1798* (London, 1894), reprinted in Curtis, *Apes and Angels*, 35. The original illustration appeared in Maxwell, *History of the Irish Rebellion*. The incident is described on page 66 and the illustration appears on the next page. On Cruikshank's work on the book, see Patten, *George Cruikshank*, 19.

22. *Punch*, December 28, 1867, reprinted in Curtis, *Apes and Angels*, 39.

23. "This Is a White Man's Government," *HW*, September 5, 1868.

24. "The Ignorant Vote—Honors Are Easy," *HW*, December 9, 1876.

25. For the argument that Nast was anticlerical but not anti-Catholic, see Hackett, "Thomas Nast."

26. Kendall Mattern, "A Degree of Intolerance: The Anti-Catholic Cartoons of Thomas Nast and Joseph Keppler," *Target*, Spring 1988.

27. Nissenbaum, *Battle for Christmas*; Restad, *Christmas in America*.

28. "Santa Claus in Camp," *HW*, January 3, 1863.

29. "Christmas Eve," *HW*, January 3, 1863.

30. "Christmas, 1863," *HW*, December 26, 1863.

31. "The Same Old Christmas Story Over Again," *HW*, January 4, 1873, 8–9; accompanying article, 10.

32. "Humors of the Day," *HW*, April 28, 1877, 327–28.

33. Paine, *Thomas Nast*, 6.

34. "Christmas Eve—Santa Claus Waiting for the Children to Get to Sleep," *HW*, January 3, 1874; "Santa Claus," *HW*, January 3, 1874, 4–5.

35. "Here We Are Again!," *HW*, January 5, 1878.

36. Paine, *Thomas Nast*, 4–6. Nast family Christmas cards can be found in the Nast collection at the MFPL. On sentiment in American culture, see Samuels, *Culture of Sentiment*; Schlereth, *Victorian America*; and McDannell, *Christian Home*.

37. On Coke's Santa and his connection to Nast, see http://www.thecoca-cola company.com/heritage/cokelore_santa.html; "Merry Old Santa Claus" plate, Reed and Barton, 1979. "The Nast Santa Claus" is part of Duncan Royale's line "The History of Santa," containing three sets of figurines, each produced in a different year. The Nast Santa is part of Santa I, made in 1983. Wedgwood's Nast Santa salad plates are in the Mayfair line, the industry code for which is WW Mayfair. The plates have been discontinued. Tierney, "Santa Claus Paper Dolls in Full Color"; see page 19 in his book for a discussion of the Nast images, plates 11 and 12.

38. "The Library of Congress Christmas Coloring Book," purchased in 2009, in the author's collection.

39. "There Is Nothing Mean about Us," *HW*, May 30, 1874; "The Horse and His

Rider," and "Our Living Skeleton Standing Army," *HW*, June 27, 1874; "The Mere Shadow Still Has Some Backbone," *HW*, August 8, 1874.

40. Henry called for subscriptions in late December 1877 and collected responses until the presentation in 1879; see Paine, *Thomas Nast*, 372–73. On Sherman, see ibid., 407–9. See also "The Ass and the Charger," *HW*, January 25, 1879.

41. "The Good and Bad Spirits at War," *HW*, March 7, 1874. Nast alters a line from Shakespeare's *Henry VI*, part 1, act 1, scene 2, which reads, "Woman, do what thou canst to save our honours; Drive them from Orleans and be immortalized." "The Bar of Destruction" and "Commit Him for Manslaughter in the Greatest Degree," *HW*, March 21, 1874; the final cartoon in the spate of temperance images that month was "Bacchus Drowns More than Neptune," *HW*, March 28, 1874. Nast continued to produce individual cartoons on behalf of temperance, for instance, "Jewels among Swine," *HW*, June 13, 1874.

42. "Laying Down the Law," *HW*, July 4, 1874; "Dog-Days" *HW*, July 11, 1874, and editorial with the same title, 582; "An Object of Pity," *HW*, July 11, 1874. The city ordinance in question forced dog owners to muzzle dogs and imposed penalties (fines and confiscation, including the killing of confiscated dogs if not retrieved) for noncompliance. See "The Board of Aldermen," *NYT*, April 10, 1874, and "Board of Aldermen," *NYT*, June 25, 1874.

43. "This is the Most Magnificent Movement of All," *HW*, January 3, 1874; see also Venet, *Strong-Minded Woman*, 199.

44. "Parepa Rosa," *HW*, February 14, 1874. With her husband, Carl Rosa, Parepa-Rosa formed the Parepa-Rosa English Opera Company of New York. Nast mourned her death in childbirth.

45. "The New Postage Stamp on Third-Class Matter," *HW*, April 10, 1875.

46. "Post-Haste," *HW*, December 18, 1875.

47. "The Third Term Panic," *HW*, November 7, 1874. Summers (*Press Gang*, 2) examines the symbolic meaning of each animal and finds that many of the animals likely reflected qualities in the editors or papers they represented.

48. Morton Keller, "The World of Thomas Nast," paper presented at *Celebrating Thomas Nast's Contributions to American History and Culture*, a symposium at the Ohio State University held December 7, 2002, 9–10.

49. Summers, *Press Gang*, 268.

50. "A Midsummer Night's Dream," *HW*, October 4, 1873; "Our Modern Canute at Long Branch," *HW*, October 11, 1873; "The Power of the (Noisy) Press," *HW*, October 25, 1873; "'Where There Is Evil' (Caesarism Scare) 'There Is a Remedy'" *HW*, November 8, 1873; see also "Another Inflated Power Burst," *HW*, October 4, 1873, and "Shoo, Fly!," *HW*, November 22, 1873. The ghost appeared again in 1874, still wearing his toga. See "There It Is Again!," *HW*, July 25, 1874.

51. "A Burden He Has to Shoulder," *HW*, October 24, 1874.

52. "The Hobby in the Kinder-Garten," *HW*, October 24, 1874.

53. O'Brien, *Story of "The Sun,"* 304; "Don't Let Us Have Any More of This Nonsense. It Is a Good Trait to Stand by One's Friends, But—," *HW*, July 18, 1874.

54. Paine, *Thomas Nast*, 294–95; "The Independence of the Press," *HW*, July 18, 1874, 594.

55. Nast, "Caught in a Trap—The Result of the Third-Term Hoax," *HW*, November 21, 1874; "The Man Who Laughs," *HW*, November 21, 1874; "Now Gnaw Away!," *HW*, December 5, 1874.

Chapter Ten

1. Curtis, so long active in civil service reform and the woman suffrage movement, was himself a target of the caricaturist's pencil. See "Men of the Day," Folder 1872, NYHS. Curtis appears as "A Sweet Thing in Reform," in a woman's dress, his gloved hands clutching a needlework sampler. The image was the work of cartoonist Frank Bellew and was printed by R. Shugg & Co., in New York.

2. "Homo-Phobia," *HW*, July 10, 1875.

3. "The President's Letter," *HW*, June 19, 1875.

4. "The Blighting Effect of the President's Message," *HW*, January 1, 1876.

5. Paine, *Thomas Nast*, 320–21.

6. See, for example, "The Democratic Tiger Gone Mad," *HW*, May 20, 1876; "'The Foremost Champion of This Spirit of Reform'—H. Seymour," *HW*, May 20, 1876; "Bottom Facts," *HW*, May 27, 1876; and "Why We Laugh," *HW*, June 3, 1876.

7. Keller, *Art and Politics of Thomas Nast*, 282.

8. Simpson, *Reconstruction Presidents*, 201. See also Foner, *Reconstruction*, 567.

9. R. B. Cowen to Rutherford B. Hayes, May 9, 1872, RBHPL, Nast/Hayes file. Keller (*Art and Politics of Thomas Nast*, 324) also points out Nast's ambivalence to Hayes.

10. On Hayes, see Simpson, *Reconstruction Presidents*, chap. 7; and "Continue That I Broached in Jest," *HW*, June 24, 1876.

11. A photographic copy of these woodblocks, which fit together to form a single sketched image, is held by the Rutherford B. Hayes Presidential Library.

12. Paine, *Thomas Nast*, 434–36. Hancock's candidacy is discussed in chap. 7.

13. Williams, *Hayes*, 22–23 (entries for May 21 and 25, 1876); letter from Hayes to Curtis regarding reform in ibid., 112 (entry for December 31, 1877); regarding the address at the Academy of Music, see ibid., 182 (entry for January 1, 1879). Hayes's presidential run was based in part on promises regarding civil service reform. His commitment to reform appealed to men like Curtis, for whom civil service reform was one of the most pressing issues of the day. See planks 5 and 6, Republican Party Platform of 1876, in Johnson and Porter, *National Party Platforms, 1840–1972*, 53.

14. "Between Two Fires," *HW*, October 14, 1876.

15. Plank 3, Republican Party Platform of 1876.

16. On Reconstruction, see Williamson, *Crucible of Race*; Drago, *Hurrah for Hampton!*; Nelson, *Iron Confederacies*; and Zuczek, *State of Rebellion*.

17. "Is This a Republican Form of Government?," *HW*, September 2, 1876. On Redemption, see Olson, *Reconstruction and Redemption*, and Edwards, "Extralegal Violence." A description of the violence in South Carolina appears in Foner, *Reconstruction*, 570–75.

18. Foner, *Reconstruction*, 575–81.

19. Fischer, *Them Damn Pictures*, 12–13.

20. Hayes took the oath privately on March 3, then again publicly on March 5. See Simpson, *Reconstruction Presidents*, 207.

21. Polakoff, *Politics of Inertia*, 318. Polakoff points out here that the removal policy continued a last-minute order by President Grant and was therefore not an entirely new policy.

22. Simpson, *Reconstruction Presidents*, 208–9.

23. C. Vann Woodward points out that this "realignment" of Republican thought brought together the elite classes of both sections in order to achieve greater harmony in national politics. Woodward, *Reunion and Reaction*, 230. Woodward also points out that the change in attitude apparent in Curtis's editorials can be seen in other Republican papers, such as the *National Republican*.

24. *Nation*, November 16, 1876; *Semi-Weekly Observer*, August 20, 1878; *Daily Graphic*, August 6, 1877. References to the *Sun* and *World* appear in Paine as well (*Thomas Nast*, 361). Rumors about the artist included one in which he had poisoned himself with a chemical agent while working and was unable to continue drawing.

25. Paine, *Thomas Nast*, 321.

26. B. R. Cowen to Rutherford B. Hayes, May 9, 1872, Nast/Hayes file, RBHPL. Cowen and Hayes were concerned about Nast's attacks on Carl Schurz.

27. See, for example, John W. Harper's repeated references to his business concerns in an 1883 letter to Nast in Paine, *Thomas Nast*, 466.

28. Robert Kennedy ("Crisis and Progress," 56) argues that Curtis's thirty-seven-year association with Harper and Brothers, and especially with *Harper's Weekly*, was predicated on his desire to expose the maximum number of readers to his reform ideals. This view is borne out by correspondence between Curtis and author and educator Charles Eliot Norton. See GWC to CEN, April 26, 1865, GWCP, no. 265.

29. Draper Hill, "Tommy on Top," 86, unpublished essay, TNC, RBHPL, GA-33, Box 1.

30. "American Caricaturists," pt. 5, pp. 807–11, unknown journal, probably English, TNC, MFPL.

31. Harper, *House of Harper*, 242.

32. How much power Curtis had within the Republican Party is hard to determine. He spoke for the party in *Harper's Weekly* and in his lecture tours, enumerating the values and policies of the Republicans with depth and care. On the other hand, his devotion to woman suffrage and civil service reform led to mockery by Republicans who thought him too soft and idealistic. Curtis never successfully exercised nominating power or served in a major party office, but his public voice meant that he was never without influence, either. The best source for his frustrations with and hopes for the party is his letters, held at Houghton Library, Harvard University.

33. Paine, *Thomas Nast*, 369. Curtis was deeply hurt by Conkling's remark. "I had not thought him great, but I had not expected how small he was," Curtis wrote to Norton. See GWC to CEN, September 30, 1877, GWCP, bMS AM 1124, no. 359.

34. GWC to TN, 1872, as reproduced in Harper, *House of Harper*, 302.

35. This position is reflected in Nast's letters from Washington in 1872; see TN to SEN, February 6, 1872, TNP, HM no. 27761.

36. "Caricature," TNC, RBHPL, AC 12167, GA-33, Box 1, Thomas Nast folder "Articles in the hand of Mrs. Nast."

37. Joseph W. Harper (writing as proxy for Fletcher Harper) to GWC, 1872, as reproduced in Harper, *House of Harper*, 304.

38. Paine, *Thomas Nast*, 203.

39. "Caricature" and Thomas Nast, draft of a chalk talk speech on caricature (esp. pages 10–11), both in TNC, RBHPL, AC 12167, GA-33, Box 1, Thomas Nast folder "Articles in the hand of Mrs. Nast."

40. Schurz, *Reminiscences*, 214.

41. TN to SEN, January 29, 1872, TNP, RBHPL, AC 12167, GA-33, Box 1. The RBHPL lists this letter as dated June 1872, but Nast was not in Washington at that time, and other letters were clearly written during the same stay with N. P. Chipman, all dated late January and early February.

42. Joseph W. Harper to GWC, 1872, as reproduced in Harper, *House of Harper*, 304.

43. Curtis was just the political editor of *Harper's Weekly*. Other parts of the paper, such as the fiction it published or its advertisements, were the purview of other, less distinguished (in Curtis's opinion), men. See Harper, *House of Harper*.

44. GWC to TN, reproduced in Harper, *House of Harper*, 302.

45. TN to GWC, August 3, 1868, TNP, RBHPL.

46. GWC to John Henry Harper, 1882, as reproduced in Harper, *House of Harper*, 493–96.

47. Keller, *Art and Politics of Thomas Nast*, 326, attributes this primarily to Joe Brooklyn, but John Henry placed himself in the midst of the battle as well in Harper, *House of Harper*.

48. Paine, *Thomas Nast*, 354.

49. Ibid., 355.

50. Nast described this in an undated essay on caricature, likely a draft of one of his chalk talk speeches, a two-page item beginning, "I have always been a great admirer of John Tenniel . . . ," 2, in "Various on caricature" file, TNP, RBHPL. Paine (*Thomas Nast*) refers to Nast's exhaustion and what was probably arthritis in Nast's hand and arm beginning in the 1860s and making his work very difficult by his fifties.

51. Thomas Nast, undated draft of chalk talk held by RBHPL, 14–15.

52. Many of these can be seen in the collection of the RBHPL. They span the years from his first employment in New York in the early 1860s to his death in Ecuador in 1902.

53. TN to SEN, October 8, 1873, HM no. 27766. The letter itself gives only the month and day; the year provided by Huntington. Errors in spelling and grammar are in the original.

54. The emphasis on past events is evident in the drafts of "Caricature" text prepared for chalk talks in RBHPL. They do not include any reference to the audience or any participation by it.

55. Keller (*Art and Politics of Thomas Nast*, 324) describes Nast in this period as

"increasingly aloof and dispassionate," which points to the distance growing between Nast and the world that shaped his earlier work.

56. Stimson, *Vanderbilts and the Gilded Age*, 108–9.

57. Keller, *Art and Politics of Thomas Nast*, 219.

58. McPherson, *Abolitionist Legacy*.

59. GWC to CEN, March 25, 1862, GWCP, no. 191, Box 3.

60. Ibid., September 25, 1862, no. 201.

61. Woodward, *Reunion and Reaction*, 233.

62. According to Keller (*Art and Politics of Thomas Nast*, 325), Nast perceived the moral change in Republican policy as well. Quoted phrases are drawn from Ezekiel.

63. Mott, *History of American Magazines*, 3:5; 2:43–46. The first two illustrated weeklies were *Gleason's Pictorial Drawing-Room Companion* and the *Illustrated American News* (both founded in 1851, in Boston and New York, respectively). *Frank Leslie's Illustrated Newspaper* began in 1855, while *Harper's Weekly* issued its first edition in 1857. Mott notes that for these publications, the terms "magazine" and "newspaper" were often interchangeable. *Harper's Weekly* was not the first weekly magazine Harper and Brothers created, however. From 1850 to 1853, Fletcher Harper headed the *Harper's New Monthly Magazine*, which published prose, poetry and women's fashion in a small pamphlet style. This publication helped spur Fletcher Harper's interest in a magazine with illustrated content. See Exman, *Brothers Harper*, 303–5.

64. See Schudson, *Discovering the News*, esp. 77; Leonard, *Power of the Press*, esp. 132–34; Leonard, *News for All*, 138–46; and Mott, *History of American Magazines*, 3:22–24. On the increasingly complex world of journalism and the challenges posed to older publications on every front, see Brown, *Beyond the Lines*. Nast confronted this problem again in later years when he could not find magazines that would allow him editorial freedom. See Paine, *Thomas Nast*, 534.

65. Fitzgerald, *Art and Politics*, 4–5. Nast's bitterness about this change in status lingered for many years. Paine's biography of Nast appeared in bookstores in 1904, almost thirty years after Curtis ousted Nast. Even so much later, Nast managed to convey the value of Fletcher Harper's protection and support. Paine dedicated the book to Harper's memory, noting that his "unfailing honesty and unfaltering courage made possible the greatest triumphs of Thomas Nast" (Paine, *Thomas Nast*, frontispiece).

66. Mott, *History of American Magazines*, 3:5.

67. Paine, *Thomas Nast*, 362–64, suggests that Curtis may have objected to Nast's cartoon because of Lowell's public service, much as he had objected to portrayals of Sumner. Another explanation is that Lowell was related through marriage to Curtis's wife, Anna Shaw Curtis. Keller, *Art and Politics of Thomas Nast*, 218, says Curtis "disapproved of the drawing's message," because it was too nationalistic and disdainful of the European powers.

68. James Parton to TN, September 25, 1877, as reprinted in Paine, *Thomas Nast*, 365–66.

Chapter Eleven

1. Nast's production in these years was remarkably steady. In 1877, 96 drawings appeared in *HW*; in 1878, 132; in 1879, 139; in 1880, 121; in 1881, 113; and in 1882, 141. It was only in 1883 that his production slowed, partly due to a late-autumn illness. On Nast's cartoons, see *JTNS* 6, no. 1 (1992): 82–104; and 7, no. 1 (1993):51–75. On his illness, see Paine, *Thomas Nast*, 468–69.

2. Paine, *Thomas Nast*, 286.

3. "The Millennium," *HW*, November 3, 1877; Paine, *Thomas Nast*, 369–71.

4. On economics, see "Always Killing the Goose that Lays the Golden Egg," *HW*, March 16, 1878; "Earn More than you Spend," *HW*, April 13, 1878; "Why Take a Crooked Road When There Is a Straight One?," *HW*, April 20, 1878; "The Tramp Period" and "Probabilities," *HW*, May 4, 1878; "The 'Silver Lunatic' Not Quite Loose Yet," *HW*, May 11, 1878; "Seed That Bears Fruit," *HW*, May 18, 1878; and "Waiting," *HW*, June 1, 1878. Another series appeared in October and early November. On crew, see "Hail, C-o-l-u-m-b-i-a!" and "America Always Puts Her Oar In," *HW*, July 27, 1878.

5. J. B. Pond and Mark Twain tried to convince Nast to lecture during the 1877 season, but Nast was still recovering from his break with Curtis. In the summer of 1878, Pond reached out again. This time, he promised Nast $300 a night for up to six weeks, a rate that could have yielded Nast almost $10,000. Nast again declined. See Paine, *Thomas Nast*, 385.

6. Ibid., 417–18.

7. Summers, *Party Games*, 64–65, 117. Nast commented on Tilden's role in the "cipher telegrams" in "Cipher Mumm(er)y," *HW*, November 2, 1878, in which he portrayed Tilden as an Egyptian mummy, emblazoned with signs related to the scandal.

8. "Nay, Patience or We Break the Sinews," *HW*, May 5, 1877; "Our Patient Artist," *HW*, November 30, 1878. See also Paine, *Thomas Nast*, 404–5.

9. On Garfield, see Ackerman, *Dark Horse*, and Taylor, *Garfield of Ohio*.

10. Keller, *Art and Politics of Thomas Nast*, 324–25.

11. Paine, *Thomas Nast*, 432.

12. Ibid., 432–37. On *Puck*, see West, *Satire on Stone*.

13. See *Puck*, March 31, 1880, and West, *Satire on Stone*, 194. One of the young men *Harper's* hired was James Wales, the future founding artist of *The Judge*, a comic weekly that rivaled *Puck* in popularity. See West, *Satire on Stone*, 199.

14. Paine, *Thomas Nast*, 435. As in other cases, Paine says *Harper's Weekly* received a variety of complaints in defense of Nast. However, Paine does not reprint them and the Harper and Brothers papers at Columbia University do not include readers' letters to the magazine.

15. Keller, *Art and Politics of Thomas Nast*, 325; Paine, *Thomas Nast*, 454–55.

16. Paine, *Thomas Nast*, 466. Nast's last political cartoon of that year appeared on March 24. In December, *HW* published a Santa Claus drawing. It was not until March 1, 1884, that *Harper's* would publish another Nast cartoon.

17. Paine, *Thomas Nast*, 468.

18. Ibid., 468–70.

19. Ibid., 469.

20. Ibid., 473.

21. Ibid., 476.

22. "The Sacred Elephant," *HW*, March 8, 1884.

23. See GWCP, where most of Curtis's correspondence with Norton is held.

24. GWC to CEN, April 26, 1865, GWCP, no. 265.

25. Kennedy, "Crisis and Progress." See also Cary, *George William Curtis*, and McFarland, *Mugwumps, Morals and Politics*.

26. See Summers, *Rum, Romanism, and Rebellion*.

27. In "The Nomination," Curtis argued that Blaine's nomination would split the Republican Party—a warning that went unheeded. See "The Nomination," *HW*, May 3, 1884. Paine, *Thomas Paine*, 485, also asserts Curtis's hope that he could prevent the nomination.

28. "Out-'Shining' Everybody in Humiliation at Albany," *HW*, July 16, 1881. For Paine's treatment of the meeting between Nast and Arthur, see *Thomas Nast*, 486–87.

29. Curtis quote in Paine, *Thomas Nast*, 499. On Cleveland, see Jeffers, *Honest President*.

30. McFarland, *Mugwumps, Morals, and Politics*, 11–34.

31. Keller, *Art and Politics of Thomas Nast*, 325.

32. Paine, *Thomas Nast*, 386.

33. See, for example, "The Civilization of Blaine," *HW*, March 8, 1979; "A Matter of Taste," *HW*, March 15, 1879; "Blaine Language," *HW*, March 15, 1879.

34. James G. Blaine to TN, January 31, 1880, as quoted in Paine, *Thomas Nast*, 420–21.

35. *HW*, June 14, 1884, quote from 374. See also Paine, *Thomas Nast*, 485–93.

36. "Too Heavy to Carry," *HW*, June 14, 1884.

37. "Death before Dishonor," *HW*, March 21, 1884; Paine, *Thomas Nast*, 494. The story of Appius Claudius and Virginius appears in Macauley's *Lays of Ancient Rome* (1842) and is referenced in Shakespeare's *Titus Andronicus*.

38. Quoted in Paine, *Thomas Nast*, 496; and J. Chal Vinson, "Thomas Nast and the American Political Scene," *American Quarterly* 9 no. 3 (1957): 344.

39. See *Judge*, June 28, 1884, and Fischer, *Them Damned Pictures*, 32–37. See also Paine, *Thomas Nast*, 501–2.

40. See, for example, "Plumed Crow," *HW*, June 21, 1884; "A Roaring Farce—The Plumed Knight in a Clean Shirt," *HW*, June 28, 1884; "The Brazen Knight of the White Feather on His Round Trip for Votes," *HW*, October 4, 1884.

41. Paine, *Thomas Nast*, 506; "The Foremost Man of the Time," *HW*, August 16, 1884; "The Blaine Tariff Fraud," *HW*, November 1, 1884; "The Question Decided on Election Day," *HW*, November 8, 1884. The last cartoon shows the canvas bag inscribed "Are 20 years of Blaine enough? ."

42. The letters appeared in *HW*, September 27, 1884, in the supplement. See also "Brazening It Out," *HW*, September 27, 1884; and "The Self-Convicted Knight" and "Knightly Sentiments and Daily Contradictions," *HW*, October 18, 1884.

43. "A Job Lot," *HW*, October 25, 1884; "The Blaine Tariff Fraud" and "The Great Boodle Monopoly," *HW*, November 1, 1884,

44. "Very Democratic," *HW*, June 28, 1884; "The Republican Boss," *HW*, July 19, 1884; "Grave Regrets," *HW*, September 27, 1884. In the last of these cartoons, Nast shows Tweed observing Blaine from the grave and wondering whether he, himself, could have run for president.

45. *HW*, July 26, 1884, 490–91.

46. There are two pairs of these cartoons: "Is This 'The True American Policy'?" and "A Sham-Fight Campaign," *HW*, July 26, 1884; and "The So-Called 'Intensely American Candidate'" and "Thoroughly American, Yet Seeking Peace," *HW*, August 16, 1884.

47. Summers, *Rum, Romanism and Rebellion*, 214–16.

48. "What It Means," *HW*, November 15, 1884.

Chapter Twelve

1. Paine, *Thomas Nast*, 511–13.

2. See McFeely, *Grant*, and Perry, *Grant and Twain*. For cartoon, see Paine, *Thomas Nast*, 484.

3. Paine, *Thomas Nast*, 483–85.

4. The tour attracted large audiences, and Paine asserts that its receipts equaled those of previous excursions but that increased overhead reduced profits. See Paine, *Thomas Nast*, 513.

5. "One of the First Fruits of the Victory," *HW*, November 22, 1884; "On Earth Peace, Good-Will Toward Men," *HW*, December 27, 1884.

6. "A Happy New Year to You, and May You Fill Your New Office as Successfully as Your Old One," *HW*, January 3, 1885.

7. Paine, *Thomas Nast*, 508. Quote from "The President and the Republican Party," *HW*, January 3, 1885, 2. Even in late January, Nast continued to produce cartoons showing his hopes for Cleveland and a less racially charged South. See "Proclaim Liberty Throughout All the Land Unto All the Inhabitants Thereof," *HW*, January 24, 1885.

8. "The First Shot of the New Rebellion," *HW*, March 14, 1885; "New White House Regulations," *HW*, March 21, 1885. See also, "Have the Democrats an Elephant on Hand?," *HW*, February 28, 1885; "Inspecting the Kitchen," "Another Civil Service Outrage," and "The House That Needs Dusting Very Much," *HW*, March 28, 1885; and "It May Not Be Civil but It's Right," *HW*, April 18, 1885.

9. Waugh, *U. S. Grant*; Perry, *Grant and Twain*.

10. "The Hero of Our Age," *HW*, August 1, 1885.

11. Paine, *Thomas Nast*, 517.

12. See *JTNS* 6, no. 1 (1992); and 7, no. 1 (1993).

13. Paine, *Thomas Nast*, 526–27.

14. See *JTNS* 8, no. 1 (1994): 93. During this period, Nast actively endorsed Police Commissioner Theodore Roosevelt.

15. Paine, *Thomas Nast*, 528.

16. Joshua Brown (*Beyond the Lines*, 234) dates the beginning of *Harper's* decline to the 1884 election, arguing that the loss of many loyal Republican readers began the slide. However, it seems more likely that the failing finances of the Harper and Brothers publishing house (which culminated in failure in 1899), including *Harper's Weekly*, in combination with the death of Curtis (in 1892) pushed the magazine toward collapse.

17. TN to William Church, April 7, 1893, William Church Papers, Box 2, II-28-I, 4, LOC. It appears that Nast may have meant Leif Ericsson, but the letter does not explain.

18. TN to A. R. Spofford, February 14, 1898, Spofford Papers, LOC.

19. The state of Nast's finances is not clear, in part because his record-keeping was inexact. Nast lost a substantial portion of his income in the disaster at Grant and Ward, but he retained his home in Morristown and the last couple of years' worth of his *Harper's Weekly* salary. It was with this money, and with the trickle of income from freelance cartooning and painting, that Nast invested in Colorado and paid for his travels.

20. Paine, *Thomas Nast*, 529–33. A mountain was named for Nast in Colorado, but this failed to lift the cartoonist's spirits much.

21. Ibid., 533.

22. Keppler originally founded *Puck* as a German-language paper. The English-language version appeared the next year. See West, *Satire on Stone*, 72.

23. Ibid., 127.

24. Brown, *Beyond the Lines*, 237.

25. Paine, *Thomas Nast*, 529.

26. Ibid.

27. The only complete set of the *Weekly* is held by the University of Minnesota library, Minneapolis.

28. Paine provides little specifics about this period. He does say that Nast had an advertising agent, but even that man was skeptical about the viability of the paper. He demanded a high percentage fee on advertising contracts, only to find that the fee was worthless because the total number of ads was so low and the paper died too quickly. See Paine, *Thomas Nast*, 538–39.

29. Ibid., 539.

30. *Nast's Weekly*, March 4, 1893, 7.

31. TN to Henry Watterson, June 18, 1895, Henry Watterson Papers, Misc. "N" letters file, Box 10, no. 1211, LOC.

32. TN to George Edward Pond, May 12, 1896, TNP, RBHPL.

33. TN to Henry Watterson, Henry Watterson Papers, June 18, 1895, Misc. "N" letters file, Box 10, no. 1211, LOC.

34. TN to A. R. Spofford, February 14, 1898, Spofford Papers, LOC.

35. See Paine, *Thomas Nast*, 545–47.

36. Ibid., 534, 537.

37. "A Sad Death," *Jerseyman*, May 5, 1899.

38. Diary of John E. Parker, Monday, May 1, 1899, entry, TNC, MFPL. There is reason to believe that Julia did kill herself and that she and Nast were estranged.

According to the article in the *Jerseyman*, Thomas Nast Jr. collected his sister's body and arranged for it to be buried in Woodlawn Cemetery in Manhattan. In the Paine biography, there is no reference to Nast traveling to New York, seeing his daughter, or attending a funeral. Indeed, there is no reference to her funeral at all.

39. See Paine, *Thomas Nast*, 553.

40. Ibid., 554–55.

41. Ibid., 535.

42. Ibid., 543.

43. Burlingame and Ettlinger, *Inside Lincoln's White House*; Burlingame, *Lincoln's Journalist*.

44. In 1877, George William Curtis was offered the opportunity to choose any position he wanted within the diplomatic corps. He declined but was again offered a position with the United States Mission to Germany in 1879. He recognized that the offers were a compliment to him. See GWC to CEN, May 19, 1877, no. 355, and January 19, 1879, no. 364, GWCP.

45. Another editorship, that of *Putnam's Magazine*, would have paid Harte $5,000 per year. See Bret Harte to Fields, Osgood, and Company, September 16, 1870, in Scharnhorst, *Selected Letters of Bret Harte*, 39. Harte was also offered, and accepted, a contract from publisher James R. Osgood. For $10,000 a year, Harte would provide at least twelve publishable works, mostly poems like "The Heathen Chinee." Harte was excited about the contract, but in typical fashion failed to provide the manuscripts, then fought with Osgood about whether or not he, Harte, had fulfilled his end of the bargain. See Bret Harte to James R. Osgood, March 6, 1871, in Scharnhorst, *Selected Letters of Bret Harte*, 48–49.

46. Bret Harte to Anna Harte, April 19, 1878, in Scharnhorst, *Selected Letters of Bret Harte*. See also Noah Brooks, "Bret Harte, A Biographical and Critical Sketch," in *Overland Monthly*, September 1902, 200–208, HM no. 10915; O'Connor, *Bret Harte*, 190.

47. James Russell Lowell (1819–91) also received a diplomatic post, in 1877, to London. He retained the position until 1885. Lowell was one of the "Fireside" poets and the author of numerous books. His letters were edited by George William Curtis's closest friend, Charles Eliot Norton. See Scudder, *James Russell Lowell* and *Letters of James Russell Lowell*.

48. TN to John Hay, March 12, 1902, Reel 15, Hay Papers, LOC. See also TN to John Hay, April 3, 1902, ibid.

49. As he had been doing for decades, Nast sketched in the pages of his letters. Most of the letters from the Guayaquil period are housed at the Rutherford B. Hayes Presidential Library.

50. TN to SEN, August 12, 1902, TNP, HM no. 27767; various letters from Nast to Sallie and to Nast from consular figures in Quito, Ecuador, in TNP, RBHPL. Tom Miller, in his book on Ecuador, mentions Nast's consulship and argues that Nast was relatively popular with the local population. Had they seen his private correspondence, they might have changed their minds. See Tom Miller, *The Panama Hat Trail* (Washington, D.C.: Adventure Press, National Geographic, 2001), 94.

51. TN to SEN, October 13, 1902, in Paine, *Thomas Nast*, 567.

52. Robert B. Jones to David J. Hill, December 9, 1902, TNP, HM no. 27776.

53. Herbert H. D. Peirce to Robert B. Jones, December 10, 1902, TNP, HM no. 27772.

54. Herbert H. D. Peirce to SEN, undated, TNP, HM no. 27775.

55. C. M. Fairbanks to John Hay, July 15, 1904, Reel 20, Hay Papers, LOC.

56. TN to SEN, December 1872, TNP, RBHPL AC 12167.

57. J. W. R. Crawford to John Hay, March 22, 1904, Reel 19, Hay Papers, LOC.

58. Both informal (handwritten preliminary documents) and formal inventories are in the collection of the Huntington Library. The final tally led to the Treasury Department calculating Nast's pay; see TNP, HM no. 27768.

Conclusion

1. According to Nast's *New York Times* obituary, the total estate was valued at $10,000, a sum that would not support Sallie for very long without some addition. See Richard Simon, "The Last Days of Thomas Nast," *JTNS* 6, no. 1 (1992): 62–63; and *NYT*, December 19 and 28, 1902.

2. Biographical materials related to Albert Bigelow Paine are in Bigelow Paine Cushman and Anne Cushman collection, Deer Isle, Maine. Portions of Paine's autobiographical writing were published during his lifetime, including "Mark Twain's Biographer," *Bookman* 31, no. 4 (June 1910).

3. On Twain's note, see Paine's memorial to Edmund Clarence Stedman in *Pearson's Magazine*, April 1908, 433–37.

4. See "The Christmas Bulletin of the Latest and Best-Selling Books," Baker and Taylor Company, New York, 1912, 66, in Bigelow Paine Cushman and Anne Cushman collection, Deer Isle, Maine.

5. Paine described this as part of his theory of biography in an address to the Paul Brush Club on October 26, 1922, in Bigelow Paine Cushman and Anne Cushman collection, Deer Isle, Maine.

6. The Santa Claus debate, initiated by Henry Llewellyn Williams on May 11 and involving Lumley, Paine, Charles Schott, and the editorial staff of the *New York Times Book Review*, was fairly cordial. The exchange centered on other examples of Santa Claus prior to Nast's famous drawings. Although Paine stuck to his position, his tone was conciliatory, and he seems to have been willing to acknowledge that earlier Santa images existed. On May 28, he temporized by arguing that Nast's work popularized Santa for children in the "McLaughlin toy books," which Nast illustrated. See Albert Bigelow Paine scrapbook, RBHPL.

7. "Santa Claus and Thomas Nast," *NYT Book Review*, June 4, 1904, in ibid.

8. Nast's letters to Sallie from Harrisburg and Carlisle, Pennsylvania, housed at the Huntington Library prove at least those parts of Paine's account in his scrapbook, RBHPL. Military passes, other correspondence, and sketches from the front would reinforce Paine's account of Nast's war illustrations, but unfortunately they are either no longer extant or are not available for research. In the Paine materials held by Mrs. Anne Cushman, there is a passport dating from Nast's trip to Italy for the Garibaldi campaign but no other evidence of his presence in combat zones. It

is possible that some of these items were purchased by private collectors during the three auctions of Nast's belongings in 1907 and 1908.

9. "Mr. Albert Bigelow Paine Replies to Mr. Arthur Lumley on That and Other Heads," *NYT Book Review*, June 11, 1904, Albert Bigelow Paine scrapbook, RBHPL.

10. "Mr. Arthur Lumley Returns to the Nast–Santa Claus Discussion," *NYT*, June 25, 1904; "Mr. Albert Bigelow Paine Defends the Memory of the Famous Caricaturist," *NYT*, July 2, 1904; "The Nast Controversy," *NYT*, July 2, 1904. Works on the other cartoonists that have been compared to Nast include Hill, *Fashionable Contrasts*; Hill, *Mr. Gillray*; George, *Hogarth to Cruikshank*; and Olson, *Gavarni*.

11. Paine, *Thomas Nast*, 84.

12. Fletcher Harper's affection for Nast, and his willingness to allow Nast as much freedom as he needed, was well known. See Paine, *Thomas Nast*, 94, 122; and Exman, *House of Harper*, 83–92.

13. *JTNS* 11, no. 1 (1997): 86. See also the auction catalogs in the collection of the New York Public Library and TNC, MFPL.

14. See thank-you note from Cyril to Albert Bigelow Paine regarding Paine's note of condolence, in Bigelow Paine Cushman and Anne Cushman collection, Deer Isle, Maine.

15. "Thomas Nast, Jr.," *Morristown Daily Record*, January 2, 1943.

16. See notecards in TNC, MFPL.

BIBLIOGRAPHY

Archival Collections

CAMBRIDGE, MASSACHUSETTS
Houghton Library, Harvard University
George William Curtis Papers

FREMONT, OHIO
Rutherford B. Hayes Presidential Library and Center
Thomas Nast Collection, File Code 33
Thomas Nast Diary

MINNEAPOLIS, MINNESOTA
Special Collections Library, University of Minnesota
Thomas Nast's Weekly

MORRISTOWN, NEW JERSEY
Morristown Free Public Library
Thomas Nast Collection

NEW YORK, NEW YORK
Columbia University Library, Columbia University
Harper Company Papers
Eugene Exman Papers
Museum of the City of New York
William Street File
New-York Historical Society
Gilder Lehrman Collection
Library
James Parton Papers
Print Room
Caricature and Cartoon File
New York Public Library
Thomas Nast scrapbook

PRINCETON, NEW JERSEY
Department of Rare Books and Special Collections, Princeton University
Library
Thomas Nast Manuscript Collection

SACRAMENTO, CALIFORNIA
 California State Library
 Norton Parker Chipman Collected Works

SAN MARINO, CALIFORNIA
 Manuscript Division, Huntington Library
 Thomas Nast Papers
 Albert Bigelow Paine Correspondence

WASHINGTON, D.C.
 Library of Congress, Manuscript Division
 John Hay Papers
 A. R. Spofford Papers
 Charles Sumner Papers

Periodicals

Boston Daily Globe
The Boston Globe
The Daily Graphic
Frank Leslie's Illustrated News
Harper's New Monthly Magazine
Harper's Weekly
The Jerseyman
Judge
Louisville Courier-Journal

Morristown Daily Record
Nast's Weekly
The Nation
New York Illustrated News
The New York Times
The New York Tribune
Puck
The Semi-Weekly Observer
Sunday News Magazine

Books and Articles

Abbott, Jacob. *The Harper Establishment: Or, How the Story Books Are Made.* New York: Harper and Brothers, 1855.

Abbott, Richard H. *For Free Press and Equal Rights: Republican Newspapers in the Reconstruction South.* Edited by John W. Quist. Athens: University of Georgia Press, 2004.

Ackerman, Kenneth D. *Boss Tweed.* New York: Carroll and Graf, 2005.

———. *The Dark Horse: The Surprise Election and Political Murder of James Garfield.* New York: Carroll and Graf, 2003.

Adler, Jonathan, and Draper Hill. *Doomed by Cartoon: How Cartoonist Thomas Nast and the New York Times Brought Down Boss Tweed and His Ring of Thieves.* New York: Morgan James, 2008.

Agnew, John A. *Place and Politics: The Geographical Mediation of State and Society.* Boston: Allen and Unwin, 1987.

Allen, Oliver E. *The Tiger: The Rise and Fall of Tammany Hall.* Reading, Mass.: Addison-Wesley Publishing Company, 1993.

Almond, Gabriel A., and Sidney Verba, eds. *The Civic Culture Revisited.* Boston: Little, Brown, 1980.

Altschuler, Glenn C., and Stuart M. Blumin. *Rude Republic: Americans and Their Politics in the Nineteenth Century*. Princeton, N.J.: Princeton University Press, 2000.

Anbinder, Tyler. *Five Points: The Nineteenth Century New York City Neighborhood That Invented Tap Dance, Stole Elections, and Became the World's Most Notorious Slum*. New York: Plume Books, 2002.

———. *Nativism and Slavery: The Northern Know-Nothings and the Politics of the 1850's*. New York: Oxford University Press, 1992.

Anderson, Benedict. *Imagined Communities: Reflections on the Origins and Spread of Nationalism*. Rev. ed. New York: Verso, 2006.

Anderson, George McCullogh. *The Work of Adalbert Johann Volck, 1828–1912*. Baltimore, Md.: Privately Printed, 1970.

Asbury, Herbert. *The Gangs of New York*. New York: Knopf, 1927.

Baker, Jean H. *Affairs of Party: The Political Culture of Northern Democrats in the Mid-Nineteenth Century*. New York: Fordham University Press, 1998.

Bales, William Alan. *Tiger in the Streets*. New York: Dodd, Mead, 1962.

Barnes, David M. *The Draft Riots in New York, July 1863: The Metropolitan Police: Their Services during Riot Week*. New York: Baker and Goodwin, 1868.

Barnes, Horatio. *History of the Thirty-Ninth Congress of the United States*. New York: Harper and Brothers, 1868.

Beckert, Sven. *The Monied Metropolis: New York City and the Consolidation of the American Bourgeoisie, 1850–1896*. New York: Cambridge University Press, 2001.

Benjamin, Steven M. *Papers from the Second Conference on German-Americana in the Eastern United States*. Radford, Va.: Intercultural Communications Center, Radford University, 1981.

Benjamin, Steven M., and Michael Ritterson. *Papers from the Third Conference on German-Americana in the Eastern United States*. Radford, Va.: Intercultural Communications Center, Radford University, 1985.

Berger, Arthur Asa, ed. *Political Culture and Public Opinion*. New Brunswick, N.J.: Transaction, 1989.

Berger, John. *Ways of Seeing*. New York: Penguin Books, 1973.

Bernstein, Iver. *The New York City Draft Riots: Their Significance for American Society and Politics in the Age of the Civil War*. New York: Oxford University Press, 1990.

Berwanger, Eugene H. *The West and Reconstruction*. Urbana: University of Illinois Press, 1981.

Billigmeier, Robert Henry. *Americans from Germany: A Study in Cultural Diversity*. Belmont, Calif.: Wadsworth, 1974.

Blaisdell, Thomas C., Jr., and Peter Selz. *The American Presidency in Political Cartoons, 1776–1976*. Salt Lake City, Utah: Peregrine Smith, 1976.

Boime, Al. *Art of Exclusion: Representing Blacks in the Nineteenth Century*. Washington, D.C.: Smithsonian Institution Press, 1990.

———. "Thomas Nast and French Art." *American Art Journal* 4, no. 1 (Spring 1972): 43–65.

Boyd, Willis D. "James Redpath and American Negro Colonization in Haiti, 1860–1862." *The Americas* 12, no. 2 (October 1955): 169–82.

Brancaforte, Charlotte L., ed. *The German Forty-Eighters in the United States*. New York: Peter Lang, 1989.

Brown, Joshua. *Beyond the Lines: Pictorial Reporting, Everyday Life, and the Crisis of Gilded Age America*. Berkeley: University of California Press, 2002.

Bunker, Gary L. *From Rail-Splitter to Icon: Lincoln's Image in Illustrated Periodicals, 1860–1865*. Kent, Ohio: Kent State University Press, 2001.

Burlingame, Michael. *Lincoln's Journalist: John Hay's Anonymous Writings for the Press, 1860–1964*. Carbondale: Southern Illinois University Press, 1998.

Burlingame, Michael, and John R. Ettlinger, eds. *Inside Lincoln's White House: The Complete Civil War Diary of John Hay*. Carbondale: Southern Illinois University Press, 1999.

Burnham, John C. *Bad Habits: Drinking, Smoking, Taking Drugs, Gambling, Sexual Misbehavior, and Swearing in American History*. New York: New York University Press, 1993.

Callow, Alexander B. *The City Boss in America: An Interpretive Reader*. New York: Oxford University Press, 1976.

————. *The Tweed Ring*. New York: Oxford University Press, 1965.

Cantor, Norman F., and Michael S. Werthman, eds. *The History of Popular Culture since 1815*. New York: Macmillan, 1968.

Carney, Court. "The Contested Image of Nathan Bedford Forrest." *Journal of Southern History* 67, no. 3 (August 2001): 601–30.

Cary, Edward. *George William Curtis*. Boston: Houghton Mifflin, 1895.

Childs, Elizabeth, and Kirsten Powell. *Femmes D'esprit: Women in Duamier's Caricature*. Hanover, N.H.: University Press of New England, 1990.

Choy, Philip P., Lorraine Dong, and Marlon K. Hom. *The Coming Man: Nineteenth-Century American Perceptions of the Chinese*. Seattle: University of Washington Press, 1994.

Clark, Terry Nichols, and Vincent Hoffman-Martinot, eds. *The New Political Culture*. Boulder, Colo.: Westview Press, 1998.

Clarke, Eliot. *History of the National Academy of Design, 1825–1953*. New York: Columbia University Press, 1953.

Colldeweih, Jack, and Kalman Goldstein, eds. *Graphic Opinions: Editorial Cartoonists and Their Art*. Bowling Green, Ohio: Bowling Green State University Press, 1998.

Cook, Adrian. *The Armies of the Streets: The New York City Draft Riots of 1863*. Lexington: University Press of Kentucky, 1974.

Coupe, W. A. "Observations on a Theory of Political Caricature." *Comparative Studies in Society and History* 11, no. 1 (January 1969): 79–95.

Coward, John M. *The Newspaper Indian: Native American Identity in the Press, 1820–1890*. Urbana: University of Illinois Press, 1999.

Cuff, Robert Penn. "The American Editorial Cartoon–A Critical Historical Sketch." *Journal of Educational Sociology* 19, no. 2 (October 1945): 87–96.

Cummings, Thomas S. *Historic Annals of the National Academy of Design.* Philadelphia, Pa.: George W. Childs, 1865.

Curran, Thomas J. *Xenophobia and Immigration, 1820–1930.* Boston: Twayne, 1975.

Curtis, L. Perry. *Apes and Angels: The Irishman in Victorian Caricature.* Washington, D.C.: Smithsonian Institution Press, 1997.

Delzell, Charles F. *The Unification of Italy, 1859–1861.* New York: Holt, Rinehart and Winston, 1965.

Dewey, Donald. *The Art of Ill Will: The Story of American Political Cartoons.* New York: New York University Press, 2007.

Dickens, Charles. *The Posthumous Papers of the Pickwick Club, with Fifty-Two Illustrations by Thomas Nast.* New York: Harper and Brothers, 1873.

Diner, Hasia. *Erin's Daughters in America.* Baltimore, Md.: Johns Hopkins University Press, 1983.

———. "'The Most Irish City in the Union': The Era of the Great Migration, 1844–1877." In *The New York Irish,* edited by Ronald H. Bayor and Timothy J. Meagher, 87–106. Baltimore, Md.: Johns Hopkins University Press, 1996.

Donald, David Herbert. *Charles Sumner and the Coming of the Civil War.* New York: Fawcett Columbine, 1960.

———. *Charles Sumner and the Rights of Man.* New York: Random House, 1970.

———. *Lincoln.* New York: Simon and Schuster, 1996.

Dormon, James H. "Shaping the Popular Image of Post-Reconstruction American Blacks: The 'Coon Song' Phenomenon of the Gilded Age." *American Quarterly* 40 (December 1988): 450–71.

Drago, Edmund L. *Hurrah for Hampton! Black Red Shirts in South Carolina During Reconstruction.* Little Rock, Ark.: University of Arkansas Press, 1999.

Duncan, Russell, ed. *Blue-Eyed Child of Fortune: The Civil War Letters of Colonel Robert Gould Shaw.* Athens: University of Georgia Press, 1992.

Dunlop, M. H. *Gilded City: Scandal and Sensation in Turn-of-the-Century New York.* New York: Perennial, 2000.

Edwards, Laura. "Extralegal Violence and the Planter Class: The Ku Klux Klan in the Alabama Black Belt during Reconstruction." In *Local Matters: Race, Crime, and Justice in the Nineteenth Century South,* edited by Christopher Waldrep and Donald G. Nieman, 125–54. Athens: University of Georgia Press, 2001.

Ellis, Richard J., and Michael Thompson, eds. *Culture Matters: Essays in Honor of Aaron Wildavsky.* Boulder, Colo.: Westview Press, 1997.

Erie, Steven P. *Rainbow's End: Irish-Americans and the Dilemmas of Urban Machine Politics, 1840–1985.* Berkeley, Calif.: University of California Press, 1988.

Ernst, Robert. *Immigrant Life in New York City, 1825–1863.* New York: King's Crown Press, 1949.

Exman, Eugene. *The Brothers Harper.* New York: Harper and Row, 1965.

———. *The House of Harper.* New York: Harper and Brothers, 1967.

Fahs, Alice. *The Imagined Civil War.* Chapel Hill, N.C.: University of North Carolina Press, 2001.

Fahs, Alice, and Joan Waugh, eds. *The Memory of the Civil War in American Culture.* Chapel Hill, N.C.: University of North Carolina Press, 2004.

Faust, Albert Bernhardt. *The German Element in the United States.* Vols. 1 and 2. New York: Steuben Society of New York, 1927.

Feaver, William. *Masters of Caricature: From Hogarth and Gillray to Scarfe and Levine.* New York: Knopf, 1981.

Feinberg, Leonard. *The Satirist.* New York: The Citadel Press, 1965.

Finlay, Karen. "Daumier and 'La Caricature.'" Pamphlet by the Art Gallery of Toronto, 1984–1985.

Fischer, Roger A. "Nast, Keppler and the Mass Market." *Ink Spots* 4, no. 2 (May 1997): 26–31.

———. *Them Damned Pictures: Explorations in American Political Cartoon Art.* North Haven, Conn.: Archon Books, 1996.

Fisher, Edwin, Mort Gerberg, and Ron Wolin, eds. *The Art in Cartooning: Seventy-Five Years of American Magazine Cartoons.* New York: Charles Scribner and Sons, 1975.

Fitzgerald, Richard. *Art and Politics.* New York: Greenwood Press, 1973.

Flower, Milton E. *James Parton: The Father of Modern Biography.* Durham, N.C.: Duke University Press, 1951.

Fogelman, Aaron Spencer. *Hopeful Journeys: German Immigration, Settlement, and Political Culture in Colonial America, 1717–1775.* Philadelphia: University of Pennsylvania Press, 1996.

Foner, Eric. *Free Soil, Free Labor, Free Men.* 2d ed. New York: Oxford University Press, 1995.

———. *Reconstruction: America's Unfinished Revolution, 1863–1877.* New York: HarperCollins, 2002.

Forbes, Edwin. *Thirty Years After: An Artist's Memoir of the Civil War.* New York: Howard and Hulbert, 1890. Reprint, Baton Rouge: Louisiana State University Press, 1993.

Fry, William F., Jr. *Sweet Madness: A Study of Humor.* Palo Alto, Calif.: Pacific Books, 1963.

Furer, Howard B. *The Germans in America, 1607–1970.* Dobbs Ferry, N.Y.: Oceana Publications, Inc., 1973.

Gambee, Budd Leslie, Jr. *Frank Leslie and His Illustrated Newspaper.* Ann Arbor, Mich.: University of Michigan Department of Library Sciences, 1964.

Gambone, A.M. *Major-General Darius Couch: Enigmatic Valor.* Baltimore, Md.: Butternut and Blue, 2000.

Gardiner, John A., and David J. Olson, eds. *Theft of the City: Readings on Corruption in Urban America.* Bloomington: Indiana University Press, 1974.

George, M. Dorothy. *Hogarth to Cruikshank: Social Changes in Graphic Satire.* New York: Viking Press, 1988.

Gerber, David, and Alan Kraut. *American Immigration and Ethnicity.* New York: Palgrave Macmillan, 2005.

Gilman, Ernest. *The Curious Perspective: Literary and Pictorial Wit in the Seventeenth Century.* New Haven, Conn.: Yale University Press, 1978.

Gombrich, E. H. *Art and Illusion*. Princeton, N.J.: Princeton University Press, 1960.

——. *Caricature*. Middlesex, England: King Penguin Books, 1940.

——. *The Uses of Images: Studies in the Social Function of Art and Visual Communication*. London: Phaidon, 1999.

Gorn, Elliott J. *The Manly Art: Bare-Knuckle Prize Fighting in America*. Ithaca, N.Y.: Cornell University Press, 1986.

Gould, Ann, ed. *Masters of Caricature: From Hogarth and Gillray to Scarfe and Levine*. New York: Knopf, 1981.

Greeley, Horace. *What I Know of Farming: A Series of Brief and Plain Expositions of Practical Agriculture as an Art Based upon Science*. New York: G. W. Carleton, 1871.

Greenfield, Lisa. *Nationalism: Five Roads to Modernity*. Cambridge, Mass.: Harvard University Press, 1992.

Greer, Scott. *Governing the Metropolis*. New York: Wiley and Sons, 1962.

——. *Metropolitics: A Study of Political Culture*. New York: John Wiley and Sons, 1963.

Gronowicz, Anthony. *Race and Class Politics in New York City Before the Civil War*. Boston: Northeastern University Press, 1998.

Guernsey, Alfred H., and Henry M. Alden. *Harper's Pictorial History of the Great Rebellion*. Vols. 1 and 2. New York: Harper and Brothers, 1866 and 1868.

Hamerow, Theodore S. "The Two Worlds of the Forty-Eighters." In *The German Forty-Eighters in the United States*, edited by Charlotte Brancaforte, 19–35. New York: Peter Lang, 1989.

Handlin, Oscar. *Boston's Immigrants*. New York: Athenaeum, 1972.

Harding, Vincent. *There Is a River: The Black Struggle for Freedom in America*. New York: Harcourt, 1981.

Harper, J. Henry. *The House of Harper*. New York: Harper and Brothers, 1912.

Harring, Sidney L. *Policing a Class Society: the Experience of American Cities, 1865–1915*. New Brunswick, N.J.: Rutgers University Press, 1983.

Harris, James F. "The Arrival of the Europamude: Germans in America after 1848." In *The German Forty-Eighters in America*, edited by Charlotte Brancaforte, 1–17. New York: Peter Lang, 1989.

Harrison, John M. *The Man Who Made Nasby: David Ross Locke*. Chapel Hill: University of North Carolina Press, 1969.

Hawgood, John A. *The Tragedy of German-America: The Germans in the United States of America during the Nineteenth Century and After*. New York: G. P. Putnam's and Sons, 1940.

Headley, Joel Tyler. *The Great Riots of New York, 1712–1873*. New York: E. B. Treat, 1873.

Hess, Stephen, and Sandy Northrop. *Drawn and Quartered: The History of American Political Cartoons*. Montgomery, Ala.: Elliott and Clark, 1996.

Higham, John. *Strangers in the Land: Patterns of American Nativism, 1860–1925*. New Brunswick, N.J.: Rutgers University Press, 1998.

Hignite, Todd. *In the Studio: Visits with Contemporary Cartoonists*. New Haven, Conn.: Yale University Press, 2006.

Hill, Draper. *Fashionable Contrasts: 100 Caricatures by James Gillray*. London: Phaidon, 1966.

———. *Mr. Gillray: The Caricaturist*. London: Phaidon Press, 1965.

Hills, Patricia. "Cultural Racism: Resistance and Accommodation in the Civil War Art of Eastman Johnson and Thomas Nast." In *Seeing High and Low: Representing Social Conflict in American Visual Culture*, edited by Patricia Johnston, 103–23. Berkeley: University of California Press, 2006.

Hobsbawm, E. J. *Nations and Nationalism since 1780: Programme, Myth, Reality*. Cambridge: Cambridge University Press, 1992.

Hodges, Graham. "'Desirable Companions and Lovers': Irish and African Americans in the Sixth Ward, 1830–1870." In *The New York Irish*, edited by Ronald H. Bayor and Timothy J. Meagher, 107–24. Baltimore, Md.: Johns Hopkins University Press, 1996.

Hogge, Jeffery A. *Norton Parker Chipman: A Biography of the Andersonville War Crimes Prosecutor*. New York: McFarland, 2008.

Holzer, Harold. "'Spirited and Authentic': Thomas Nast, Civil War Artist." In *Thomas Nast and the Glorious Cause: An Exhibition by Macculloch Hall Historical Museum*, edited by Carol Bere. Morristown, N.J.: Macculloch Hall Historical Museum, 1996.

———, ed. *Prang's Civil War Pictures: The Complete Battle Chromos of Louis Prang*. New York: Fordham University Press, 2001.

Homberger, Eric. *The Historical Atlas of New York City*. New York: Holt, 1998.

Hoobler, Dorothy. *The German American Family Album*. New York: Oxford University Press, 1996.

Ingersoll, L. D. *The Life of Horace Greeley*. Chicago: Union Publishing Company, 1873.

Ivins, William M., Jr. *Prints and Visual Communication*. Cambridge, Mass.: Harvard University Press, 1953.

Jarman, Baird. "The Graphic Art of Thomas Nast: Politics and Propriety in Postbellum Publishing." In *American Periodicals: A Journal of History, Criticism, and Bibliography* 20, no. 2 (2010): 156–89.

Jeffers, H. Paul. *An Honest President: The Life and Presidencies of Grover Cleveland*. New York: Perennial Books, 2002.

Johnson, Donald Bruce, and Kirk Harold Porter. *National Party Platforms, 1840–1972*. Urbana: University of Illinois Press, 1973.

Johnston, Patricia, ed. *Seeing High and Low: Representing Social Conflict in American Visual Culture*. Berkeley: University of California Press, 2006.

Keese, William L. *William E. Burton, Actor, Author, and Manager: A Sketch of His Career with Recollections of His Performances*. New York: G. P. Putnam's Sons, 1885.

Keller, Morton. *The Art and Politics of Thomas Nast*. New York: Oxford University Press, 1968.

———. "The World of Thomas Nast." Ohio State University Cartoon Research Library, http://cartoons.osu.edu/nast/keller_web.htm.

Kelly, Robert. *The Transatlantic Persuasion: The Liberal Democratic Mind in the Age of Gladstone*. New York: Knopf, 1969.

Klein, Carole. *Gramercy Park: An American Bloomsbury*. Baltimore, Md.: Johns Hopkins University Press, 1987.

Knobel, Dale T. *Paddy and the Republic: Ethnicity and Nationality in Antebellum America*. Middletown, Conn.: Wesleyan University Press, 1986.

Kouwenhoven, John A. *Adventures of America, 1857–1900: A Pictorial Record from "Harper's Weekly."* New York: Harper and Brothers, 1938.

Kraut, Alan. *American Immigration and Ethnicity*. New York: Palgrave MacMillan, 2005.

Lamb, Chris. *Drawn to Extremes: The Use and Abuse of Editorial Cartoons*. New York: Columbia University Press, 2004.

LeBeau, Bryan F. *Currier & Ives: America Imagined*. Washington, D.C.: Smithsonian Institution Press, 2001.

Leonard, Thomas C. *News for All: America's Coming-of-Age with the Press*. New York: Oxford University Press, 1995.

———. *The Power of the Press: The Birth of American Political Reporting*. New York: Oxford University Press, 1986.

"Letter of Acceptance from U.S. Grant." *Official Proceedings of the National Republican Conventions of 1868, 1872, 1876, and 1880*. Philadelphia, Pa.: C. W. Johnson, 1903.

Levine, Bruce. *The Spirit of 1848: German Immigrants, Labor Conflict, and the Coming of the Civil War*. Urbana: University of Illinois Press, 1992.

Levine, Lawrence. *Highbrow, Lowbrow: The Emergence of Cultural Hierarchy in America*. Cambridge, Mass.: Harvard University Press, 1988.

Lively, James K. "Propaganda Techniques of Civil War Cartoonists." In *Public Opinion Quarterly* 6, no. 1 (Spring 1942): 99–106.

Locke, David Ross. "In Search of the Man of Sin." In *Modern Eloquence*. Vol. 5, edited by Thomas Brackett Reed et al., 759–85. New York: J. D. Morris, 1900.

———. *The Struggles of Petroleum V. Nasby*. Edited by Joseph Jones. Boston: Beacon Press, 1963.

Low, David. *British Cartoonists, Caricaturists and Comic Artists*. London: William Collins, 1942.

Lubetkin, M. John. *Jay Cooke's Gamble: The Northern Pacific Railroad, the Sioux, and the Panic of 1873*. Norman: University Press of Oklahoma, 2006.

Lucie-Smith, Edward. *The Art of Caricature*. Ithaca, N.Y.: Cornell University Press, 1981.

Manchester, William. *The Last Lion: Visions of Glory, 1874–1932*. New York: Bantam Doubleday Dell, 1983.

Mandelbaum, Seymour J. *Boss Tweed's New York*. Chicago: Ivan R. Dee, 1965.

Marzio, Peter. *The Democratic Art*. Fort Worth, Tex.: Amon Carter Museum of Western Art, 1979.

Masur, Louis P. "'Pictures Have Now Become a Necessity': The Use of Images in American History Textbooks." *Journal of American History* 84, no. 4 (March 1998): 1409–24.

Maxwell, W. H. *History of the Irish Rebellion in 1798*. London: H. G. Bohn, 1854.

Mayer, Henry. *All on Fire*. New York: W. W. Norton, 2008.

McDannell, Colleen. *The Christian Home in Victorian America, 1840–1900*. Bloomington: Indiana University Press, 1994.

McFarland, Gerald. *Mugwumps, Morals, and Politics, 1884–1920*. Amherst: University of Massachusetts Press, 1975.

McFeely, William S. *Grant: A Biography*. New York: W. W. Norton, 1982.

McKay, Ernest A. *The Civil War and New York City*. Syracuse, N.Y.: Syracuse University Press, 1990.

McKitrick, Eric L. *Andrew Johnson and Reconstruction*. New York: Oxford University Press, 1988.

McKivigan, John. *Forgotten Firebrand: James Redpath and the Making of Nineteenth-Century America*. Ithaca, N.Y.: Cornell University Press, 2008.

McPherson, James. *The Abolitionist Legacy*. Princeton, N.J.: Princeton University Press, 1975.

————. *Abraham Lincoln and the Second American Revolution*. New York: Oxford University Press, 1990.

Moore, Lucy, ed. *Con Men and Cutpurses: Scenes from the Hogarthian Underworld*. New York: Penguin Books, 2000.

Morris, Roy, Jr. *Fraud of the Century: Rutherford B. Hayes, Samuel Tilden and the Stolen Election of 1876*. New York: Simon and Schuster, 2003.

Mott, Frank Luther. *A History of American Magazines*. Vols. 2 and 3. New York: Oxford University Press, 1938.

Mushkat, Jerome. *Fernando Wood: A Political Biography*. Kent, Ohio: Kent State University Press, 1990.

————. *Tammany: The Evolution of a Political Machine, 1789–1865*. Syracuse, N.Y.: Syracuse University Press, 1971.

Nadel, Stanley. "The Forty-Eighters and the Politics of Class in New York City." In *German Forty-Eighters in America*, edited by Charlotte Brancaforte, 51–66. New York: Peter Lang, 1989.

Neely, Mark E., Jr. *The Union Divided: Party Conflict in the Civil War North*. Cambridge, Mass.: Harvard University Press, 2002.

Nelson, Scott Reynolds. *Iron Confederacies: Southern Railways, Klan Violence, and Reconstruction*. Chapel Hill: University of North Carolina Press, 1999.

Nevins, Allan, and Frank Weitenkampf. *A Century of Political Cartoons: Caricature in the United States from 1800 to 1900*. New York: Charles Scribner's Sons, 1944.

Nissenbaum, Stephen. *The Battle for Christmas*. New York: Vintage, 1997.

Nochlin, Linda. *Representing Women*. New York: Thames and Hudson, 1999.

O'Brien, Frank Michael. *The Story of "The Sun," New York: 1833–1918*. New York: George H. Doran, 1918.

O'Connor, Richard. *Bret Harte: A Biography*. Boston: Little, Brown, 1966.

Olson, Nancy. *Gavarni: The Carnival Lithographs*. New Haven, Conn.: Yale University Art Gallery, 1979.

Olson, Otto H. *Reconstruction and Redemption in the South*. Baton Rouge: Louisiana State University Press, 1980.

Overdyke, W. Darrell. *The Know-Nothing Party in the South*. Gloucester, Mass.: Peter Smith, 1968.

Paine, Albert Bigelow. *Thomas Nast: His Period and His Pictures*. New York: Harper and Brothers, 1904.

Paludan, Phillip Shaw. *A People's Contest: The Union and Civil War, 1861–1865*. Lawrence: University Press of Kansas, 1996.

Parton, James. *Caricature and Other Comic Art in All Times and Many Lands*. New York: Harper and Brothers, 1877.

———. *The Life and Times of Aaron Burr*. Boston: Houghton, Mifflin, 1886.

———. *The Life of Horace Greeley*. New York: J. R. Osgood, 1872.

Patten, Robert L. *George Cruikshank's Life, Times, and Art*. Princeton, N.J.: Princeton University Press, 1992.

Paxson, Frederick L. "The Rise of Sport." *Mississippi Valley Historical Review* 4, no. 2 (September 1917): 143–68.

Pearson, Andrea G., *"Frank Leslie's Illustrated News* and *Harper's Weekly*: Imitation and Innovation in Nineteenth-Century Pictorial Reporting." *Journal of Popular Culture* 23, no. 4 (Spring 1990): 81–111.

Perry, Mark. *Grant and Twain: The Story of a Friendship That Changed America*. New York: Random House, 2004.

Pfitzer, Gregory M. *Picturing the Past: Illustrated Histories and the American Imagination, 1840–1900*. Washington, D.C.: Smithsonian Institution Press, 2002.

Phillipe, Robert. *Political Graphics: Art as a Weapon*. New York: Abbeville Press, 1980.

Pierce, Sally, and Catharine Slautterback. *Boston Lithography, 1825–1880*. Boston: Boston Athenaeum, 1991.

Polakoff, Kenneth Ian. *The Politics of Inertia: The Election of 1876 and the End of Reconstruction*. Baton Rouge: Louisiana State University Press, 1973.

Pond, J. B. *Eccentricities of Genius: Memories of Famous Men and Women of the Platform and Stage*. New York: G. W. Dillingham, 1900.

Quennell, Peter. *Hogarth's Progress*. New York: Viking Press, 1955.

Quigley, David. *Second Founding: New York City, Reconstruction, and the Making of American Democracy*. New York: Hill and Wang, 2004.

Rael, Patrick. *Black Identity and Black Protest in the Antebellum North*. Chapel Hill: University of North Carolina Press, 2002.

Ray, Frederick E. *Alfred R. Waud: Civil War Artist*. New York: Viking Press, 1974.

Restad, Penne. *Christmas in America*. New York: Oxford University Press, 1996.

Riall, Lucy. *Garibaldi: Invention of a Hero*. New Haven, Conn.: Yale University Press, 2007.

Ridley, Jasper. *Garibaldi*. New York: Viking Press, 1974.

Rock, Howard B., Paul A. Gilje, and Robert Asher, eds. *American Artisans: Crafting Social Identity, 1750–1850*. Baltimore, Md.: Johns Hopkins University Press, 1995.

Rogers, W. G. *Mightier than the Sword: Cartoon, Caricature, Social Comment*. New York: Harcourt Brace, 1969.

Rothan, Reverend Emmet H. *The German Catholic Immigrant in the United States, 1830–1860*. Washington, D.C.: Catholic University of America Press, 1946.

Ryan, Michael. *Politics and Culture: Working Hypotheses for a Post-Revolutionary Society*. Baltimore, Md.: Johns Hopkins University Press, 1989.

Samuels, Shirley, ed. *The Culture of Sentiment: Race, Gender, and Sentimentality in Nineteenth-Century America*. New York: Oxford University Press, 1992.

Sanjek, Roger. *The Future of Us All: Race and Neighborhood Politics in New York City*. Ithaca, N.Y.: Cornell University Press, 1998.

Savage, Kirk. *Standing Soldiers, Kneeling Slaves: Race, War, and Monument in Nineteenth-Century America*. Princeton, N.J.: Princeton University Press, 1997.

Saville, Julie. *The Work of Reconstruction: From Slave Labor to Wage Labor in South Carolina, 1860–1870*. New York: Cambridge University Press, 1996.

Scharnhorst, Gary, ed. *Bret Harte's California*. Albuquerque, N.M.: University of New Mexico Press, 1990.

———. *Selected Letters of Bret Harte*. Norman: University of Oklahoma Press, 1997.

Schlereth, Thomas J. *Victorian America: Transformations in Everyday Life, 1876–1915*. New York: HarperCollins, 1991.

Schlesinger, Arthur M. *History of U.S. Political Parties*. Vol. 2. New York: Chelsea House, 1973.

Schudson, Michael. *Discovering the News: A Social History of American Newspapers*. New York: Basic Books, 1978.

Schurz, Carl. *The Autobiography of Carl Schurz*. Abridged ed. New York: Charles Scribner's Sons, 1961.

———. *The Reminiscences of Carl Schurz*. Vol. 3. Garden City, N.J.: Doubleday, Page, 1917.

Scisco, Louis Dow. *Political Nativism in New York State*. New York: Columbia University Press, 1901.

Scudder, Horace Elisha. *James Russell Lowell: A Biography*. New York: Scholarly Press, 1968.

———. *Letters of James Russell Lowell*. New York: AMS Press, 1990.

Serrin, Judith, and William Serrin, comp. *Muckraking! The Journalism that Changed America*. New York: New Press, 2002.

Shelley, Percy Bysshe. *Prometheus Unbound*. In *The Poetical Works of Percy Bysshe Shelley*, edited by Mary Wollstonecraft Shelley. London: E. Moxon, 1839.

Silverman, Debora. *Van Gogh and Gauguin: The Search for Sacred Art*. New York: Farrar, Strauss and Giroux, 2000.

Simpson, Brooks. *The Reconstruction Presidents*. Lawrence: University Press of Kansas, 1998.

Simpson, Roger. *Sir John Tenniel: Aspects of His Work*. Cranbury, N.J.: Associated University Press, 1994.

Skowronek, Stephen. *Building a New American State*. New York: Cambridge University Press, 1982.

Smith, Anthony D. *National Identity*. Reno: University of Nevada Press, 1993.

Smith, Shawn Michelle. *American Archives: Gender, Race, and Class in Visual Culture*. Princeton, N.J.: Princeton University Press, 1999.

Spann, Edward K. *Gotham at War: New York City, 1860–1864*. Wilmington, Del.: Scholarly Resources, 2002.

———. "Union Green: The Irish Community and the Civil War." In *The New York Irish*, edited by Ronald H. Bayor and Timothy J. Meagher, 193–212. Baltimore, Md.: Johns Hopkins University Press, 1996.

Sperber, Jonathan. *The European Revolutions, 1848–1851*. Cambridge: Cambridge University Press, 2005.

St. Hill, Thomas Nast. *Thomas Nast: Cartoons and Illustrations*. New York: Dover, 1974.

Stimson, Robbe Pierce. *The Vanderbilts in the Gilded Age*. New York: St. Martin's Press, 1991.

Street, John. *Politics and Popular Culture*. Cambridge, England: Polity Press, 1997.

Summers, Mark Wahlgren. *A Dangerous Stir: Fear, Paranoia and the Making of Reconstruction*. Chapel Hill: University of North Carolina Press, 2009.

———. *The Era of Good Stealings*. Chapel Hill: University of North Carolina Press, 1993.

———. *Party Games: Getting, Keeping, and Using Power in Gilded Age Politics*. Chapel Hill: University of North Carolina Press, 2004.

———. *The Press Gang: Newspapers and Politics, 1865–1878*. Chapel Hill: University of North Carolina Press, 1994.

———. *Rum, Romanism, and Rebellion: The Making of a President, 1884*. Chapel Hill: University of North Carolina Press, 2000.

Taine, Hippolyte. *The Philosophy of Art*. London: Williams and Norgate, 1867.

Tatham, David. *Winslow Homer and the Pictorial Press*. Syracuse, N.Y.: Syracuse University Press, 2003.

Taylor, John M. *Garfield of Ohio: The Available Man*. New York: W. W. Norton, 1970.

Taylor, Joshua C., ed. *Nineteenth-Century Theories of Art*. Berkeley: University of California Press, 1987.

Thompson, W. Fletcher. *The Image of War: The Pictorial Reporting of the American Civil War*. New York: Thomas Yoseloff, 1959.

Toll, Robert C. *Blacking Up: The Minstrel Show in Nineteenth-Century America*. New York: Oxford University Press, 1974.

Tolzmann, Don Heinrich. *The German-American Experience*. New York: Humanity Books, 2000.

———. *The German-American Forty-Eighters, 1848–1998*. Indianapolis: Max Kade German-American Center, 1997.

Trefousse, Hans. *Carl Schurz: A Biography*. 2d ed. New York: Fordham University Press, 1998.

Trommler, Frank, and Joseph McVeigh, eds. *America and the Germans: An Assessment of a Three-Hundred-Year History*. Philadelphia: University of Pennsylvania Press, 1985.

Trommler, Frank, and Elliott Shore, eds. *The German-American Encounter: Conflict and Cooperation between Two Cultures, 1800–2000*. New York: Berghahn Books, 2001.

Valencius, Conevery Bolton. *The Health of the Country: How American Settlers Understood Themselves and Their Land*. New York: Basic Books, 2002.

Vann, J. Don, and Rosemary T. VanArsdel, eds. *Victorian Periodicals and Victorian Society*. Toronto, Canada: University of Toronto Press, 1994.

Venet, Wendy Hammond. *A Strong-Minded Woman: The Life of Mary Livermore*. Boston: University of Massachusetts Press, 2005.

Vinson, J. Chal. *Thomas Nast: Political Cartoonist*. Athens: University of Georgia Press, 1967.

Warren, Joyce W. *Fanny Fern: An Independent Woman*. New Brunswick, N.J.: Rutgers University Press, 1994.

Waugh, Joan. *Unsentimental Reformer: The Life of Josephine Shaw Lowell*. Cambridge, Mass.: Harvard University Press, 1997.

—————. *U. S. Grant: American Hero, American Myth*. Chapel Hill: University of North Carolina Press, 2009.

Wechsler, Judith. *A Human Comedy: Physiognomy and Caricature in Nineteenth-Century Paris*. Chicago: University of Chicago Press, 1982.

Weigley, Russell Frank. *Morristown: A History and Guide*. Washington, D.C.: National Park Service, 1984.

Weintraub, Stanley. *Whistler: A Biography*. New York: Da Capo Press, 1974.

Welch, Stephen. *The Concept of Political Culture*. New York: St. Martin's Press, 1993.

Wells, David A. *Robinson Crusoe's Money; or, The Remarkable Financial Fortunes and Misfortunes of a Remote Island Community*. New York: Harper and Brothers, 1876.

Werner, M. R. *Tammany Hall*. Garden City, N.Y.: Doubleday, 1928.

West, Richard Samuel. *Satire on Stone: The Political Cartoons of Joseph Keppler*. Chicago: University of Illinois Press, 1988.

Widmer, Edward L. *Young America: The Flowering of Democracy in New York City*. New York: Oxford University Press, 1999.

Williams, Robert C. *Horace Greeley: Champion of American Freedom*. New York: New York University Press, 2006.

Williams, T. Harry, ed. *Hayes: The Diary of a President, 1875–1881*. New York: McKay Company Press, 1964.

Williams, William H. A. *'Twas Only an Irishman's Dream: The Image of Ireland and the Irish in American Popular Song Lyrics, 1800–1920*. Urbana: University of Illinois Press, 1996.

Williamson, Joel. *The Crucible of Race: Black-White Relations in the American South Since Emancipation*. New York: Oxford University Press, 1984.

Wittke, Carl. *Refugees of Revolution: The German Forty-Eighters in America*. Philadelphia: University of Pennsylvania Press, 1952.

Woodward, C. Vann. *Reunion and Reaction: The Compromise of 1877 and the End of Reconstruction*. Rev. ed. New York: Doubleday, 1956.

Wright, Thomas. *A History of Caricature and Grotesque in Literature and Art.* London: Virtue Brothers, 1865.

Yellowitz, Irwin, ed. *Essays in the History of New York City: A Memorial to Sidney Pomerantz.* Port Washington, N.Y.: National University Publications, 1978.

Zucker, A. E. *The Forty-Eighters: Political Refugees of the German Revolution of 1848.* New York: Columbia University Press, 1950.

Zuczek, Richard. *State of Rebellion: Reconstruction in South Carolina.* Columbia: University of South Carolina Press, 2009.

Unpublished Dissertations and Theses

Bell, Christine Anne. "A Family Conflict: Visual Imagery of the 'Homefront' and the War Between the States, 1860–1866." Ph.D. diss., Northwestern University, 1996.

Broome, Michael John. "Horses' Heads, Mint Drops, Talking Rats and Bell Ringers: Mid-Nineteenth Century American Politics and the Wild World of Political Cartoons." Ph.D. diss., University of Virginia, 2001.

Hackett, M. A. "Thomas Nast: Anti-Catholic or Anti-Clerical? ." Master's thesis, University of Virginia, 1983.

Kennedy, Robert Charles. "Crisis and Progress: The Rhetoric and Ideals of a Nineteenth Century Reformer, George William Curtis (1824–1892)." Ph.D. diss., University of Illinois at Urbana–Champaign, 1993.

Khalsa, Puran Singh. "Thomas Nast and *Harper's Weekly*: 1862–1886." Ph.D. diss., University of California, Santa Barbara, 1984.

Slap, Andrew. "Transforming Politics: The Liberal Republican Movement and the End of Civil War Era Political Culture." Ph.D. diss., Pennsylvania State University, 2002.

Vlasak, Marian. "Political Cartoonists in the Land of Oz: The Source of L. Frank Baum's Imagery." Master's thesis, Syracuse University, 1996.

INDEX

Italic page numbers refer to illustrations.